Picturing the Past

Picturing the Past

Illustrated Histories and the American Imagination, 1840–1900

Gregory M. Pfitzer

SMITHSONIAN INSTITUTION PRESS
Washington and London

COPY EDITOR: Karin Kaufman
PRODUCTION EDITOR: Ruth G. Thomson
DESIGNER: Janice Wheeler

Library of Congress Cataloging-in-Publication Data
Pfitzer, Gergory M.
 Picturing the past : illustrated histories and the American
imagination, 1840–1900 / Gregory M. Pfitzer.
 p. cm.
 Includes bibliographical references and index.
 ISBN 1-58834-084-8 (alk. paper)
 1. United States—Historiography. 2. Illustrated books—
United States—History—19th century. 3. Historiography—
Social aspects—United States—History—19th century.
4. Visual communication—Social aspects—United States—
History—19th century. 5. National characteristics, American.
I. Title.
E175.P477 2002
973′.07′2—dc21 2002018801

British Library Cataloging-in-Publication Data available

Manufactured in the United States of America
09 08 07 06 05 04 03 02 5 4 3 2 1

For my father, Dr. Emil A. Pfitzer,

the most loving of all care givers,

and for my mother, Jeanne F. Pfitzer,

experiencing the long good-bye

Contents

Illustrations

Preface
Picturing History

The general purpose of this study is to consider the role of visual literacy in the development of an American historical imagination. More specifically, I am interested in the life cycle of a little-studied genre of historical literature: nineteenth-century pictorial histories of the United States. Working primarily between the years of 1840 and 1900 the authors of these illustrated works employed "pictorial modes of knowing" as a means of supplementing and redefining traditional interpretations of the past. They adapted changing representational print forms available to artists (woodcuts, lithographs, and eventually photographs) to the purposes of finding more accessible and more democratic modes of historical understanding, in the process influencing the channels through which historical ideas entered the national consciousness. My goal is to analyze the forms of these channels with special attention to the ways in which the interaction of visual images and printed words determined the kind and intensity of history Americans absorbed. I am also interested in how and why such pictorial forms achieved, sustained, and then lost popularity over time.

My personal interest in these pictorial texts emerged, appropriately enough, as a revolt from formalized, scholarly approaches to the past. As a graduate student I spent countless hours during the months I should have been preparing for my oral examinations prowling around used bookshops, thumbing through mildewed volumes and chatting with bearded, pipe-smoking booksellers about how "business was going." During such "study breaks" I found myself drawn irresistibly toward "pictorial" histories of the United States, a mildly scandalous captivation I should add, because these illustrated histories were so very different from the professional monographs with which I was occupied as a graduate student. Many of these distracting pictorial works were fanciful and overwritten, others simpleminded and unprofessional. They included highly sentimentalized and distorted visual images as well as competent and richly exquisite ones, and my fascination with them was an academic sacrilege of sorts in an age when graduate students were trained in the best postmodern tradition to fear what W. J. T. Mitchell called "the absorption of all language into images and 'simulacra.'" Better to

"collect" and enjoy these pictorial histories as curios and diversions, my conscience told me, and to stay focused intellectually on the headier texts associated with my training as a professional historian.

After nearly two decades of teaching and writing history, I have now returned to my bookshelves and to the pictorial histories I collected apologetically many years ago. My decision to research these volumes now, years after I first amassed them, derives from two sources: the growing confidence I take in the rise over the past few years of "visual culture studies" and the emergence of methodologies suitable for evaluating the power of visual images to captivate readers. And captivate they do. Every aspect of their packaging, from their flamboyant covers to their mawkish illustrations to their pictorial idioms, was devised to provide maximum visual effect. Marketed for diverse audiences at the national and international level, they were often "epic" and grand in scale. They were targeted at semiliterate and immigrant populations who needed to get their history as much through pictures as through texts as well as at those more conversant in American historical traditions who wished to reaffirm their commitments to nationhood by refamiliarizing themselves with stirring narrative portrayals and dramatic visualizations of sacred historical events. They were mass-marketed and overproduced (hence their availability in used bookstores even today), yet they retain their special ability to attract the "eye" of the contemporary reader.

Even more than other forms of neglected popular culture, these illustrated histories seemed to me to be crying out for intellectual treatment, and so I determined to ask certain questions of them, especially three: (1) In what ways is the past understood differently when it is presented in pictures *and* words rather than in traditional literary form merely? (2) How do illustrations interact with the narrative discourses in these volumes and how do various word/image combinations condition, alter, and even distort the past? (3) What does the popularity of pictorial histories tell us about the visual literacy and reading habits of nineteenth-century Americans?

In seeking answers to these questions I quickly discovered that the story of the rise and fall of illustrated histories is inevitably one of the collaboration of authors, illustrators, publishers, and book agents, all of whom contributed in differing degrees to the advancement of the genre. In the 1840s the role of illustrators in pictorial histories was limited by the inadequate technologies available for reproducing visual images in texts. Publishers maintained a great deal of control over the printed page, integrating crude woodcuts only where modest pictorial efforts would help the marketability of their works. Writers rarely composed their historical texts with pictures in mind, recognizing as they did that the use of any illustrative material was limited and at the discretion of the publisher. As technologies of duplication improved and the costs of reproduction were reduced, however, artists assumed a larger role in the planning and formatting of pictorial histories. By the 1870s illustrators had become so central to the manufacturing and marketing of such books that historians composed narratives in anticipation of the requirements of the artists who would be pictorializing them. Throughout this period illustrations were incorporated into historical works in relationships ranging from what Mitchell calls the "disjunctive" (illustrations that bear little relationship to the texts in which they are included) to the "synthetic" (pictorial devices that obscure the distinctions between writing and drawing). In nearly all cases the presumption among producers of pictorial histories was that an intricate symbiosis exists between words and images.

By the late nineteenth century, improvements in

chromolithography and photography not only increased capabilities for reproducing pictorial images but also provided new opportunities for visualizing historical events as they occurred. In light of such advances illustrated histories became highly valued as agents of the visual in the 1890s, sparking a golden age of pictorial history. In the last decade of the nineteenth century nearly every major publishing house marketed at least one pictorial history of the United States (and frequently more), inventing more and more elaborate and dramatic ways to affirm the relationship between historical narratives and the pictorial elements used to embellish them. Yet, ironically, the attention gained for such works by the active advertising campaigns of publishers also invited closer scrutiny of illustrated texts by a new breed of turn-of-the-century professional historians who expressed deep concerns about the usurping qualities of the visual and the "deverbalization" of culture. These professionals spearheaded a rebellion of sorts against the use of all visual evidence in history, warning of the potential dangers of pictorial forms for vulnerable readers of popular historical literature. For reasons we will consider later, these attacks on the visual by scholars had a greater impact on the general public's reading of history than on almost any other area of intellectual inquiry, contributing to a rather abrupt curtailment of the genre's claims and influence. Although some practitioners of pictorial history persisted into the twentieth century, many more succumbed to the criticisms directed against them in the 1890s by conservative "custodians of culture" and by professional historians affiliated with historical associations and academic institutions. Having outlived its usefulness after more than half a century of service in the cause of strengthening historical understanding, the genre of pictorial history was forced to give way to less visually oriented forms of historical presentation, including the monograph, the journal article, and the professional paper.

The study of the visual has become very fashionable in many areas of cultural inquiry over the past decade. In offering my own contribution to this discussion, I have drawn particularly on the interdisciplinary methodologies of my professional field of American Studies (I did manage to finish graduate school), in the process making connections among the areas of popular culture, the history of the book, picture theory, and the literary exegesis of texts. In ranging so widely I have made substantial use of a number of theoretical insights from important works in the fields of literary criticism, philosophy, and art history, especially those of W. J. T. Mitchell, Estelle Jussim, Alan Trachtenberg, and David Morgan. Although I have appropriated a number of the influential ideas developed in the provocative works of these scholars concerning the relationship between the word and the image, I have made a conscious effort (as indeed have most of them) to avoid the jargon that accompanies much of the literature of "picture theory." I do so as a way of reaching out to readers not conversant in the languages of iconology and semiotics nor comfortable with the terminologies of signifiers and the signified. It is my hope that the important theoretical ideas so fundamental to contemporary professional scholarship on visual and verbal literacy might be made more understandable and useful to general readers by an elimination of their specialized vocabularies.

In presenting an illustrated history book on the history of illustrated history books, I feel a little like Cosmo Kramer, the meddlesome but loveable neighbor of Jerry on the *Seinfeld* television show, who attempted to market a coffee table book on coffee tables. The idea seemed sound enough to Kramer, but most could not get beyond the ironic redundancy of

the subject. In trying to explain to family and friends what I have been working on these past years, I have not been successful always in clarifying that I am not writing a pictorial history of my own so much as analyzing the illustrated histories of others. Some of those closest to me who have witnessed my struggles to select visual images for this study have assumed that I have been laboring hard to embellish my text with pictures when in fact pictures are my text to a large extent. I am also well aware that the selections of pictorial materials I have made here will be subject to the very criteria of judgment used by me to criticize the visual choices of nineteenth-century pictorial historians. But my ambition is not to compete with the illustrated works that are both cause and effect of my own work. Instead, my real purpose is to suggest the value of such pictorial histories for our understanding of how the visual affects historical memory and to chart the complex relationships between words and images in the construction and narration of memory.

If I can direct scholarly attention to this underappreciated genre of historical literature, I will be happy. But I will be happier still if I can persuade general readers to take an interest in those dusty volumes of pictorial history that continue to occupy space on the shelves of used bookstores where bearded, pipe-smoking booksellers distract graduate students from their conventional wisdoms.

Acknowledgments

There are many people I need to thank for helping me to complete this book, not the least of whom is my mechanic, Sid, who kept several of my old cars in running order so that I could make research trips to remote public libraries and private archival collections across the country. Some once highly popular but now little-known people wrote and illustrated the pictorial histories studied in this book, and their obscure manuscripts, letters, and prints would have been impossible to track down without Sid's genius for auto repair.

I owe a special debt of gratitude to the directors and staffs of various archival collections for their tireless efforts in retrieving materials and in providing me with comfortable surroundings in which to work. I wish to acknowledge especially the staffs of the following libraries: the Huntington Library, the Library of Congress, the Pennsylvania Historical Society, the Rutherford B. Hayes Presidential Library, the Houghton Library, the New York Historical Society, the Crandall Library, the American Antiquarian Society, and the New York Public Library. I also wish to thank the patient and hardworking staffs at the following university libraries for their attentiveness to

my needs: Princeton, California at Berkeley, Columbia, Harvard, Iowa, De Pauw, Tennessee at Knoxville, Indiana, Syracuse, Wisconsin, and Cornell. I am in debt to numerous art institutes and museums as well for permission to consult their collections and to cite materials, especially the William L. Clement Library at the University of Michigan, the Pennsylvania Academy of the Fine Arts, and the Office of the Architect of the Capitol in Washington, D.C.

Let me take this opportunity to extend a special note of thanks to friends and colleagues who listened uncomplainingly over the years as I prattled on about my project or who performed the more herculean task of reading drafts of the manuscript, including David Baum, Alan Brinkley, David Lowenthal, Mark Hirsch, Catherine Golden, and Neil Jumonville. Their suggestions for improvement have been incorporated throughout this book. My colleagues in American Studies at Skidmore College have been a constant source of inspiration, especially Brian Black, Wilma Hall, Phil Hardy, Mary Lynn, Mary Nell Morgan, Alondra Nelson, Jerry Philogene and Joanna Zangrando. I also received indispensable help from Skid-

more associates Nancy Otrembiak, Hunt Conard, Amy Syrell, Marilyn Scheffer, Ruth Copans, Mary O'Donnell, Sandra Brown, and David Seiler. Skidmore deans Phyllis Roth, John Berman, and Chuck Joseph also provided much-needed financial and administrative support as the book progressed.

Finally, I would like to thank those closest to me, family and friends, some of whom reached maturity along with this project. Members of my immediate family, including my in-laws and new house mates, Mary and Charles McCrossan, have been constant supporters of my work, as have their children, their children's spouses, and their grandchildren, Fran, Pat, Steve, Kathy, Meaghan, Matthew, Patrick, Mary Beth, Daniel, and Carrie. I hope these McCrossans will not object to my singling out for special mention my nephew, Gregory McCrossan, who can no longer say now (as he did many times during the production of *Picturing the Past*) that he has never had his name in a book. I would also like to express my abiding love and appreciation for my brothers and sister, Gary, Gordon, and Margaret, and for their spouses and children, Gabriela, Terry, Ian, Connor, Seeley, and Katie, who motivated me to do the very best I could on behalf of the family name. I owe the deepest debt of gratitude to my parents, Emil and Jeanne, whose untold sacrifices prepared the ground for the writing of this work. *Picturing the Past* is dedicated to them.

Most of all I want to thank my wife, Mia, who has taken up more than her fair share of the tasks left undone by me as I worked on this book, and my children, Michael Charles and Sarah Jeanne (Sally), who inspire me every day with their passions for learning. It was their love of reading picture books at bedtime that renewed my interest in illustrated volumes. With every selection they made from their bookshelves at night, they answered implicitly the rhetorical question posed in the *Adventures in Wonderland:* "What is the use of a book," asked Alice, "without pictures and conversations?"

Picturing the Past

Introduction

"I Can Read Pikturs to a D——n"

In an 1839 volume of the Crockett almanacs there is an uproarious account of an exchange between Davy Crockett and a mythical, nautical hero named Ben Harding, a Mike Fink of sorts who boasts and spits in the best tradition of American maritime folk heroes. One day, the story begins, Crockett was floating down the Mississippi River asleep, using "a piece of river scum for a pillow," when he was prodded awake by a sharp pole wielded by Harding, who was drifting down the muddy river himself on a raft constructed of three kegs lashed to some logs (fig. 1). Harding had imagined Crockett a Mississippi catfish, and surprised to find him a human being instead, he inquired of Crockett in his coarse nautical way, "Where are you cruising, old rusty bottom; You are the queerest rigged sea craft that I ever saw on sounding or off." Drowsy and offended by Harding's strange way of talking, Crockett snarled back that if he was not left alone he would metamorphosize himself into a snapping turtle or an alligator and give the intruder "a taste of my breed." Provoked in turn by this unfriendly response, Harding "took a long string of toibakkur out of his pocket" (big enough to "hang a

buffalo," we are told) and, emboldened by its potency, roared back, "I'll shiver your mizzen in less time than you can say Jack Robinson, you fresh water lubber! You rock crab! You deck sweeper, swab!" Davy's response was equally cantankerous: "I'll double you up like a spare shirt. My name is Crockett and I'll put my mark on your infarnal wolfhide before you've gone the length of a panther's tail further."[1]

In a typical allegorical exchange between rival folkloric figures, such dialogue is usually the preamble to some outrageous fistfight pitting the symbolic strength of the land against that of the sea. But when Harding discovers that his supposed catfish is Davy Crockett, he breaks into uncontrollable laughter, recognizing that his adversary is "the feller that makes them allmynacks about cruising after panthers and snakes and swimming over the Mississippi." "Give us your flipper then, old chap," chortles Harding, glad to make the acquaintance of the man whose tall tales he has had read to him by a shipmate on the forecastle while at sea. Crockett, in turn, learns that his new acquaintance is an equally fabled figure, whose exploits include adventures among pirates, flirtations with

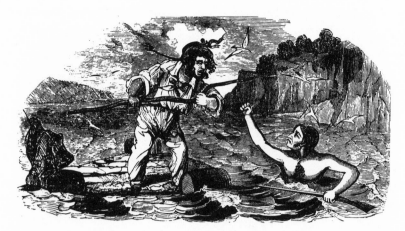

mermaids, and epic struggles with sea monsters. The two soon become fast friends, Crockett inviting Harding to his frontier home for food and whiskey, where the latter, under the influence of these powerful intoxicants, spouts "such stories about what he had sees as made the gals dream o' nights for a fortnite arter he was gone." Convinced after a night of listening to such ribald tales that readers of his almanac "would like to hear some of 'em," Crockett decides to "put 'em in print." Subsequent editions of the almanac included numerous of Harding's outlandish yarns, told in Harding's own salty language and crudely illustrated with woodcuts depicting his unmistakable form.[2]

Aside from the obvious folkloric significance of this exchange, there are several literary features of the dialogue that underscore the relationship between vernacular history and pictorial representation in the 1830s. First, it is significant that Harding has been exposed to the Crockett legends through the dramatic readings of a shipmate, as Harding himself is illiterate. "For d'ye see, I can't read," Harding admitted to Crockett. "I got my larning under the lee of the long boat, and swear my prayers at a lee earing in a gale o'wind." Steeped in an oral tradition centered on the power of the spoken word, Harding distrusts "book-

larnin'" that does not make concessions to proud but illiterate folks like himself who read, as he notes quaintly, "in a different way." And reading Harding's way means reading pictorially. "I could spell out your crocodile's tails from their heads when I see 'em drawed out in your book," Harding notes with pride. "I can read pikturs to a d——n." Indeed, Harding's inability to decipher the written word is one reason why he is so attracted to the Crockett almanacs in the first place. The almanacs are not only extensively illustrated but also bring to life for Harding history of a uniquely popular and vernacular sort. The importance of the visual is amplified still further for Harding when he becomes a central figure himself in the Crockett narratives, because he cannot recognize even his own tales except as translated through the visual pictographs provided by Crockett's editor. Harding, like many "readers" of the Crockett almanacs, is dependent utterly on the visual forms of the illustrated text for literary meaning.[3]

Second, the Harding-Crockett exchange underscores the difficulty of translation of any spoken word to the written page. Though hardly offered as a sophisticated intellectual debate about semiotics, the Harding-Crockett incident illustrates the importance of the visual in transposing language from one ver-

nacular form to another. Anxious to relate Harding's sea yarns to the editor of his almanacs, Crockett admits that he cannot do justice to the tales of his new friend because he does not really understand Harding's maritime jargon. Additionally, problems of interpretation arise from Crockett's own deficiencies as a writer and literate thinker. Harding's voice is "so ruff," Crockett acknowledges in his own crude manner, that "I can't rite it doun."[4] As a recorder of Harding's tales, Crockett is both an imprecise listener and an inaccurate transcriber, limiting the potential value of the almanacs as conveyers of Harding's meanings. But Crockett's editors advance a pictorial solution to the problem of translation, providing readers with a visual equivalent of Harding's elusive speech—a woodcut depiction of crude words exiting his mouth (fig. 2). Here the editors of the Crockett journals turn the vernacular in on itself, presenting a series of visual images of a dialogue that is too primitive to be translated into any other form. Neil Harris has argued that prior to the 1830s "verbal description was the only means of conveying visual images," noting that "before Americans made pictures they used words."[5] If so, then the Crockett almanacs suggest how gradually after the 1830s the inverse was true as well, as Hard-

ing's voice is only translatable in terms of visual images. If ekphrasis, "the painting of pictures in words," defined much of early-nineteenth-century literary expression, its opposite, "the painting of words in pictures," had emerged as a useful literary convention by midcentury, at least within vernacular traditions.[6] In both cases—Harding's inability to read the literary passages in Crockett's almanac and Crockett's incapacity to find the words to describe Harding's voice—the respective storytellers are saved by pictures.

That the considerable power of the visual was appreciated and exploited first by publishers of almanacs is significant, because it reminds us of some of the predispositions of conventional publishers in the early nineteenth century. Both in Europe and America, for instance, elements within the established literary community were suspicious of "pictorial effects." Eighteenth-century literary criticism was dominated by an "aesthetic of invisibility," a system that proclaimed deep truths to be "imageless" and favored language over art as "the best available medium for evoking that unseeable, unpicturable essence." A reaction in part to the pictorial excesses of the baroque period, this philosophy posed distinctions between "outward, material visibility" and "invisible, intangible 'powers' of the mind" and contended that "imagination is a power of consciousness that transcends mere visualization."[7] Antipictorialism grew naturally from the suspicion that images corrupted the mind and from the belief that the best protection against such defilement was the transcendent power of language. The result was "the triumph of the word" in eighteenth-century critical thinking, a victory of words over images secured by the use of the printing press as an instrument for the dissemination and the promotion of language.[8] In that century the book emerged as both an agency and an exemplar of the power of words, and many authors wrote as a correc-

Figure 2. "Picture of Ben Harding's Voice," from *The Crockett Almanac, 1839* (Courtesy of the University of Tennessee Library)

tive to the distortions of oral and visual traditions. The oft-quoted and variously interpreted axiom of Horace that "painting is mute poetry, and poetry a speaking picture" (*ut pictura poesis*) encouraged the literal-minded to value a boisterous literature over a visible poetry and to contend that words could do what images could not.[9]

Part of the iconophobia of the eighteenth century derived from the association of art with the powerful visual propaganda of church and state. In the eyes of the disenfranchised viewing public the production and circulation of images had always been the domain of the privileged, and the control of visual representations was associated with the exercise of power. It is not coincidental that Bibles, especially versions such as the King James, were among the first works to be illustrated because the pictorializing of these holy texts was monitored carefully by state-sanctioned "guardians of the word" who regulated visual imagery in accordance with strict religious and political standards. Biographical works, primarily of saintly figures or statesmen, were sometimes illustrated as well, although in many cases the celebratory images in such books were understood to be little more than visual propaganda, devoid of authenticity. Astute readers of eighteenth-century illustrated biographies distrusted such pictorial images because they were often more political constructions than accurate representations of original sources. Such works tended toward standardization of imagery, as "one portrait type drove out all others and thus acquired the sort of authority that is derived from constant repetition."[10] History paintings, the most widely reproduced visual materials in eighteenth-century European books, were especially susceptible to these idealizing and standardizing tendencies, implicating the publishers who used them for illustrated books in conspiracies to distort and politicize the past.

Given these suspicions, it is not surprising that the preliminary work of establishing the place of illustrated books in American literary culture was left to the popular presses. The expense of illustrations meant that only certain kinds of texts could be illustrated—either deluxe volumes catering to a small, wealthy clientele or (more frequently) popular works that promised a large enough circulation to justify the time and cost of pictorial embellishment. These latter volumes often originated with popular presses that specialized in specific genres and subjects, as with the small Nashville press that published the Crockett almanacs. Specialization was made necessary by the unique demands of publishing illustrated texts for which wide markets needed to be created. In the case of Crockett, for instance, the publishers of the almanacs could assume a certain interest in a standard biographical treatment of the frontiersman, but to ensure sales wide enough to justify an illustrated work they had to transform him into a mythological figure of universal interest. The publishers of the Crockett almanacs did so by advertising his frontier feats, by blurring the distinctions between noteworthy human effort and supernatural achievement, and by spreading rumors that he had not died at the Alamo but was alive and as rambunctious as ever. Significantly, the manufacturers of this mythic Crockett persona marketed their tall-tale hero in pictorial almanacs, inexpensive vernacular formats with a strong American ancestry.[11]

As the work by engraver William Croome in the Crockett almanacs suggests, publishers of these popular volumes were rarely interested in the quality of the pictures that embellished them. They often elected primitive and unadorned images at reduced costs over sophisticated and beautiful illustrations for which no adequate remuneration in the form of sales was likely. Their goals were to realize the economies of scale as-

sociated with the mass circulation of a popular product and to encourage the development of a trade in pictorial books that could sustain itself over time.[12] Established publishing houses adept in the conventions of print and adhering to higher standards of publication were unwilling generally to experiment with these crude visual formats, but smaller upstart companies employed them in an effort to challenge convention and to tinker with form. Constrained by costs, these renegade publishers advanced only modest programs for pictorializing texts at first, illustrations serving mainly an unambitious mimetic function. The visual images of Davy Crockett and Ben Harding in the Crockett almanacs, for instance, do not presume to compete with the outlandish text; they do not challenge, engage, or subvert the ideas elaborated in the narrative. Instead, they "represent" those ideas in a denotative sense, helping to reiterate visually the literary themes of the story. By using pictures in this limited way, by respecting cherished assumptions about the superiority of the word to the image, that is, the stigma of illustration as "deceptive illusionism" could be reduced.[13]

The use of illustrations gained acceptance more quickly in vernacular genres because American readers of popular texts had particular literary needs, primary among which was to understand the universal lessons embedded in a narrative. Literacy rates are hard to determine with much accuracy, but insofar as Americans of the 1830s recognized that an "informed citizenry" implied certain educational obligations, pictorial works were encouraged as instruments of literary instruction and democratic improvement. In this sense, the act of reading popular literature was associated with the recognition of patterns relevant to the collective, public objectives of the author, the most acceptable use of illustration being to elucidate the "visible language" of a text and thereby clarify its ubiq-

uitous meanings. To the extent that pictures could reflect narrative meaning without distorting it—could "paint speech" as eighteenth-century literary critic Alexander Cruden put it—they were accepted as adjuncts to the text.[14] The unassuming woodcut in Crockett's almanac depicting the dynamics of Ben Harding's voice provides a perfect example of this type of transliterative illustration in popular literature of the 1830s. The crudity of Harding's voice is mirrored in both the form and the function of Croome's illustration, its qualities as a literal reflector of language superseding any implied symbolic meanings or complex artistic intentions. When illustrators did not take themselves too seriously, when they did not try to assert the prerogatives of the interpretive artist (as William Croome clearly did not), they were abided as tolerable additions to the materiality of a book.

Publishers worked hard to legitimize the limited practice of illustrating popular texts, acknowledging that "words and pictures skillfully and sensitively brought together in a book could each enlarge the other's meanings without undermining the integrity of either the author or the artist."[15] Ultimately these incipient publishing houses had to sell Americans on the value of visual literacy, had to educate them in a new way of "reading the past through pictures."[16] If such a strategy challenged the conventions of print, the need to attract mass audiences to a house's titles (especially in the depressed book market after the Panic of 1837) was sufficient inducement to test tradition.[17] Even the unconventional publishers of the Crockett almanacs recognized that their pictorial concessions to readers needed to be explained and justified in conventional terms, asserting the reliability of their materials in instructional "'Go Ahead' Reader" sections to their volumes. Other marketers of early pictorial histories included elaborate apologia in their prefaces intended to reassure readers that although il-

lustrators had been employed in the projects, their works had been screened carefully to avoid the abuses to which much visual representation was predisposed. "Great care has been taken to secure accuracy" in all illustrations, noted a typical disclaimer, "so that they may not convey false instruction."[18]

Under self-imposed restrictions such as these, publishers of popular books in the 1840s took tentative steps toward establishing a fragile symbiosis between texts and illustrations. Inspired by the initial enthusiasm for vernacular works modestly illustrated, but operating in the shadow of suspicions about the place of visual images in print culture, the genre of pictorial history was born.

The Literature of the Unlearned

The Emergence of the Visual, 1840–1861

"An Aid to the Imagination"

The Pictorial Mode and the Rise of Illustrated History

The traditional distrust of illustrations in books was not the only barrier publishers of the Crockett almanacs needed to overcome in order to sell readers on the advantages of visual formats. There were technical difficulties as well that threatened to restrict the kind of pictorial images available in illustrated texts to the crude and rudimentary woodcuts of Croome. The primary challenges for publishers who wished to illustrate their texts were (1) how to reproduce images with clarity and fidelity to the intentions of the image maker and (2) how to incorporate those images into the body of a printed text.[1] Neither of these challenges was met easily in the primitive technological climate of the early 1840s.

Illustration as a "Fatal Facility"

With regard to the first problem, the chief method for transcribing images was the unrefined technique of wood engraving, by which engravers transferred an artist's original drawing onto a wood block. Working generally on the end grain of the block, an engraver would carve away extraneous portions of wood not identified by the artist as significant, leaving a copy of the original picture in relief. The resulting engraved block would then be set up in a press, where it was inked, pressed, and cleaned in succession, and where, if its structural integrity was not compromised, it could be used to generate multiple impressions. Improvements in the durability of the block were made by creating metal molds from the original engraving and then by pouring hot metal into the molds to produce replicas. This process (known as stereotyping) allowed for superior precision in duplication, more copies, and an increased ease of transference of images from one illustrated source to another. Despite these improvements, however, the continuing "intrusion of [the] intermediary hand" of the engraver meant that inaccuracies of translation resulted from the process of reproducing images, and these inaccuracies discouraged many would-be illustrators. Even when artists drew directly on the block themselves, the distortions of the graver so altered their intentions for an image that many refused to sign their work. Frequently it was the engraver rather than the artist whose name appeared etched in the corner of an illustration, and engravers often received more to "cut a drawing" than did the artist who sketched it.[2]

With regard to the second problem, the incorporation of visual material into a text, the challenge was to find a mechanism for the simultaneous integration of words and images on the printed page. Original woodcut illustrations were often produced on special presses, requiring a publisher to operate multiple printing machines for the production of a single book. This was an expensive prospect, one that obligated publishers to employ technicians trained in multiple areas of printing competency. Images manufactured in this fashion also often necessitated the use of special paper for processing, requiring in turn that the illustrations be "tipped" or glued into a book separate from the corresponding text.[3] Apart from the perceptual incongruities this mismatching of paper caused, the process also produced intellectual disjunctures, literally divorcing, as it did, words from images. Readers already alert to the distinctions between language ("heard, quoted, inscribed") and visual images ("seen, depicted, described") were not encouraged by these separations to freely mix verbal and visual forms.[4] Developments in wood-block technology eventually allowed most illustrations to be integrated with any page of text, but in the early nineteenth century such consolidations were rare. More often illustrators had to have faith those readers could negotiate the sometimes-tricky juxtapositions of visual and verbal evidence in pictorial texts. Their disappointments in this regard discouraged many artists from contributing to illustrated volumes, severely curtailing their participation in an enterprise that might have brought them much work. For these and other reasons, many fine artists continued to view pictorial illustration "as irrelevant to the serious aims of art."[5]

In Europe some of these technical obstacles to illustrating texts (and their attendant philosophical objections) had been overcome by the early nineteenth century. Alterations in the power structures on the Continent, especially those related to the authority of the Church and the State, freed up the machinery of publication and created marketing opportunities in new fields of inquiry, including natural science, political economy, and history. A related rise in literacy throughout Europe and the emergence of reading as

a leisure activity created a market for published books, and as competition increased within that market, publishers were encouraged to be innovative in their formatting and packaging of the visual. For those willing to "read" not only between the lines of a text but also beyond them, illustrations were offered as embellishments to the "symbolism, plot, theme and characterization" of a story. This impulse was particularly strong in England, where "visually descriptive texts and 'telling' pictures" were viewed as mutually reinforcing elements of narrativity.[6]

Eroding further the traditional antipictorialism of a previous age were technical improvements that widened the choice of images available to viewers. The emergence of lithography, a technique for engraving on stone, increased the quality of many book illustrations and broadened the commercial uses of visual materials in ways that reduced costs. Lithography allowed artists to draw with a grease crayon directly on polished stones, which, when treated with a solution of gum arabic containing traces of nitric acid and wetted and inked, produced an image everywhere the grease repelled the water. Alternatively, a stone prepared with gum and acid before drawing and then wetted thoroughly and scratched with a graver produced lines that accepted ink that was otherwise rejected by the stone's surface. Lithographs produced in this "incised" manner printed black on white paper and had the appearance of lines created by metal engraving. As early as the 1820s some fairly sophisticated illustrated works were being produced in Europe using lithography, clearing the way for the "development of the book as a major vehicle of artistic expression."[7]

The "cult of illustration" was slower to develop in the United States, however, in part because of circumstances unique to the American condition. In the United States the distrust of visual images used in the service of arbitrary authority was especially strong, and it is no coincidence that during the American Revolution works of imperial art (like the equestrian statue of King George III in New York City) became special targets of democratic rage. Patriots were quick to raise up and sanctify substitutes for lost imperial icons, but these new idols were almost always written documents like the Declaration of Independence or the Constitution, literary texts that defended the principles of free speech of which they were the most conspicuous exemplars. As Moses descended Mount Sinai demanding the substitution of the written (or chiseled) word for the graven images of golden calves, so Americans of the post–Revolutionary War era elevated the sacred word over the usurping symbol, at least in the earliest stages of self-invention. Feeble efforts were made to develop a visual iconography, especially centered around George Washington, but it was not until Jonathan Trumbull's epic series of paintings glorifying the heroes of the Revolution was unveiled in the Rotunda of the Capitol building in 1819 that Americans could claim any pictorial production approaching the visual grandeur of European historical painting.[8] And the most famous of Trumbull's works, *The Declaration of Independence*, celebrated the signing of a hallowed document and was appreciated more for its commemorative value as a tribute to the written word than for its artistic contributions to the promotion of the visual image.[9]

The acceptance of visual art in the United States was also slowed by the inadequacy Americans felt in the face of established traditions of evaluation and order within the field of art criticism. If, as Sir Joshua Reynolds argued, history painting was the highest form of visual presentation, then Americans suffered from an embarrassing lack of history to paint.[10] In comparison with most European nations America was an infant without an appreciable past, and this "un-

historied" condition made any attempts at grand historical representation seem shallow and puerile. No matter how one strained to create a sense of the epic tradition in art, the Battle of Bunker Hill was not the Battle of Hastings, and the defeat of the British fleet on Lake Erie did not approximate the demise of the Spanish Armada. European history painters faced difficult challenges regarding what to select for their canvases among myriads of historically significant episodes, whereas American artists were accused of manufacturing scenes of historical importance and of investing those scenes with a false significance in a sad effort to legitimize themselves and their work. George Templeton Strong articulated American sensitivities to this lack of meaningful history: "We have not, like England and France, centuries of achievements and calamities to look back on; we have no record of Americanism and we feel its want. . . . We crave history, instinctively, and being without the eras that belong to older nationalities . . . we dwell on the details of our little all of historic life, and venerate every trivial fact about our first settlers and colonial governors and revolutionary heroes."[11] As late as 1851 the *Bulletin of the American Art-Union* quipped that after "taking out the Indians and the Puritans, what is there left [to paint] besides the contentions of deliberate assemblies and the mathematical evolutions of the wars with Great Britain and Mexico?"[12]

The failure of visual formulas in the early Republic had something to do as well with an anti-intellectual strain in America that discouraged reflection on historical experience of all kinds. Some Americans rejected not only visual images of the past, that is, but history itself. If Europeans like Sydney Smith complained of the lack of good literature or art in the United States, Americans justified the absences by denying the historical foundations on which such traditions rested.[13] History was too constraining and restrictive for a nation on the move, and Americans were too focused on the future to be distracted by historical reflection.[14] Nathaniel Hawthorne caught the spirit of this antihistorical sentiment in *The House of the Seven Gables,* when his hero, Holgrave, asks to be liberated from the Past, which "lies upon the Present like a giant's dead body." History, Holgrave reminds us, makes us "slaves" to "by-gone-times" and is incompatible with a nation in search of an autonomous identity.[15] But Hawthorne also understood the difficulty of maintaining this ahistorical posture, as the plot of his novel centered on the inescapable nature of transmitted sin.[16] Visual images also dominate the narrative, as Susan Williams has suggested, not only in the portraiture of the ancient Pyncheon family but also in the daguerreotypes created by Holgrave, a photographer by profession.[17] As a fixer of visual images, Holgrave is a candid reminder of the unavoidable need for reflection on personal and national history, even in intellectual environments where skepticism augers against historical meditation and pictorial representation.

Finally, the technical problems faced by book illustrators in Europe were magnified in the United States. Materials were not as readily available in America, and it was difficult for the few engravers who could secure supplies to receive adequate training in the profession. In addition there was not enough publishing work in the young nation for artisans to hone their skills, especially in the area of book illustration. Engravers in America were frequently self-taught jacks-of-all-trades, such as Paul Revere, who advertised himself as a printer, bookseller, clock repairer, and silversmith as well as an engraver. Those American illustrators who did find jobs in the book industry were primarily copyists who worked from pirated editions of European works and had few opportunities to create original drawings.[18] As a result of these condi-

tions, the emergence of a more sophisticated tradition of book illustration in America "awaited the development of conditions that fostered artistic life in general." Until Americans secured the "apparatus of artistic sophistication" (including art academies, exhibitions, private patrons, art unions, and reproductive engravings, and opportunities for study abroad), they were unlikely to acquire a taste for "imaginative" images such as were popular in Europe, especially those associated with "religious, literary, and historical subjects."[19] It was well into the nineteenth century before Americans enjoyed these accouterments of a flourishing art community, and in lieu of them, American engravers made only modest contributions to the field of book illustration and pictorial history.

To create a market for illustrated works, publishers had to reach audiences for whom visual representation was less a breach of aesthetic theory than a valuable aid to understanding. American publishing firms concerned more with the bottom line than with intellectual debates over the "aesthetic of invisibility" took a utilitarian approach toward illustration, asking where pictures could be employed to attract readers needing assistance in the comprehension of texts. Publishers singled out immigrants as likely beneficiaries and purchasers of illustrated books because the diversity of their cultural backgrounds increased the need among them for a standardized expression of national ideals. In an age when the written word in translation created as much confusion as clarity for migrants to the United States, pictures promised a more universal vocabulary.[20] Publishers noted a political incentive as well. What better way to avoid the transference of ancient animosities from the Old World to the New World, and to assure the presence of social and political unity in America, than to encourage historical literacy through pictures? Pictorial representations provided a form of shorthand for those unwilling or unable to struggle through written texts and constituted a symbolic language by which Americans communicated national priorities and cultural beliefs to one another.[21]

Children represented an even more important market for the visual in a growing nation where concerns for literacy and universal education encouraged publishers to find innovative ways to advance the learning process. Whereas there was skepticism about the value of illustrations for adults, most acknowledged the power of pictures for the pre-literate, juvenile mind. A "book of pictures" in the hands of a child, wrote one promoter of illustrated texts, fosters that "deep, unrecognized, sacred hunger of the soul after the true, the beautiful [and] the perfect" that we lose as we grow older. It is "an all-sufficing balm for the heaviest sorrows of infancy, transforms a slate and pencil into a magician's tools and prompts to endless innovation."[22] Noble and beautiful images gleaned from historical paintings were thought to be especially helpful in teaching the lessons of the past with which children often struggled. "Children, like common people," wrote one early advocate of pictorial history, "have no books other than painting, which by representing past events in colour can, as a sort of mute history, insinuate into simple minds these examples of good and evil that others, better educated, would read in the form of written records."[23] Illustrations in pictorial texts could also be used as inducements for proper behavior. Nathaniel Hawthorne offered "illustrated almanacs" to his children as incentives for adhering to their bedtime schedules. "Mamma begins to undress him," Hawthorne wrote in his journal of son Julian who refused to get ready for bed unless he was allowed to look at a pictorial book. "He remonstrates, and demands to be allowed to 'see when I'm bareness'—that is, to look at the book

after he is undressed. There he is, in his bareness, his face brimming over with good-humor and fun, so that it throws a light down upon the pictures he is looking at. Now, mamma is putting on his night-gown; and as his head comes through the opening, still he looks at the pictures."[24]

Despite these incentives, the first American efforts to produce pictorial histories for children, immigrants, and others in need of acculturation were halting ones. In 1822 Charles Augustus Goodrich, a clergyman who left the pulpit to write and edit hundreds of works for young Americans, published a "popular" unillustrated *History of the United States of America*.[25] It had only a modest circulation. Several decades later, his brother, Samuel Griswold Goodrich, a former clerk and publisher of hundreds of moralistic books for children, revived his brother's idea of a popular history but gave the project a pictorial format.[26] He did so at considerable risk, because, by his own accounting, nearly two-thirds of all illustrated works proved either heavy financial failures or barely covered the costs of production. As early as 1828 Samuel Goodrich had published a pictorial periodical called *The Legendary*, devoted to an "illustrative" discussion of "American history, scenery and manners." Although the journal was "kindly treated by the press," it "proved a miserable failure," Goodrich concluding after the fact that the "time had not come for such a publication." But he had observed the greater success of illustrated books in England in the same decade, pictorial formats having produced in his estimation "a certain revolution in the public taste" there, and he hoped to emulate such "charming works" in America.[27] Convinced that there was a "strong necessity in the public mind for books enriched by all the embellishments of art," Goodrich took a chance on the *Pictorial History of America* (1845).[28]

Goodrich's recognition of the potential for illustration emerged first from the public reaction to a series of children's books he published throughout the 1830s and 1840s under the pen name Peter Parley. Goodrich's narrator, Parley, was "an old silver haired gentleman with a gouty foot and a wooden cane" who told stories ("parleyed") about his family, his travels, and, occasionally, about the history of America. Goodrich's Parley books were generally illustrated, often crudely, but with a consistency that underscored his strong belief in the power of the "realistic" visual image to train young minds. As Goodrich later wrote in his autobiography *Recollections of a Lifetime* (1856), "[I] came to the conclusion that in feeding the mind of children with facts, with truth, and with objective truth, we follow the evident philosophy of nature and providence, inasmuch as these had created all children to be ardent lovers of things they could see and hear and feel and know. Thus I sought to teach them history and biography and geography, and all in the way in which nature would teach them—that is, by a large use of the senses, and especially by the eye—the master organ of the body as well as the soul." Goodrich chose subjects for his Parley books that were "capable of sensible representation" and provided children "with a distinct image" of historical subjects prior to reading about them. So committed was Goodrich to the idea of visual formats for his books that he made his home in Boston a "stopping place" of sorts for numerous young artists such as John Cheney (whom he regarded as "the first of American engravers in sweetness of expression and delicacy of execution") and his brother Seth Cheney, who illustrated numerous books and journals for Goodrich throughout the 1830s and 1840s.[29]

Goodrich's *Pictorial History of America* was published in two versions, one for adults and one for children, with only subtle distinctions of structure and argumentation between them.[30] Both editions shared

a common commitment to accuracy of evidence, emphasized not only in the preciseness of their geographic descriptions of the Americas (complete with the proper coordinates for the longitude and latitude of major regions of the country) but also in the lengthy appendices that charted the careful distinctions among dozens of Indian tribes in both North and South America. Relatively restrained in terms of nationalist cant, Goodrich poured his energies into sweeping pronouncements about the authenticity of his insights and modes of presentation. The work was characterized by a strong visual sense, not just as a result of its many admittedly crude illustrations but also because of the numerous literary annotations Goodrich provided as supplements to those pictures. A good example of this pictorial enhancement is found in the detailed descriptions of facial features that accompanied the illustrations of Indian chiefs in the *Pictorial History of America,* Goodrich drawing on the "science" of physiognomy popular in his day as a way of evaluating the human character of "aborigines."[31] The juxtaposition of pictorial evidence with physiognomic analysis, particularly in the children's edition of the work, suggested the degree to which Goodrich relied on the compatibility of literary and visual evidence as a device for instructing readers in the subtleties of historical understanding.

Goodrich's faith in accurate illustration for children was controversial in his day for reasons he understood more clearly at the end of his career than at its beginning. In his memoirs he noted retrospectively that many rejected his pictorial formats in the 1830s on the basis of conventional philosophies of education. "In the first place, it was thought that education should, at the very threshold, seek to spiritualize the mind, and lift it above sensible ideas, and to teach it to live in the world of the imagination," Goodrich wrote. "A cow was very well to give milk, but when she got into

a book, she must jump over the moon; a little girl going to see her grandmother, was well enough as a matter of fact, but to be suited to the purposes of instruction, she must end her career in being eaten up by a wolf." Goodrich's plan to illustrate realistic stories with authentic pictures was therefore "deemed too utilitarian" and "too materialistic" by its critics, especially in England, where it prompted a campaign to save Mother Goose from the ravages of Parley's unimaginative literalism. In the second place Goodrich was accused of trivializing learning through visual codes, of "bringing up the child in habits of receiving knowledge only as made into pap, and of course putting it out of his power to relish and digest the stronger meat, even when his constitution demanded it." Goodrich's use of engravings in books for instruction "was deemed a fatal facility" by his detractors, "tending to exercise the child in a mere play of the senses, while the understanding was left to indolence and emaciation."[32] Such concerns even carried over into criticisms of his "adult library," a collection of pictorial works designed to illuminate the broad themes of literature and history. In England these volumes were condemned as too "sullied by coarse phrases and vulgar Americanisms" and too crude in illustration to be useful to refined British readers.[33]

Some of these criticisms hit home with Goodrich, who as an American was already sensitive to accusations of incompetency leveled by the British against the illustrated book industry in the United States. By the end of his career he had written and edited 170 volumes of mainly illustrated works, a corpus of which most might have been proud but of which Goodrich was not. Recognizing that his prodigious output had "required drudgery rather than creativity," he confessed in his memoirs that his literary and artistic efforts had been largely failures. "In looking at

the long list of my publications, in reflecting upon the large numbers that have been sold, I feel far more of humiliation than of triumph," he wrote. "If I have sometimes taken to heart the soothing flatteries of the public, it has ever been speedily succeeded by the conviction that my life has been, on the whole, a series of mistakes, and especially in that portion of it which has been devoted to authorship. I have written too much, and have done nothing really well." Prolific to a fault, Goodrich overproduced out of financial need, causing him to reflect with sad but honest judgment on the futility of his career. "You need not whisper it to the public, at least until I am gone; but I know, better than any one can tell me, that there is nothing in this long catalogue that will give me a permanent place in literature," he admitted. "A few things may struggle upon the surface for a time, but—like the last leaves of a tree in autumn, forced at last to quit their hold, and cast into the stream—even these will disappear, and my name and all I have done will be forgotten."[34]

In passing such harsh judgment on his intellectual abilities, Goodrich proved revealingly prescient in his predictions about the obsolescence of most pictorial historians of the 1830s and 1840s like himself. Along with a handful of other experimenters in the pictorial form at work in those decades, men with now-unknown names such as Hugh Murray, John Warner Barber, and John Howard Hinton, Goodrich has faded indeed into obscurity.[35] The financial returns on the labor of these writers were not substantial enough to encourage more competent work in pictorial history. Consequently, authors like Goodrich, who had high aspirations for his *Pictorial History of the United States*, eventually abandoned the field to the crude, unsophisticated practitioners such as those employed by the Crockett almanacs. As Alexis de Tocqueville noted, Americans "prefer books which may be easily procured, quickly read, and which require no learned researches to understand." The style of such works was frequently "fantastic, incorrect, overburdened, and loose," the Frenchman noticed, their "untutored and rude vigor" appealing to a democratic people who had not gained "a sufficiently intimate knowledge of the art of literature to appreciate its more delicate beauties." The failures of Goodrich's pictorial histories were attributable to what de Tocqueville called the "slighted" and "sometimes despised" vernacular forms fashionable in the United States.[36] Goodrich's fate was sealed, in part, by his association with a literature that as yet "had not acquired . . . respect in the eyes of the world."[37]

History as Suited to the Purpose of Art

Although Samuel Goodrich condemned himself for his failures to create a sustained market for illustrated histories, the conditions for the popular acceptance of such works were in place and slowly revealing themselves. On a technical level gradual improvements in the old "craft-based" forms of engraving, especially the development of mezzotint, aquatint, etching, and copper engraving, reduced the costs of production and encouraged a wider use of illustrations.[38] These developments in the mechanics of engraving led to major advancements in the "autographic control" artists experienced in the replication of their images. With improvements in lithography, especially, artists and publishers grew increasingly more comfortable with the inclusion of pictorial images in their works. These changes led to an explosion of illustrated volumes in America after the 1840s, particularly in those categories of publication whose presumed didactic benefits justified higher production costs, including Bibles, children's books, and pictorial histories.[39]

Still more, an intellectual revolution took place in

America at midcentury that reversed partially the antihistorical pattern that characterized some of its early life. By the 1840s Americans were becoming gradually convinced of their own historical legitimacy and staying power. After nearly seventy-five years of nationhood, it seemed more permissible to discuss distinctive American traditions, especially as the first generations of American heroes gave way to a post-heroic age of sons and daughters determined to keep the memory of the founders alive.[40] A new cast of champions emerging from the Mexican War also provided opportunities for documenting and memorializing American achievements. In addition, the successes of writers associated with the golden age of the American Renaissance in literature—Irving, Cooper, Poe, Emerson, Thoreau, Melville, Whitman, and others—made Americans less defensive about their literary output. Indeed, overzealous cultural promoters now insisted that Americans would soon be at the forefront of every field of literary endeavor, including historical writing, because the unique conditions of the American nature (once thought to be a liability but now imagined a distinct advantage) allowed for more spontaneous and honest modes of expression.[41] A decade earlier de Tocqueville had criticized Americans for their habit of deferring to the British to determine the worth of their authors, "just as, in pictures, the author of an original is held entitled to judge the merit of a copy."[42] By the 1840s, however, this acquiescence had given way to a brash American self-assuredness as to the value of original works of literature and art produced in the United States.

But the most important preparation for the general acceptance of pictorial histories in mid-nineteenth-century America was the development of what Donald Ringe has called the "pictorial mode," a manner of writing and thinking rooted in the romantic tradition of "visual communication." Advocates of this new philosophy expressed "a deep concern with the need for close and accurate observation of the physical world in order to discern its meaning," Ringe notes, and they came to believe that the "visual mode ... was the basic means by which they could reach the minds of their readers." Seeing "an important philosophic relation between the objects of physical nature and the truths of the moral world," supporters of pictorial literature believed that "the verbal and graphic landscapes may combine their various parts in such a manner as to suggest related wholes, the form and tone of which may excite the imagination of the reader and viewer to a perception of related meanings and the enjoyment of a similar emotional response."[43] A direct challenge to the aesthetic of invisibility, this theory argued that poetry and painting were "sister arts" that drew strength in equal proportion from each other. Pictorial evidence was not just to be tolerated; it was to be pursued in the name of thoroughness and comprehension. Under the persuasive logic of this new thinking, concerns about the distorting power of images gradually gave way to an appreciation for the eye as an instrument of insight. Art was no longer presumed subordinate to narrative; indeed, in some senses it was expected to lead the way in helping to achieve a newly defined epistemology of learning. The implications of the pictorial mode for history were especially significant, because they altered not only the methodologies by which historians sought to obtain "perceptive insights" into the past but also transformed the patterns of presentation used to elucidate them, primarily illustration.[44]

The major spokesperson for the use of the pictorial mode in popular history was novelist and literary critic William Gilmore Simms. A southern writer devoted to the celebration of American literature and art both at home and abroad, Simms published an important article in that cause in 1845 titled "The Epochs

and Events of American History as Suited to the Purposes of Art in Fiction."[45] This piece was inspired by Simms's complaint that no meaningful history of the United States existed because American historians were mere annalists and compilers of facts who ignored what is truly important about the study of the past: its aid to the imagination. "Certain venerable Cantabs" in his day, Simms wrote, were ruining history by insisting that it be stripped of its literary and artistic adornments and that the "golden ornaments of rhetoric and passion" be expunged from the historical enterprise in America. The residue of this expurgation was the "motionless automata of history," an obsession with which prevented Americans from producing a national equivalent to "those glowing pictures" of humanity produced by Greek and Roman historians, whose "narratives of soul and sweetness" set a high standard for literary art. Simms envisioned history as "so much raw material, in the erection of noble fabrics and lovely forms, as an art, akin to fiction" and declared that "it is the artist only who is the true historian." Historians have obligations to wrestle with facts when they present themselves, he noted, but if writers of history offend "against no facts which are known and decisive, no reasonable probabilities or obvious inferences," then they are free to act as "artists," "supplying appropriately the unsuggested probability, of filling the blanks of history with those details without which the known were valueless." Still more, he believed that in a democratic nation every individual has the right to invent a personalized vision of history based on informed conjecture and reasoned imagination. In a phrase later adopted by Carl Becker, Simms noted that the goal of history was for "each man to become his own historian," portraying "to the mind's eye" the personal significance of a hero or event as "a limner, a painter, a creator" would do.[46]

Simms's artistic metaphor suggests the degree to which his relativistic philosophy was informed by a belief in the visual image as a protection against the usurping power of the written word. Simms noted that the printing press had hindered rather than aided historical understanding, because, although it had served to "render our facts less questionable," it had "deprived the artist of his resources and his courage" and of the "partial obscurity and doubt in history" that "leaves genius most free to its proper inventions." The arrival of the printed word, with its provisions for the verification of historical fact, left "incidents too clearly stated upon the record," Simms argued, and impaired "the courage of him who seeks after the ideal" by imposing the "definitive boundaries of the real." Visual imagery was a more appropriate language for the historian, because the imaginative character of the pictorial arts ensured that the "pictured story of the painter" would remain long after the scribblings of the "chronicler are dust." Simms urged American historians to sketch a national panorama, "to burn" a "wondrous" composite story "upon the canvas" of American life, allowing the past "to become a visible form and existence to their eyes." And Simms intended this painterly analogy to be understood literally with reference to the congruence of art and history; that is, he wished for painters to consult historians regarding subjects of significance for their easels and for historians to elucidate their volumes with the artistic products of those discussions. The implications of this thinking for the rise of pictorial history are obvious, because no format was better suited for the marriage of history and art than the illustrated history book.[47]

Simms provided an extended outline of his ambitions for pictorial history in an essay titled "Pocahontas: A Subject for the Historical Painter."[48] In this piece Simms urged artists and historians to fashion pictorial and literary tributes to Pocahontas's 1607

rescue of John Smith, arguing that there is "no better subject for painter or poet" than the dramatic deliverance of the founder of the Jamestown colony by the young Indian girl. Simms acknowledged that some excellent paintings of episodes in the life of Pocahontas had been attempted, including the *Baptism of Pocahontas* (1837–40) by John G. Chapman, which graced the Rotunda in the Capitol, but none of these productions approximated the drama inherent in Smith's rescue scene. In Simms's estimation America needed artists to seize upon this episode as a point of inspiration for conveying the power of early colonial encounters. The artists' job would be to give concrete form to the emotions inherent in the suspenseful moments just prior to Smith's imminent execution and to convey the "physical material" of the scene for "the sight of eyes to whom its beauties never came before even in dreams." This was a task appropriate to the artist as much as the writer, Simms noted, because it required the "attributes of genius, taste and imagination" implicit in pictorial representation.[49] It mattered little to Simms that some historians had questioned the veracity of the Smith rescue story; its value as an allegorical episode was sufficient to justify its sanctification in a painting of broad, national significance and appeal.[50]

In issuing his challenge to artists for a dramatic depiction of the Pocahontas rescue, Simms was keenly aware of the difficulties facing anyone trying to depict graphically the personages or events associated with a historical event of such magnitude. There were obvious technical challenges related to the grouping of forms in a restricted wilderness landscape, with the rendering of line, balance, and value, and with the proper use of light for dramatic effect. But the biggest difficulty faced by any would-be painter of the rescue scene was in conveying complex narrative action in a solitary historical moment. Historians writing about

the John Smith episode in traditional narrative forms had the luxury of preparing the reader for the death scene through extended literary treatments of the cause and effect relationships of the many parties involved. Simms recognized, however, the problems inherent in "the special resistance of pictorial art to narrativity," that is, the dependency of two-dimensional canvases on the "atemporality of stopped-action."[51] He warned that the artist had "but a moment of time for his delineations—but a single moment—and if he fails so to select this moment as to compel the picture to tell its own story, the subordinate merits of exquisite elaboration will not avail to maintain his claims as a *builder* and a master." In any dramatic historical depiction, Simms noted, the artist must locate the precise instant "when the struggle is at its height, when face and form, and eye and muscle in each of the dramatis personae, are wrought upon by the extremity of the action—when the crisis is reached of human hope, or fear, or endurance, and nothing that follows, can, by any possibility, add to the acuteness of that anxiety with which the beholder watches the scene—that the artist must snatch the occasion to stamp the story in life-like colours upon the canvas."[52]

With regard to the John Smith rescue, Simms believed that the precise moment of greatest artistic potential was when Pocahontas interposed her own body between that of Smith and his executioner. Imagining the British explorer as a hero patiently awaiting "the stroke of death," Simms provided a descriptive blueprint for the rendering of the scene. "A jagged rock sustains his head," he wrote:

> The executioner stands above him with his mace—a stalwart savage, who has no shrinkings of the heart or muscles—who will be only too happy when bade to strike—who will drink in, with a fierce phrenzy, the groans of the victim—nay, bury his hand within his bosom and pluck

the heart from its quivering abode, while life yet speaks in the pulses of the dying man!

He waits, he looks with impatience to the savage monarch for the signal when to strike. That signal is made—the word is spoken!—The arm that holds the mace is bending, The heavy stroke of death descending.

This backdrop was all prefatory to the moment Simms most wished to have rendered by the artist, the precise instant when the "interposition of an angel" in the guise of an Indian maiden occurred. Pocahontas should be a "young girl just budding into womanhood," Simms wrote, a woman wrestling with "her timid sex and years and the holy strength of maternal nature in her heart." As her "maternal" instinct overcomes her obligations to paternal and tribal authority, "she darts from her seat—voiceless—gasping with new and convulsive emotions, which lead her, she knows not whither, while she flings herself between the captive and the blow. One arm is thrown upward to prevent the stroke—one covers the head of the victim—while her dilating but tearless eyes, turn in fear and entreaty to the spot where sits the fierce old monarch, Powhatan!" According to Simms, "This is the moment of time for the painter; [i]t is the crisis in the fortunes of the scene."[53]

For Simms, this richly textured moment of truth was evocative of important tensions within the relationship between a white man and an Indian girl and provided a perfect opportunity for some artist to immortalize himself by the dramatic rendering of so poignant a scene. "How completely would such a picture, though grasping but a single moment of time, tell its own history!" Simms declared. Yet he noted with puzzlement and concern at the end of his essay that despite its considerable attractions, "our artists . . . have shrunk from this subject."[54]

Part of the reason for the avoidance of the Pocahontas rescue scene by artists could be found in an irony embedded in Simms's article itself. Despite his championing of visual images as a corrective to the usurpations of written words, Simms's unillustrated piece demonstrated how much more detailed and elaborate a literary treatment of the Smith rescue scene could be than that of a painting. Because painters are required to collapse distinctions of time and place so dramatically, it is difficult for them to compete with literature in conveying the dense complexities of historical episodes. Such limitations on paintings as explanatory tools were compounded by the problems of distribution and circulation of paintings in the nineteenth century. Simms's literary recreation of the Smith rescue moment stood a far greater chance of reaching the eyes of Americans through its publication in the *Southern and Western Magazine* than did a Pocahontas painting on display in the Capitol Rotunda. Until the means to reproduce historical paintings of the detailed sort Simms had in mind could be perfected, the published word remained the most viable way to reach wide audiences effectively.[55] Crude woodcut images like those in the Crockett almanacs were available to publishers willing to resort to vernacular forms, but the complex imagery Simms envisioned required a representational capability not yet achieved by most publishing houses. Simms was left to wrestle, therefore, with the obvious irony that only words could convey his misgivings about words, a paradox roughly equivalent to that experienced by the Nashville publisher of the Crockett almanacs who found crude pictograms of Ben Harding's voice the only means available to demonstrate the unreliability of a pictographic language for the articulation of peculiarities of speech.

The convenience of literary forms over those of the visual did not convince Simms to abandon his arguments on behalf of the pictorial mode, however. Instead, he looked to book illustration as a technique for

improving the circulation of visual images and for enhancing the American historical imagination. Simms argued that a more sophisticated reading public with a greater appreciation for the visual and the literary potential of a scene like the Smith rescue would one day come to appreciate the need for better graphic representation. "When our people shall really have acquired some intellectual appetites in sufficient number to make and mould the popular taste; and books shall have become an aliment as absolutely necessary to us as brandy and tobacco," he wrote, then shall Americans demand the highest standards of "poetic illustration." As with many things, Simms believed a more refined tradition of illustration would be dictated by the "laws of demand and supply" that govern the literary marketplace. Despite his concerns about the unimaginative qualities of American historical literature and his disgust for the simpleminded acceptance of crude of pictorial representation, Simms remained optimistic that a new sensibility would emerge when publishers found it profitable to produce illustrated books of high quality. Pictorial histories, he assumed, would lead the way in this insurgence, balancing as they did the concerns of visual and literary acuity. Produced properly, Simms believed, pictorial histories could elevate the American past to its proper place as both a handmaiden to the arts and an inducement to the imagination.[56]

"Impressing Historical Events upon the Mind"

Simms's optimism about the pictorial mode and the liberating potential of illustrated histories was premature in the mid-1840s, perhaps, but it did bear some fruit. In the same year that Simms was composing his challenge to American historians, John Frost published his four-volume *Pictorial History of the United States* (1844). If Simms had urged historians to

view themselves as "'artists' etching with words," then Frost could claim a special "suggestive power" for his work.[57] He was a Philadelphia schoolteacher turned writer and publisher whose career reveals the vicissitudes of those seeking to popularize the study of history through pictorial texts in the early nineteenth century. Born in Kennebunk, Maine, in 1800 and educated at Bowdoin and Harvard, he spent the majority of his early career as a teacher and principal. When not engaged in the training of minds, Frost pursued his own substantial literary ambitions, aspirations that did not always endear him to those of his students who were made to act as "assistants" in his various projects. Accusing Frost of manipulating their children for personal gain, several wealthy parents withdrew their financial support from his school, and he was forced to resign. As a biographer noted, Frost's passion for teaching proved "incongruous" with his love of literature, and "literature triumphed."[58]

In the years following his resignation from teaching, John Frost produced hundreds of books for the popular market. As with Charles and Samuel Goodrich, part of his incredible productivity was motivated by necessity. Like many better-known historians in his day (Parkman and Prescott especially), Frost was often "in severe bodily pain," and he spent a good deal of money and time trying to repair physically. He was also the father of ten children, and although a number of them did not survive to maturity, Frost was saddled with financial concerns throughout his career. "Weighed down in his last years by business perplexities and troubles," he was accused by many of producing "potboilers" in order to generate quick profits. Such hurried productivity came to symbolize, in the eyes of its detractors, the irresponsibility and lack of attention associated with pictorial history.[59]

If Frost cut corners in order to produce books rapidly, such tendencies allowed him to publish works of

an enormous variety and breadth. He began by writing mainly schoolbooks on every conceivable subject (literature, foreign language, oratory, natural history). He then progressed to general histories with titles such as *The Battlegrounds of America, Remarkable Events on the History of America, Thrilling Adventures Among the Indians,* and *Heroic Women of the West.* He produced travel accounts, captivity narratives, ancient histories, and broad and ambitious compendia with titles such as *The Wonders of History,* "comprising remarkable battles, sieges, feats of arms, and instances of courage, ability and magnanimity, occurring in the annals of the world, from the earliest ages to the present." He penned works designed to edify, such as *The Book of Good Examples Drawn from Authentic History and Biography,* which was intended to make moral examples out of certain "illustrative" historical figures.[60] In his spare time Frost also published a series of playful stories about natural history for boys and girls under the pseudonym Robert Ramble, his answer to Goodrich's Peter Parley.[61] This remarkable production of books for readers of all ages earned Frost a reputation throughout the United States and even Europe, where his works were stolen or cannibalized by publishers anxious to capitalize on the European interest in things American.

That Frost was from Philadelphia was significant, because the city of brotherly love was the center for book publishing in America in the eighteenth and early nineteenth centuries. In the first years of the 1800s, Philadelphia press builder George Clymer introduced the Columbian Press, which substituted the fulcrum for the screw as the source of impressing power and increased speed of production while reducing costs. By the 1820s the science of mechanics had developed sufficiently to encourage the use of cylindrical applications of power, and the river systems of the Philadelphia region were useful for generating such power. New techniques for papermaking also encouraged the use of the dense Pennsylvania woods for the book industry.[62] Dozens of small presses established themselves in the region, and it was good fortune that Frost was located in the area, as no other part of the country offered him access to the variety of publishing options he needed for popularized and pictorial texts. Frost's publisher, Benjamin Walker, had founded one of these businesses on South Fourth Street in Philadelphia, and the two carried on a partnership that lasted for many decades. Although each has suffered the painful obscurity Goodrich predicted for himself and others in the pictorial field, during the 1840s both Frost and Walker were considered prominent members of a growing literary community.[63]

One of the ways Frost distinguished himself in his day was to link his pictorial ambitions to an agenda of unabashed nationalism. His expressed goal was to provide a unified vision of the American past as a technique for inspiring readers to act in responsibly "American" ways. To that end, Frost organized the *Pictorial History* around the principle of liberty, which he viewed as the single greatest stimulus to unity and the fulfillment of national purpose. Because Americans exercised freedom of choice in nearly all things, he argued, they were receptive to liberty's promise as revealed by the hand of destiny. On many occasions in Frost's narrative "the arm of Providence saved the colonists" from the storms, shipwrecks, pestilence, and self-destruction that disabled weaker nations. In documenting the role of Providence in the American saga, Frost appealed to the strong pride and vanity of Americans who were only too willing to view themselves as important players in God's master plan. And Frost's literary techniques reinforced with dramatic clarity the inviolability of his historical message. Frost's discoverers of America do not merely sail and

explore; they are "fired . . . with a romantic spirit of adventure" that guides them to their "immortality." American soldiers do more than just skirmish and die; they perish triumphantly knowing that their death struggles are a "direct manifestation of the fact that Omnipotence" has guaranteed the success of the cause for which they gave the final measure.[64]

Such literary techniques borrowed from the romantic and Gothic traditions proved highly effective in creating a palpable sense of the drama of the past. Like other historians of his own day, including Bancroft, Parkman, and Prescott, Frost used pictorial devices as well to enhance the descriptive power of his writing.[65] Elaborating on the theme of human freedom, Frost made reference to physical forces observed in external nature that suggested the expansive power of liberty. Anne Hutchinson created a "terrible storm of excitement" when she challenged the Puritan magistrates; news of victory in the Revolution "flew like a meteor through America"; and "the flames of revolt and revolution, which raged so fiercely in England . . . inflamed by fresh incentives, burst forth in a blaze of insurrectionary violence" in the colonies.[66] Whether depicting storms, meteors, or conflagrations, these allusions to the physical forces of nature were intended as visual embodiments of the abstract power of liberty. Because carefully crafted literary allusions were thought to convey the "essence" of the objects in the external world to which they corresponded, writers such as Frost could use the pictorial mode to elicit responses from their readers fundamentally the same as if they were confronted by the objects themselves. Others more fully ensconced in the romantic tradition created more meaningful visual associations in the minds of readers than Frost ever did, but his limited use of the technique at least suggested the recognition that forces and objects "are presented to the imagination primarily through the avenue of sight."[67] In addition, Frost's early experimentation with the pictorial element in historical literature suggested a freedom of expression that was itself a legacy of the very American liberty he chose as his subject.

Importantly, Walker and Frost were not content to restrict their celebration of liberty to engaging literary metaphors or vivid pictorial analogies. They also employed artists and engravers to lend visual force to their dramatic literary expressions. The specific ways in which publisher and author used illustrations in the *Pictorial History of the United States* are revealing of the early challenges faced by promoters of pictorial formats. On the one hand, they did not have to look far for illustrators willing to take on the project. A small colony of competent artists and engravers had emerged in the Brandywine Valley of southeastern Pennsylvania, a place sought out for its "bracing and pestilent-free air" by those who had fled Philadelphia during the yellow fever epidemics of the 1790s.[68] Many of the artists from this region, such as William Croome, had been working to develop a "freer and more artistic drawing on the block," and they took pride as a community in the growing accomplishments of their art.[69] Walker and Frost hired Croome as the primary illustrator and engraver of the *Pictorial History of the United States* because they believed that his "pictorial embellishments" struck closest to the heart of what Americans wanted from visual enhancements. "The effect which pictures, well conceived and ably executed, have in impressing historical events upon the mind, must be apparent to every attentive reader," Frost noted of Croome's work. "Such delineations furnish luminous points, around which are clustered a host of agreeable associations." Frost professed a nineteenth-century version of a Lockean epistemology, in which the mind serves as a blank slate, a tabula rosa, on which visual images are imprinted. "In selecting the subjects for his designs," Frost wrote in his preface, "Mr. Croome has taken those

Fünf und zwanzigstes Capitel.

Beginn des Feldzuges von 1757. Prag und Kollin.

o war der Winter vergangen und der ernstlichere Kampf um das weitere Dasein der preußischen Herrschaft mußte bald beginnen. Friedrich hatte sein Heer so weit verstärkt, daß er (nach ausgedehntester Berechnung) über ungefähr 200,000 Mann zu gebieten hatte; aber er konnte auch berechnen, daß ihm die Feinde, mit vereinten Kräften, an 500,000 Mann entgegenzusetzen im Stande seien. Doch waren weder Frankreich, noch Rußland, noch Schweden, noch die Reichsarmee mit ihren Rüstungen fertig; nur Oesterreich stand ihm drohend

Figure 3. "Battle Scene," from Franz Kugler, *Geschichte Friedrichs des Grossen*, 1840

Death of Pulaski.

militia, two hundred and forty-one, were killed or wounded. Among those who fell, none was more deeply lamented than the gallant Count Pulaski, a Polish officer in the American service. Immediately after this unsuccessful assault, the militia almost universally went to their homes, and Count D'Estaing, re-embarking his troops and artillery, left the continent.

While the siege of Savannah was pending, a remarkable enterprise was effected by Colonel John White, of Georgia. Previous to D'Estaing's arrival, about one hundred Tory regulars had taken post near the Ogeechee river, twenty-five miles from Savannah. There were at the same place, five British vessels, four of which were armed, and manned with forty sailors. The largest armed vessel carried fourteen guns, and the smallest four. Colonel White, with six volunteers, one of whom was his own servant, captured all this force. On the 30th of September, at eleven o'clock at night, he kindled a number of fires in different places, adopted the parade of a large encampment, practised a variety of other stratagems, and finally concluded his demonstrations by summoning the

Figure 4. "Death of Pulaski," 1844, engraved by William Croome for John Frost's *Pictorial History of the United States*

which it was deemed important to impress upon the mind of the reader,—those prominent incidents and characters which deserve to be cherished in the memory of every American." Evoking the language of the graver, Frost hoped Croome's images would make their "impression" on readers by taking "a stronger hold of the imagination than any effort of descriptive power" and "remain[ing] longer and produc[ing] a livelier satisfaction than any mere record of language."[70]

On the other hand, even Frost's most enthusiastic

endorsement of Croome's work could not obscure some of the defects of the illustrations in the *Pictorial History of the United States*. For one thing, the expense of illustrating the text limited the number of pictures Frost could include. On average one illustration appears for every five pages of text, a frequency that gave Frost's history a less pictorial and more literary appearance. Of course, one way to reduce the cost of illustrating was to hire lesser-known artists to depict simpler scenes at reduced cost. Walker followed this

Figure 5. "Death of Wolfe," 1844, as redrawn from the Benjamin West painting by William Croome and engraved by George T. Devereux for John Frost's *Pictorial History of the United States*

practice by commissioning four Indian scenes from then-unknown illustrator F. O. C. Darley and by hiring George T. Devereux to engrave a handful of less challenging pictures discarded by Croome.[71] Devereux's reputation as a lesser light among the Brandywine illustrators was acknowledged in the preface to a Philadelphia sketchbook he engraved, in which the publisher admitted that others had been approached to do the work in advance of Devereux. "During the particular time we were engaged in the preparation of these pages," the publisher conceded, "an unusual activity prevailed among our best wood engravers, in consequence of large orders from the Government. We were, therefore, forced to employ artists of ordinary talent."[72] One wonders what Devereux thought of that curious admission! Even with these acknowledged reductions in costs, the

publisher of the Philadelphia sketchbook announced that more than seventeen hundred dollars had been spent on illustrations for the work, an expenditure that he hoped would convince readers to overlook deficiencies in the execution of a few pictorial treatments.

Among other cost-cutting measures, Croome and Devereux employed shortcuts such as copying illustrations from other works of history instead of creating original compositions themselves. Sometimes this meant modifying a preexisting image, as when Devereux altered the perspective and the number of human figures in an eighteenth-century English print of *Burgoyne's Encampment on the Hudson* in order to accommodate the space limitations of Frost's text. At other times, illustrations were transposed recklessly out of context, as when Devereux adapted a drawing

from Franz Kugler's biography *Geschichte Friedrichs des Grossen* (published in Leipzig in 1840) depicting the death of a Prussian soldier in the Seven Years' War in Europe for use in a pictorial representation of the death of Polish mercenary soldier Casimir Pulaski at the Siege of Savannah during the American Revolution (figs. 3 and 4).[73] In superimposing the uniforms of Prussian soldiers on Revolutionary officers, Devereux did more than shamelessly "borrow" an image; he also distorted the historical record by suggesting that the military strategies and accouterments of war in Europe of the 1750s were interchangeable with those in America during the 1770s. In addition, Walker appropriated these engravings without fear of retribution, because there were no copyright laws on visual materials in the 1840s. He knew that it was relatively easy for engravers to make adjustments to plates that were already prepared; it was a far more difficult and expensive proposition to commission and execute original works of art for the book industry.[74]

The reissuing of original art in alternative pictorial contexts did not protect publishers from the inaccuracies of translation or bad technique that were often characteristic of early pictorial histories. In looking back at the works of Goodrich or Frost, one is struck by the pervasive two-dimensionality of their illustrations and the glaring failure of Croome and others to create an illusion of the three-dimensional world in their pictorial efforts. In order to more adequately convince viewers of the visual realities of their depictions of historical events, these artists and engravers needed to provide a better sense of the "relief" of the surfaces of their images, demonstrating depth of field through accurate presentation of gradients of texture and variations of light and shade. Even in Frost's day graphic artists had available to them some rather sophisticated ways of conveying undulations of surface and contour in their illustrations, including the use of

cross-hatching and, in the case of lithography, "stippling," in which the engraver's burin is "flicked" across the surface of a stone to create the illusion of modeling. Despite the obvious advantages of these new techniques for the communication of three-dimensionality, Devereux relied almost exclusively on traditional "profiling" as a means of conveying depth, delineating contour by use of the outer edge of objects as determined by their profile at a maximum extension in space. The result was that illustrations in Frost's *Pictorial History of the United States* such as "Death of Pulaski" have a flat, scratchy texture to them, compressing their field of vision and reducing their effectiveness as transmitters of action on the battleground.[75]

In addition to these shortcomings of technique, many of the illustrations in Frost's volumes were of the sort Croome had produced for the Crockett almanacs—literal rather than interpretive translations of the written word. Many engravers viewed themselves as essentially copyists, and as such their allegiance was to the "original" and to the abstract principle of fidelity in translation. Later engravers recognized the art as interpretive and sometimes presumed to add personal touches to an original work of art; but in Frost's day, such touches were considered as in violation of the engraver's mission.[76] Hence, in terms of illustrative content, the *Pictorial History of the United States* is dominated by prosaic portraits and conventional depictions of historical episodes in the American past. Some of these pictorial treatments are adequate representations and some are not, but in almost all cases they fail to do justice to the literary passages with which they are associated. Their effect is almost always to reduce the drama and suppress the action explicit in Frost's writing.

The restrained quality of many of Frost's illustrations may derive as well from the inability of pictorial art to convey the passage of time adequately, as

Figure 6. "Pocahontas Rescuing Captain Smith," 1844, by William Croome for John Frost's *Pictorial History of the United States*

William Gilmore Simms had warned. Illustrations could portray confidently the details of individual moments in time, but without the use of friezes, diptychs, or triptychs, it was virtually impossible to suggest narrativity and time sequencing.[77] Put differently, the illustrations in the *Pictorial History of the United States* remind us that "history as *event* lends itself more readily to the painter's craft than history as *process*."[78] Croome's pictorial representations "freeze" the action of Frost's narrative, disturbing its pace and reducing its power to advance the reader forward through time. Because the job of the historian was presumed to be to make connections across temporal periods, these limitations created an incongruity between visual images and the written word in the *Pictorial History of the United States* that was difficult to overcome. The literary aspects of Frost's production far outpaced the visual ones, suggesting the continuing triumph of the word at midcentury.

The illustrations in Frost's work fall into several traditional mimetic categories. Some have a purely documentary value; they aspire only to provide accurate depictions of persons, places, and things. Hence, Frost included a number of authentic contemporary sketches of geographic locations mentioned in his text. In other instances he commissioned drawings of buildings, such as Carpenters' Hall in Philadelphia, where the Continental Congress was organized. Although the edifice was still standing in the 1840s when Frost's history was published, the engraving was made from an original print of the building produced in the 1770s, lending an additional air of authority to the depiction.[79] Occasionally Croome attempted to provide accurate renditions of the flora and fauna of a region,

relying on handbooks and natural history manuals to reproduce faithful botanical and physiological forms. Although the Crockett almanacs allowed Croome greater interpretive license than he enjoyed in illustrating Frost's history, in both sources he demonstrated a commitment to accuracy of detail even as he worked in the cause of the imagination. The abilities to transfer skills from one format to another and to reproduce objects with fidelity of a copyist in any format were essential to illustrators working in an increasingly diversifying market.[80]

A small number of the illustrations in the *Pictorial History of the United States* are interpretive in the anecdotal sense and move beyond the literal to the connotative. Although he prided himself in providing readers with authentic pictorial representations, Frost admitted that accurate visual information about historical episodes such as battle scenes must be "necessarily incomplete and imperfect."[81] In such instances Frost felt justified in borrowing images from history painters who endeavored to capture the essence of unrecorded events through imaginative recreations. Hence, the *Pictorial History of the United States* included a rendition of Benjamin West's *Death of Wolfe* as redrawn by Croome and engraved by Devereux (fig. 5). West's original painting of the death of James Wolfe on the Plains of Abraham in Quebec during the French and Indian War was controversial when it was completed in 1771 because, although it included well-established images of heroic death and evidence of strong classical posturing, it depicted eighteenth-century actors in contemporary military dress rather than "the classical costume of antiquity." Fearing that "the presentation of heroic death in everyday dress would destroy respect" for Wolfe, the president of the Royal Academy, Sir Joshua Reynolds, advised the painter to clothe the general and his entourage in togas after the manner of classically inspired history

Figure 7. Frontispiece to volume 1 of John Frost's *Pictorial History of the United States*, 1844, by William Croome

painters on the Continent. West's oft-quoted defense of his choice—that the "same truth that guides the pen of the historian should govern the pencil of the artist"—occasioned a penitent Reynolds to recant his objections to the period costuming and to declare the work a "revolution in art."[82] So successful was West's painting, in fact, that it established a vocabulary of symbolic images irrefutably associated with Wolfe's death (the pietà posture, the foreboding clouds, the noble savage), a lexicon of images that overshadowed all competing pictorial representations of the event. Like many popular historians of his time, Frost could

Figure 8. Head-letter emblem from John Frost's *Pictorial History of the United States*, 1844

not ignore the power of such imagery, and he included an engraving of West's allegorical work in the *Pictorial History of the United States* as a tribute to the painter's historical vision.

Frost's use of West's interpretive painting might be construed as an effort to allow pictorial art to compete on equal terms with the written word as an explanatory device for understanding history. But such a deduction would ignore the "replicated" quality of West's painting as well as the culture of reception into which such a standardized image was introduced. Nearly all the illustrations derived from history paintings in the *Pictorial History of the United States* were examples of visualizations so powerful as to have become the clichéd representations of the historical events they depicted. Viewed by the public as nearly synonymous with the events themselves, these works were frequently overreproduced in such numbers as to become symbolic as well as literal "stereotypes," mass-produced images printed and reprinted through the process of stereotyping. Walker's use of clichéd historical paintings rather than original productions meant that his illustrations often had a banal, decorative quality to them. Frost's decision to reproduce

West's painting may have reflected financial as much as editorial preferences (it allowed the publisher to use a widely circulated image rather than to commission a new one), but its ultimate consequence was to weaken the impact of pictorial representation relative to Frost's written narrative. West's painterly treatment of the death of General Wolfe was not incompatible with Frost's written description of the general as one who "expired in the arms of victory," but neither was it aided noticeably by the use of a hackneyed image to which Frost makes no reference in his text. Art was subordinate to the text in this instance and remained secondary to the written word in its power to evoke the human drama of the struggle for empire in the eighteenth century.[83]

Another example of the restricted use of interpretive illustrations can be found in Croome's "Pocahontas Rescuing Captain Smith" (fig. 6). In this instance the illustrator does execute an original drawing, although it has none of the theatrical overtones of the "glowing pictures" demanded by Simms of this subject. Arguing for a mode of illustration that would place pictorial art at the dramatic center of the historical enterprise, Simms was disappointed undoubtedly by subdued pictorial versions of the Pocahontas story such as this one. In Croome's rendering

Figure 9. "Scalping Knife," by William Croome for John Frost's *Pictorial History of the United States*, 1844, based on an illustration from Franz Kugler, *Geschichte Friedrichs des Grossen*, 1840

of the episode there is none of the elaborate backdrop of unbroken forest that Simms requested, none of the play of light or preparation of scene. Still worse, there is little of the charged human emotion Simms demanded of pictorial representations of the rescue scene. The executioner does not appear ready to "drink in the groans of the victim" or to pluck his heart from its "quivering abode" as Simms required. The illustration was more typical of the "motionless automata of history" that Simms rejected than of the living, breathing presence he desired. In fairness to Croome we should note that some of the limitations in "Pocahontas Rescuing Captain Smith" result from the failure of woodcut technology to depict motion (and emotion) adequately.[84] But according to Simms's criteria, the real deficiencies were conceptual rather than mechanical. Croome had chosen the wrong moment to illustrate his subject. He had missed the "crisis in the fortunes of the scene" when "the struggle is at its height" and had failed to capture the "heavy stroke of death" permeating the episode. Once again, the potential use of pictorial art as a strong tool for the conveyance of historical meaning was repudiated in favor of its more modest employment as a crude depictive device.

In order that style might recapitulate theme, Frost used ornamental art to mark transitions among his chapters and to bring material unity to a narrative about national solidarity. Patterned designs served mechanical bookmaking purposes, smoothing over physical breaks in the narrative with decorative connecting devices, but they also reaffirmed Frost's intellectual commitment to consensus by providing culturally agreed upon symbols of liberty and progress. Hence, highly iconographic representations of liberty caps and flags or of sacred landmarks such as Plymouth Rock provided familiar bench marks for nineteenth-century readers searching for shared national traditions. Other end pieces were designed to increase Frost's scholarly authority, including those of dusty bookshelves, bespattered inkwells, and collections of books bearing the names of glorified historians such as Grahame and Bancroft.[85]

In still other cases, illustrations were more interactive, devised to serve as gateways or points of entry into a text. The frontispiece to the *Pictorial History of the United States* depicts an Indian who stands watch over the entrance to an Arcadian landscape that readers must enter by ducking symbolically beneath a labyrinth of vines (fig. 7). From a technical point of view, this illustration was not very successful in terms of conveying a proper sense of figure and ground or depth of field, but as a symbolic representation, it served its purpose well, requiring readers opening Frost's book to supply their own subliminal interpretations of "perspective" and thereby to contribute to the creation of meaning.[86] Croome also introduced head-letter emblems in the style of illuminated manuscripts, such as that in which Indians peer with wonder and incredulity into Frost's text through an oversized C for Christopher Columbus, whose explorations separated them as profoundly from Western civilization as their pictorial signifiers are disconnected from the written word (fig. 8). When one contrasts this image of bewildered and alienated Indians with the more combative symbolism implicit in the end piece to the volume on the seventeenth century titled the "Scalping Knife" (fig. 9), one sees how such ornamental depictions also served an important narrative function in the *Pictorial History of the United States*, underscoring as these two depictions do the failing fortunes of Indians in North America. In this specialized decorative role art assumed a limited partnership with the written word in conveying Frost's narrative intentions.

By and large, however, the pictorial representations

in Frost's work were embellishments rather than interpretations of text. This is nowhere evidenced better than in connection with the most frequent illustrative material found in the *Pictorial History of the United States:* portraiture. In an age enticed by Carlyle's concept of the "Great Man," the study and depiction of "great character" took on an exaggerated significance.[87] Portraits were valued into the nineteenth century as the only accurate means for preserving visually the physical and spiritual characteristics of a subject. When photography made its commercial appearance in midcentury and the costs of producing *carte de visites* lowered sufficiently to make sitting for one's portrait a nearly universal experience, traditional portrait painting lost some of its exclusive hold on the American imagination. But even photography, with its ability to record with fidelity the external appearance of things, seemed less capable than portraiture of capturing "the inner essence" of a subject. As painter William Page put it, "While the camera may be useful as an aid to drawing, it is a 'misapprehension of the object of art' to think that '-reproduction of nature' by itself can achieve it. 'Soul' can 'never be made visible through a machine-rendered body, however perfect in its kind that may become.'"[88] The desire to reproduce the inner "soul" of historical subjects encouraged the publication of portrait volumes containing the likenesses of "illustrious Americans" whose images were preserved pictorially in the tradition of "pantheon portraiture."[89]

For Frost, the extensive use of portraits in the *Pictorial History of the United States* was associated with his desire to provide readers with accurate history. In the 1840s it was still barely possible to recover the history of the American Revolution and the War of 1812 from personal interviews with survivors, and the value of "eyewitness accounts" and primary documents was well appreciated by Frost. But such con-

Figure 10. "George Washington," 1844, as redrawn by William Croome from the Gilbert Stuart portrait for John Frost's *Pictorial History of the United States*

tacts were infrequent, and Frost did not have the time or money to stockpile massive archival records of the visual "recollections" of these survivors. Instead, he relied on portraiture as a device for eliciting the character of the age and its people. "The portrait of a distinguished man gives additional force and distinctness to our recollection of character," he wrote in the preface to the *Pictorial History of the United States,* adding that illustrator Croome "has had recourse to original portraits and approved engraved likenesses; and he has made the costumes of the different periods

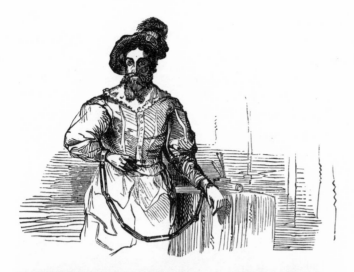

Figure 11. "Columbus in Chains," 1844, by William Croome for John Frost's *Pictorial History of the United States*

Figure 12. *Portrait of Gian Galeazzo San-Vitale,* by Francesco Parmigianino (Courtesy of the Museum Capodimonte, Naples, Italy)

comprised in the history, the subject of careful and attentive study. If in these respects there is any error, he has erred with the countenance of learned and respected authorities."[90]

The principles of selection employed by Frost in his choice of portraits for the *Pictorial History of the United States* are revealing of the ways in which the visual functioned relative to the written word in his historical imagination. "In order to give his delineations as much of the authenticity of history as it is competent for the pictorial art to attain," Frost wrote, Croome was asked to choose among numerous subjects worthy of illustration and between competing images of those subjects where multiple likenesses existed. "If particular characters have been made conspicuous, and single events have been dwelt upon with emphasis, it was because they were considered more influential than others, that have been passed over or comparatively thrown into the shade," he noted using pictorial language.[91] In some cases, as with Frost's hero Washington, Croome relied on the most popular and conventional images of the first president to evoke a positive response in readers. Croome's reproduction of the popular Gilbert Stuart portrait of Washington, despite its obvious deficiencies of execution and its potential for clichéd reductionism, would have awakened strong nationalistic sentiments in most Americans in the 1840s (fig. 10).

In other cases, where no clear consensus existed as to the physical appearance of an "illustrious character," Croome selected from among a number of widely circulating images. In depicting Columbus, for instance, Croome worked from a portrait by sixteenth-century Italian artist Francesco Parmigianino (figs. 11 and 12). In Parmigianino's work the sitter appears as an intelligent, bearded, genteel man, serene even in his moments of despair, a delineation that comported well with Frost's depiction of Columbus as a contemplative and self-sacrificing discoverer. It is revealing, however, that in adapting his portrait of Columbus from Parmigianino, Croome perpetuated an error of identity that had been made several hundred years earlier. Anxious to find pictorial representations of the Italian explorer, especially dignified ones, eighteenth-century historians of portraiture convinced themselves that the Parmigianino likeness was that of Columbus, when in fact it was later shown convincingly to have been a likeness of sixteenth-century Italian nobleman Gian Galeazzo San-Vitale.[92] Croome was not to blame for the perpetuation of the mistake, of course, because the Parmigianino Columbus was widely accepted as authentic before scholars proved its misidentification. But such errors were not uncommon in pictorial histories in which accuracy of attribution was less important than pictorial effect. A heroic figure such as Frost's Columbus required a pictorial image suitable to his largesse, and Croome's illustration fit the purpose.[93]

In other instances, however, Croome's illustrations failed to do justice to a figure Frost wished to lionize. Such was the case with his depictions of Sir Henry Vane, a British nobleman who served briefly as governor of the Massachusetts Bay Colony in the 1630s. Frost proclaimed Vane a leader of "angelic grandeur," a man so "animated with such ardent devotion to the cause of pure religion and liberty" that his entire life "was one continued course of great and daring enterprise." When Vane ran afoul of shortsighted religious factions in New England because his "ideas of civil and religious liberty were at least a century in advance of the people among whom he was settled," he was shipped back to Old England, where he was eventually executed as a renegade. Willing to die for his principles, Vane became for Frost a tragic, martyred figure, who met death "with a heroic and smiling intrepidity, and encountered it with tranquil and dignified resig-

nation."[94] Such a grand literary portrait of Vane by Frost presupposed an equally glorified pictorial treatment by Croome, but the illustrator was not up to the task. Croome's portrait of the Massachusetts Bay governor was undistinguished, failing as it did to conform to any of the pictorial conventions of the physiognomy of greatness, and his adaptation of Corbould's *Execution of Vane*, though more dramatic in conception, lacked the power and pathos of Frost's description. Croome's failure in these pictorial reproductions reminds us that in the *Pictorial History of the United States* language almost always outstripped visual images in the communication of historical meaning.

Frost's varied use of literary and pictorial portraiture to elicit the characters of Washington, Columbus, and Vane suggests the extent to which success in characterization depended largely on the degree to which a figure's visual image had fixed itself in the popular mind. In some cases the reproduction of well-established images threatened to generate clichéd responses in viewers, but readers also demanded some recognizable features in the pictorial representations of their heroes. The limitations of woodcut technology made it difficult for illustrators and engravers like Croome or Devereux to satisfy this need for discernable profiles, and in the cases of historical figures

without certified visual identities, failures of artistic execution were often fatal to reputations. Hence, although the crude reproduction of Gilbert Stuart's portrait of Washington probably contained enough recognizable points of reference to achieve its desired heroic effect, a decidedly unflattering portrait of Lord North by Devereux almost certainly doomed him to a place of infamy or obscurity in the eyes of Frost's readers (fig. 13). The deficiencies evident in illustrations like that of Lord North may not be attributable wholly to a failure of technique, of course; one could view North's portrait as intentionally satiric, in the best tradition of sardonic political cartoonists such as Hogarth. But such a reading would make the portrait incompatible with the somewhat more charitable treatment of North in Frost's text, where the British prime minister is presented as a misguided but respectable opponent to the revolutionary cause. In the case of North the absence of a fixed visual image in the public mind with which to overcome Devereux's uncomplimentary depiction left the prime minister's reputation susceptible to misinterpretation in ways that Washington's was not.

Some of the discrepancies between text and illustrations were conditioned by the availability (or lack thereof) of adequate original prints from which to work. In Croome's depiction of the Polish soldier of fortune Gen. Thaddeus Kosciusko, for instance, the illustrator made skillful use of a masterful portrait by H. B. Brown (fig. 14). In other cases in which no suitable replicas were available, however, Frost's illustrators proved remarkably inept at producing either realistic portraiture or authentic historical action. Hence, Croome's depiction of "General Wayne Defeating the Indians" has a crude, hurried quality to it reminiscent of the Crockett almanacs, providing no visual cues as to where Wayne even appears in the drawing (fig. 15). But at still other times the failure of

artistic technique could not be explained away by the unavailability of sources. The engraving of George III, for instance, was an incompetent rendering of the least flattering of the many hundreds of procurable images of the king (fig. 16).[95] For nineteenth-century readers of the *Pictorial History of the United States,* this awkward representation could have been viewed as a political statement only, because its inadequacies were too glaring in comparison with the original painting to be attributed to poor craftsmanship merely (fig. 17). For those who may not have known the widely circulated archetype of George III, comparisons internal to the text with the triumphs of a portrait like that of Kosciusko would have sufficed to make the political point. Such variations in the style and tone of the illustrations and the inconsistencies they created between visual imagery and text underscored the power and the limitations of pictorial technique in the 1840s.

Frost was aware of many of the shortcuts that his publisher had taken in the *Pictorial History of the United States* and suspected that readers might perceive them as inappropriate. Still he offered the volumes in the hopes that they would help to accomplish his larger intellectual goal of providing a unified vision of American culture to readers in his own day. He wrote somewhat too optimistically in the concluding paragraphs of his history, "It is gratifying to be able to close a history of the United States at a period when the country is at peace with all the world; when it is enjoying the blessing of internal tranquility; when every species of industry is receiving ample rewards; and when science and literature are shedding their auspicious light, with increased brilliancy, in every part of the union."[96] Reviews of Frost's work were naturally mixed, depending on how sympathetic readers were to its unifying and nationalistic goals.[97] Europeans continued to snicker at Americans and their

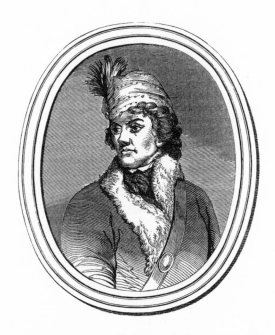

short-lived pasts, the brevity of Frost's work serving as a literal reminder of the terseness of the nation's history. Others, including some of those artists and engravers who worked on the volumes, came to regret the history's sloppy, hurried qualities. Illustrator F. O. C. Darley noted that he was "enticed into [the] project," discovering only too late that the *Pictorial History of the United States* was "an ambitious and pretentious" enterprise that "collapsed from a dearth of talent and skill."[98]

In one important sense, however, Frost's four-volume history was the success he had hoped it would be—it sold. Whereas a series such as George Bancroft's *History of the United States* cost nearly twenty-five dollars to purchase and was released in separate volumes over five decades, Frost's expeditious *Pictorial History* was only five dollars, was far easier reading, and was more widely circulated than Bancroft's early work.[99] Frost's history sold more than fifty thousand copies in its first years on the market, netting him sufficient monies to keep food on the table for his robust

Figure 14. "General Thaddeus Kosciusko," 1844, engraved by William Croome after the portrait by H. B. Brown for John Frost's *Pictorial History of the United States*

Figure 15. "General Wayne Defeating the Indians," 1844, by William Croome for John Frost's *Pictorial History of the United States*

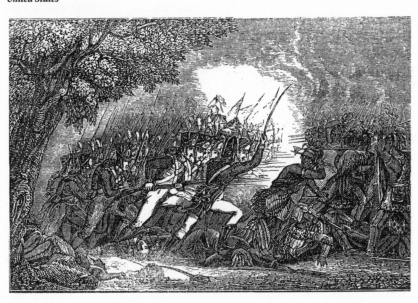

Figure 16. "George III in the First Year of His Reign," 1844, by William Croome for John Frost's *Pictorial History of the United States* (Courtesy of the Radio Times Hulton Picture Library, London)

Figure 17. Portrait of *George III* (Courtesy of the Radio Times Hulton Picture Library, London)

family and revealing new commercial opportunities for the genre of pictorial history.[100] In addition, the success of Frost's volumes contributed to a growing demand on the part of the reading public for illustrated books, the *Cosmopolitan Art Journal* noting in the 1850s that wood engravings in works such as Frost's were "a popular and artistically respectable means of beautifying American life and elevating the public taste."[101] Emboldened by this sales record, oth-

ers jumped into the pictorial publishing field, looking for ways to improve on Frost's deficiencies while retaining the financial and intellectual benefits of his successes. Few of these early pioneers of pictorial history achieved the kind of integrity Simms desired for prototypes of the pictorial mode, but by the late 1840s the genre was clearly a more established presence in the bookmaking industry than the cynical Samuel Goodrich had anticipated.

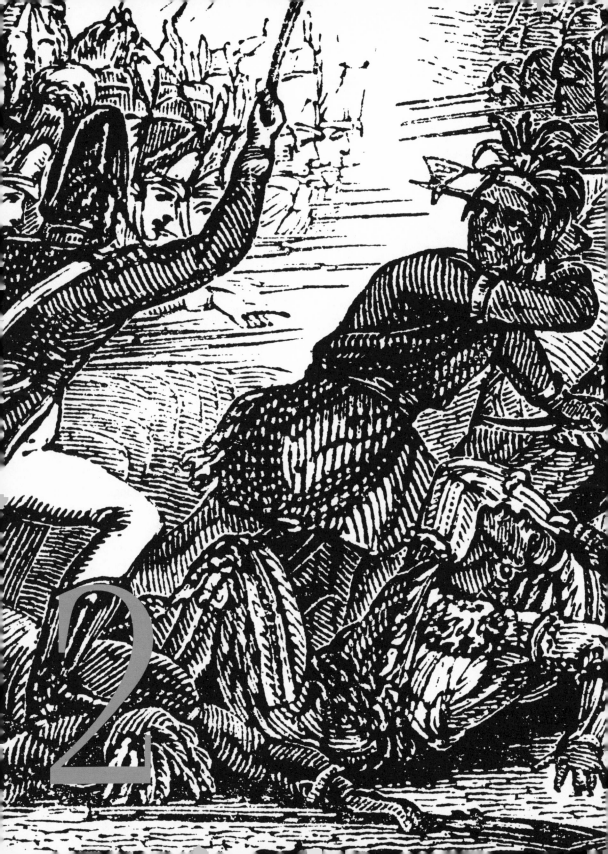

"Pictures on Memory's Wall"

Visual Perspective and the Pictorial Field Books

rost's early forays into the pictorial book market, successful as they were, revealed problems of production that doubtless discouraged many would-be competitors from entering the field. Among the greatest difficulties were those associated with coordinating the needs of authors, artists, engravers, and publishers, all of whom brought different agendas and concerns to bear on illustrated projects. In the case of Frost's pictorial history a major stumbling block was the frequent incompatibility of text and illustrations, as author and illustrator worked at cross-purposes in their literary and visual depictions of historical subjects. Some of these discrepancies were created by financial exigencies, as when Walker was forced to use pictorial images for purposes other than those for which they were created. Additional incongruities resulted from a lack of communication between Frost and Croome, because, like many authors and artists at work on such hurried

projects, they had little time to consult each other on editorial matters. While creating illustrations for Frost's pictorial history, for instance, Croome was simultaneously at work on the Crockett almanacs, Goodrich's "Parley's Magazine," a pictorial history of the United States Navy, an illustrated geography, and numerous other children's books and popular magazines.[1] Frost, in turn, was involved with six publishing projects of his own, including several primers for students and a pictorial history of the world.[2]

Kindred Spirits

Even if time had permitted, conversations between authors and illustrators were not commonplace in the 1840s. Typically publishers rather than writers hired illustrators of books, and publication staffs made decisions as to how to illustrate a text (the size, style, and even the subject matter of pictures) after copy had been approved. Eventually the larger publishing firms established their own art departments, which increased the potential points of contact between artists and writers, but even in such cases illustrators were obligated more to the publishers who paid their salaries than to the authors whose texts they embellished.[3]

A still bigger obstacle to efficient production of pictorial histories resulted from the considerable tensions that existed between engravers and illustrators. As the sometimes-inadequate work of Devereux in Frost's pictorial history suggested, artists were often at the mercy of engravers whose job it was to translate pictorial images drawn on the wood block into forms suitable for printing. Pressures from publishers to work quickly and efficiently often resulted in substandard products. Faces were presumed to be the most crucial area for mastery, and it was here that the greatest potential for "bungling" existed, as the "slightest hairline deviation of the graver's stroke" could alter a subject's expression and compromise its physiognomic codes.[4] Given the importance of portraiture in nineteenth-century pictorial histories, such flaws in facial depiction were of special consequence and explain why some artists regarded engravers as undesirable intermediaries between their visualizations and the viewing public. The oft-quoted complaints of Pre-Raphaelite painter Dante Gabriel Rossetti typified the reaction of many artists toward careless translators of visual images. "These engravers! What ministers of wrath!" he complained. "Your drawing comes to them . . . delicately" but is shortly "hewn in pieces before the Lord Hurry." One such butcher-engraver had rendered Rossetti "an invalid," the painter complained, by dismembering one of his drawings and then "performing his cannibalistic jig [the engraver's signature] in the corner."[5]

Henry Pitz has characterized engravers in a slightly more charitable manner as skilled artisans who worked long, tedious hours, with "eyeshades titled over their brows, bent over their boxwood blocks" carving out "nick by nick and threadlike line by threadlike line" with their gravers "the intricate arabesque of tiny printing shapes." They were a "cocky and independent company," he acknowledged, but their hubris derived justifiably from their sense of themselves as artists manipulating the graver with dexterity not unlike that of the painter's brush. Additionally, artists who "showed not the slightest interest in or understanding of the mechanics of wood engraving and blandly expected miracles from their poorly prepared drawings" often put engravers in impossible situations. Most illustrators drew directly onto wood blocks that engravers then chipped away, so original drawings are not generally available for purposes of comparison, but anecdotal evidence suggests that many artists provided too few details and

guidelines for the successful translation of their own images onto the printed page. There were many "lazy illustrators who gave the engraver only a few jottings and expected him to fill in and amplify certain areas and reviled him when things were not to their taste."[6] These failures of communication hindered efforts to produce acceptable illustrated books, as authors, artists, engravers, and publishers blamed one another for the inadequacies of the pictorial format.

Finally, numerous problems existed between publishers and authors who argued incessantly over what piece of the publishing pie each would receive. As is still the case, authors felt publishers underpaid them wildly. In turn publishing companies often reminded writers of the high costs of production associated with illustrated books as well as of the substantial expenses incurred for advertising and marketing. The financial risks of the pictorial book market were great, and on occasion publishers were forced into bankruptcy by mistakes made in the production of even a single book. The "gentility" thought to pervade the publishing industry in the 1830s and 1840s was but an illusion, noted one observer of the scene, obscuring the profession's "greed, ruthlessness, and small heed to the fundamental decencies of civilized business relations." Publishers and writers, it seems, dealt badly with each other out of sheer habit.[7]

Some of these communication problems dissipated slightly in the cultural and technological climate that emerged after the publication of Frost's work. Broken relations between writers and artists were repaired in social clubs that sprang up in publishing centers like New York City, where mutual interests in the pictorial mode encouraged writers, painters, and poets to celebrate the interdependencies of the arts. Members of organizations like the Sketch Club or the Bread and Cheese Club, including Irving, Cooper, Bryant, and Cole, gathered regularly to acknowledge and pursue their collective identity as "kindred spirits" in the search for links between literature and the fine arts.[8] They sought to reconcile competing interests by learning from each other and by attempting to consolidate as many features of their operations as possible into a centralized managerial intelligence. Publishers searched among like-minded club members for writers who had artistic abilities and artists who could write.

The advantages of this sort of concentration of skills were nowhere better evidenced than in the work of Benson J. Lossing, a writer-turned-illustrator and engraver who eventually established his own publishing company. Assuming responsibility for nearly all features of illustrated book production, from the authorship of texts to the sketching of historical scenes to the engraving of wood blocks, Lossing developed an integrated specialty within the genre of pictorial history, the pictorial field book. These "narrative sketch-books" were illustrated travelogues based on visits to scenes of historical importance in which Lossing used both literary pen and sketching pencil to provide written and pictorial accounts of history.[9] The field books introduced a new synchronized format for pictorial history by combining in one agent the functions of historical observer and artistic interpreter. Although there were risks to such a single-minded enterprise, Lossing's insistence on illustrating with one hand what the other was writing implied a unity of form and function never imagined or achieved by Frost, Croome, and Walker.

The pattern of Lossing's career suggests the important transitions pictorial history underwent as a genre in the middle decades of the nineteenth century. Born in 1813 in Beekman, New York, just north of New York City on the Connecticut–New York line, Lossing was the son of farmers who descended from early Dutch settlers in Albany. His parents died before

Lossing reached the age of twelve, and so he was forced to become, in his own words, a "self-made man." Apprenticed to a watchmaker in Poughkeepsie, he there received the only formal education he ever had—two years in the local school system. He learned history piecemeal—through an odd volume of Gibbon's *History* he found among some rubbish in his master's shop, through a discarded edition of John Marshall's *The Life of George Washington*, and through the Bible—all of which he read by "rising before daybreak, and deciphering the words by the glowing embers of the shop fire." Eventually Lossing became a partner in the watchmaking business, and then, at the age of twenty-two, he began his literary career by accepting a position as the editor and joint owner of the *Poughkeepsie Telegraph* (the county's Democratic newspaper) and later a short-lived literary paper called the *Casket*.[10]

Young and ambitious, Lossing wished to increase the circulation of his newspapers by incorporating pictorial representations. He began modestly by using patterned illustrations for ornamentation as a way of catching the reader's eye and later experimented with more elaborate forms of woodcut presentation. Lossing discovered quickly that he could not afford to pay a woodcut engraver to illustrate his daily papers, so he decided somewhat brashly to train himself to become an illustrator. In 1837 he contacted the preeminent New York City wood engraver Joseph A. Adams for a two-week course of instruction, paying Adams the handsome sum of fifty dollars "to instruct him in the use of tools and material necessary for engraving."[11] He then borrowed some instructional manuals on drawing from the National Academy of Design, and within a month of the inception of his training Lossing commissioned his first illustration—an article he had written on an Indian legend for the *New York Mirror*. Over the next six months he honed his skills,

adapting numerous illustrations for use in his papers and writing editorial "Letters" to proclaim the value of drawing for those who wished to "bring to mind the recollection of circumstances which have escaped the memory in the lapse of years." Within the year he had become so proficient at the arts of drawing and engraving that he reversed his vocational priorities altogether, reducing his newspaper work significantly in order to become a full-time wood engraver.[12]

Judged by today's rigid vocational categories, Lossing's switch from newspaper work to engraving might seem drastic and abrupt, but for Lossing the transition was a relatively uncomplicated one from a literary to a visual form of artistic expression. The ease with which Lossing moved back and forth between these compatible forms suggests the important congruence he felt between visual and written components of the pictorial mode. For Lossing, engraving was not merely the tedious practice of translating from one visual code to another but a form of high art, akin to great literature to which it was related. Later in life Lossing lectured frequently on the subject of art, and he always reserved his most exalted language for the power of engraving, a trade he viewed as both refined and democratic. The value of pictorial engraving, he argued, was not merely in its aesthetic intricacies but in its status as "the literature of the unlearned." Pictures allowed illustrators to carry "knowledge alike and in the same vehicles to the King and the peasant," he wrote, "to the rich and the poor; to the learned and the unlearned, for on the wings of the Printing Press it is scattered like seeds in Summer, in every direction, and almost as freely." When the printed word proved inadequate to the task of describing the external appearance of objects, Lossing added, the engraver employed his "creative power" to reveal the material world "in all the exactitude of Truth." Admitting that he was "more accustomed to

drawing figures of objects upon tablets of wood, than figures of speech before a public audience," Lossing struggled to articulate his religious faith in the "Holy Art" of engraving, a divine calling that obligated the limner to spread "the word" in pictorial form to the widest range of peoples in the spirit of pious and democratic mission.[13] He had less trouble illustrating the point (in the literal sense), elucidating his lectures and books as he often did with visual representations that revealed by concrete example the creative power of the engraved image.

Lossing united his interests in writing and art as early as 1838, when he was hired by J. S. Redfield, publisher of the *Family Magazine,* to edit and illuminate "the first fully illustrated periodical in America." Reviews of his work suggest his relative success.[14] One commentator called the journal "an excellent work—much superior to the *Penny Magazine,* so much in vogue a few years since," and others praised the superb integration of the engravings with the literary text.[15] For Lossing, this marriage of image and word was crucial to the revolutionary potential of print culture, a point he raised dramatically not only in the columns of the *Family Magazine* but also in several provocative public addresses on the value of both verbal and visual print forms. Lossing credited the printing press with exposing "the falsehoods of civil government" by unmasking the "ogre, war," and by laying "bare the sinkhole of moral pollution into which the Church had fallen."[16] But he disagreed with those who argued that the new pictorialism subverted "the hard-won discipline of verbal mastery."[17] Illustration brought "visible language" to the masses, Lossing noted, and, in tandem with printing, encouraged a profound revolution in human behavior. Pictorial evidence and the candor of the printed word encouraged subjects "to question the 'divine right' of kings; and as generations rolled away, new features of the idea of equality were presented, and new concessions to its demands were made," he argued. "Political, social, and moral revolutions were observed on every hand, until at length the intellectual sunlight of the present century burst upon the nations, and the Printing press was apotheozed [*sic*] by universal acclamation."[18]

Such pronouncements, overwritten as they were, suggest the degree to which Lossing viewed engraving in the broadest historical perspective possible. His campaign to elevate engraving to an art form and his personal success as an engraver of illustrated magazines and circulars attracted the attention of those cooperative writers and artists associated with New York City's literary clubs who were ever in search of talented artisans to include in their widening circle. At first these participants in an emerging American literati knew Lossing primarily through his work with the graver, some of them commissioning him to illustrate materials for them.[19] One assignment included instructions from Samuel Goodrich to engrave a frontispiece for "Parley's Adventures of Gilbert Go-Ahead" from a very superficial preliminary sketch, using a "bold" style, with "strong light & shadow," and providing his protagonist with a "tall" frame and "sharp Yankee face" (fig. 18).[20] Lossing's success in accomplishing this task from such sparse original materials testified to his talents and increased his growing reputation among the Knickerbockers as both an engraver and an artist (fig. 19).[21]

Increasingly these club members also came to know Lossing for his proficiency as a writer of historical works. Entering into an unspoken competition with Frost and others in the 1840s to be the first to articulate the pattern and direction of popular historical studies in America, Lossing penned one book after another in a conspicuous challenge to European arguments about the paucity of historical literature in

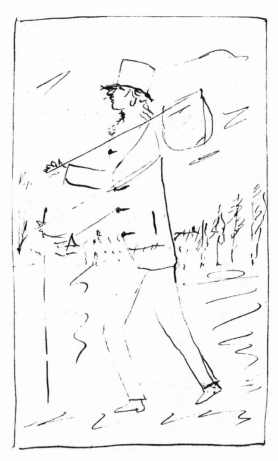

Figure 18. "Sketch for Gilbert Go-Ahead," 1855, by S. G. Goodrich (Courtesy of the Rutherford B. Hayes Library)

Figure 19. "Setting Forth from Sandy Plain," 1856, by Benson Lossing for S. G. Goodrich, *Parley's Adventures of Gilbert Go-Ahead*

America. As prolific as Irving, Cooper, and Bryant were, none of these literary club members wrote more than Benson Lossing. The modest historical works on which Lossing's reputation was established with this New York intelligentsia included several illustrated histories, such as *Outline History of the Fine Arts* (1840); *The Lives of the Presidents of the United States* (1847); *Seventeen Hundred and Seventy-Six; or, The War of Independence* (1847), a young people's history of the Revolution; and *Biographical Sketches of the Signers of the*

Declaration of American Independence (1848).[22] The engraving work alone for these books was enough to keep the firm of Lossing and Barritt in business through midcentury.

Not every one of Lossing's readers was as encouraging about this prodigious output as members of the Sketch Club, however. Reviewers were often critical of a certain deficiency of rigor in Lossing's methodology that they attributed to his lack of training as a historian. The *Outline History of the Fine Arts* "can rightfully

claim a place in no library," wrote one rather savage critic, because it "wants the first requisite of a historical work, accuracy in the statement of facts; it is a crude compilation, carelessly put together, without order, and without examination of the authorities upon which it relies."[23] Others noted that in trying to influence the popular imagination, Lossing had overestimated his talents, his historical interests proving more antiquarian and pedantic than would satisfy the average reader. In addition, his works were criticized (as Frost's had been) for their hurried appearance and their lack of originality. *Seventeen Hundred and Seventy-Six* was written in less than eight months from conception of the idea to submission of the manuscript, an accelerated rate of production that raised suspicions among readers about Lossing's appropriation of "the fruits of the labors of others."[24] Some unappreciative reviewers doubted whether Lossing had the intellectual capability to produce even "mediocre works" quickly. Lossing biographer Harold Mahan has suggested that the rough treatment Lossing received at the hands of such critics "dissuaded him from thinking he could succeed as an historian" and for a number of years prompted Lossing to devote himself almost exclusively to his work as an engraver and editor.[25]

Despite these deficiencies, Lossing's histories came to be appreciated by a widening circle of popular readers who acknowledged with gratitude his efforts to preserve memories of eras such as the American Revolution. The techniques of compilation and editorial comment displayed in *Seventeen Hundred and Seventy-Six*, for instance, caught the ever-watchful eye of Samuel Goodrich, who proclaimed its author more than a "mere engraver." Attracted by Lossing's interest in interviewing the survivors of historical events, Goodrich encouraged him to extend the practice, reminding Lossing that reliable eyewitness accounts were "not to be found in any of the current popular histories" and promising that such would prove a "point of high merit" that "can give you the truth." In pursuing a career as a historian as well as an engraver, Goodrich urged Lossing not to adopt the "flatteries of national vanity and partisan creed" that diminished the value of so many histories of the United States, including George Bancroft's, "written apon [*sic*] a theory which taints every page . . . with falsehood—tho' the work has some transcendent merits." Comparing American historical literature unfavorably with more respectable histories produced by Europeans, Goodrich asked in the familiar cant of Sydney Smith, "Why cannot we have such histories of our national career, as the English and French have of their countries,—sober, honest & truthful. The time has come for a manly, honest, history," Goodrich concluded his note to Lossing, and "I look to you, to give it to us."[26]

"A Perfect Unity of Purpose and Execution"
Eventually Lossing did "give it to" his readers in the form of the aforementioned pictorial field books of the United States on which he began work in the late 1840s. Derived in large part from suggestions like Goodrich's that Lossing record history through first-hand accounts, these pictorial field books were based on personal travels to areas of historical importance and on observations of the people and terrains of sacred historical grounds. Lossing was aware, for instance, that many Americans who had heard of places like Saratoga, Rocky Mount, King's Mountain, or Cowpens still had no geographic or pictorial sense of them, so he determined to provide "accurate chorographical knowledge" of such locales along with reliable historical accounts of their significance for American history.[27] He had already gained a modest reputation for providing "an honorable illustration of

the refinement of intellectual power, which is being developed in this country, in connexion with the exercise of practical mechanics and arts."[28] Now he planned to extend his consolidating technique into the literary arena by producing personalized travelogues of sites of historical significance for the American people. The merging of literary and artistic functions in the work of a single historian transformed pictorial history at midcentury and secured Lossing's reputation as an innovative if somewhat idiosyncratic interpreter of American history.

Lossing developed his plan for pictorial field books in the same manner that he made other career-altering decisions, as a consequence of happenstance. One day, while taking a well-deserved break from his publishing work, Lossing visited the sites of several Revolutionary War battles in Connecticut, including one associated with a conflict between the forces of Gen. Israel Putnam and the British at Horseneck Landing in 1779. Discovering an "odd rock stairway in a valley wall" at the battle scene, Lossing asked an elderly local resident of its significance and learned that his aging respondent had been an officer in the Connecticut militia and had witnessed Putnam escape dramatically from British dragoons down that stairway. This casual encounter with both artifact and envoy of history changed Lossing's life forever. He later wrote of the event, "I had been brought suddenly into the presence of animate and inanimate relics of the old war for independence, both of which were fading away and soon to be seen no more on the earth forever." Motivated by a belief in the mutability of all nature, Lossing dedicated himself on the spot to preserving the rich material and testimonial culture of the Revolution before they were irretrievably lost. "I felt an irrepressible desire to seek and find such mementoes of the great conflict for freedom and independence, wherever they might exist," he wrote, "and to snatch

their lineaments from the grasp of Decay before it should be too late."[29]

Lossing was keenly aware that he had no special training as a historian and that there were others who were perhaps better equipped to undertake the project of preserving the nation's revolutionary past. But these others seemed "indisposed" to take up the task, so Lossing accepted for himself the challenge of safeguarding the "remaining physical vestiges of that struggle" before the ravages of time rendered them obsolete. His comparative advantage in this mission, to the extent that he had one, was in his background as an artist and engraver, because training in these fields allowed him to create an on-site pictorial record of the locations and personages he visited. The artist's eye was central to his historical sensibility. A visual approach to history, Lossing reasoned, might entice some to study the past who had not desired previously to do so. "As my journey was among scenes and things hallowed of the feelings of every American," Lossing later wrote of his pictorial technique, "I felt a hope that a record of the pilgrimage, interwoven with that of the facts of the past history, would attract the attention, and win to the perusal of the chronicles of our Revolution many who could not be otherwise decoyed into the apparently arid and flowerless domains of mere history." Reflecting the special urgency of a late-1840s artist working to preserve ephemeral images from the 1770s and 1780s, Lossing abandoned his newspaper work and devoted himself for twenty-two months to traveling, sketching, and writing. He recognized that his task would not be an easy one because "the genius of our people was the reverse of antiquarian reverence for the things of the past" and because Americans rarely ever "looked back to the twilight and dim valleys of the past through which they had journeyed." Nonetheless he hoped he could induce his countrymen to abandon their antihistori-

cal attitudes by attracting them to a pictorial catalogue of the vanishing artifacts of the war. "I knew that the invisible fingers of decay, the plow of agriculture, and the behests of mammon, unrestrained in their operations by the prevailing spirit of our people, would soon sweep away every tangible vestige of the Revolution," Lossing wrote, concluding that "it was time the limner was abroad."[30]

If in combining the functions of illustrator and author Lossing could avoid some of the image/word incongruities that hampered pictorial historians like Frost, he could not elude altogether problems faced by his predecessors in the financing and publishing of his work. Money matters threatened to subvert Lossing's project from the moment of its inception because he did not have the disposable income necessary to take an extended leave of absence from his business or the substantial outlays of money required to finance ambitious trips throughout the United States. The prospect of publishing an illustrated field book also implied greater costs above and beyond the expenses he would incur for the redrawing and engraving of his own visual images. In the distant future Lossing would be able to offset such costs by revenues generated from his earlier writings, monies that allowed him to have a financial interest in his own publishing company. But in the 1840s he was forced to find institutional support for his work, and he was fortunate in having chosen Harper and Brothers to make his request for a sixty-five-hundred-dollar advance for research on the book.[31] At the time the House of Harper was emerging as the preeminent publisher of pictorial volumes in America, its *Harper's Illuminated and New Pictorial Bible* (1844), illustrated by Lossing's mentor Joseph A. Adams, having proven a major boon to the firm. Harper and Brothers was aggressive about marketing its books, scattering publicity releases to agencies throughout the Americas and Europe and selling volumes by auction, catalog, and mail in places as distant as India.[32] Anxious to tie his fortunes to those of this rising publishing house, Lossing outlined a plan for the company that would free him up for two years of research, writing, and engraving in exchange for exclusive publication rights to the field book. Harper and Brothers accepted his proposal and drew up a contract that called for a single-volume work of about six hundred pages and three hundred engravings at an estimated cost of sixty-five hundred dollars.[33]

The acceptance of Lossing's proposal by Harper and Brothers was an important step in legitimizing the genre of pictorial history. Whereas the writing of history had been undertaken by John Frost at the persistent risk of personal financial collapse, for Lossing, high-profile backing of the field book by Harper and Brothers meant the luxury of time for more thorough research and a prominent public endorsement of his history's methodology. And Lossing's account books for this period suggest what an undertaking the field book was financially. He itemized traveling expenses at $1158.93; letter portage, genealogical fees, and express charges at $115.37; and cash paid for engravings (to the firm of Lossing and Barritt) at $9516.37.[34] It was very clear early into the work, in fact, that the field book was a much bigger project than either author or publisher had anticipated and far more costly. By the time of its publication the pictorial history had expanded to two 750-page volumes with more than 1,100 engravings at a cost of $12,000, nearly twice the projected total.[35] And these expenditures did not include the thousands of dollars necessary to print the volumes. Mahan recounts "the mixture of amazement and frustration that overtook Lossing and Harper and Brothers when they realized the project had attained unexpected proportions." Because the work was first issued serially, such expansions in the original proposal threatened to decrease "the project's profit margin," as subscribers

who paid in advance for the entire series received more material than they or the publishers had expected.[36]

When it became clear that Harper and Brothers was involved in a project of much greater magnitude than anticipated, the publisher began a massive advertising campaign to attract readers to the field books, and this campaign did much to popularize the notion of the legitimacy of pictorial history as a genre. In a specially prepared circular Harper and Brothers unabashedly announced that "upward of THIRTY-FIVE THOUSAND DOLLARS have been expended in the publication of this first edition" of Lossing's history, and that under the circumstances prices for the work (about eight dollars for the two-volume popular edition) were reasonable and more than justified.[37] For readers who could not afford such rates, Harper and Brothers offered "liberal allowances" to "buy to sell again" in the resale market, an innovation developed by publishers to increase the circulation of marginally more expensive works.[38] The publishing house especially touted the work's pictorial format, arguing in its circular that the illustrations in the field book "make the whole subject of the American Revolution so clear to the reader that, on rising from its perusal, he feels thoroughly acquainted, not only with the history, but with every important locality made memorable by the events of the War of Independence." Lossing's was a work "of perfect unity of character," the publishers argued, arranged in a popular "form and style which gives delight to every reader, whether young or mature, a student or ripe scholar."[39] The subtitle to the work, *Illustrations, by Pen and Pencil, of the History, Biography, Scenery, Relics, and Traditions, of the War of Independence,* reaffirmed Lossing's overlapping literary and artistic purposes.[40] "Being himself both artist and writer," another Harper and Brothers circular proclaimed of Lossing, "he has been able to combine the materials he had collected in both

departments into a work possessing perfect unity of purpose and execution."[41]

If at times Harper and Brothers was guilty of hyperbole in its promotion of the "perfect unities" of Lossing's field book, it is nonetheless true that the structure and style of the work recapitulated each other to a degree unprecedented in the young field of pictorial history. In researching his volumes Lossing made contacts with local residents in nearly every town he visited, especially survivors of the Revolutionary conflict. The American Revolution had commenced seventy-five years before Lossing began his research during the late 1840s, but in nearly every location to which he traveled one or two ancient citizens appeared who claimed to have reliable personal memories of the war. "In the evening I visited the son of Colonel Van Vechten just named, a man of three score and ten years," Lossing wrote of one such encounter. "His memory is unclouded, and extends back to the closing scenes of the Revolution. His father stored that memory with the verbal history of his times, and every noteworthy locality of Saratoga is as familiar to him as the flower-beds of his beautiful garden." Of another aged veteran who served as a captain in the Connecticut militia Lossing noted with admiration, "He is yet living . . . in the ninety-ninth year of his age. We found him quite strong in body and mind. Many scenes of his early years are still vivid pictures in his memory, and he was able to reproduce them with much interest." And in Middlebrook, New Jersey, Lossing discovered an eighty-four-year-old woman, Polly Van Norden, who during her interview "became quite excited with feelings of the bitterest hatred against the Tories," evidencing a malice "the keenness of which the lapse of seventy years has scarcely blunted."[42]

Lossing's extensive use of such oral testimony and "eyewitness" accounts was consistent with the visual orientation of the field books, because testimonials

from those who had "seen" the events they described lent an air of "absolute, observed accuracy" to their narratives.[43] Their recollections provided "pictures on memory's wall," he noted, mental and physical residues of history's dim reflection. Indicative of this mystical association of the past with the present was Lossing's interview with a ninety-two-year-old woman whose "mental faculties were quite vigorous" and who "related her sad experience of the trials of that war with a memory remarkably tenacious and correct." In pressing her hand at the end of the interview it occurred to Lossing that "we represented the linking of the living, vigorous, active present, and the half-buried, decaying past; and that between her early womanhood and now all the grandeur and glory of our Republic had dawned and brightened into perfect day." Using his pen and sketching pencil to preserve the sights and impressions of his subjects, Lossing lamented the fact that there were not more amateur historians like him gathering "the facts concerning the Revolution from the lips of those who participated in its trials." As such, Lossing worked with a sense of urgency and respect for the fleeting quality of time. "A hundred times in the course of my pilgrimage to the grounds where 'Discord raised its trumpet notes, And carnage beat its horrid drum,'" Lossing admitted, "have my inquiries for living patriots of that war been answered with 'Five years ago captain A. was living'; or 'three years ago Major B. died'; or 'last autumn Mother C. was buried'; all of whom were full of the unwritten history of the Revolution."[44]

Lossing was aware of some of the pitfalls of extrapolating from the memories of a few aging patriots to a general profile of the age of Revolution. Many of his subjects were not reliable in their recollections, at least as judged by the rigorous standards of later oral historians. But Lossing had faith that his researches were sound and his skills as a writer and illustrator could overcome any deficiencies of historical technique. He felt confident in this regard because, even more than Frost, Lossing was a proponent of the pictorial mode, and he placed a strong emphasis on the eye of the "seer" as the point of origin for all historical reflection. Emerson's ubiquitous transparent eyeball was a revealing symbol for an age that valued the visual faculty above all others as a means to truth, and like Emerson, Lossing sought to establish "an original relationship to the universe" rather than one as recorded "through the eyes of others."[45] Even before Francis Parkman made his reputation as a historian by sojourning to the battlefields of the French and Indian War, Lossing had earned distinction by sketching his "on-site" impressions of the Revolution.[46] Because the arm of the artist was presumed to be but an extension of the "insights" of the mind as shaped by the all-seeing eye, artists of the historical were appreciated to the degree that they could translate tangible artifacts into meaningful visual codes for those not able or willing to travel to historic sites. Lossing's training as both artist and writer gave him special authority in this interpretive process and helped reduce further the complications that might arise from inadequate transliteration of the eye's visual messages.

Lossing's commitment to the visual as a mechanism for conveying historical meaning was evidenced in the attention he gave in his field books to matters of perspective and vantage point. He was careful to identify for readers the exact locations from which he produced his literary and artistic sketches of the Revolution, and at every opportunity he emphasized the power of point of view as a precondition for historical understanding. For Lossing, "perception" as a structuring concept had both literal and philosophical connotations. Complaining of the 168 stone steps he had to climb to reach the top of the Groton Monument, for instance, Lossing soothed himself with Swedenborgian reflec-

tions on the metaphysical significance of his efforts. "It was a toilsome journey up that winding staircase, for my muscles had scarcely forgotten a similar draught upon their energies at Breed's Hill," he wrote, "but I was comforted by the teachings of the new philosophy that the *spiral* is the only true ascent to a superior world of light, and beauty, and expansiveness of vision; and so I found it, for a most magnificent view burst upon the sight as I made the last upward revolution and stood upon the dizzying height."[47]

Lossing's devotion to the observational aspects of historical work was apparent also in the visual and literary devices he used in the field book. He employed painterly concepts of chiaroscuro, the contrast of light and dark, to heighten the dramatic impact of certain battlefield scenes.[48] He also framed literary descriptions in the *Pictorial Field-Book of the Revolution* in the classic *coulisse* of nineteenth-century landscape painters, who used natural objects such as trees and swirling clouds as framing devices to guide the viewer's eye to the interior of a painting.[49] In addition, Lossing made extensive use of established categories of aesthetic theory, especially the picturesque and the sublime, to define the crucial role of nature in human history. While traveling down the St. Lawrence River on a Sabbath day of rest, Lossing reread Edmund Burke's "Essay on the Sublime and Beautiful," remarking that its value was enhanced perceptibly by the "illustrative examples" of the aesthetic duality present "on every side" of him. The "idea of sublimity was forcibly illustrated" in the "number and confusion" of the Thousand Islands region of the St. Lawrence, he wrote, which in its imposing chaos "wooed our attention from the tuition of books to that of nature."[50]

The use of these aesthetic categories is revealing because they suggest how deliberately Lossing positioned himself in nature as an artist and storyteller. Describing himself as a conduit for the historical ab-

stractions "induced by the place and its traditions," Lossing took up station near the ruins of Fort Ticonderoga, where "association, with its busy pencil, wrought many a startling picture." In this sense History coaxed the narration of its own story from an observant Lossing, the "beautiful rural panorama" that "the eye takes in" at such a height motivating the historian to compose pages "on which are recorded the stirring events that were enacted within the range of our vision." In other instances Lossing identified consciously with the role of the artist by detailing the precise physical and mental attitudes he assumed as a sketcher of the past.[51] The significance of the role of the "historian as seer" was also evident in Lossing's desire to seek visual confirmation of details lost to the historical record. For instance, local legend had it that General Putnam had rigged planks together as a means of entry from one of his vessels that had been grounded before the gates of Fort Oswegatchie near Ogdensburgh, New York. Unable to corroborate the story through archival research, Lossing went to the site of the fort and drew the following conclusion: "From personal observation of the ground, I am inclined to think that a plank twenty feet long could hardly have *reached the abatis* from the water, even in a perpendicular position, unless the altitude of the shores was less then than now. Very possibly the ingenious idea of wedging up the rudders of the vessels and of scaling the outworks of the fort was conceived by the fertile mind of Putnam, but it is not one of the strong points upon which the reputation of the general for skill and bravery rests, for it must have been a failure if attempted."[52]

In his work as a historian, Lossing almost always privileged firsthand testimony over accumulated legend, arguing characteristically from the "book of Nature" rather than from innuendo and speculation. At the center of Lossing's philosophy of history was the

Figure 20. Head-letter
emblem, 1852, by
Benson Lossing for
*Pictorial Field-Book of
the Revolution*

image of the historian as an eyewitness to the past, filtering history through the "mind's eye" and reducing the distinctions between time and place by dint of the observer's empathy for the participants in historical events. In Lossing's case his skills as both a writer and an artist allowed him to articulate these associations in integrated ways, the hand of the artist operating as an extension of the seeing eye in a manner once described by F. O. Matthiessen as characteristic of the "optative" mood.[53] By actually traveling to the sites of significant historical events and by viewing and touching the artifacts affiliated with them Lossing was able to center his observations on the perceiving "self," keeping them free of the incompatibilities that marred frequently the productions of collaborative pictorial histories. This integrated approach was not just a methodological convenience for Lossing; it was deeply grounded in a relativistic philosophy of history that sought to purify historical insight by eliminating points of view outside the controlling narrative persona (the "I"). The past might communicate directly with the present, Lossing argued, but only if historians were receptive in all their faculties to the meaning implicit in history's physical and spiritual residues. Refusing to take anything on vague suspicion that could be verified by personal inspection, therefore, Lossing traveled directly to scenes of past glory in order to identify and record faithfully the visual and literary remnants of the past. For Lossing, ever the pragmatist, only seeing was believing.

The Eye of the Beholder

The meticulous illustrations and engravings that graced Lossing's *Pictorial Field-Book of the American Revolution* were intended to complement the observational candor of his literary "word paintings" and establish a standard of excellence unequaled by other works in the genre. In striving for accuracy in the area of visual representation Lossing hoped to distinguish his pictorial history from the sort of sensational illustrated books being published by popular presses in Europe in the 1840s and 1850s. Such "pleasure books," as Lossing dubbed them, were corrupting to the genre because they relied for effect on scandalously dramatic visual materials to the exclusion of sound and temperate analysis. "The exciting literature

of the day, ranging in its intoxicating character from the gross pictures of sensual life drawn by the French writers of fiction, to the more refined, but not less intoxicating works of popular and esteemed novelists, so cheaply published and so widely diffused, has produced a degree of mental dissipation throughout the land, destructive, in its tendency, to sober and rational desires for imbibing useful knowledge," Lossing noted. Reiterating the didactic purposes of pictorial histories as ascribed to them by Frost and Goodrich, Lossing warned of the "deleterious" effects of pictorial excesses, especially on young minds, where "dissipation is most rife." Children needed to be introduced to illustrated texts in a controlled fashion and with the gravest attention to fidelity of visual detail, he noted, because the "woof of our history is too sacred to be interwoven with the tinsel filling of fiction, and we should have too high a regard for truth to seek the potential aid of its counterfeit in gaining audience in the ear of the million." In presenting the *Pictorial Field-Book* to the American people, in other words, Lossing scrupulously avoided the corrupting influences of sensationalized art. He viewed himself instead as setting tightly controlled standards for the use of visual evidence, always adhering to the philosophy that illustrations should be introduced only where they have "a lasting and intrinsic value as delineations of fact."[54]

In the preface to the *Pictorial Field-Book*, Lossing underscored his commitment to the accuracy and representational quality of his illustrations. "In the pictorial department, special care has been observed to make faithful delineations of fact," he wrote. "If a relic of the Revolution was not susceptible of picturesque effect in a drawing, without a departure from truth, it has been left in the plainness, for my chief object was to illustrate the *subject*, not merely to embellish the *book*. I have endeavored to present the features of things as

I found them, whether homely or charming, and have sought to delineate all that fell in my way worthy of preservation." Such a strategy gave his illustrations a reportorial quality and encouraged him to use hundreds of small, literal representations rather than several dozen larger, symbolic ones. His training as an artist and engraver made this documentary task more manageable, but he reassured readers that although his volumes required a large number of engravings, he had been careful not to inflate the numbers beyond what "perspicuity demanded, else the work would be filled with pictures to the exclusion of essential reading material."[55] In terms of dramatic effect Lossing's prose outdistanced his illustrations by a good measure, although Lossing was closer to achieving the accuracy demanded of a historian in the latter category than he was in the former.

Because of Lossing's commitment to a reportorial style, the illustrations in the *Pictorial Field-Book of the Revolution* are understated in comparison to those in Frost's *Pictorial History of the United States*, although some of the same techniques are evident in each work. Both men experimented with decorative mastheads and varied display typographies. Like Frost, Lossing employed conventional head letters, making pictures the literal point of entry into the text and establishing the interchangeability of words and images. Some of Lossing's introductory pictograms mirrored the action of the text, as when an Indian pulling a long bow was used to introduce a section on "savage warfare" in the Mohawk Valley or when shattered chests of tea bobbing in Boston Harbor opened a section on the violence of the Revolution in New England. In other instances Lossing created personalized head letters that reaffirmed the symbolic language of the field books. Hence, his chapter on the natural landscape of the Hudson River Valley is introduced by the letter *N* formed by bent pond reeds, and a chapter on the dense, sublime

View from Washington's Rock. Another similar Rock at Plainfield. Celebration at Pluckemin in 1779,

ing Raritan and the Delaware and Hudson Canal. Little villages and neat farm-houses dotted the picture in every direction. Southward, the spires of New Brunswick shot up above the intervening for- and rises from a slope of the hill, ests, and on the left, as seen in the pic- ture, was spread the expanse of Raritan and Amboy Bays, with many white sails upon their bo- soms. Beyond were seen the swelling hills of Staten Island, and the more abrupt heights of Neversink or Navesink Mountains, at Sandy Hook. Upon this lofty rock Washington often stood, with his telescope, and reconnoi- tered the vicinity. He overlooked his camp at his feet, and could have de- scried the marchings of the enemy at a great distance upon the plain, or the evo- lutions of a fleet in the waters beyond. In the rear of Plainfield, at an equal ele- vation, and upon the same range of hills, is another rock bearing a similar appella- tion, and from the same cause. It is near the brow of the mountain, but, unlike the one under consideration, it stands quite alone, February 6, the anniversary of the alliance of America with France.[1] He remembered an 1778. incident which I have not seen mentioned in the published accounts of that

about twenty-five feet from base to summit. From this latter lofty position, it is said, Washington watched the movements of the ene- my in the summer of 1777, recorded on page 331.

While upon the mount- ains, a haze that dimmed the sky in the morning, gathering into thick clouds, assumed the nimbus form, and menaced us with rain. This fact, and the expectation of the speedy ar- rival of the train for Somer- ville, where I was to take stage for Easton, on the Del- aware, hur- ried us back to the village. There I met an old gentleman (whose name I have forgot- ten), who, though a small boy at the time, remembered the grand display at Pluckemin during the encampment, on

Figure 21. "Washington's Rock," 1852, by Benson Lossing for *Pictorial Field-Book of the Revolution*

wilderness of the Lake George region is presented by the letter *A* in the shape of a blasted tree. Lossing also reasserted the power of his most prevalent literary metaphors, such as the veil, by incorporating classical drapery into some of his head letters, which were often tied back in a dramatic form of *coulisse* (fig. 20). These pictorial representations implied a compatibility of text and image that far surpassed anything Frost and Croome had accomplished, because they were not merely embellishments of the text but were referenced within the text as well. Author and illustrator at one and the same time, Lossing often made literary refer- ence to the subjects of his head letters, text and image doubling back on themselves as it were in the process.

The compatibility of text and image was further as- sured by technical innovations in printing that allowed Lossing to expand the kinds of illustrations he could

include in his pictorial history. Croome had used pri- marily a black-line woodcut style of engraving in which a knife or graver was employed to cut on each side of a line to be inked, the outer contours of the line thus printing black. This type of engraving was best suited to reproduce pen-and-ink or pencil draw- ings made directly on the block, because "its messages were conceived in units of contour rather than of tex- tural gradients, outlines rather than chiaroscuro." Hence, an illustrator such as William Croome, who re- lied almost exclusively on the black-line woodcut style, was reasonably proficient at reproducing large, blockier forms but found it very difficult to recreate either the subtle facial characteristics of portraiture or the textual differentiations of landscape. But an im- portant innovation in the reproduction of images helped Lossing achieve a greater subtlety of expres-

of the battery, the Americans halted to reconnoiter. The guard at the battery and the artillerymen with lighted match-es were perfectly silent, and Montgomery concluded that they were not on the alert. But Barnsfare, through the dim light of early dawn and the drifting snow, saw faintly their movements. Montgomery, in the van of his troops, cried out, "Men of New York, you will not fear to follow where your general leads. March on!" and rush-ed boldly over heaps of ice and snow to charge the battery. At that moment, when the Americans were within forty paces, Captain Barnsfare gave the word, the match was applied, and a discharge of grape-shot swept the American column with ter-rible effect. Montgomery and both his aids (Cap-tains Cheeseman and M'Pherson) were killed, to-gether with several privates near. The rest, appalled at the dreadful havoc and the death of their general, fled in confusion back to Wolfe's Cove, where Colonel Campbell took the command, but made no further attempts to force a junction with Arnold. Ten minutes the battery belched its iron storm in the dim space, but, after the first discharge, there was no enemy there to slaughter.

CAPE DIAMOND.²

Figure 22. "Cape Diamond," 1852, by Benson Lossing for *Pictorial Field-Book of the Revolution*

sion and more delicate effects in his field book than Croome. In 1842 Harper and Brothers introduced elec-trotyping to its publication process, a technique in which electrolysis is used to duplicate more precisely the relief surface of an engraving onto a printed page. Electrotyping involved the creation of a wax plate from an original engraving, which was then covered by a "thin shell of copper or nickel" by electrolytic process and melted type-metal cast until it formed a rigid duplicating plate.[56] The durability of this inno-vation not only allowed for greater frequency of reprinting for mass-produced books but also provided illustrations with greater clarity than had been the case when black-line engravings were printed directly from the wood block. Because of this modification, il-lustrations in a work such as Lossing's *Pictorial Field-Book of the Revolution,* which were engraved originally in wood and then electrotyped, demonstrated a greater degree of "shadowing," "textual gradients," and "undulations of surface and contour" than those in Frost's *Pictorial History of the United States.*[57]

Despite the innovation of electrotyping, the work of engraving in wood the original pen and pencil sketches by Lossing was hard and tedious and left lesser engravers on the verge of breakdown. In 1853, for instance, Lossing received the following letter from one of his employees, G. W. Davey, who broke his indenture with the firm under the strain of the in-tense work required by the pictorial field books and other demanding projects in this increasingly com-petitive field:

Dear Sir: You have probably been supprised [sic] at my leaving your employment in the manner in which I did especially before my apprenticeship had expired. . . . I have grown so nervous that I cannot work more than three or four hours a day at the most. My eyes are also af-fected, my eyesight has grown very poor so that I am al-most nearsighted—any object that is any distance from me I cannot see, and I am satisfied that it is caused by the business. Another reason is that I am convinced I can never make a Great Engraver. I have been at the business over three years and cannot engrave any better than I did

Forts Webb, Wyllys, and Putnam. Visit to Constitution Island. Remains of Fort Constitution.

The winding road from Fort Putnam to the plain is well wrought along the mountain side, but quite steep in many places. A little south of it, and near the upper road leading to the stone quarries and Mr. Kingsley's, are the ruins of Fort Webb, a strong redoubt,

built upon a rocky eminence, and designed as an advanced defense of Fort Putnam. A short distance below this, on another eminence, are the remains of Fort Wyllys, a still stronger fortification. I visited these before returning to the hotel, and from the broken ramparts of Fort Webb sketched this distant view of Fort Putnam.

After a late breakfast, I procured the service of a water-man to convey me in his skiff to Constitution Island, and from thence down to Buttermilk Falls,[1] two miles below West Point. I directed him to come for me at the island within an hour and a half, but, either forgetting his engagement or serving another customer, it was almost noon before I saw him, when my patience as well as curiosity was quite exhausted. I had rambled over the island, making such sketches as I desired, and for nearly an hour I sat upon a

RUINS OF FORT PUTNAM, AS SEEN FROM FORT WEBB.

smooth bowlder by the margin of the river, near the remains of the redoubt made to cover and defend the great chain at the island end. On the southeast side of a small marshy cove, clasping a rough rock, a good portion of the heavy walls of Fort Constitution remain. The outworks are traceable several rods back into the stinted forest. The sketch on the next page is from the upper edge of the cove, and includes, on the left, a view of the re-

[1] These falls derive their name from the milky appearance of the water as it rushes in a white foam over the rocks in a series of cascades.

Disposition of the American Troops. Preparations for Blockading Boston. Charlestown and adjacent Grounds.

ment were at Chelsea ; Stark's regiment was at Medford, and Reid's at Charlestown Neck, with sentinels reaching to Penny Ferry and Bunker Hill

It was made known to the Committee of Safety that General Gage had fixed upon the night of the 18th of June to take possession of and fortify Bunker Hill and Dorchester Heights. This brought matters to a crisis, and measures were taken to perfect the blockade of Boston. The Committee of Safety ordered Colonel Prescott, with a detachment of one thousand men, including a company of artillery, with two field-pieces, to march at night and throw up intrenchments upon Bunker Hill, an eminence just within the peninsula of Charlestown, and commanding the great northern road from Boston, as well as a considerable portion of the town. To make the relative position of the eminences upon the Charlestown peninsula and the Neck, to Boston, more intelligible to the reader, I have copied from Frothingham's *History of the Siege of Boston*, by permission of the author, the annexed sketch, communicated to him, in a manuscript of 1775, from Henry Stevens, Esq. I also quote from Mr. Frothingham's work a description of the localities about Bunker Hill. The peninsula of Charlestown is opposite the north part of Boston, and is about a mile in length from north to south. Its greatest breadth, next to Boston, is about half a mile. It is connected with the main land by a narrow isthmus or neck. The Mystic River, half a mile wide, is on the east, and the Charles River, here formed into a large bay, is on the west, a part of which, by a dam stretching in the direction of Cobble Hill, is a mill-pond. [See map, page 543.] In 1775, an artificial causeway [4] was so low as to be frequently overflowed by the tides. The communication with Boston was by

a ferry, where Charles River bridge is, and with Malden by another, called Penny Ferry, where Malden Bridge now is. Near the Neck, on the main land, was a large green, known as the Common. Two roads ran by it : one in a westerly direction, as now, by Cobble Hill (M'Lean Asylum), Prospect Hill, and Inman's Woods, to Cambridge Common ; the other in a northerly direction, by Plowed Hill (Mount Benedict) and Winter Hill, to Medford—the direct road to West Cambridge not having been laid out in 1775. Bunker Hill begins at the isthmus and rises gradually for about three hundred yards, forming a round, smooth hill, sloping on two sides toward the water, and connected by a ridge of ground on the south with the heights now known as Breed's Hill. This was a well-known public place, the name, " Bunker Hill," being found in the town records and in deeds from an early period. Not so with "Breed's Hill," for it was not named in any description of streets previous to 1775, and appears to have been called after the owners of the pastures into which it was divided, rather than by the common name of Breed's Hill. Thus, Monument Square was called Russell's Pasture ; Breed's Pasture lay further south, and Green's Pasture was at the head of Green Street. The easterly and westerly sides of this height were steep. On the east, at its base, were brick-kilns, clay-pits, and much sloughy land. On the west side, at the base, was the most settled part of the town [5]. Moulton's Point, a name coeval with the settlement of the town, constituted the southeastern corner of the peninsula. A part of this tract formed what is called Morton's Hill. Bunker Hill was one hundred and ten feet high, Breed's Hill sixty-two

CHARLESTOWN IN 1775.

[1] No. 1 is Bunker Hill ; 2, Breed's Hill ; 3, Moulton's Point ; 4, a causeway near the Neck, at the foot of Bunker Hill ; 5, Charlestown, at the foot of Breed's Hill. Charlestown Neck is on the extreme left.

Figure 23. "Ruins of Fort Putnam, as Seen from Fort Webb," 1852, by Benson Lossing for *Pictorial Field-Book of the Revolution*

Figure 24. "Charlestown in 1775," 1852, by Benson Lossing for *Pictorial Field-Book of the Revolution*

at the expiration of the first eighteen months. I suppose it is partly from my want of taste for the business and partly Mr Barritt's fault for instead of advancing me as he ought to have done he has kept me on common work most of the time. It is my intention never to work at wood engraving again, as I am fully satisfied that it would never agree with my health. I need a business that will keep me in active work and in the open air such as a mason or some such work. . . . I can never bring myself to believe that Mr. Barritt has acted either faithfully to me or creditably to your interests. . . . I have been more sinned against than sinner. If I ever am able I am willing to remunerate you for the time thus lost.[58]

The loss of Davey notwithstanding, Lossing and his partner Barritt were able to deliver the engravings on schedule to Harper and Brothers, whose artists then used them in experimental efforts to find new ways to influence pictorial quality and page design.

Among the most interesting advancements per-

Figure 25. "Signers of the Declaration of Independence," 1852, by Benson Lossing for *Pictorial Field-Book of the Revolution*

mitted by Harper and Brothers' new technologies was the latitude to include dozens of miniature landscapes in unusual places in the field books. Hence, the illustration of the rugged crags of "Washington's Rock," where Washington positioned himself in 1777 to reconnoiter the enemy's troops near Middlebrook, New Jersey, is "wedged" into the text, symbolically representing the "narrow and tangled path" traveled by the general (fig. 21). A similar effect is achieved in Lossing's sketch of the cliffs of Cape Diamond at Quebec, the illustration scaling up the page as it were in imitation of the arduous ascent of American troops at the ill-fated Battle of Quebec (fig. 22). In a few places throughout the *Pictorial Field-Book* these attempts at word-image integrations in page configuration failed to achieve their purpose, as in the awkward positioning of the text in relation to the illustration in "Ruins of Fort Putnam, as seen from Fort Webb" (fig. 23) or the vertical orientation of "Charlestown in 1775," which required the reader to rotate the volume ninety degrees to read the accompanying footnote describing locations enumerated in the sketch (fig. 24). But all these attempts to establish consistency between texts and images in the field book were good faith efforts on the part of Harper and Brothers to confirm the authenticity of Lossing's visual depictions in the context of the new innovations in the art of book illustration.

The biggest advantage these technological improvements provided Lossing was their increased capacity to establish the living presence of history by allowing the artist to record with exactitude the artifacts of the past still extant in the present. Sometimes Lossing confirmed his authority in this regard by transcribing images of medals struck to honor historical figures, such as those commemorating the heroics of General Wayne at Stoney Point. In reproducing such medals Lossing borrowed consciously from one of the earliest and most durable forms of historical illustra-

tion, as ancient medallions and coins "provided by far the most accessible supply of figured images" as well as the most easily transferable and readily datable pictorial record.[59] Material artifacts featuring depictions of historical events were also illustrated in Lossing's text, including the decorative guards on Lafayette's sword, the embossed wax seals of royal governors, and the patterned stitching on embroidered military flags. These mementoes were sometimes allegorical representations in their own right, and their inclusion might have undercut the literal-mindedness of Lossing's text. But in choosing to reproduce such images, Lossing's primary commitment was to the faithful codification of the artifact itself. Where Lossing discovered inaccuracies in the materials he replicated, he documented them carefully in his voluminous footnotes, some of which included additional pictorial evidence as correctives to the imprecision of the originals.

Lossing also increased his claims to authenticity by providing detailed portraits of the heroes of the Revolutionary War about whom he wrote. Whereas the woodcut technology used by Croome in Frost's pictorial history was inadequate for portraiture, the new engraving practices employed by Lossing allowed for better expression of facial modulations and even flesh tones.[60] His compilation illustration of the "Signers of the Declaration of Independence," for instance, was an improvement in terms of facial detail over not only Croome's depiction of the event but also the original Trumbull painting on which it was based (fig. 25). For one thing, Lossing increased the purity of Trumbull's representation by removing the peripheral details of the architecture of Independence Hall and grouping the signers in rows with names affixed for purposes of accurate identification. For another, he enlarged Trumbull's admittedly too-compacted portraits of the signers, adding names to the profiles as a way of particularizing the visual depictions. Because

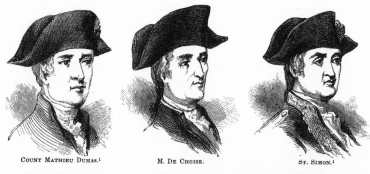

Figure 26. "Portraits of M. de Choise, St. Simon and Count Mathieu Dumas," 1852, by Benson Lossing for *Pictorial Field-Book of the Revolution*

COUNT MATHIEU DUMAS.¹ M. DE CHOISE. ST. SIMON.¹

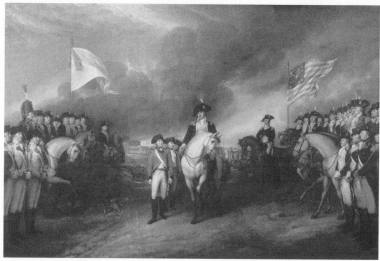

Figure 27. *The Surrender of Lord Cornwallis at Yorktown*, 1787–1828, by Jonathan Trumbull, United States Capitol Art Collection (United States Capitol Art Collection; courtesy of the Architect of the Capitol)

the painter's original work was itself a "composed fiction" (all the signers were never in the same room at the same time as they are depicted), Lossing cross-checked Trumbull's portraits against other corroborating images of the founding fathers in historical societies and private collections throughout the country, and he did so often to benefit of the subjects.[61]

Conversely, Lossing was less effective in reproducing the images of historical figures for which there were few reliable substantiating models. Hence, many of his portraits of less prominent individuals in the struggle for nationhood have an indistinguishable anonymity to them, emerging from generalized prototypes that obscured nuance and detail. His portraits

of French mercenary soldiers M. de Choise, St. Simon, and Count Mathieu Dumas (fig. 26), adapted from Trumbull's too-crowded picture in the Rotunda of the Capitol, *The Surrender of Lord Cornwallis* (fig. 27), are so similar to each other as to be virtually interchangeable and suggest none of the authenticity characteristic of his portraits of the signers. In the introduction to his field books Lossing warned that he did not want pictures to overwhelm the text, although in failing to elaborate with purposeful detail the features of some of his subjects he ran the counterrisk of failing to make his illustrations meaningful.

Lossing's most effective portraiture, however, was that associated with the little-known survivors of the

Figure 28. "Portrait of Joseph Dibble," 1852, by Benson Lossing for *Pictorial Field-Book of the Revolution*

Dibble "was too nearly a wreck to give me any clear account of revolutionary matters in that vicinity," Lossing wrote, "and it was with much difficulty that he could be made to understand my object in wishing to sketch his portrait and obtain his autograph." In the case of Jacob Dievendorff, who had been scalped and left to die by Indians during a Tory uprising near Currytown, New York, Lossing felt little compunction about providing not only a sketch of Dievendorff's weathered face but of the disfigured portions of the back of his head as well (fig. 29). Commenting in detail on the horrifying methods used by Indians to separate a scalp from a victim's skull, Lossing noted that it had taken five years for the patriot's head to heal adequately, adding with gruesome specificity, "When I saw him (August 1848), it had the tender appearance and feeling of a wound recently healed."[62]

Such realistic literary and visual depictions were designed to do more than merely establish the failings or hardships of Lossing's subjects, however; they were

Revolution whose uncelebrated images he sketched on his journeys. Because these figures were generally unknown beyond the borders of their small communities, Lossing worked hard to establish trustworthy visual and literary portraits of them. Reliability sometimes spilled over into brutal frankness, however, as Lossing recorded the many frailties and deformities of subjects often nearing one hundred years of age. He made little effort to obscure the wrinkled skin and feeble countenances of his aged subjects, for instance, and he took an almost perverse pride in supplementing the graphic illustrations of his subjects' lives with commentary on their diminishing mental and physical capacities. Hence, a none-too-flattering portrait of Loyalist sympathizer Joseph Dibble of Danbury, Connecticut, was accompanied by a medical report on the dementia that was slowly overtaking him (fig. 28).

Figure 29. "Portrait of Jacob Dievendorff—Front and Back Views," 1852, by Benson Lossing for *Pictorial Field-Book of the Revolution*

Figure 30. Frontispiece to *Pictorial Field-Book of the Revolution*, 1851, by Benson Lossing

included as well to document the character of those who carried with them the sometimes painful reminders of a War for Independence. If his subjects were too feeble to articulate fully their memories of the conflict, that is, the war's influence could be read nonetheless in the physiognomic features of their countenances—in the wrinkles on their faces or in the feel of their scalps. In the same spirit Lossing procured and reproduced autographs (like the feeble one of Dibble alluded to above), because he viewed handwriting as an extension of inner essence and as an accurate indicator of individual character. From a literal point of view, one's autograph is a pictorial representation of self, the word deriving from the Greek *autographos,* meaning "self-pictured or self-written," but Lossing had in mind a more figurative association as well in which personal inscription was synonymous with individual style and self-worth. Lossing, who was an inveterate dealer in signatures, reproduced faithfully from his own collections the autographs of the singers of the Declaration and those of every major military figure discussed in the *Pictorial Field-Book.* He also replicated with fidelity the pictograph inscriptions of illiterate Indian chiefs and the ciphered codes of conspiring agents.[63] These "signatures" were forms of illustration in Lossing's mind because they revealed character in graphic form, and collectively they reiterated the connections he perceived at the points of interface between historical and contemporary identity. Lossing felt so strongly about the role of autographs in establishing the authority of his visual and literary portraits that he even inventoried them in his index.

Lossing's many illustrations for the *Pictorial Field-Book of the Revolution* strengthened even more firmly than did the text his commitment to historical veracity. Whereas Lossing could not resist slipping into romantic reveries occasionally in his prose, his illustrations studiously avoided the excesses he associated with French sensationalism in the arts. The closest Lossing came to a romanticized moment in his drawings was in the frontispiece of his book, which depicted an aged veteran narrating his tales of bygone glories to a somewhat distracted audience of children, women strollers, and men of leisure (fig. 30). The tangled vines and luxuriant ferns that frame the illustration, as well as the half-buried relics and the nature-inspired typography surrounded by them, contributed to a mood of contemplative pastoral repose that might have misled some readers into thinking they were about to enter a literary world of romantic distraction. But the sentimental overtones of the frontispiece were moderated

quickly by the serious manner of the preface, the density of the historical research it announced, and the documentary quality of so many of the illustrations. These latter features were more representative of Lossing's intentions for the volumes than was the cover page, and they spoke more directly to his goal of establishing a functional historical literacy among Americans. That such literacy required both visual and verbal cues went without saying (although Lossing did say as much repeatedly); but importantly, Lossing used these pictorial and literary prompts to demonstrate the value of reliable evidence for popular audiences unfamiliar with the rigorous standards of historical literature. If he sold a few volumes in the process, even because of a somewhat sensationalized frontispiece, then the justification was that he worked for the noble cause of preserving America's glorious revolutionary past.

"The Best Got Up Book of the Kind"
The general reaction of popular readers to Lossing's integrated field books was positive. One reviewer remarked on the happy pictorial effect of the volumes on the youth of America and wished that "a copy of it might go into the hands of every American child."[64] Another thanked Lossing for the "pleasant surprises and most agreeable alternations into the nooks and eddies of history which receive additional interest from the graceful spirit of the narrative." Commenting especially on the power of the visual representations, he added, "I have never met a book . . . that ever illustrated an historical epoch more fully, in its way, than this" with its "perfect art of the engraved pictures which are so thickly studded over its pages."[65] Still another reader applauded the pictorial format and handsome packaging of the work, which would assure it a place "more ornamental to the centre-table than many a work of far greater cost and preten-

sion."[66] The *New Orleans Delta* proclaimed it the "best got up book of the kind ever published in this country."[67] Finally, a smattering of readers commented on the economical value of the volumes, the eight-dollar asking price acknowledged by most as more than reasonable for an illustrated book of substantial quality. "The cheapness of the work is truly remarkable," wrote the *Home Journal*, "and we are confident that the *Field-Book of the Revolution* will be one of the household books of the country."[68]

Although the judgments of literary critics toward Lossing's pictorial field books are relatively easy to assess through reviews in journals and newspapers, it is a more difficult task to determine why the general reading public responded as positively as sales figures would indicate it did. The financial registers of Harper and Brothers were lost in a fire in December of 1853 (as were all the unsold copies of the first edition of the *Pictorial Field-Book of the Revolution*), but the stereotype plates of the text and the original engravings survived and postfire records indicate that Lossing sold tens of thousands of copies of subsequent editions of the work in the first two decades of sales. More than twenty-five years after their first appearance, a *Publishers Weekly* poll declared Lossing's pictorial volumes still the most "salable [*sic*]" work on the topic of the Revolution.[69] Part of the reason for this remarkable response to the work of an author who had never achieved anything close to such success before had to do with Lossing's ability to direct the attention of readers to the personalized stories of loss and decay that he experienced while researching the *Pictorial Field-Book of the Revolution*. It also seems fair to conclude that in its pictorial format Lossing's history benefited from the general "illustration mania" that was beginning to sweep the country in the 1850s. "Nothing but illustrated works are profitable to publishers, while the illustrated magazines

and newspapers in everybody's hands—are vastly popular," noted a commentator for the *Cosmopolitan Art Journal* of this trend, adding that it was Lossing's publisher Harper and Brothers that "initiated the era, by their illustrated Bible."[70]

Scholars as well as general readers endorsed the field book in ways that not only gratified Lossing but also helped legitimize pictorial history as a genre. George Bancroft took time to thank Lossing for his contributions to historical literature. "Your pictured pages are not only charming and instructive from the illustrations, but you have used copious materials; have given your narrative in an unaffected and attractive style, and have brought to your work uniform candor and judgment," he noted admiringly.[71] Lossing's main competitor in the field of pictorial history, John Frost, wrote J. W. Harper to say that he had read the field books "with great pleasure and advantage." "I consider it one of the most useful & by far the most delightful book on that subject which I have ever met with," he noted graciously of his competitor in the pictorial history market, adding that Lossing "richly merits the thanks of his countrymen for the industry, perseverance & fidelity with which he has illustrated the most interesting & glorious period of American history."[72] Lossing was still more pleased by the endorsement he received from his friend and fellow historian, Washington Irving. In a personal note Irving told Lossing, "I have the work constantly by me for perusal and reference. While I have been delighted by the freshness, freedom and spirit of your narrative, and the graphic effect of your descriptions, I have been gratified at finding how scrupulously attentive you have been to accuracy as to facts, which is essential in writings of an historical nature. There is a genial spirit throughout your whole work that wins for you the good-will of the reader." Somewhat startled by Lossing's rapid success, Irving added perceptively,

"I am surprised to find in how short a time you have accomplished your undertaking, considering you have had to travel 'from Dan to Beersheba' to collect facts and anecdotes, sketch, engrave, write, print, and correct in press—and, with all this, to have accomplished it in so satisfactorily a manner."[73]

Despite the success of the field books, Irving's last comment hinted at a potential danger faced by publishers who intended to market pictorial histories as Harper and Brothers had the *Pictorial Field-Book*. The accumulated effects of time and the sheer weight of history made it difficult to imagine anyone attempting to duplicate Lossing's arduous methods of traveling, sketching, interviewing, illustrating, engraving, and writing. In order to satisfy the needs of popular readers for such unified and synthesized histories future Lossings would need to reduce larger and larger chunks of history into smaller and smaller literary spaces. Irving's concern amounted to whether one person could be relied on to write an accurate history of the nation's past without spending a lifetime to do it, as George Bancroft was doing in his study of the Revolution.

In addition, growing sectional animosities made it increasingly unlikely that a national consensus would emerge regarding the value of Lossing's pictorial field book. David Swain, president of North Carolina University, echoed this apprehension, noting that Lossing's ambitions outdistanced his scholarly abilities to fulfill them adequately. "I have detected occasional errors, especially in the names of persons and places, and take it for granted that like inaccuracies may be found in other parts of the work," he wrote of the field book. Admitting that all "errors of this kind no human foresight could, in every instance, have avoided," Swain nonetheless accused Lossing of a misplaced "anxiety to do justice to every section of our country," even those areas of history (geographic and intellectual) about which he was not well informed. The resulting

misrepresentations were particularly significant, Swain implied, because Lossing's work was "popular" and "destined to obtain a very wide circulation."[74]

Apart from these potential limitations on accuracy and fullness of coverage, Lossing's approach was also endangered by the relativistic dilemmas confronting all historians who emphasized personalized points of view on the past. If an understanding of history was inextricably tied to the subjective vision of the seer, then one person's Revolution must inevitably differ from another's according to the idiosyncrasies of the viewer's eye. Put differently, Lossing's field book suggested the possibility of a dangerous brand of intellectual solipsism, a form of idealism in which the "self" can know only its own modifications and states and recognizes only its own historical judgments as useful. Lossing was comfortable enough with this dilemma, acknowledging that his Revolution was not necessarily synonymous with anyone else's and offering the field books as a personal reflection that must be weighed against the countervisions of others. But by taking on the multiple identities of artist, engraver, and writer, Lossing magnified the potentially pernicious aspects of solipsism by reducing all disparities between word and image to the usurpations of a single, consolidating outlook. Lossing's nearly unrestricted free exercise of both pen and graver made for an interesting but too personalized report, one which left its author open to charges of whimsy and iconoclasm. In this regard the Reverend William Cruikshank noted in a review in the *American Whig Review* that Lossing's subjectivity resulted in the publication of a "tissue of absurdities," a volume of personal anecdotes so influenced by the peculiarities of the author's aimless wanderings as to be useless.[75]

Lossing was hurt by such reviews, especially the *American Whig Review* piece, because it impugned the integrity of his pictorial sensibilities. He thought he had shown appropriate restraint in his illustrations, guarding vigilantly against the corrupting influence of pictures, and he resented the insinuation that he should follow European leads in such matters. In a private letter to Cruikshank, Lossing complained that the review's "language of contemptuous sarcasm" was unwarranted. "You alone have seen fit to use the scalpel and caustic, instead of the probe and the balm," Lossing wrote Cruikshank defensively. "Would it not have been better to have been guided by the spirit of the blessed master?"[76]

Despite these criticisms Lossing remained optimistic that his book would withstand the test of time. His optimism was based less on potential financial returns than on the idealistic hope that a work like the *Pictorial Field-Book of the Revolution* could save America from itself by preserving the literary and visual memory of happier eras. As the 1850s wore on, however, that hope proved more and more chimerical, as did Lossing's expectation that a single individual like himself could master all the techniques and perspectives necessary to provide a complete visual and written record of any era of American history. The diversification of functions within the illustrated book publishing industry and the fragmentation of the fragile political unity within the United States made it impossible to imagine a future Lossing producing a history in form and content of the consolidated sort attempted in the *Pictorial History of the Revolution*. Profound changes in the American nation and its history augured for alternative strategies of visual and literary communication, strategies that reordered the relationship between image and word and transformed the genre of pictorial history into a more diversified but also more fragmented enterprise.

"Vulgar and Strict Historical Truth"

Giftbooks, Sentimental History, and the Grand Manner

By the early 1850s Benson Lossing had identified a potential market for pictorial histories of America dedicated to the preservation of the animate and inanimate past. Implicit in his methodology was the assumption that historical recovery projects such as his served not only antiquarian needs but also the larger psychological demands of a divided nation in search of diversions. To many readers the field book represented an appeal to a more unambiguous past and a much-needed check against a contentious present. "Mr. Lossing has come to the rescue at the right period," wrote a reviewer of the *Pictorial Field-Book of the Revolution* for the *New York Daily Times;* "ten years more and it would have been too late."[1] In this apparent double entendre the reviewer recognized in Lossing both a hedge against the debilitating effects of time on the decaying artifacts of the past and a protection against the impending forces of sectionalism and civil strife overtaking the nation.

"Something to Treasure, Like a Work of Art"
Lossing's field book offered a noncombative, practical guide for the recovery of a forgotten past, its words and illustrations serving more as archeological tools for the preservation of a distant age than as inducements for deep reflection on the meaning of historical conflict in the present one. Drawing attention to the technical, documentary aspects of historical research, Lossing refrained purposefully from applying the larger lessons of the American Revolution to a generation threatening to dismantle the federal machinery created by that Revolution.

For some, however, Lossing's understated intentions irresponsibly ignored the moral obligations of the historian. The vision of history as an implement for the recovery of a lost past was not ample enough usage for those looking to confront contemporary troubles or find solutions to current problems. History must rouse readers to new levels of civic concern, these critics argued, must persuade them to construct fresh moral philosophies for the living of lives. A debate in the periodical literature of the 1840s and 1850s underscored the division of opinion surrounding the proper applications of history. Some journals expressed a "delight in the unadorned facts" of history as presented by authors such as Lossing, declaring, as a writer for the *North American Review* did, that Americans "have always been a documentary people." These thinkers appreciated the "minuteness of detail which forms one of the principal charms in books" and extolled "the smaller matters of individual experience" that more synthetic history "in its stately march could not step aside to notice."[2] Other journals, however, envisioned a more exalted role for the past, associating history with the metaphysical objective of revealing universal truth. The anonymous author of an 1854 article in the *Westminster Review* titled "History, Its Uses and Meaning" noted that historians such as Lossing had an obligation to do more than record trivial facts; they needed to identify the grand, inspirational themes that transcended the simple elements of individual experience and translate those themes into elaborate guidelines for moral behavior in the present. Valuing "ultimate truths" above the minutia of the past, this author echoed the sentiments of William Gilmore Simms in asserting that "all eras of human greatness have not been eras of accurate knowledge of human things; they have been eras of idealism and imagination, of credulity and dreams."[3]

Such grand aspirations required a more substantial literary and visual packaging than had been employed by the less ambitious pictorial histories of Frost and Lossing. The assumption was that the crude engravings of Croome were inadequate to an aesthetic based on heightened moral concerns, the decidedly lowbrow products of the vernacular press proving insufficient to the task of reforming a disunified nation. Nor were Lossing's muted illustrations high-minded enough to satisfy those in search of a pictorial format that would startle readers into change. What was needed was a new visual calculus, a system of word/image relationships that gave illustrations more than a supporting, reportorial role in history texts by allowing pictures to assume a larger responsibility for the conveying of historical meaning. This prioritizing implied a new intellectual purpose for visual images—one that went beyond the mere embellishing of texts to a celebration of images as texts. It also encouraged publishers of pictorial histories to ask, How can the story of the past be told more effectively and more lucratively when presented in elaborate pictures?

In the years prior to 1850 this intriguing question was seldom posed, because technical limitations in the area of book illustration and production made it difficult to imagine history books that could use pictures

more effectively than texts in the service of reform. In addition, traditional suspicions about visual evidence reduced further the likelihood that such volumes could justify their own costs of production. But new advances in the process of the visual translation of images, especially steel-line engraving, increased the prospect of books with more elaborate pictorial designs. An "incision" rather than a "relief" process, steel-line engraving allowed artisans using metal tools called burins to cut V-shaped furrows in a prepared metal plate at varying depths. When ink was applied to these furrows and pressed under significant pressure using an intaglio process (rather than the stamping action of a wood block), it left deposits on the paper of varying thickness. This technique gave engravers an opportunity to reproduce the subtle effects of light and dark and to convey the roundness of shapes and the undulation of surfaces, especially human forms.[4] Indeed, Lossing's warnings about the pictorial excesses of French publishers in the early 1850s acknowledged the rapid pace at which the new technologies of image reproduction were sweeping through the publishing world. Although Lossing feared that an overly exuberant pictorial packaging would spill dangerously into the sensational, many welcomed a larger role for visual evidence because they saw in the elaborate use of illustrations a strategy for increasing the public's awareness of pressing national concerns. Perhaps more to the point, they also recognized the value of pictorial devices for selling books.

One strategy used by American publishers anxious to promote the visual features of their books was to borrow from the "giftbook" tradition then flourishing in Europe. Giftbooks were eye-catching volumes distinguished by their ornate title pages, their lavish steel engravings printed on high-quality paper, and their superior leather bindings. From a literary point of view, giftbooks were often only a slight advancement over the cruder almanacs they superceded. Most were superficial anthologies of contemporary events or facile compendia of facts with little historical insight. But from a commercial standpoint, giftbooks were a great improvement over their predecessors because they were highly crafted works whose serious artistic intentions seemed to dignify the written materials included in their pages. They were volumes built to last, and their durable physical appearance signified the aspirations many of their authors had for the permanence of their intellectual ideas. More expensive than Crockett almanacs but also more highly valued, such publications were part of a broad revolution in American literary culture in which middle-class readers "learned to look at a book in a way only the elite had done before,—that is, as something to treasure, like a work of art."[5] Giftbooks became collectibles and keepsakes, circulating among members of a slowly emerging genteel culture and serving (in the words of Samuel Goodrich) as "messengers of love, tokens of friendship, signs and symbols of affection, luxury, and refinement."[6]

In the mid-nineteenth century, such volumes were displayed in parlors in much the same manner as coffee table books are exhibited in living rooms today, and in keeping with the conventions of American parlor life in the mid-nineteenth century, they were written with the entire family in mind. Advertised as "important tools in the moral and religious education of the family," giftbooks were promoted as devices for drawing members of fractured households back to the domestic hearth and, by association, for unifying a nation in the midst of its own "civil" strife. Because most annuals and giftbooks were "intended for family reading," they were designed in ways that could be enjoyed simultaneously by all members of a family, parents and children turning oversized, visually attractive folio pages together. The literal act of reading

pictorial giftbooks collectively was celebrated in volumes such as Catherine and Harriet Beecher's *American Woman's Home*, the frontispiece of which featured a family huddled around a parlor table perusing a book by lamplight. By transforming reading from a private act of communion between a reader and a text to a communal "crusade to nurture and safeguard certain values," giftbooks increased the role and importance of illustrations as conveyors of meaning within texts.[7] Giftbooks also contributed to the elevation and gentrification of the pictorial industry, as "beautiful books" became objects of respect and desire in a growing culture of commodification.

Among the leaders in the historical branch of this giftbook industry was the firm of Johnson, Fry and Company, a publishing house that produced hundreds of such fancy picture books from the 1850s to the 1870s. The ambitious head of this concern was Henry Johnson, a publisher who was dedicated to elevating the standards of middle-class readers who had been victimized by the "grossness and racy humor" characteristic of American popular literature.[8] Like most giftbooks at midcentury, those produced by Johnson were highly sentimental and didactic in character, designed to edify as much as record.[9] The pictures and literary texts of his works contributed to "a kind of dream world of heightened sensibility and emotionalism," noted one assessor of the genre, in which historical themes "illustrated or described inevitably conform to the emotionalizing of life."[10] They were "wish-books" in which authors and illustrators emphasized "a somewhat impossibly glorious national history" in hopes of dignifying an as yet undistinguished past. As a crusader in the effort to advertise the value of American history, Johnson was ever in search of literary projects that emphasized an idealized past as a nostrum against the dangers of the present, and every element of the packaging of his

books was directed at achieving this sentimentalizing goal. The lofty truths and allegorical meanings of the prose of his authors were the "verbal counterpart of gilt stamping on gift-book covers" and the "sweet, ideal faces" of his illustrators' engravings were the artistic complement of a genteel literary style.[11]

Since the early 1850s Johnson had been at work on a series of illustrated giftbooks on historical subjects, and his pet project was a pictorial history of the United States. Titled simply *History of the United States*, this work was anything but simple in its production history. Johnson conceived of a volume that went well beyond Lossing's passive, documentary accounts; he imagined instead an exceptional book of high moral value that could play an activist's role in revitalizing an inert nation. Recognizing that such high ambitions would place unusual demands on his production staff, and acknowledging that giftbooks required a specialization of function that made it virtually impossible for a single individual such as Lossing to write, edit, and illustrate a pictorial giftbook, Johnson set about to assemble a team of prominent contributors, each of whom would be responsible for a specific feature of the production. In particular the publisher sought an author and an illustrator who were committed to his elaborate goals and who were sufficiently compatible in their outlooks to negotiate the sometimes-tricky interactions of collaborative work.[12]

One of Johnson's most challenging tasks was to find an author who shared his desire to "move the soul of the beholder" by creating books that emphasized the "critical element of dramatic content."[13] A lengthy search finally identified such a writer in minister-turned-historian, Jesse Ames Spencer. Born in 1816, one of ten children, Spencer lived primarily in Lossing's Hudson River Valley (Hyde Park, Poughkeepsie, and New York City). As with Frost and Lossing before

him, Spencer's first job was in a printing office, where, after two and a half years, he "became master of the compositor's art." But unlike his predecessors in the field of pictorial history, Spencer was diverted from these publishing activities by a calling to the ministry that took him to Columbia College and eventually the Columbia Seminary. After a brief career as a parish minister, he was forced to resign for health reasons, and he accepted a job with the "General Protestant Episcopal Sunday School Union," serving as a recommender of "suitable reading books for Sunday school libraries, as well as a full series of instruction books." Engaged for five to six hours a day perusing works under consideration, Spencer generated lists of "Approved Books" that might, "on examination, be found unobjectionable for the most part for additions to reading books in Sunday-school libraries, etc." It was a somewhat thankless task, as he read on average more than three hundred volumes a year—"with very scant returns for our list," he added—but this activity familiarized him with a wide range of popular works and helped him develop a strong editorial sense of what constituted good writing.[14]

It was in this capacity as a writer and reviewer that Spencer branched out into new, more fulfilling lines of literary endeavor. But serious intellectual work that paid a living wage was difficult to find. By 1854 Spencer had entered a self-described period of "dark days" during which he was forced to write circulars "for such articles as shoe-blacking, self-acting pins, root-beer, etc." Discouraged by this "*infra dignitate*," he was dependent nonetheless on its "proportionate pecuniary return," although Spencer remarked that if he had been asked to do so "for 'wine which is a mocker, and strong drink which is raging,' no amount of money, or extremity of straitness, could have hired me to write a line in its praise."[15] Such self-righteousness made him a perfect choice for the production of an il-

lustrated history on the plan of Johnson, and the publisher approached Spencer about the project in the fall of 1854. The minister-turned-writer was not sure whether working on a glorified giftbook was a worthy enough project, but he took it on out of financial necessity. "In the existing posture of affairs, I was necessarily compelled to turn my attention to [such] spheres of labor," Spencer explained of his decision to join Johnson. Although the details of his contract with Johnson, Fry and Company have not survived, Spencer's later comments about the abuses he suffered at the hands of publishers suggest he was not well compensated for his efforts. "Having done a very large amount of work for [publishing] houses in New York, I may claim some right to speak on a matter wherein publishers and authors hold quite opposite views," he wrote. "From an author's point of view, I think that the publishing fraternity are not usually as liberal as they might be, without harm to themselves; to which their reply is, that authors and literary men are continually seeking large and even extravagant prices for their labors." Noting that publishers "manifestly have all the advantage on their side," Spencer railed against the "scandalous wrong" done to authors like himself, which he characterized as "a great shame [in] every way."[16]

Because the literary standards of giftbooks were often determined by commercial considerations, Spencer worried as well that in accepting Johnson's offer he was compromising his integrity as a reviewer and writer, selling out as it were to the very forces of materialism against which he had preached as a spiritual leader. But he spent the next three years preparing the *History of the United States* for publication in denial of such thoughts, adapting the voracious reading habits he had acquired at the Sunday School Union to the goal of making Johnson's pictorial history a literary performance of unusual quality, even for a gift-

book. The result was a highly sentimental and moralistic manuscript whose prose rivaled in grandeur and intensity the symbolic intent of the giftbook's ornate packaging even while it quibbled intellectually with the corrupting market forces from which the giftbook industry in general and the *History of the United States* in particular benefited so profoundly.[17]

Memory Traces

A firm commitment from Jesse Spencer to write the *History of the United States* represented a good start to Johnson's grand scheme of producing a magnificent, pictorial history to rival those of Frost and Lossing. But the publisher also recognized that the most important component of any giftbook was the illustrations, and he knew hiring the right artist for such an elaborate production would be an expensive proposition. Skilled engravers earned upward of $250 a plate for steel-line engravings, and they often commanded most of the operating budget for a work like the *History of the United States.* Johnson's engravers were so vital to the illustration process that they began cutting their names or initials into the burnished plates used to illustrate his books, indicating their co-ownership of the publisher's pictorial products. It was imperative, therefore, that Johnson hire illustrators whose works were compatible with the steel-line process and who could create with the needs of his engravers in mind.[18]

Under the circumstances Johnson devoted more attention to the search for a suitable illustrator of the *History of the United States* than he had to the pursuit of an author. The publisher desired that the illustrations in the pictorial work serve as "memory-traces" of those moral patterns identified in the manuscript and, in some instances, expected them to anticipate such forms. In this sense the visual artwork for the history needed to be sentimental, theatrical, and morally charged, revealing of the higher idealistic purposes at the heart of meaningful acts of historical recovery. Cost-conscious publishers such as Benjamin Walker had appropriated for use in pictorial histories images that were already in the public domain, especially those produced by foreign painters that were readily available and not protected by copyright. Johnson, however, was anxious to hire an illustrator who would "pictorialize" *his* text specifically—either someone with an established portfolio of portraits and historical paintings whose works were worthy of the ambitions of Spencer's prose or an artist who could create original, monumental images produced expressly for the *History of the United States.* The distinction was between someone who was an "illustrator" in the broadest sense of the term—that is, one who created pictorial originals from the historical imagination—and someone who performed the explicative function of "illustrating" another's words.[19]

In the New York City of the 1850s a few skilled artisans fit one or the other of these categories, but Johnson knew of no one who met both conditions. Then a chance conversation between Johnson and an art collector, the Reverend Elias Magoon, alerted the publisher to the only artist in the business that might meet all of his needs. Magoon, a Baptist minister who lectured widely on religious, artistic, and historical subjects and was well known for his "bold enunciation of broad humanitarian views," was also a collector of art who had recently viewed the work of portraitist and history painter Alonzo Chappel at the distinguished Goupil Gallery in New York City.[20] Magoon was so impressed with the artistic and moral value of Chappel's paintings that he began purchasing them for his extensive private collection. These sales were crucial to Chappel, whose need for money nearly prompted him to accept an offer of seven thousand dollars a year to move to England to produce paintings for a picture

importer. Saved from this self-imposed exile by Magoon, Chappel and his benefactor concocted a plan to promote the artist's works as illustrations for the American book and print market. In pursuit of this plan the art collector contacted his friend Henry Johnson, who was just then in search of an illustrator, and arranged for Chappel to meet the publisher. From that meeting a lifelong business relationship commenced, Spencer's *History of the United States* serving as the prototype for a series of historical works created eventually by Spencer, Chappel, and Johnson.[21]

In choosing Chappel for the project, Johnson acquired the services of one of America's most gifted young artists. Born in 1828 in the Bowery in Lower Manhattan, Chappel began his illustrating career at the early age of nine, submitting to the American Institute Fair a portrait of Washington titled *The Father of His Country*. By the time he was twelve Chappel was working the streets of Manhattan, charging between five and ten dollars for portraits. He dropped out of school at fourteen to study the arts of japanning and window-shade painting, but by sixteen he was listed in the *New York City Directory* as a portrait artist earning twenty-five dollars a painting. While he acquired spare money painting stage scenery for plays in Manhattan, Chappel took art lessons from Samuel F. B. Morse, and it was through Morse that he was first exposed to European artistic conventions. His interests in these techniques were honed over the next few decades, as Chappel came into contact with painters such as George Inness with whom he helped establish the Brooklyn Art Association.[22] Unlike the crude vernacular forms of Croome or the utilitarian self-taught methods of Lossing, Chappel practiced a form of portraiture in the "grand manner" based on the monumental style common to Benjamin West in England, Emanuel Leutze of the Dusseldorf school in Germany, and Paul Delaroche in Paris. These history painters viewed

themselves as not merely literal transcribers of events but as interpreters of their historical and philosophical meanings. Their style included the use of heavy symbolism, bordering on the allegorical, as well as sentimental depictions of figures rendered in heroic casts. Wishing to "break with the tyranny of portraiture," Chappel gave his illustrations an inspirational quality that spoke to universal truths.[23]

Henry Johnson appreciated the strong biographical quality of Chappel's "civic" portraits as well as the monumentality of his narrative history paintings, many of which picture "the demise of the hero rather than the conflict itself, thus downplaying the significance of the historical event in favor of the didactic value of the individual's conduct."[24] It was this quality of idealism that persuaded Johnson to commission Chappel to illustrate the *National Portrait Gallery of Eminent Americans.*[25] In his sketches for this and other works Chappel endowed his subjects with a solemnity that bespoke the historical significance of the times in which he worked, relying, for instance, on traditional neoclassical posturing for full length portraits and on the introspective diverted gazes of traditional Roman busts "in the guise of republican virtue: *gravitas, dignitas, fides.*"[26] Chappel's large-scale, theatrical portraits were supplemented by equally heroic literary sketches provided by Johnson's editor, Evert Duyckinck, who was a close friend of Spencer's and a believer that great history, like great art, should entice people beyond the facts toward an appreciation of the higher, poetic imagination.[27] Both artist and writer employed allegorical devices that enabled them "to build layers of traditional meaning" into their works "without elaborating detail," while relying on "the viewer's knowledge to fill in the gaps."[28] Chappel and Duyckinck adhered to the advice of a contemporary art critic who argued that historical painters should endow their works with "a poetic spirit, which

can form a striking conception of historical events, or create imaginary scenes of beauty" when necessary for public edification.[29] Visual representations in a text should be more than ornamentations, the pair believed; they should be "tendenzbilden" or "thesis pictures," as the Germans called them, works "with a theme outside art" with an implied "intervention in public affairs."[30]

In a work such as the *National Portrait Gallery of Eminent Americans,* Johnson's preference for sentimentalized images encouraged Chappel to make alterations to the standard sources of visual imagery associated with bygone heroes and to embellish already available pictures of living subjects. In fact, none of Chappel's portraits for Johnson's series was drawn from life; most were adapted from an 1830s prototype volume, and others were compilation portraits created from assorted daguerreotypes. This composite technique of portraiture was satisfactory to Johnson from a business point of view because it allowed Chappel to work in his Brooklyn studio rather than to traverse the country in search of "life sittings" as Lossing had done. Some complained of Chappel's "slapdash" methods, as did Azel Ames, who protested that the portrait of his (and Jesse *Ames* Spencer's) ancestor Fisher Ames "was simply a 'made-up' picture," taken "a part from a photograph, part from any old plate" and patched together as "an outline (never having a 'sitter' from the subject of a sketch), and engraving from the ENSEMBLE."[31] But Chappel subscribed to Sir Joshua Reynolds's dictum that painters and authors "must sometimes deviate from vulgar and strict historical truth, in pursuing the grandeur of . . . design."[32] And Duyckinck viewed his biographical commentaries as extended captions for Chappel's heroic picture gallery, his literary portraits enhancing the "countenance" of figures "faithfully preserved to posterity by the pencil" of the artist. As

Duyckinck freely admitted, the point of origin for his narrative tributes was the popular and vaunted images of American heroes already well established in the public eye by artists.[33]

In deferring so readily to the prior authority of the visual, Johnson and Chappel contributed to a midcentury trend in which images began to compete with words for preeminence in historical texts. History paintings executed in the "grand manner" had always had a usurping effect on the historical imagination, but by the mid-nineteenth century the use of steel-line engraving and lithographic technologies of reproduction increased greatly the circulation and inviolability of canonical works by West, Trumbull, and Leutze. These duplicating technologies encouraged multiple uses of an image in both illustration and prints, contributing to the quality and durability of these productions and ensuring their hold on the historical memory. Not everyone was thrilled with the greater potential for circulation of historical paintings in illustrated books, of course. British dramatist Charles Lamb complained that historical paintings displayed at the popular Boydell Gallery and reproduced subsequently in pictorial volumes made it difficult for him to design innovative stage sets for Shakespearean revivals because theater audiences rejected all formulas that deviated in any way from the prior visual authority of these depictions.[34] Concerned about the "irresistible spell cast over our spirit by the visible beauty of a picture," another critic noted that "as more and more visual material for the appreciation of the past became quite generally available, so thinking and writing about the past [would fall] into increasing neglect."[35]

Alonzo Chappel was not immune to the appropriating tendencies of mass-circulated art, and he played an active role in the dissemination of clichéd images. Part of his incentive was financial. Like many artists, Chappel participated in gallery exhibitions at places

such as the National Academy of Design where visitors paid for the privilege of viewing and purchasing his paintings, but for the most part such commissions were not lucrative.[36] "Historical painting has not proved profitable to those who pursued it," art critic F. C. Adams noted at the time. "Most of them either having died poor or deeply in debt."[37] Consequently, many artists supplemented their incomes by working as book illustrators not only to put food on the table but also to provide promotional opportunities for the further marketing of their painted images. Painters who had been previously at the mercy of wealthy patrons who dictated the subject matter and style of their work now recognized an opportunity to reach the masses with visual imagery of their own making. The freedom of expression permitted by lithography changed the way artists conceived of their graphic work as well, many choosing for the first time to produce pieces for the print market that could be adapted secondarily for the purposes of book illustration.[38]

Chappel was a case in point. He had begun his career painting portraits for paying customers on the streets of New York, working in a rented studio on more ambitious historical projects only when time permitted. By the 1850s, however, Chappel had moved his operations from New York City to a warehouse in Long Island, where he hired a group of young artists to translate his oil paintings into lithographs for the pictorial book and print markets. Known as "Chappel's factory," this colony of artists was so prolific and yet inconsistent in its work that the phrase "based on an original oil painting by Alonzo Chappel" became synonymous with mechanized or processed art. The overuse of the inscription on hundreds of illustrations caused one art critic to question the existence of Chappel altogether. "All the so-called Chappel pictures are made up," he wrote. "I have heard it said there is no Chappel. It is merely a named used."[39]

Chappel did exist, of course, but it is hard to this day to determine the true extent and value of his artistic corpus. Many of Chappel's most outstanding oil paintings were never appreciated fully by American audiences, held as they were in the private collections of publishers and print makers who circulated sometimes-inadequate reproductions of them in mass-produced books and lithographs. Because so many of these originals were lost subsequently, Chappel's reputation as a painter has rested (often to his disadvantage) on the inferior copies of original works that were engraved by his employees for pictorial markets.[40]

In the 1850s, in fact, the largest collection of original Alonzo Chappel paintings was at the offices of Henry Johnson, who hired the painter to translate his canvases into illustrations for Spencer's pictorial history. "The work has been placed in the hands of a distinguished painter, Alonzo Chappel, who has the highest reputation in London and New York," Johnson's business partner acknowledged.[41] Committed to producing a worthy packaging for Chappel's luxurious drawings, the publisher also hired the very best in book designers who outfitted the volumes with gilt-edged pages and bordered texts. Even the typography was high-minded, dominated by modern face types embellished with decorative encasements and beautifully cast. If Spencer wondered where the money to meet his unmet financial requests had gone, he need not have looked beyond the corniced, Moroccan leather–bound covers of the *History of the United States*, which drove the price of the three-volume series into the double-digit range.[42] In investing so much in the visual packaging of the work, Johnson trusted in the wisdom of the emerging literary cliché that readers judged books by their covers.

Such prioritizing ran the risk of alienating Spencer, who shared the concerns of Charles Lamb and others that excessive visual packaging might obscure the lit-

erary intentions of a work. Although both Spencer and Chappel were committed to sentimental forms that emphasized the moral underpinnings of history, a subtle competition developed between them as to whose idealized visions would be given top billing. This rivalry had important financial implications for both author and artist, because each stood to benefit in terms of sales of future work if his name was associated first in the public mind with the *History of the United States*. In the words of Spencer, it would take some very "skilful [*sic*] business management" by Johnson to satisfy all parties in light of the escalating costs of the project, and in the end not all were satisfied.[43] But the competition between Spencer and Chappel represented more than just petty self-interest; it also reflected something central to the debate over the proper forms for disseminating historical information to a people in need of enlightenment about the past. It revealed disagreements about the proper prioritizing of visual and narrative evidence in pictorial histories and cut to the heart of changing intellectual concerns about the direction of the genre.

Illustrious Lives

A superficial look at the *History of the United States*, published in 1858, would suggest that Spencer had gained the upper hand in the battle to establish and control the idealizing tone of Johnson's volumes. Certainly Spencer succeeded in bringing a strong moral compass to bear on the nation's misguided past. In the introduction to the three-volume history the author outlined his hopes for a moral revolution in America. In the self-acknowledged role of reformer he argued that the historian's traditional commitment to truthfulness and impartiality, though sacred, must be directed at eliciting the past's "higher purposes." His expressed authorial goal was "to present a truthful,

impartial, and readable narrative" of the divine "progress of that mighty Republic which now extends from ocean to ocean, and which is moving onward, year after year, with gigantic strides, to increased power and importance among the family of nations." Balancing factual details with transcendent truths was a tough challenge because it required the historian to move easily between levels of concrete specificity and moral abstraction, but Spencer claimed he had "no ends to gain but those of truth and right" and "no theories to establish, no partisan views or wishes to gratify" other than those associated with the desire "to penetrate, or pronounce upon, the motives of men and nations . . . as plainly and fairly deducible from their acts." Put differently, Spencer wished to make it clear to his readers that although he valued facts, he would not allow objectivity to obligate him to dispassionate prose.[44]

As Johnson desired, Spencer's convictions and sympathies were strongly connected to nationalistic and patriotic concerns, as both author and publisher believed that historians had an obligation to take a proactive approach toward glorifying the American past. Unlike Lossing, Spencer felt a duty to remind readers of the responsibilities that went along with living out their destinies as Americans in the 1850s. Providence, he believed, had charted a special course for Americans, and he viewed it as part of his mission as a historian to illuminate the twists and turns of that path for a shortsighted public. But to outline the direction of America's destiny was not to secure it, Spencer warned. Americans could not simply sit by passively while forces controlled them; they must act on the strength of their moral convictions lest Providence be deflected from its rightful path. Hence, in Spencer's estimation, historians must do more than preserve memories of the past as Lossing sought; they must use history to motivate citizens to action in the

present and the future. Like many of his contemporaries, Spencer was convinced that God was watching over the new country, and he spoke often of the "superintending care and control of Divine Providence in our country's affairs" that must appeal to "all honest lovers of our highly favored land."[45]

Predictably, Spencer's heroes, such as Sam Adams, established their greatness by living consistently exemplary lives. Spencer gushed over Adams's impeccable character, describing him as "one of the most perfect models of disinterested patriotism, and of republican genius and character in all its severity and simplicity, that any age or country has ever produced." In an adjectival barrage unmatched even by the loquacious Frost, Spencer described Adams as a "sincere and devout Puritan in religion, grave in his manners, austerely pure in his morals, simple, frugal, and unambitious in his tastes, habits, and desires; zealously, and incorruptibly devoted to the defence of American liberty, and the improvement of American character; endowed with a strong, manly understanding, an unrelaxing earnestness and inflexible firmness of will and purpose, a capacity of patient and intense application which no labor could exhaust, and a calm and determined courage which no danger could daunt and no disaster depress." And most impressive of all, Spencer added, Adams "rendered his virtues more efficacious by the instrumentality of great powers of reasoning and eloquence, and altogether supported a part and exhibited a character of which every description, even the most frigid that has been preserved, wears the air of panegyric." This extravagant appraisal should have been sufficient to enshrine Samuel Adams in the pantheon of American greats, but Spencer continued to heap on the praise in a manner that revealed his preferences for only the most exaggerated types of historical portraiture:

He defended the liberty of his countrymen against the tyranny of England, and their religious principles against the impious sophistry of Paine. His sentiments ever mingled with his political views and opinions; and his constant aim was rather to deserve the esteem of mankind by honesty and virtue, than to obtain it by supple compliance and flattery. Poor without desiring to be rich, he subsequently filled the highest offices in the state of Massachusetts, without making the slightest augmentation to his fortune; and after an active, useful, and illustrious life, in which all the interests of the individual were merged in regard and care for the community, he died without obtaining or desiring any other reward than the consciousness of virtue and integrity, the contemplation of his country's happiness, and the respect and veneration of his fellow-citizens.[46]

This highly bombastic, even saccharine, form of heroism crescendoed in Spencer's description of George Washington. In the histories of both Frost and Lossing, Washington had been treated in hagiographic ways, but Spencer outdid his predecessors in his filiopietistic treatment of America's patriarch. In lines reminiscent of the work of another minister-turned-historian, Parson Weems, Spencer wrote that Washington's character had been established even in boyhood, when his "schoolfellows appealed to him to decide their little differences, and his sincerity and strict integrity and fairness gave him the undoubted ascendancy at all times," presaging, "especially to a mother's prophetic ken, the greatness and nobleness of the career before him." A man of superhuman strength rivaling Croome's Davy Crockett, Spencer's Washington was "accustomed to clamber precipices and wade morasses, to swim his horse over swollen streams, to sleep for nights under the canopy of heaven, wrapped up in a bear-skin, and deem a seat by a blazing log-fire a place of luxury, to live hard, to cook his own rough meal with a wooden fork, and to cope betimes with the wild forests and their wilder tenants." Even the effusive Washington Irving had not outdone

Spencer in declaring for the messianic qualities of the first president and the "superintending to care and favor of Divine Providence" that guided his actions while in office. Christ-like in his sacrifices and in his occasional martyrdom, the first president was, in Spencer's rendering, "raised up" by "that God" who "imposed upon him" duties and obligations that no other man could face. As with Christ, "trials and perplexities, and humiliations waited upon his every step," the kind of "jealousies" that "every great and good man must expect to meet with in an envious and malicious world." "But trials are not sent without design," Spencer moralized, and "Washington was formed of that material which is purified and strengthened by trial." Borrowing a metaphor from Lossing's field book, Spencer concluded that Washington was the only leader who could look "beyond the veil which concealed the unknown future" to see the "irrefragable proofs" of his and his nation's greatness.[47]

Spencer's portraits of Adams and Washington were intended as more than literary celebrations of the greatness of individual leaders. They also provided a convenient shorthand for establishing the values Spencer esteemed above all others in the more generalized American character. But they were over-sentimentalized in ways that giftbooks tended to be, and their extravagances implicated Spencer in a number of unfortunate literary choices that marred the overall quality of the text. The conflict between Spencer's desire to startle readers with dramatic moral revelations and his commitment to the faithful recording of the facts of history, for instance, led to awkward authorial interruptions in the text. Aware of his own tendencies to overwrite, Spencer stepped back occasionally from the sentimental abyss to reflect on more mundane events, as when he chose "to gather into one chapter such brief notices of omitted topics as may interest the reader, and afford him a larger insight into the actual condition of affairs in the northern, southern, and western sections of our vast country."[48] Even in such instances, however, Spencer emphasized the ways in which grand moral themes were reflected in small, seemingly trivial details. This deductive technique served to remind readers of their own potentially important place in the destiny of the nation. In short, Spencer intended the *History of the United States* as a functional history, one that would have a particularly sanguine effect on the great masses of democratic readers who might engineer solutions to the nation's ills. By emphasizing how the grand and epic emerged from the small and common, by focusing on how timeless truths derived from the minutia of a specific past, Spencer developed an applied brand of history with implications for all human communities. Occasionally his idealistic tendencies encouraged dangerous resort to the excesses of the sentimental, but Spencer was willing nonetheless to accept the risks of excess in exchange for the benefits of an informed imagination.

If Spencer's prose established the virtues of strength, leadership and courage in American history, then the highly iconographic representations Henry Johnson chose for use in the *History of the United States* provided a visual counterpart to Spencer's ennobling language. The historical text is filled with full-page steel engravings printed on special acid-resistant paper and protected by liners, giving the illustrations grandeur appropriate to Spencer's purposes. Indeed, in some ways Chappel's drawings stood separate and above Spencer's prose, printed as they were on the thicker paper required of the intaglio process. In addition, Johnson's sentimentalizing ambitions encouraged him to employ engravings not just as Lossing had used them, to bring greater clarity to portraits than Croome had achieved, but also as a way of reducing the details of large, stately, allegorical paint-

Figure 31. "Landing of Columbus," 1858, engraved by H. B. Hall after the painting by John Vanderlyn, 1858, for Jesse A. Spencer's *History of the United States*

ings for use in smaller, more compacted illustrations suitable for standardized books. As such, he was among the first American publishers to reproduce successfully in books engravings of grand historical paintings, thereby making accessible to readers images previously reserved only for those able to travel to galleries and exhibition halls. The mastery with which Johnson's engravers achieved reductions of scale without loss of detail impressed readers, and the promise their techniques suggested for the mass circulation of monumental paintings contributed to a renaissance of sorts in the genre of historical painting. Johnson's goal was to wed Chappel's "grand man-

ner" style with the highly principled imperatives of Spencer's text, creating a richly textured visual and literary history suitable for readers in need of moral regeneration at the end of the 1850s.[49]

A good example of the ways in which Johnson used illustrations to match the intensity of Spencer's prose is seen in the reproduction of John Vanderlyn's *Landing of Columbus* in the *History of the United States*. The highly regarded H. B. Hall engraved the illustration from the original oil painting, which had been commissioned by Congress in the 1830s for one of the historical panels in the Rotunda of the Capitol (fig. 31). As with many of the paintings in the Rotunda series, Van-

Figure 32. Frontispiece to volume 1 of Jesse A. Spencer's *History of the United States*, 1858, by Alonzo Chappel

derlyn's work was criticized by those who objected to the subject as not sufficiently American to warrant inclusion in the Capitol (Columbus never having set foot in what would become the United States).[50] But when the painting was completed and mounted in 1847, the thousands of visitors who viewed it came to regard it as the standard "American" image of Columbus's epic moment of discovery. Vanderlyn's "Americanization"

of the landing was consistent with Spencer's nationalizing portrait of the discoverer in the text of the *History of the United States*, a compatibility of image and word that derived from the fact that both artist and author drew their impressions of Columbus from the same source—Washington Irving's biography of the discoverer. *The Landing of Columbus* borrows heavily from the "lacunae of Irving's story" and establishes "a

contrast of Europeans and native Americans, promoting the linkage then being forged between national character (the traits that prompted Columbus's feat) and national destiny (the possession of a continent already occupied, but 'only' by a people 'easily' and 'deservedly' removed)." This symbolic interpretation of Columbus's discovery had become so popular by the mid-1850s that Vanderlyn's depiction began to appear everywhere—on stamps, towels, and even circus wagons, as well as Spencer's text. Johnson's use of *The Landing of Columbus* implied not only an endorsement of Vanderlyn's nationalist intentions but also a desire to associate the *History of the United States* with its "official imprimatur."[51]

Altered versions of Vanderlyn's *Landing of Columbus* were also adapted and readapted by popularizers in every industry in the mid-nineteenth century by advertisers who wished to associate their products with the genesis of the American identity. Henry Johnson used this commercial strategy in the frontispiece to the *History of the United States,* commissioning Chappel to produce a modified version of the Vanderlyn piece to serve as a symbolic gateway into the text (fig. 32). Chappel succeeded well in this task. His assembled figures were adapted from the standardized "types" in the original oil painting (the militiaman leaning on his crossbow, the robed priest, the merchant-gentlemen, the supplicating Indian bearing gifts, etc.), yet Chappel intensified the central drama of discovery by eliminating some of the most distracting elements of Vanderlyn's original painting (the frantic sailors combing the beaches for gold, for instance).[52] In fact, Columbus's ethereal gaze and the dramatic body language of Chappel's figures outstrip the heroism not only of Vanderlyn's original composition but also of Spencer's literary description of Columbus. Keenly aware of the importance of enticing readers into texts with pictures placed at strategic

points of entry, publisher Johnson encouraged excesses of an almost baroque nature in the frontispieces to the *History of the United States.* By doing so he not only provided a striking portal of origin through which readers could enter his texts, he also dramatized the beginnings of national experience by highlighting the origin rituals cherished in common by most Americans. Such contrivances increased the value of Johnson's volumes as collectible items by appealing to a public-spirited, mass-consumer ethic on which the giftbook and pictorial history industries depended for their survival.

Johnson employed a similar strategy by including in the *History of the United States* an engraving of *De Soto's Discovery of the Mississippi,* a painting by William Henry Powell also commissioned originally for the Capitol Rotunda (fig. 33). This "original moment" work in oil, depicting De Soto entering an Indian encampment on the banks of the Mississippi, was a composite painting that has been described accurately as a "theatrical spectacle."[53] In conscious imitation of the triumphal arrival scenes of Roman emperors in painting and processional sculpture, Powell's De Soto enters the village on a white steed ahead of a cavalcade of armored soldiers who have emerged in a great flurry from a dense wilderness. Somehow a cannon has preceded De Soto to the scene, as have various hooded and shadowy priests citing incantations over the installation of a cross. Some Indian women embrace in fear, other men stand around naïvely nonchalant, and still others flee in canoes; yet this is essentially a nonconfrontational, nonthreatening episode, a celebratory meeting of cultures consistent with other "moment-of-origin" paintings. Such works of art became "symbolic touchstones of the nation's destiny" and were especially well suited to the visual mechanics of an illustrated book like the *History of the United States.* The limitations imposed by the single frame format of his-

Figure 33. "De Soto's Discovery of the Mississippi," 1858, after the painting by William Henry Powell, for Jesse A. Spencer's *History of the United States*

torical painting, in fact, "peculiarly favored the American tendency to conceive the national past in terms of significant individual birth-events," while the autographic tendencies of steel-line engraving encouraged grand history painters in their assumptions that "*it is the first manifestation of a thing that is significant,* not its successive epiphanies." Spencer contributed further to this historiography of commencement by embedding Powell's visual imagery in a narrative rich in the language of origin rituals.[54]

Some contemporary reviewers of *De Soto's Discovery of the Mississippi* were concerned by the excessive political tone of Powell's theatrical vision and complained that as a Rotunda selection it distorted the past by making too many concessions to "Congress's western constituency."[55] A reviewer for *Literary World* doubted the veracity of the encounter altogether and argued that "the subject itself should have been at all events an actual point of history."[56] But such criticisms in the press had little impact on those who viewed the painting in person and proclaimed it a masterpiece, its visual grandeur and place of prominence in the Rotunda guaranteeing it protection against such literalists. There have been times in history "when seeing has appeared to provide a more useful way of understanding the past than reading,"[57] and this was certainly the belief of an American writer for the *Anglo-American* who argued in 1847 that when it came to knowing the "history of [our] own country," citizens could "find more information . . .

Figure 34. "Washington Crossing the Delaware," 1858, engraved by J. C. Buttre after the painting by Emanuel Leutze

without trouble, at any time, and most agreeably, by a visit to the [rotunda paintings] in the Capitol" than they could get "from libraries of books."[58] Johnson's decision to include a steel engraving of *De Soto's Discovery of the Mississippi* in the *History of the United States* suggests his desire to achieve for his history the kind of elevated truth-status belonging to the nationalizing paintings in the Rotunda collection and aspired to by Spencer's prose.

The most prominent example of Johnson's efforts to use art in the service of high-minded didacticism was his decision to include a reproduction of Emanuel Leutze's *Washington Crossing the Delaware* (fig. 34). Leutze was a German-born immigrant to the United States who returned to Dusseldorf to participate in

the revival in monumental painting that was occurring there at midcentury.[59] His original oil painting, which was both cause and effect of a renewed celebration of Washington as the grand patriarch of the Republic, made a strong sensation in the art world when it was first exhibited in 1850.[60] A young Henry James viewed the painting in a gallery in New York City in October 1851 and wrote of the lasting impact it had on him:

> No impression here, however, was half so momentous as that of the epoch-making masterpiece of Mr. Leutze, which showed us Washington crossing the Delaware in a wondrous flare of projected gaslight and with the effect of a revelation to my young sight of the capacities of accessories to 'stand out.' I live again in the thrill of that evening. . . . We gaped responsive to every item, lost in

the marvel of the wintry light, of the sharpness of the ice-blocks, of the sickness of the sick soldier, of the protrusion of the minor objects, that of the strands of the rope and the nails of the boots, that, I say, on the part everything, of its determined purpose of standing out; but that, above all, of the profiled national hero's purpose, as might be said, of standing up, as much as possible, even indeed of doing it almost on one leg, in such difficulties, and successfully balancing. So memorable was that evening.[61]

James's comments suggest the first flush of enthusiasm for a work whose sensationalism was well suited to a young mind. Within only a few years of the painting's exhibition it became mandatory for publishers of pictorial histories such as Johnson to include some engraved version of it in their illustrated works out of deference to young readers. For children especially the image "seemed to send a thrill through the system," as the *Georgetown Advocate* noted, carrying "the mind back to a time when Washington . . . thought it necessary to make a daring attempt to save the great cause in which the future of the country was involved."[62]

Spencer's literary account of the crossing of the Delaware was consistent with Leutze's high-minded depiction but was understated in comparison. Foregrounding the "masses of floating ice" choking the river that cold Christmas Day, Spencer highlighted the profound courage of the patriarch Washington in daring to traverse the Delaware, but beyond that he wrote nothing else about the episode.[63] Johnson's decision to supplement Spencer's prose with Leutze's pictorial dramatization demonstrated his understanding that Americans wanted more rather than fewer of these strident depictions of Washington. He shared something in common with the art critic of *Home Journal* who, in an 1851 article titled "National Glory and the Arts," asked with a keen sense of urgency why more paintings of the founders like Leutze's were not forthcoming in an age of despera-

tion and failed leadership: "What greater benefit could be conferred upon the social condition of our people—how more efficiently could be seconded the endeavours of our foremost statesmen, to keep the government of our country in line of that magnanimous policy which presided over the formation of the Union—than to bring the visible images of those earlier legislators and heroes before the eyes of the community of this day!"[64]

In the friendly competition between Spencer and Chappel to see which images, verbal or visual, could produce the most sentimental reactions in readers of the *History of the United States*, the author almost always yielded to the illustrator in keeping with the national trend toward the visual processing of historical information. Occasionally painters were familiar with a historical episode by prior literary rather than visual association with it. At a young age Alonzo Chappel had demonstrated an insatiable "taste for reading history" (especially the "early annals of the United States"), and "he encountered no difficulty in finding material for his inexperienced brush" or for use in gift-books from the products of his literary inquisitiveness.[65] But more often than not after the 1850s, it was illustrations that dictated to texts, artists who anticipated writers. Henry Johnson's editorial strategy in the *History of the United States* at least was clear: place before readers those pictorial images that had risen to the level of indisputable icons, even if at times these outdistanced accompanying prose, because it was the visual around which readers established preconceived notions of historical worth, and it was the visual that increasingly conditioned interest in the literary.

A good example of the deference granted painters by historians was the willingness of Spencer to accept the historical validity of Benjamin West's depiction of the signing of Penn's Treaty, reproduced in an attractive steel engraving for the *History of the United States*

Figure 35. *Penn's Treaty with the Indians*, 1771–72, by Benjamin West (Courtesy of the Pennsylvania Academy of the Fine Arts, Philadelphia; gift of Mrs. Sarah Harrison [the Joseph Harrison Jr. Collection])

(fig. 35). Critics of West's painting of the "famous traditionary interview with the Indians under the great elm of Shakamaxon" had argued that such a meeting had never occurred, the first published mention of the supposed 1682 event appearing in a biography of Penn by Thomas Clarkson written forty years after West's painting was first exhibited. Because Clarkson consulted West directly on the details of the ceremony before writing his account, and because the biographer's characterization of it "reads suspiciously like a description of West's painting, which, indeed, seems to be the earliest known document of any sort indicating that such an event took place at all," many doubted the authenticity of the meeting altogether. Other inaccuracies in West's painting, including Penn's appearance as an older man than he would have been in 1682 and the eighteenth-century dress of seventeenth-century Quakers, raised further suspicions regarding its validity. But these concerns did not prevent Spencer from relating the story of the signing of Penn's Treaty in a manner that conformed nearly exactly to West's depiction of a nonconfrontational meeting among traditional enemies in the interests of

peace and harmony.[66] Extrapolating from West's "scene of deep and touching interest" to a generalized description of Penn as a leader, Spencer argued from evidence internal to the painting that it was Penn's "sincerity and good will" that prevented "Quaker blood" from ever being "shed in contests with the aborigines of that region."[67] In asserting as much, Spencer sacrificed some accuracy of detail for the sake of his larger moral objective, subordinating his literary text to the allegorical imperatives of West's visual algorithm.

Other examples of the growing power of visual images over prose were evident in the original drawings Chappel produced for the *History of the United States*. In the frontispiece to volume 2 of the series, for instance, Chappel relied on classical figural conventions to depict the departure of minutemen for the battlefields of the American Revolution (fig. 36). Orienting the space in this illustration in a manner reminiscent of ancient pediment sculpture, Chappel borrowed the "storytelling" function of Greek friezes to emphasize the narrative and allegorical qualities of this dramatic episode. A similar symbolic vocabulary was employed

by Chappel in his portrait of George Washington in which the first president is surrounded by *objets de vertu* associated with his important life: documents of state, flags, an eagle, a sword and the principle of E Pluribus Unum (fig. 37). Presented with the same symbolic intent as the "speaking pictures" in sixteenth-century emblem books, these objects collectively "conveyed a literary conceit or moral precept in pic-

torial form."[68] By his own admission, Spencer's fawning verbal tribute to Washington was less effective than these mélanges in dramatizing the moral genius of the man through the historical bric-a-brac of his career. "In attempting to express in words an adequate conception of the character of Washington," he conceded, "we feel how poor and weak is all language, at our command, to enable us to do justice to the ven-

Figure 37. "G. Washington," 1858, engraved by G. R. Hall from the painting by Alonzo Chappel for Jesse A. Spencer's *History of the United States*

eration and love with which the millions of Americans regard the father of their country."[69] An acceptable substitute could be found, however, in allegorical illustrations that transformed secular events into sacred ones. Such pictorial depictions provided a catalogue of moral lessons with which no written text could compete reliably.

Chappel was a master at conveying through visual artifices the dramatic power of specific moments in history, and, occasionally, Spencer deferred completely to the artist's superior depictions by subordinating his own literary treatments of events. Hence, Spencer confined to a footnote his description of the spectacular rescue from Algerian pirates of Commodore Stephen Decatur by a sailor, Reuben James, who interposed his head before the sword of an at-

Figure 38. "Decatur's Conflict," from the painting by Alonzo Chappel for Jesse A. Spencer's *History of the United States*

tacker to save the life of his commander.[70] The understated nature of Spencer's brief reference to the event was in curious contrast to the elaborate illustration of "Decatur's Conflict" by Chappel in the *History of the United States,* portraying the startling moment of the seaman's heroic sacrifice (fig. 38). Part of the stirring effect of the representation is created by the perspective of the illustration, Chappel using a dramatic angle-of-vision to place the viewer nearly in harm's way aboard the deck of Decatur's gunboat as witness to the death struggles of the combatants. The intense stares of all the participants bespeak the high stakes of the struggle, as do the strongly modeled quality of their contorted bodies and the dramatic gestures of their limbs. Lest the specific historical episode be lost to some viewers amidst the high drama of the scene, Chappel provided clues as to the identities of the contenders, especially heroic Reuben

James, who is distinguished by an identifying tattoo of his name on his left forearm. This image, one of the most successful Chappel ever created, was reproduced again and again in pictorial histories of the United States throughout the nineteenth century, and it had an independent life of its own as a lithographic print that Chappel sold by subscription.

Later reviewers of "Decatur's Conflict" have objected to Chappel's depiction on the grounds of accuracy, noting that a sailor named Daniel Frazier rather than James performed the selfless act of heroism.[71] But as with William Croome's occasional misidentifications, the factual accuracy of the "Decatur's Conflict" was perhaps less important than the power of its forceful visual imagery in confirming the place of Chappel as historical image maker at midcentury. In illustrations such as this Chappel viewed documented facts in the same light as William Gilmore Simms and other idealists had characterized them—as less significant to readers than visually cohesive dramatizations of the past. The painstaking care with which Johnson's engravers used short flicks of the burin to follow the projections of the muscles of the combatants or portrayed the urgency of their struggles by crossing the V-shaped furrows horizontally to the axis of each form was far more important to the overall impact of the illustration than were a few subtleties of fact entombed in Spencer's footnotes.[72] Certainly Chappel's images, beautifully rendered and presented, afforded Spencer a wider audience for his literary thoughts than he had ever enjoyed before. The author flattered himself that the "extensive circulation" of the pictorial history resulted from the fact that "in spirit and tone" his writing was "considered to be fair and candid," but he could not have failed to understand that it was Chappel's illustrations that primarily sold the work.[73]

If there were any questions in Spencer's mind about the true selling point of the volumes, the advertisements in a later edition of the *History of the United States* left few doubts about how Johnson prioritized the contributions of writers and artists. In these ads there was little effort made to promote the reputation of Spencer; he was acknowledged only in passing as the author of the series. But Chappel received a great deal of attention as the "well-known artist" of lavish "Pictorial Illustrations" that had been completed "in steel in the best style of the art" and for which "no pains or expence [*sic*]" had been spared.[74] This was consistent with the growing place of prominence afforded illustrated material in the advertisements for books in leading literary journals of the day. From the point of view of the marketability of giftbooks, at least, the authority of the visual was irrefutable.

"Veritable 'Snapshots' of Historical Events"

Despite the undeniable power of visual imagery, historians such as Spencer were not willing to give complete control of their texts to illustrators. Spencer complained to editors, for instance, when the prioritizing of visual sources over written ones led to embarrassing incongruities between words and images. One such inconsistency in *The History of the United States* resulted from the juxtaposition of Spencer's essentially negative portrait of the New England Puritans with highly heroic visual depictions of the same people. In Spencer's estimation the Puritans acted both "unwisely and unfairly" in their efforts "to force conformity by stringent and oppressive legislation," and he condemned their "arbitrary system," which was marred "by a spirit of puritanical severity within themselves, and a harsh and rigid exclusiveness towards those without."[75] Yet this disapproving literary description was challenged by the sympathies created for the Puritans in dramatic exodus paintings such as

Figure 39. "English Puritans Escaping to America," 1858, engraved by G. R. Hall, from the painting by Emanuel Leutze, for Jesse A. Spencer's *History of the United States*

English Puritans Escaping to America, adapted for Spencer's pictorial history from an Emanuel Leutze painting (fig. 39). Similar in conception to his *Washington Crossing the Delaware*, this swirling composition features another motley band overseen by a towering leader in battle against the forces of oppression. A "small painting," the *Bulletin* noted in 1849, and "not so carefully finished as many of his other works," *English Puritans Escaping to America* might well have been intended as a study of sorts for his more monumental work.[76] Despite its unfinished quality, it re-ceived wide circulation in engraved form when it was recycled by Henry Johnson in the *History of the United States*, its use suggesting that authors were less and less consulted about the illustrations that adorned their texts.

There is also evidence in the *History of the United States* that illustrators worked without Spencer's manuscript before them when they conceived and executed their pictorial depictions. Chappel's "Landing of Roger Williams," for instance, bears little resemblance to Spencer's discussion of the arrival of

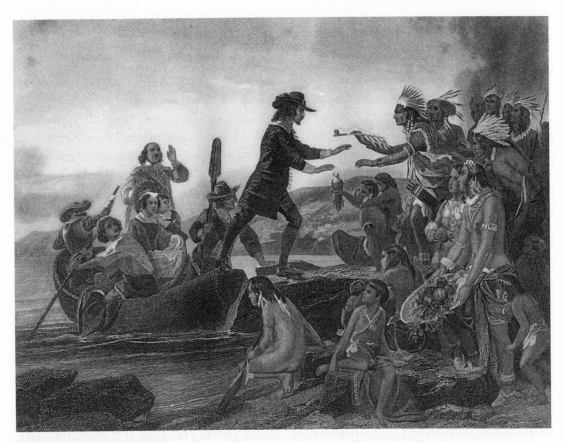

Figure 40. "Landing of Roger Williams," 1858, engraved by G. R. Hall from the painting by Alonzo Chappel for Jesse A. Spencer's *History of the United States*

Williams in Providence, Rhode Island (fig. 40). The Indians in the illustration, some of whom are barebreasted despite Spencer's discussion of Williams's arrival in the dead of winter, appear more indigenous to the Caribbean than to New England. And in addition to the fact that the *History of the United States* contained no specific reference at all to an embarkation, the mixed things Spencer did have to say about the controversial minister were certainly incompatible with Chappel's romantic depiction.[77] In creating his imagery Chappel was evidently trying to lend a bit of romance to a scene about which little is known, per-

haps in imitation of Vanderlyn's *Landing of Columbus*, although, as one expert has noted, the depiction is "apocryphal and of no historical value as far as the life of Roger Williams is concerned"; there is, in fact, "no . . . evidence to prove that it ever did occur."[78] Inconsistencies between images and words might be excused if they resulted from the cost-cutting tendencies of publishers to graft old illustrations onto new texts, but Chappel's "Landing of Roger Williams" had been commissioned expressly for Spencer's pictorial history, so the responsibility of its contradictions rested squarely with the firm of Johnson, Fry and

Company. Still more disturbing to Spencer was the fact that although his prose description of Williams's arrival achieved no special recognition, Chappel's sentimentalized visual imagery took hold of the popular imagination. It was repeated endlessly in medallions and china throughout the nineteenth century and was even incorporated into the city seal of Providence, long after Spencer's words had been forgotten.[79]

The mass appropriation of Chappel's whimsical depiction of Roger Williams suggested the danger of relying too heavily on visual images that might become hackneyed and subsequently lose their abilities to convey dramatic historical meaning. Leutze's widely circulated *Washington Crossing the Delaware* provided a sad confirmation of the hazards of such overuse. Henry James, who had been so smitten with Leutze's image as a boy, noted that when he revisited the painting in a gallery as an adult, it had lost much of its sentimental power over him. Attributing his jaded reaction to the ravages of age ("the cold cruelty with which time may turn and devour its children," he wrote), James bemoaned the fact that the painting was now "dead" to him, buried with "half the substance of one's youth."[80] Although the fluctuations in his reactions to the Leutze painting were due in part to a midlife crisis James was experiencing at the time, they were also certainly an acknowledgment of the loss of power that accompanies the overproduction and mass circulation of visual imagery. Mark Twain expressed a similar lack of patience at the ubiquitous appearance of Leutze's imagery above mantels and in "thunder-and-lightening crewels" on the walls of every frontier household in America. Twain complained with characteristic sarcasm in *Life on the Mississippi* that Leutze had created a "work of art which would have made Washington hesitate about crossing, if he could have foreseen what advantage was going to be taken of it."[81] The injudicious repetition of an image, he implied, was unhealthy for a nation already given to slavish mimicry in its visual representations.

At the time Spencer's *History of the United States* was published, Leutze's *Washington Crossing the Delaware* was less than a decade old and had not yet acquired the tired, clichéd reputation attributed to it by James and Twain. But artists employed by Johnson for Spencer's history, such as Alonzo Chappel, contributed to the trivializing of its imagery by experimenting endlessly with the Leutze formula, even adapting its embarkation format for illustrations that had nothing to do with George Washington. For instance, Chappel's frontispiece for an 1869 *History of the World*, on which Duyckinck, Spencer, and Johnson all collaborated, retained the compositional structure of the Leutze original but reversed its orientation and transposed its historical context by substituting Columbus for Washington (fig. 41).[82] Twenty years after Leutze's original painting had been exhibited in the United States, its features had become so standardized as to have encouraged Chappel to imagine Columbus as a conquering patriot and the Native Americans of the Caribbean as would-be Hessian and British resisters.

Apart from the inaccuracies created by the recycling of such images, the real danger of unchecked repetition was the disproportionate influence it had on the historical imagination. Works such as *Washington Crossing the Delaware* were reproduced with such frequency in pictorial works such as the *History of the United States* that they came to seem synonymous in the popular mind with the events they described. Viewers felt they were "in the presence of veritable 'snapshots' of historical events" when they saw Leutze's much-circulated and clichéd depiction, its imagery crowding out all other competing conceptions of the event, either visual or literary.[83] Leutze's Delaware River episode is treated pictorially "more dramatically than facts warranted," one critic has

Figure 41. "Landing of Christopher Columbus," 1869, frontispiece to volume 4 of *History of the World: Ancient and Modern*, 1869, by Alonzo Chappel

ner."[85] If Leutze's illustration did not convey with accuracy what happened during Washington's crossing, it depicted what many Americans believed could have (and ultimately should have) happened.

Although Spencer was forced to accept many of the incongruities that resulted from the usurping power of images over words, there was one issue on which he refused to be upstaged by artists: slavery. Recognizing that not every subject lent itself to meaningful visual construction, Johnson chose not to commission for the *History of the United States* theatrical illustrations of the brutalities of slavery; indeed, the last quarter of Spencer's third and final volume is given over completely to uninspired portraits of civic leaders rather than sentimentalized visions of dramatic encounter moments. Perhaps unwilling to lose for his volumes a potential southern market, Johnson's decision not to add maudlin illustrations of the abuses of slavery suggested that the idealizing and escapist qualities of sentimental giftbooks made them inappropriate for the visual depiction of the "detestable commerce" of the slave trade. Spencer, however, showed no such restraint. Nowhere does a work like the *History of the United States* assert the authority of the written word more, therefore, than in the ministerial dogmatism of Spencer's prose polemic in the wake of the pictorial silence regarding enforced servitude. Slavery reflected poorly on the character of a nation whose "moral sense" was "becoming blunted," Spencer noted with candor, and whose history was marred by a grave, unspeakable sin that introduced the "elements of evil, and tendencies to discord and ruin." The historian warned his fellow Americans that they were unmistakably at a crossroads of sorts wherein their moral resolve would be tested as never before, and he urged them to awaken to their moral responsibilities before it was too late. In the last paragraphs of the *History of the United*

noted, the painter having positioned Washington at the vanguard of the procession like "a modern Moses" despite numerous historical accounts testifying to the general's location near the rear of the formation.[84] But most Americans, as anxious to have agreement in their art criticism as they were to have unity in their political life, saw in Leutze's overstated hero a hopeful and believable model for deliverance from discord. "Leutze's Washington, towering over a crowded boatful of soldiers on the Delaware's icy waters, visually unites the motley band" in a manner symbolic of the way that "the father of his country embodied . . . the righteous cause for which thirteen contentious colonies had come together under a common ban-

States, in fact, Spencer's unique brand of Christian historiography exploded onto the pages with a jeremiac urgency. With unmatched vigor, Spencer warned his countrymen and women that important decisions made in the last years of the 1850s would determine which of two very different paths Americans traveled in the future.[86]

One path was that of righteousness, Spencer indicated, a path favored by "the care and guidance of Him who rules the affairs of men." The other path, however, was the enticing road to selfish aggrandizement and greedy corruption. "To the man who looks upon these things from the point of view which the Christian patriot occupies, the prospect of our country's future causes anxiety no less than exultation," Spencer wrote at the conclusion of his history. Such a patriot "scans narrowly the principles which are avowed in high places; he notes, with the deepest concern, the tone of public sentiment, the standard of public virtue and honor, and the recognizing, or the refusing to recognize, the overruling providence of Almighty God." He reads from a "sad and heavy catalogue of tendencies to natural debility and decay" that Spencer associated with the moral immaturity of the country. The same forces "are at work here, which in other ages and countries have surely wrought out the degradation and ruin of nations and people," the historian noted despairingly, exercising his considerable sermonizing powers to demand reform of his countrymen and women before it was too late. In a series of literary appeals derived in form and tone from the pulpit Spencer urged Americans to embrace the task of moral betterment before they succumbed to the "temptation to war" against each other.[87] Americans now lived in an age "of great and sore trial," Spencer wrote, "when the nation was involved in a deadly struggle to maintain its life and save the Republic from disruption and virtual ruin."[88]

These hard-hitting concluding remarks in the *History of the United States* reveal the degree to which Spencer's Christian brand of social reform clashed with the traditional pictorial escapism of giftbooks. The former minister could not restrain himself from lashing out against the malignant materialism he found eating away at the heart of America's political and cultural life. He lived and worked in an age of depravation and hardship, he recognized, when it was difficult "to hold fast to one's loyalty, and earn an honest living for one's family." Believing that it was the writer's responsibility to stand up and repudiate the "madness, and folly, and wickedness of those who had brought this terrible chastisement upon our country," Spencer used the pages of the *History of the United States* to attack those forces that "bore hardly upon those who could with difficulty get any income worth naming on which to support wife and children."[89] At times, the author of the *History of the United States* withdrew from the full implications of his powerful literary critique of American society, noting in one instance that he was reluctant to "enlarge upon the dwarfing effects" of slavery and materialism for fear that his portrayal might lead only to pessimism and despair. But in general Spencer maintained a naïve faith in the power of historical writing as a corrective to social ills and in the authority of literature as a dictator to the visual arts, the written word serving as a more effective shield against the forces of corruption and avarice than even the graven image. "Let me say here, as not importune," he noted in his autobiography, "that no one should despair, if he fall upon troublesome times," for the "pen is a mighty instrument, and can be very variously used," as in the case of the collectible keepsakes known as giftbooks, which Spencer had done so much to establish as a viable literary form in the United States.[90]

Fictions of Nationhood and Painted Lies

When the *History of the United States* was released in 1858, it had an immediate but short-lived success. For some readers, Spencer's highly moralizing text seemed to hold out idealized solutions to very real problems. Spencer likened the 1850s to some vast scene of potential destruction as depicted in paintings such as Thomas Cole's epic *Course of Empire* series, in which a favored nation like America was yet "fast expiring of its own debility," a country that was losing "not only its vigor, but the respect which it once claimed." In the "last stages of its decline," the American nation faced the same question confronted by citizens just after the Revolution: "whether it should dissolve, and even the semblance of a government be lost, or whether there should be a brave effort made by the patriots and statesmen of the day, to form a more efficient government, before the great interests of the United States were buried beneath its ruins." Spencer urged his contemporaries to seek solutions to this question in the "convictions of truth, and right, and duty" central to the sound moral principles of a Christian faith. The alternative, he noted, was submission to the harsh realities of a godless world in which grand, ethical ideas were forced to give way to petty, self-destructive impulses.[91]

Idealists such as Johnson and Spencer sought to steer Americans away from such a calamity by touting the virtues of Spencer's Christian patriotism. Alonzo Chappel aided the effort by reducing Spencer's themes to a symbolic language in which desired behaviors and intended outcomes were advanced forthrightly and without apology. If Chappel's moralizing paintings were sometimes too heavy-handed even for Spencer, they were nonetheless well suited to an age in which the threat of Civil War seemed to demand dramatic and monumental strategies for historical reflection. The *History of the United States* was offered as a conscious alternative, Spencer

noted, to the "mass of current cheap literature, in the way of newspapers, flash magazines, novels, and the like," which "foster the most absurd and wicked opinions, the most silly imaginings, the most preposterous expectations, to say nothing of suggesting and inciting to evil deeds and crimes of the deepest dye." Whether the venture would achieve its professed goal of saving the nation from itself remained to be seen, as did the ultimate influence of Spencer's monumental narrative style on the genre of pictorial history. The minister-turned-historian admitted no special insight into solutions to these matters raised in the *History of the United States*, other than that provided by his faith in God and the future. "We leave the story here incomplete," he concluded with reference to both his personal and his nation's fate in the late 1850s, "hoping that right and truth will prevail."[92]

In the *History of the United States*, then, Spencer tried to occupy a high moral ground by invoking the didactic uses of history for an age in crisis. From his point of view, the past was a tool to be utilized by national oracles to inspire readers to overcome social and political problems by acting in transcendent ways. It is hard to know how many nineteenth-century Americans were influenced by Spencer, but the fine condition of the many copies of his volumes still extant suggest that his didacticism was highly popular with those who valued books as items to be collected, treasured and learned from. Readers preconditioned to the heavy-handed symbolism of best sellers such as Harriet Beecher Stowe's *Uncle Tom's Cabin* had little difficulty in accepting Spencer's high-minded prose on the topic of slavery. Despite their vows of neutrality, historians could not ignore the practice of enslaving humans as chattel, Spencer argued, and he urged his companions in the field of history to use their sharpest pens to condemn such dehumanizing forces at work in American society.

Although Spencer's sentimental posturing was very popular with some readers, it was not universally accepted; a few dismissed it, in fact, as too idealistic and facile for solving problems in the real world. The invoking of moral will by Spencer and Chappel was not sufficient in the estimation of these skeptics to overcome concrete obstacles associated with forces such as sectionalism and slavery. Such difficulties demanded recourse to practical politics and responsible social engineering, not flights of imaginative fancy and high sentimentality. To the extent that writers such as Spencer assumed a moral authority in their narrative voices, that is, they obscured the efforts of pragmatic statesmen to achieve the unholy compromises necessary for solving political crises.[93]

Part of the complaint against Spencer and others like him had to do with the packaging of their moral programs. Spencer and Chappel were accused of trying to dazzle readers with beautiful pictures and idealized texts in an effort to entice them with "fictions of nationhood."[94] According to this line of criticism, opening the pages of the *History of the United States* was to glimpse not the American character but some distorted version of it, a rendition of the past with the wrinkles smoothed out by an idealizing conscience. In *Modern Painters* British art critic John Ruskin disparaged the romanticizing tendencies of publishers such as Henry Johnson, who used sentimental history paintings in their book illustrations to deliver their "too distorting and ideal" messages. "In nine cases out of ten," wrote Ruskin, "the so-called historical or 'high art' painter is a person . . . who has great vanity without practical capacity, and differs from the landscape or fruit painter merely in misunderstanding and overestimating his own powers." A painter like Chappel mistook "vanity for inspiration, his ambition for greatness of soul," Ruskin noted, "and takes pleasure in what he calls 'the ideal' merely because he has nei-

ther humility nor capacity enough to comprehend the real."[95] Frederick William Fairholt was even more blunt in his complaints about the exaggerations of idealists like Chappel. "As no historian could venture to give wrong dates designedly, so no painter should falsify history by delineating the character on his canvas in habits not known until many years after their death, or holding implements that were not at the time invented," he wrote. "Whatever talent may be displayed in the drawing, grouping, and colouring of such pictures they are but 'painted lies' and cannot be excused any more than history that falsifies fact and dates would be, although clothed in all the flowers of rhetoric."[96]

General readers of Spencer's volumes were probably not as concerned with the falsifying implications of these illustrations as were Ruskin and Fairholt; indeed, sales of giftbooks with steel-line engravings remained high throughout the middle of the nineteenth century and are prized even today for their detail and beauty. Nor was Chappel always one to cut corners for dramatic effect. To be fair, at times Chappel had relied for historical detail on pictorial sources with established reputations for precision and reportorial rigor, including Lossing's *Field-Book of the Revolution*. But critics noted even in these uses that inevitably he turned trustworthy sources to his own corrupting, sentimental purposes.[97] Faultfinders also complained of Johnson's habit of serializing Spencer's production, "disposing of an entire edition in a series of numbers by subscription, without the intervention of the regular trade, but through traveling agents, who scour the city and country in quest of subscribers." Spencer's agents were instructed to charge twenty-five cents for each installment, "payable on delivery only, the carrier not being permitted to give credit nor receive money in advance." This sales policy meant that "not a copy of the published work is to be found on

the shelves of the bookseller" for perusal by the would-be buyer or for the scrutiny of discerning readers. Alleging that the "highly finished" steel engravings and the handsomely executed typography of the work enticed subscribers into a financial agreement that, once begun, was not profitably ended, critics accused Spencer of pandering to popular audiences and of "greatly exaggerating" the American story in order to sell volumes. The accuracy of history was compromised still further by the inability of readers to move ahead in the narrative to confirm the consequences of events detailed in early installments or to work backward by checking references to early material in indexes and bibliographies.[98]

Among the loudest of the complainants against the work of Johnson, Spencer, and Chappel was Henry B. Dawson, writer and editor of the *Historical Magazine*.[99] Dawson was a crusader in the cause of redirecting American historical studies away from what he perceived as shoddy, popular expressions of half-truths toward an uncompromising search for the "exact truth." David Van Tassel described Dawson accurately as "a leader among a group of unknown and unsung critical historians who reacted against the established school of filiopietists and romantics" by advocating the circulation and use in historical narratives of only verifiable documents and artifacts.[100] Dawson's *Historical Magazine*, founded in 1857, was designed to serve the needs of an emerging breed of agents of history (such as historical societies, libraries, and researchers) by providing documents and historical curiosities as well as reports of meetings of historical societies, book reviews, and literature surveys.[101] Dawson's editorial policy was to reject materials polluted "by an insidious substitution of what was known to be false for what was known to be true," and he announced that he would admit nothing to the journal that did not bear "the guinea stamp of Historic Truth and Genuineness, unless for the purpose of exposing its character and denouncing its author."[102] It was for these latter objectives of disclosing falsehoods and impugning character that Dawson chose to review Spencer's *History of the United States* in 1858.

Dawson began his review by condemning Spencer as an amateur who wrote on subjects about which he knew little. By his own admission Spencer had no special training in the field of history, and in writing the *History of the United States* he had ventured into areas where his lack of qualifications was especially glaring. An expert on military warfare, Dawson had published his two-volume *Battles of the United States* the same year as Spencer's history, and he held his work up immodestly as an example of what might be done with history when it was thoroughly researched and based on primary materials.[103] Dawson concluded that Spencer was evidently "unaware of what had been done to place the subject in its true light," thereby exposing himself to the "animadversions of better informed people." The *Historical Magazine* also accused Spencer of stealing the thoughts of better-known historians, of "levying wholesale contributions upon the labors of well-known authors without the change of scarcely a word." Spencer's account of the battle and massacre of the Wyoming Valley in Pennsylvania during the Revolution, Dawson argued, was taken verbatim from Thacher's *Military Journal* "without a single remark or note to show that he had examined the subject at all." According to Dawson, Bancroft's celebrated *History of the United States* (which he noted cost a dollar less when purchased at the bookstores than Spencer's volumes cost in subscription at thirteen dollars for fifty-two installments) was produced over a lifetime of work by a scholar who made "a diligent investigation of authorities and the careful composition of the text, both as to historical accuracy and style." Spencer's work

was rushed and dishonest, the magazine averred, borrowing so indiscriminately and inaccurately from the published work of others that the "idea of investigation or research can hardly be conceived in respect to [it]." In Dawson's estimation, Spencer was a mere "compiler" rather than an author.[104]

One of those historians whose works Dawson accused Spencer of misappropriating was Benson Lossing. Lossing and Dawson were acquaintances who had corresponded on research for Dawson's *Battles of the United States*, and they shared a common belief in the need to establish rigorous standards for historical scholarship in America.[105] When the *Historical Magazine* experienced financial difficulties in its first year, Lossing and a few others distributed a "Confidential Circular" to attract new subscribers.[106] Perhaps to return the favor, the editors appended to Dawson's review a "letter to the editor of the *New York Times*" from Lossing, accusing Spencer of having misused material from his *Seventeen Hundred and Seventy-Six* for his discussion of the Battle of the Wyoming Valley. Among other things, Lossing was angry at Spencer for perpetuating an embarrassing error that Lossing himself had made concerning an episode in which Indians and Tories were accused of killing women and children by setting their barracks on fire. Lossing had retracted the allegation several years later in the *Pictorial Field-Book of the Revolution* after having discovered "existing documents and then existing eye-witnesses" who provided factual evidence "impregnable in its integrity" that revealed "the utter untruthfulness of much that had been written on the subject."[107] Spencer had ignored these correctives, however, an omission that might have been excused if he had never read the *Pictorial Field-Book of the Revolution*, but, of course, he had. There was ample evidence in the *History of the United States*, however, that Spencer had used the field book liberally, often failing to acknowledge his debts.

"It seems to me that common fairness on the part of Dr. Spencer required him to cite my *Field Book*," Lossing wrote the editor of the *New York Times*, adding, "I regret the necessity that calls for this communication, but justice to myself seemed to demand it."[108]

The intensity of these criticisms by Lossing and Dawson begs the question why this group of anti-idealists was so determined to expose the excesses of sentimental writers like Spencer or artists like Chappel. Part of the answer lies in the emergence of a new scholarly ethic that was infusing the study of history. Dawson took his intellectual cues from Germany, where newly minted doctors of philosophy were challenging the "grand manner." More significant perhaps was the bloody American Civil War, which did much to deflate the high-minded idealism of sentimental historians. Spencer's ambitions for a revitalized nation at the end of the 1850s collapsed under the weight of the very political and moral failures that he exposed in his narrative, making the *History of the United States* a self-fulfilling prophecy of tragic insight. The depravity of the Civil War made it impossible for all but the most ardent idealists to endorse the hopelessly stylized perspectives of giftbooks. Even the irrepressible Jesse Spencer noted that the "horror and gloom that ensued" with the Civil War were so "indescribable" as to silence his pen.[109] This admission signaled the loss of something lofty but naïve in the outlooks of historical image makers. The trust that historians had placed once in the power of the "grandiose" was shattered by the war, leaving idealized pictorial forms in fragments and shards on the intellectual landscape. In some ways scholars like Dawson represented the advanced guard of a cautionary movement that valued pictorial moderation over visual excess. As this movement gained power, it also challenged the sanctity of sentimental tropes and altered attitudes about how pictures should be used in the service of the past.

Part Two

The Pictorial Turn

Realism and Visual Literacy, 1861–1890

4

"Eyewitness to History"

Challenges to the Sentimental Form

Despite the sense of disillusionment felt by advocates of the sentimental in the wake of the Civil War, idealized forms did not disappear with the firing of the first shots at Sumter. Some pictorial histories of the era "sacrificed realism for stereotyped heroics," and the pages of their works were filled with sentimental prints of "wives and mothers making their last farewells" to departing soldiers, of volunteers and militiamen parading, and of officers performing "magnificent feats of heroism."[1] Alonzo Chappel, who served during the war in the First Battalion of Artillery, Fifth Brigade, of the national guard, was one of these unrepentant sentimentalists who provided paintings and portraits of the war for a variety of publications, including Evert Duyckinck's *History of the War for the Union* published in 1862 by Henry Johnson.[2] As he had in his portraits for the *National Portrait Gallery of Eminent Americans,* Chappel idealized the war, depicting the conflict from the per-

Figure 42. "Battle of Wilson's Creek—The Death of General Lyon," 1866, by Alonzo Chappel for volume 4 of Jesse A. Spencer's *History of the United States*

Figure 43. "Death of General Lyon at the Battle of Wilson's Creek, Mo.," 1861, by Henri Lovie for *Frank Leslie's Illustrated Newspaper*, 31 August 1861 (Courtesy of Print Collection, Miriam and Ira D. Wallach Division of Art, Prints, and Photographs, New York Public Library, Astor, Lenox, and Tillden Foundations)

spective of ornately dressed officers who posed theatrically for sweethearts in stylized studios rather than of dirtied and untheatrical soldiers toiling on the nation's battlefields.[3]

Other pictorial histories imagined the war as a sublime struggle in which allegorical purpose still had its honored place. In many such histories the actual Civil War was "concealed under layers of comforting legends and nostalgic sentiments, and this haze of myth complicate[d] the task of sorting out the war's various effects."[4] One such allegorizer was Jesse Spencer, who, recognizing that the Civil War had made his three-volume *History of the United States* obsolete just two years after its publication, added a fourth volume as-

Figure 44. "Pocahontas Saving the
Life of Capt. John Smith," 1866,
by Alonzo Chappel (1866) for
volume 1 of Jesse A. Spencer's
History of the United States

sessing the nation's fratricidal tragedy.[5] Picking up
where he left off at the dramatic conclusion of his nar-
rative in 1858, Spencer argued that the Civil War was
the grand fulfillment of centuries of struggle on behalf
of liberty and against the malevolent forces of tyranny.
The illustrations in this fourth volume of the *History
of the United States* were consistent in tone with this
grandiloquent style as well as with the overstated pic-

torial imagery of the preceding three volumes. Pro-
duced primarily once again by Alonzo Chappel or
adapted from Chappel's drawings for Duyckinck's *His-
tory of the War for the Union*, these pictorial represen-
tations revealed the sentimentality of his early work.
In dramatic depictions such as "Battle of Wilson's
Creek—The Death of General Lyon" (fig. 42), Chappel
resorted to the theatrical conventions of grand man-

ner history painters, using strong diagonals to thrust the viewer headlong into the chaotic picture planes. Borrowing from the death-moment battlefield traditions of Benjamin West and others, Chappel depicted the expiration of Gen. Nathaniel Lyon as inspiring and heroic, encouraging viewers to make connections between Lyon's ultimate sacrifice and their own freedoms. When one considers that the prototype for Chappel's work was the far less sensational eyewitness sketch by Henri Lovie made on the field at the time of the battle and reprinted in *Frank Leslie's Illustrated Newspaper,* the liberties Chappel took in order to satisfy his melodramatic urges become obvious (fig. 43).[6]

Spencer and Johnson also used the fourth volume of *The History of the United States* as an opportunity to add a few new illustrations to the earlier trilogy, including Chappel's stirring depiction of "Pocahontas Saving the Life of Capt. John Smith" (fig. 44). Coming close to fulfilling Simms's challenge to American artists to find a way to "stamp the [Pocahontas] story in life-like colours upon the canvas," this illustration depicted another episode of liberation in which personal freedoms were purchased at the moment of near-death. Appearing as it did during the Civil War, Chappel's provocative illustration caused some stir in Virginia, where the custodians of culture were rebelling against the image of Southerners as maudlin and lurid beings. Hoping to rehabilitate Pocahontas from a "demeaning" sensual creature to a nobler "Lady Rebecca," such guardians rejected Chappel's imagery as immoral and ahistorical. But many others, especially in the North, accepted the representation as a reliable portrayal of the dishonorable sensationalism they imagined at the heart of Southern life. Chappel may not have had an expressly anti-Southern attitude in mind when he conceived of "Pocahontas Saving the Life of Capt. John Smith," but his juxtaposition of "raw masculine ferocity and female vulnera-

bility" certainly encouraged such politically charged interpretations. In addition, the illustration reaffirmed his belief in the superiority of timeless and universal truths (sentimentally expressed) over raw and unprocessed depictions of realism.[7]

The Rage for Facts

For every pictorial history that attempted to romanticize the war, there were many others that rejected the sentimental mode in favor of more realistic forms of literary and pictorial interpretation. There were several reasons for this turn toward realism. In the first place the frank brutality of the Civil War made heroic depictions of the battlefield seem misplaced and hypocritical. Whereas Jesse Spencer had little difficulty celebrating American military valor against a commonly vilified enemy in his description of the Battle of Buena Vista in the Mexican War, historians had a much more difficult time glamorizing the Civil War's Battle of Shiloh, in which tens of thousands of Americans killed each other in a horrifyingly bloody fratricidal struggle. Such sobering battles quickly "stripped soldiering of its romantic veneer and revealed its underlying tedium, humor, sentiment, and pain."[8] In response some chose to leave the war "unwritten" as a means of escaping the magnitude and tragedy of the conflict, but most historians of the 1860s felt they had to account for the Civil War in their pictorial narratives, the failure to confront reality squarely being viewed as an important contributing factor to the war itself.[9] These accounts abandoned sentimentality in favor of "flesh and blood" realism, as their authors and illustrators struggled mightily to depict in words and images those forces of mayhem and destruction in ways that did not require resort to the conventional tropes of the sentimental form.

In the second place, the Civil War accelerated a

movement already at work in the mid-nineteenth century—the rise of an "age of realism"—in which positivistic and scientific verification were valued over romantic idealism and spiritual transcendence. The 1860s and 1870s witnessed a "rage for 'facts,'" in which "carefully verified sense perceptions constituted the only admissible basis of human knowledge" and during which idealistic philosophy was dismissed as "mere speculation" and "religion as superstition." Realists believed that history should be reducible to quantifiable standards that could be "counted, measured, weighed," and they insisted that "God was in the details."[10] Like Benson Lossing, these realists also valued the immediacy and accuracy of firsthand eyewitness accounts, and in their histories they were willing to sacrifice some of the measured insight that comes from lengthy reflection for the currency of direct and informed reports of contemporary events. In this sense realists understood that the significant moments of the Civil War needed to be documented while the events themselves were taking place, and they made every effort to formulate methods for the accurate recording of history in the making. If idealists like Spencer sought universal truths in the lengthening shadows of the distant past, then realists focused with precision and self-assured certainty on the here-and-now.

Given these priorities, it is not difficult to understand the desire among some publishers of pictorial histories in the 1860s to enhance the "realism" of their works through reliance on two important investigative tools used during the Civil War to increase the verisimilitude of war coverage—journalistic reporting and photography. In the case of journalism the war created an obsession for immediate news from the battlefront and encouraged the rise of mass-produced weekly and daily newspapers. Such papers hired burgeoning staffs of reporters who worked on location and supplied readers with highly localized and late-breaking news of later value to historians. These special correspondents prided themselves on the accuracy of their reports, and many of them took considerable risks to keep readers informed. "Specials" generally traveled with the troops and were exposed to numerous dangers as they struggled to achieve the best vantage point for observing a military engagement. These correspondents were also required to handle the delicate negotiations associated with gaining permission to interview and report on the armies they followed. "As a general rule," wrote an appreciative editor, their "labors and efforts are understood and appreciated by both officers and soldiers, who well know that History is to be written from the materials which these laborious men are gathering together so assiduously."[11]

In the second instance, photography was appreciated for the accuracy of its visual reportage, and many pictorial historians imagined that the camera might usher in a new age of information transference and memory retention. "Seductive in its seeming veracity and neutrality, the camera provided a magical new means of enlarging the realm of the visible and thereby helped to define public perceptions of reality." Photographs seemed to offer "the closest rendering of reality possible" and, when applied to an event such as the Civil War, promised to eclipse all other conventional means for recording the past with precision.[12] In addition, the use of portable studios on wheels during the Civil War "highlighted photography's documentary function" by allowing photographers to convey a more direct sense of the gruesome aftermath of battle.[13] So confident was Alexander Gardner of the technique's applicability to history that he claimed in his *Photographic Sketchbook of the Civil War* (1866) that photography was superior not only to illustration but also to literary descriptions of the war. "Words may

not have the merit of accuracy," he wrote, "but photographic presentments of them will be accepted by posterity with an undoubting faith."[14]

Yet there were problems with both these methods for establishing accurate literary and visual portraits of historical events associated with the Civil War. With regard to journalistic reportage, newspapers could not wait for the war to come to them; they were forced to send reporters into the field to find the war, and the understandable reluctance some journalists felt about exposing themselves to the hazards and hardships of the battlefield affected the authenticity of the stories they reported. Although newspaper correspondents were generally well received by military personnel, they periodically encountered "some pompous fool or martinet," as one frustrated reporter noted, "who thinks himself the centre of the military system of creation, who affects great contempt for the 'Specials,' and who either entirely obstructs their labors, or nullifies them with absurd restrictions."[15] Such obstacles hampered efforts to tell the story of the Civil War in accordance with the facts and, in the face of unrelenting deadlines, forced more than one writer to rely on secondhand battle accounts that later proved erroneous. In addition many newspapers had a reputation for journalistic excess borne of the need to entice readers, a flaw that intensified as the competition for markets increased in the heyday of mass-produced newspapers in the 1860s and 1870s.

The value of photography was limited by perspective as well, because technical obstacles related to the processing of images made it impossible for the camera to record battles with fidelity as they were occurring. Most of the photographs emerging from the war were either prosaic views of camp life or staged scenes depicting the aftermath of battle, such as the "posed" figure of the dead sharpshooter at Antietam, offered with "the softening cushioning of sentiment and story" by Mathew Brady.[16] In addition, cameras were "large and cumbersome," and the wet plate process, which "demanded that the glass photographic plates be sensitized just before use and developed soon after exposure," proved unworkable in a hectic war environment.[17] "The caution and deliberation required for successful views of this sort are obviously impracticable in the confusion of a battle," wrote one observer, "and, therefore, it is not surprising that what we have hitherto obtained in this way has been little besides a representation of that awful 'still life' which the plain shows after the conflict is over."[18] And even if reliable images of battle could be secured, there was no good way to reproduce them in historical volumes with the precision and cheapness needed for the popular book market. Gardner's *Photographic Sketchbook* consisted of individually inserted photos set into separate pages, a format that was so cumbersome and expensive (costing would-be buyers upward of one hundred dollars a volume) that it prompted one critic to declare that "the book cannot be popular."[19] Still more troublesome, the prints in Gardner's book were subject to fading if not washed properly in the developing process to remove all traces of silver iodine. For a book advertised as a contribution to the "permanent" historical record, the potential disappearance of expensive images was certainly a problem.[20]

In lieu of good ways to mass-produce photographs in texts, realist-minded chroniclers of the war were required to rely on artists and engravers to provide visual materials for their works. Along with special correspondents, newspapers hired "Special Artists" to go out into the field to record the war pictorially, and these artists had a large impact on the "public memory" of the conflict. The front runner in this business of creating hand-wrought war images was *Frank Leslie's Illustrated*, established in the United States in 1855. Frank Leslie had worked in London, where he

was the manager of the engraving department of the *Illustrated London News,* and he brought the illustrated format to the United States, where it was embraced quickly by American readers seeking visual as well as literary confirmation of the calamitous events occurring throughout the embattled nation.[21] The selling points of the paper were its up-to-date reporting and its lavish illustrations. "You buy for sixpence, at any corner in Broadway, or in any railroad car, *Frank Leslie's Illustrated Newspaper,*" writer Nathaniel Willis noted in 1860. "Two days previous there has been a stirring scene of public excitement, five hundred miles away—and here is a picture of it! In one second (after paying your sixpence) as complete a knowledge of the affair as you would get by traveling to the spot is conveyed to your brain, and this without any effort of the imagination to locate the actors and their surroundings." Concerned with the distracting and potentially confounding qualities of the imagination, Willis applauded the commitment of artists and journalists at *Frank Leslie's Illustrated Newspaper* for providing the plain realities of a historical moment with such candor.[22]

The success of Leslie's format encouraged other competitors such as Harper and Brothers to enter the pictorial market, a presence Leslie viewed as an infringement on his prior rights. In December 1857 Fletcher Harper hired the ubiquitous Benson Lossing to prepare a cover design for a new illustrated weekly magazine called *Harper's Weekly: A Journal of Civilization.* "They determined to turn [*Harper's Monthly*] into an Illustrated Paper, in order to kill us off," Leslie warned his readers, "although they took the trouble to unnecessarily outrage the truth by assuring us in a message that theirs would not be an Illustrated Paper; that there was no rivalry against us intended." Offended by the untrustworthiness of this disclaimer, Leslie added with scorn, "We freely forgive them their feeble assault upon us and only ask that they will continue on in the way they have begun, that their journal . . . may serve . . . as a foil in its old-fogyishness to our energy and enterprise."[23] Whether or not he resented the old-fogy label, Fletcher Harper triumphed eventually over his allegedly more energetic competitor by producing an illustrated weekly paper that achieved wider circulation and greater longevity than all others in America.

The two rival publishers of these pictorial newspapers employed similar techniques for providing "on-the-spot" depictions of historical venues. Even before the war had begun, Frank Leslie showed the forethought to station special artist William Waud at Fort Sumter, where he recognized that tensions between North and South were growing. Waud set to work immediately and within a few days of his arrival in South Carolina delivered to the home offices images of the preparations for battle between troops from the North and the South. Encouraged by the response to these images, Leslie sent a second artist, Eugene Benson, to Charleston in April 1861, who arrived just in time to report pictorially the bombardment of Fort Sumter on 12 and 13 April. During the remaining course of the war, Leslie employed sixteen known special artists throughout the country, who produced more than 1,300 drawings of war subjects for eager viewers.[24] Shortly thereafter, *Harper's* announced on the cover of its 4 May 1861 issue that it too had hired "Specials" to illustrate the war, adding that "the present number contains many MORE PICTURES than any heretofore issued" while "succeeding numbers will be still richer in illustrations."[25] Increasing dramatically his budget for illustrators, Fletcher Harper employed ten well-known artists (including some lured away from Leslie's staff), who produced more than 750 drawings during the war. "Fletcher Harper and his journalists emphasized excellence in written accounts," noted one later observer of this pictorial competition, "while Leslie and his writers often resorted to sensa-

tionalizing news articles" embellished by overly dramatic pictorial lead-ins.[26] Harper maintained the advantage in terms of literary quality, although early in the war he proved reluctant to commit his weekly paper to a particular political viewpoint, an aversion that led Horace Greeley of the *New York Tribune* to condemn the publication as a "Weakly Journal of Civilization." Leslie took the opposite tack, giving his paper "a decisively Northern bent" and establishing through politicized illustrations a partisan tone that catered to readers in northeastern, urban centers such as New York City, Philadelphia, and Boston.[27]

The pictorial images generated by these special artists were significant not only as eyewitness sources of the war but also as visual catalogues for recovered memories of the conflict. Repackaging drawings in endlessly inventive ways, the publishing houses of Harper and Leslie marketed several pictorial histories during and after the war that made use of thousands of the battle images commissioned during the conflict. Such volumes, most prominently *Frank Leslie's Pictorial History of the Civil War* (1861–62) and *Harper's Pictorial History of the Civil War* (1863–67), had a significant impact on the American historical imagination because the illustrations that filled their pages established the dominant forms and perspectives that conditioned the visual memories of the war. Such recycled histories revealed much of the genius and many of the shortcomings of the original newspaper illustrations on which they were based, although the publishing houses of Leslie and Harper both claimed that in the important search for greater realism in historical assessment, the former outweighed the latter by a considerable measure. Insofar as these pictorial histories privileged visual recollections over all other forms of historical memory, they also demonstrated the continued ascendancy of artists over writers in the process of giving pictorial shape to popular historical events.

Trusting in Lead Pencils

Even before the Civil War had passed its first year of bloody consequence, publishers began marketing pictorial histories of the conflict between North and South. Many of these early publications, such as the modestly illustrated *History of Southern Rebellion* (1861) by Orville J. Victor, were superficial accounts written before the first autumn campaigns had been completed. Victor, who had been instrumental in developing the dime-novel format under publisher Erastus F. Beadle, and who was therefore well practiced in writing quickly for mass audiences, acknowledged that most of the insights in his history were not his own. Victor owed "every obligation to the New York daily journals," he admitted in his preface. Their "extraordinary facilities of information, their vast network of correspondence, render them co[n]temporary chroniclers which no book-maker can slight in the composition of a history of the times."[28] Another early entrant into the pictorial history market was John S. C. Abbott's *History of the Civil War in America* (1862–65), illustrated by F. O. C. Darley, which argued unabashedly from a pro-Unionist point of view. Unmoved by the new fascination with realism in historical depictions, Abbott noted in his introduction that greater authenticity did not "demand that one should so ingeniously construct his narrative, as to make no distinction between virtue and vice."[29] Like Victor's history, Abbott's work was derivative of the pictorial press, consisting of little more than assorted clippings from various papers accompanied by cursory historical commentary. This scrapbook format prompted some to question Abbott's qualifications as a historian. "It is sickening to see him treated in the newspapers with great deference as 'Abbott the historian,'" one critic noted.[30]

Far more in keeping with the newer realistic trends in historical writing were the aforementioned works

by Leslie's Publishing Company and the House of Harper, books manufactured out of the portfolios of special artists and correspondents piling up in editorial offices. The editor of *Frank Leslie's Pictorial History of the Civil War* (1861–62), E. G. Squier, viewed his artists as "avant couriers of history," declaring that their work constituted "a complete Pictorial History of the War" on which readers might rely for the most accurate and lasting impressions.[31] The editor of *Harper's Pictorial History of the Great Rebellion* (1863–67), Alfred H. Guernsey, made nearly the same claim for his artists, noting that "the pictorial history of the war which they have written with their pencils in the field is history quivering with life, faithful, terrible, romantic, the value of which will grow every year."[32] Both editors felt their works had a distinct advantage over competitors such as Victor and Abbott, because they made use of the timely images and stories published originally in their own newspapers, thereby increasing the realism of their accounts by minimizing the errors of transference that often occurred when secondary writers borrowed from primary sources.

An analysis of these two pictorial histories reveals a good deal about the role of visual images in history texts in an age when the sentimental was increasingly distrusted. Editors for *Harper's Pictorial History of the Great Rebellion* and *Leslie's Pictorial History of the Civil War* made a conscious effort to include illustrations that detailed both "things great and small," providing readers with a minute knowledge of "that vast body of incident and adventure which finds no mention in official reports, and which is absolutely necessary to a proper appreciation to central facts and events."[33] Leslie's publishing house had a reputation for being slightly more authentic in its illustrations than Harper and Brothers, although both insisted on the truth and accuracy of the "unerring" pencils of their artists.

Edwin Forbes, who supplied illustrations for both histories, took for granted that special artists had achieved accuracy in their sketches and that the histories derived from their visualizations had "the ring of authenticity" suitable enough to "persuade the viewer that he too is witnessing real history." In an 1862 letter Forbes wrote, "I need hardly assure you that I do my best to make [my illustrations accurate], as fidelity to fact is, in my opinion, the first thing to be aimed at."[34] As testimony to the seriousness of such endeavors, the publishers reminded readers that their artists had assumed considerable risks to secure realistic sketches, such as when Alfred Waud "endured the bullets of Confederate sharpshooters while climbing a tree to sketch a battleground for General Meade" later reproduced in *Leslie's Pictorial History of the Civil War.*[35]

And yet even Forbes acknowledged that pictorial histories of the war were more than just objective visualizations; they were also personalized statements. Certainly many of those whose visual images were adapted to pictorial histories saw themselves as explicating the past as well as recording it. This individualized perspective was evident in the fact that "specials" often included self-portraits in their illustrations, portraying themselves as artists in the act of drawing. Not only did this convention confirm "the artist's role as a witness to the scene he drew and thereby underscored the authenticity of the illustrated news report," it also perpetuated "the myth of the 'on the spot' reporter, who chose to put aside his own well-being in order to have access to and sketch the most pertinent news." Certain artists were especially self-promoting in this regard, and they "became well-known as personalities and reporters in words and pictures" when their images were recycled in pictorial histories during the war. These acts of self-identification did much to advance the role of the visual in popular history, because they served as constant

reminders that readers of works such as *Leslie's Pictorial History* or *Harper's Pictorial History* were seeing the war through the eyes of skilled observers.[36]

Anxious to encourage the celebrity status of its artists as a way of selling more of its volumes of history, Harper and Brothers requested for its specials the same respect and honor accorded to soldiers returned from the war. Referring to the "noble army of artists" who accompanied the soldiers into battle, a writer for *Harper's Weekly* argued that the "national debt to these latter gentlemen should be fully recognized." He added with flourish, "[They] have not been less busy and scarcely less imperiled than the soldiers. They have made the weary marches and dangerous voyages. They have shared the soldier's fare; they have ridden and waded, and climbed and floundered, always trusting in lead pencils and keeping their paper dry. When the battle began they were there. They drew the enemy's fire as well as our own. The fierce shock. The heaving tumult, the smoky sway of battle from side to side, the line, the assault, the victory—they were part of all, and their faithful fingers, depicting the scene, have made us a part also."[37] According to this logic, the art of depicting a battle scene or of describing a hospital recovery ward was a patriotic endeavor on a par with shouldering a gun, and individual artists should be honored for their personal sacrifices as fully as any hero who distinguished himself on the field of battle. The best way to honor them, of course, was to purchase the books in which their heroic illustrations were preserved.

For all the claims of their editors to veracity and eyewitness exactitude, then, *Harper's Pictorial History of the Great Rebellion* and *Leslie's Pictorial History of the Civil War* were still interpretive acts. The creators of these pictorial works recognized that their volumes could not be completely detached and reportorial, although they guarded assiduously against the hopelessly senti-mental. The special artist did not need to know how to "paint great pictures," wrote war commentator Harry Barnett, but "he must be able to do more than merely draw outlines swiftly and accurately; he must be at least an artist in the best sense of the word,—a man whose mind is not only open to various and broad impressions, but also stored with knowledge and strengthened by experience." Special artists "must be gifted in some measure with that rare quality, imagination," he added, "by which I do not mean the power of picturing the impossible, but the power of investing bare facts with charm, and vivifying them with spirit." Noting that "there is an idea of some sort in every incident, in every pageant, in everything worth pictorial record," Barnett concluded that it was "the business of the Special Artist to seize, and transfer as much of it as he can to his sketch" in order to elucidate the historical truths implicit in it.[38] And the business of publishers such as Frank Leslie and Fletcher Harper was to sell books by marketing such sketches in attractive visual formats without distorting the artist's intentions or violating announced commitments to realism of presentation. Reconciling the documentary and explicative functions of pictorial histories of the Civil War was sometimes difficult to accomplish.

Even if special artists had been able to present unbiased and objective visual reports from the battlefields, the distortions that accompanied the publication of these images in newspapers and subsequent pictorial histories would have called into question the fidelity of the print medium. When sketches were received from the field, for instance, they had to be translated to the printed page at the home office, and the uncertainty of this process had an undeniable impact on the visual product that emerged later in pictorial histories. Artists generally sketched in pencil or with "wash heightened with white" on tan or gray paper, and the monochromatic drawings that resulted

Figure 45. "Attack of Louisiana Tigers at Gettysburg," 1863, by A. R. Waud for *Harper's Weekly*, 8 August 1863 (Courtesy of the Library of Congress)

provided little by way of instruction for copyists who wished to introduce tonal value in their reproductions. Most sketches produced in the field were unfinished and were accompanied with instructions for the home artists such as "Make the figures rather smaller"; "Sky dull, even gray in long streaks"; and "Put as much fallen timber and dead limbs between the figures as you can." The vast and potentially distorting latitude implied by these vague instructions was magnified by the fact that the oversized format of newspaper illustrations meant that such images had to be copied in reverse onto a block of boxwood made up of subblocks (thirty-six for a double-page spread) that were bolted together (fig. 45). Because many publishers were in a hurry to get battlefield images before

the public, these subblocks were often parceled out to a number of engravers and reassembled into a composite block only when all the units were complete. Given the numbers of hands involved in this process, the finished product often lacked the "vitality and sense of immediacy" of the original sketches.[39]

Delays in transporting images from the battlefield to the home office also meant that illustrations were often hopelessly outdated by the time they made it into print: "Two weeks was a short time to get a picture of an event to the reader; three to four weeks was average; and, depending on the subject, five to eight weeks was close enough to be considered newsworthy." In order to minimize the effects of delays, publishers such as Frank Leslie and Fletcher Harper "occasionally

changed details in the drawings in order to make the images seem more timely."[40] Although this manipulation of pictorial evidence served the immediate needs of newspaper publishers anxious to demonstrate the timeliness of their stories, it did a disservice to the works of those pictorial historians who, in adopting such altered images wholesale in their later texts, perpetuated mistakes in the historical record. As one student of these illustrations has noted, "Many field artists were surprised to discover that their sketches of a minor skirmish on the picket line became, with the proper captions and some exaggeration by the engravers, illustrations showing how the enemy 'murdered' or 'assassinated' Federal soldiers."[41]

Soldiers returning home after the war were among the most interested and critical readers of pictorial histories such as *Leslie's Pictorial History* or *Harper's Pictorial History*, measuring their own experiences on the battlefield against those images adapted and crudely modified from the work of special artists. Veterans of the war "roared with laughter at sketches showing officers who wore swords on the wrong hip" and "cavalry troops who mounted from the off-side." Soldiers found special humor in "infantrymen who marched into battle at the regulation hundred and ten steps a minute but nevertheless kept pace with their colonels on horseback." Battle-tested soldiers deemed Alfred Waud's sketch depicting troops advancing on the enemy at "shoulder arms" "hilarious." Former soldiers also were more critical of the use of "rush-stroke" images by publishers—standardized, pre-planned illustrations that could be adapted as depictions of any battlefield incident. When these generic pictures were reproduced in pictorial histories, they gave such volumes a standardized look, making it hard to distinguish adequately between one battle and another. This effect was intensified by the fact that many such sketches were etched by the same

engraver, who literally typecast the images in his own consistent manner, no matter who the original sketcher was.[42]

These alterations in the original sketches of war artists, some calculated and some not, threatened to compromise the visual integrity of images in *Leslie's Pictorial History* and *Harper's Pictorial History* by obscuring the stylistic distinctions among pictorial artists of the war. Arguing that such histories had "abused" the "pictorial method of preserving memorials of this war," a writer for the *U.S. Army and Navy Journal* complained that many of the illustrations in such works were "positively lying and fabulous" and were "not . . . reliable" excepting as studies of costume. The desire of special artists to produce "striking effects sometimes overcomes all other considerations," the journal noted, "and the truth is now and then sacrificed to the demand for dramatic action or a pleasing play of light and shadow." Pictorial historians were also accused of proliferating images falsely in their too-liberal borrowings from newspaper sources. "If all the terrific hand-to-hand encounters which we have seen for two or three years displayed in the pages of our popular weeklies had actually occurred," complained one such critic, "the combatants on each side would long ago have mutually annihilated each other, like the famous cats of Irish history."[43]

So although Frank Leslie and Fletcher Harper protected reasonably against the pictorial excesses of sentimentalists such as Spencer, they could not claim to have achieved an unimpeachable accuracy in their visual and literary works. Their failures in this regard raised some important philosophical questions concerning the realist's noble dream of objectivity: Is it ever possible to render an illustration that does not reflect the personal biases of the artist who created it? Do pictures inevitably distort and do such distortions always tend toward the sentimental? Does pictorial-

izing historical works automatically compromise the integrity of accompanying texts? Although answers to these questions were not always readily apparent to the new breed of realists associated with the enterprise of pictorial history, one thing seemed clear to nearly all publishers, writers, and artists associated with the illustrated book market for Civil War histories: visual depictions created from eyewitness accounts and published within a short period of time from when those events occurred were an absolute necessity for selling volumes to readers with strong pictorial appetites. Publishers who wished to compete for the growing audience of readers of Civil War histories were therefore forced to purchase electrotyping equipment like that in use at Harper and Brothers as a means of reproducing the "new style of illustration" popularized by that house's artists and designers.[44] Its weaknesses notwithstanding, *Harper's Pictorial History of the Civil War* became a best seller during the war, and publishers sought to emulate its style and its success even as they condemned its pictorial inadequacies.[45]

Your Lasting Monument

Despite the excellent sales of the pictorial histories of Frank Leslie and Fletcher Harper, some critics were displeased with the compromises made by such publishers and thought they could do better. Benson Lossing, for instance, complained that journalists-turned-historians had not shown a high enough regard for standards of realism. In their hurry to publish pictorial histories of the war, he reasoned, they had not demonstrated a sufficient commitment to careful, scholarly reflection. The jealous spirit of competition might have motivated Lossing's criticisms in this line. Even before the first shots were fired at Fort Sumter, Lossing had begun planning a monumental pictorial history of the war that he hoped would prove the de-

finitive account of the conflict. In December of 1861 he approached publisher George W. Childs with a proposal that suggested the scope of his ambitions. "It has been my intention, from the beginning of the Rebellion, to make such a record of it as would, as it were, exhaust the subject, and make it a standard authority forever," Lossing wrote Childs. "I wish to be so thorough that no one will attempt the same task, *in the same way.*" In the "same way" meant a narrative focused on Lossing's personal eyewitness accounts of the major battles of the war, interviews with the participants in those battles, and accurate research in authentic archival materials. It also implied elaborate illustrations of every significant event of the war to be reproduced from firsthand observation by the engravers at the firm of Lossing and Barritt.[46] In essence Lossing hoped to accomplish what Frank Leslie and Fletcher Harper had failed to achieve—a definitive, realistic treatment (both pictorial and literary) of the entire war.

After some rather protracted negotiations in 1862, Childs and Lossing came to an agreement on terms for the project, and the publisher immediately made arrangements for his author to receive high-level clearance from the government for visits to relevant battlefields. The artful Childs secured a note from President Lincoln, for instance, authorizing that "Mr. Lossing" is entitled "to have every facility consistent with public service" available to him.[47] During the war, Lossing took advantage of this privilege to travel throughout the country, visiting many major battlefields, making sketches, collecting documents, and interviewing figures. He used Lincoln's authority to solicit the diaries of officers and the drawings of fortifications and plans of the movements of troops where available, and he made frequent side trips to the nation's capital to interview generals on furlough and to secure letters of introduction to civil leaders

and army officers in the South.[48] "I spent nearly two hours yesterday morning with Ex- Governors Swain and Graham, of North Carolina," Lossing told Childs of one such junket, and "this morning I am to meet GENERAL BANKS, to learn through a personal interview with him, the particulars of his operations in the Shenandoah Valley, and his campaign in the 'Department of the Gulf.'"[49] All in all, Lossing traveled more than twenty thousand miles in pursuit of his research, a journey nearly double the distance he had undertaken while researching his *Field-Book of the Revolution*. This unusual access to subjects and materials encouraged Lossing to believe he could attain the historical credibility he craved. It also allowed Childs to proclaim in an advanced circular that Lossing's history of the Great Rebellion would be the most realistic assessment of the war to date, providing as it would "a *living picture* of those localities which will soon become classic in the annals of the country."[50]

Not surprisingly, the illustrations were one of the major marketing points of Lossing's pictorial history of the Civil War. In a pamphlet titled *Information to Applicants for Agency to Canvass Lossing's Pictorial History of the Great War* Childs assured would-be sellers and buyers that, unlike the naïve subscribers to Spencer's history, they would know well in advance what they would be getting for their money with Lossing's history, including unsurpassed graphic design and beautiful illustrations. "This book will be issued in a superior style of typography, on fine white calendered paper, in not less than three volumes, of 600 pages to each volume, splendidly illustrated with about 2000 wood engravings in the highest style of the art by Lossing & Barrett *[sic]*," Childs noted. Successful applicants for the position of agent were to be given subscription books that included samples of the various styles of bindings, letter-press pages, and wood engravings, and even a "fine steel engraving,

which will be the frontispiece of the first volume." Also, agents would be aided by a sixteen-page pamphlet containing "twelve intelligent and forcible reasons why Lossing's History should be subscribed for," including the compelling rationale that "it cannot fail to be the most popular History of [the] Civil War that will be written, and must sooner or later find a place in nearly every library and household throughout the country."[51]

Childs warned potential agents, however, that, despite the assured success of the book, they would have to work hard to achieve the goal of nearly universal enrollment in the project. In bold print Childs cautioned agents about the possibility of failure: "*We wish to excite no undue expectations of success, and would caution all against undertaking to canvass for this work with a view of making it a secondary matter of business, or expect to accomplish satisfactory results without corresponding and well-directed efforts.*" The publisher wished to encourage only "thoroughgoing energetic Agents, who can in a plain, simple, straightforward manner, tell what the work will be, explaining its general plan and character, pointing out its peculiar features, and prominent points of difference between it and other Histories of the . . . Civil War they have met with, in a clear and concise manner, calculated to excite an interest in the work and command confidence and respect in the Agent." Such agents "will soon learn how to present the work successfully," and will be almost "certain to make money, which, after all, is the ultimate object of all legitimate business." Childs concluded his informational brochure to agents with an additional inducement to hard work. "In course of time I expect to publish other important works relating to the war," he noted in a comment with future implications for Lossing, "and good Agents will have the preference in securing the exclusive agency for the same."[52]

This advertising campaign by Childs created much

anticipation in would-be readers of Lossing's *Pictorial History of the Civil War*. "I am constantly getting letters from all quarters in regard to the great book," the publisher wrote his author. "I hope we may all be spared to see its completion. It will be your lasting monument."[53] Childs noted that within a few months of his appeal for agents, hundreds of applicants had made themselves available for the opportunity of selling Lossing's book. "They all think it will be the book of the age," he noted. "So do I!"[54] The key, Childs argued, was to write the first installment quickly. "I am extremely solicitous about the 1st vol.," he wrote. "It should be fully illustrated, not overburdened with minute details as we have so much ground to cover, and it should please the eye at first sight. If we get fairly started we are sure of great success."[55] Elsewhere, he hinted at the potentially rich financial rewards awaiting them if they did not delay. "As soon as we could get *one volume out* we could at once secure the market," Childs noted. Then the history would be "a 'big thing'" and "if properly managed" would secure "a fortune for author and publisher."[56]

Unfortunately for Childs, Lossing had already made a personal decision not to publish any part of his study until after the war was over. He justified the postponement by arguing that it was necessary to wait until "the proportions of that conflict were known, and its several events were so well comprehended, that it was not a difficult task to give to each act and scene its relative position and due prominence."[57] From a historical point of view this delay made sense, especially given Lossing's obsession with accuracy. But from a marketing standpoint the decision put Lossing and Childs at a grave disadvantage, because histories such as *Leslie's Pictorial History of the Civil War* and *Harper's Pictorial History of the Great Rebellion* had begun appearing from the beginning of the conflict and sold well.[58] The success of other pic-

torial volumes by Victor, Duyckinck, and Abbott prompted a concerned associate of Lossing's to write in 1862, "As the market is getting pretty full of books on this war, it will be very desirable to have [your book] before the public as early as possible."[59] Lossing acknowledged Childs's anxiety about the arrested publication schedule in a private letter of 1862 in which he admitted that "the publisher is naturally a little nervous, because several other publishers have announced histories of the rebellion[.]"[60] Two years later, with nothing as yet in print, Childs became increasingly despondent over the delays. "War literature is all the rage now," Childs noted, and the "meanest of the 'Histories of the Rebellion' are having large sales," even "trashy works."[61]

Arguing that he did not wish to compete with "trashy works" of history, Lossing reassured his publisher that patience would prove the best policy. "Others may 'take the top of the market,'" he wrote, but these works "must be ephemeral. I wish to make a work for all time, and I think the publisher's wishes will in the end be better satisfied."[62] But this strategy was small satisfaction to book agents and others counting on immediate and wide sales for the volumes even before the war was over. One discouraged agent noted in a personal letter to Lossing that he had suffered significant losses of sales to the pictorial histories of other, more aggressive chroniclers of the war. "I fear you are delaying your work on the rebellion to a late day," he wrote plaintively. "Abbot[t']s book has been distributed in this region & I suppose elsewhere, & as it is a large work, I fear you will find it in your way."[63]

To the chagrin of Childs the first volume of Lossing's trilogy was not published until 1866, and even then its author was apologetic about bringing it to the public without adequate time for appropriate reflection on the complex elements of war in all their real-

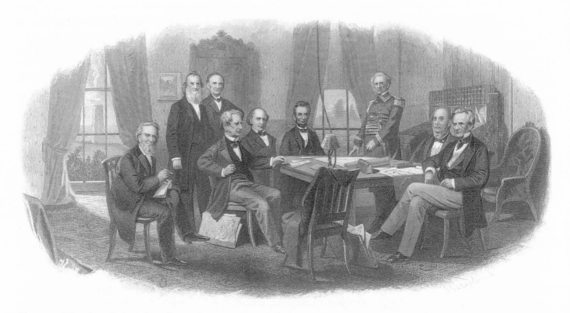

Figure 46. "Lincoln and His Cabinet," 1868, by Benson Lossing after the painting by C. Schuessele for Benson Lossing's *Pictorial History of the United States*

istic detail. Noting in the preface that the "task of making a record of the events of the late Civil War in our Republic is not a pleasant one for an American citizen" who would rather "bury in oblivion all knowledge of those events which compose the materials of the sorrowful story of a strife among his brethren, of terrible energy and woeful operations," Lossing warned that unfortunately the Civil War "cannot be hidden" but "will forever occupy a conspicuous place in the annals of mankind. What remains for the American citizen to do, is to see that the *stylus* of history shall make a truthful record." The pressing need to get the story out, he added, influenced profoundly the restricted ambitions of the format of the text. "I entitle my work 'A History of the Civil War,'" Lossing wrote in the preface, "but I ask for it no higher consideration than that of a faithful CHRONICLE, having the form of history, and aspiring to perform its highest duty, namely: to inspire mankind with a love of

justice and a hatred of its opposite, and of every thing that impedes the onward and upward march of humanity." Reciting the realist's cant against the usurpatious speculations of idealists such as Spencer, Lossing identified himself as a documenter rather than a narrator of historical events: "Taking it for granted that the reader, with the facts plainly set before him, is capable of forming just conclusions, I have confined my labors chiefly to the recording of those facts; and have only given opinions and speculations concerning their relations, and the evident motives of the chief actors in the drama, sufficient for hints for thought and premises for reasoning, without enlarging into argument or endeavoring to forestall the judgment."[64]

Despite a number of expressions of impassioned advocacy on behalf of the Union, the majority of Lossing's *Pictorial History of the Civil War* was a restrained accounting of political transactions spliced

together by small illustrations depicting buildings and artifacts associated with specific episodes in the non-military history of the war. Emphasizing his desire for accuracy in the representation of the material culture of the war, Lossing noted that the engravings for the history were "prepared under my direct supervision; and great pains have been taken to make them correct delineations of the objects sought to be represented."[65] Lossing understood this form of "objectifying" the war literally, providing illustrations of Confederate stamps, mail bags, currency and Union letterheads in lieu of more subjective or idealized pictorial treatments of military conflict. As he had in the *Pictorial Field-Book of the Revolution*, Lossing made the conscious decision not to include pictorial descriptions of battles in his history, fearing that such depictions would spill over too readily into the sentimental.[66] The one exception to this general rule was the frontispiece to the volume, the aforementioned steel engraving from a painting by Schuessele in which Lincoln and his Cabinet gather with General Scott for a council of war (fig. 46). Even this illustration, however, was more a series of posed portraits than a dramatic narrative depiction of the consequences of military decision making. Childs's art department had engraved the frontispiece for circulation among agents before any of the text had gone to print, but its subdued tone revealed that Lossing's conservatism with reference to battle scenes pervaded every feature of the enterprise.

In form the *Pictorial History of the Civil War* was nearly identical to the *Field-Book of the Revolution* with two exceptions. First, it was presented in chronological sequence rather than according to Lossing's travel itinerary. This change made the Civil War volume less picaresque and idiosyncratic than its predecessor, Lossing seldom resorting to the first-person narrative voice so evident in the *Field-Book of the Revolution*. Sec-

ond, the *Pictorial History of the Civil War in the United States* relied a good deal more than its predecessor on the literary and pictorial reports of others, including its chief competitors. Although Lossing had condemned the hurried qualities of the journalistic works of his rivals in the pictorial history market, his inability to be on hand for every battle of the war required that he borrow from their accounts. Lossing quoted extensively from Abbott's *History of the Civil War in America* and Victor's *History of the Southern Rebellion*, for instance, two works that had captured from him the lion's share of the market for pictorial histories of the war. He also leaned heavily for visual information on the illustrated newspapers, despite having questioned earlier the methods of their special artists. "I gladly availed myself of the labors of others with pen and pencil, who kindly permitted me to make use of unpublished materials—such as drawings, photographs, diaries, and letters," he acknowledged, "and I am specially indebted to the courtesy of the proprietors of *Harper's Weekly* and *Frank Leslie's Illustrated Newspaper*, whose artists accompanied the great armies throughout the whole struggle, and preserved the lineaments of a thousand objects which were soon swept away by the storms of war."[67] In borrowing so freely from Fletcher Harper and Frank Leslie, Lossing was careful not to appropriate their most sensational images. But he adapted without hesitation from artists such as Edwin Forbes, whose pictorial depictions he viewed as more responsible than most in the presentation of the visual record of the war.

The illustrations in the second and third volumes of the *Pictorial History of the Civil War* were not unlike those in the first volume—documentary records of the artifacts of war. In small sketches placed throughout the text Lossing depicted the accouterments of war—shattered gun barrels, torpedo shells, war balloons, and bayonets—but he passed once again on the

opportunity to illustrate visually such sensational scenes as the bombing of Petersburg or the assassination of Lincoln. The frontispiece to the third volume included a steel engraving of an interview concerning the surrender at Vicksburg of Confederate general Thomas Pemberton to Ulysses Grant, but this narrative illustration by H. Stephens was not representative of most of Lossing's nonstorytelling images, nor was it particularly compatible with his discussion of the episode in his manuscript (fig. 47). In the text of the *Pictorial History of the Civil War* Lossing made a point of noting that Grant and a despondent Pemberton "withdrew to the shade of a live-oak tree, where they sat down on the grass and held a conference."[68] But in Stephens's illustration a rather defiant

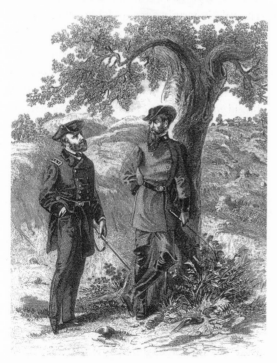

Figure 47. "Pemberton and Grant," 1868, by H. Stephens for Benson Lossing's *Pictorial History of the United States*

and smug Pemberton leans casually against a tree that appears to be other than oak with a pistol near at hand. The illustration had been adapted once again in advance of the writing to serve as an attractive point of entry into the volume, a decision Lossing had endorsed tacitly by raising no objection to "a beautiful and comprehensive Frontispiece, showing, at a glance, the main characteristics of the work." But incompatible and unrepresentative depictions were another matter, and Lossing announced his preference to his publisher for personalized reportorial sketches over allegorical narrative illustrations. At the author's request, the falsifying image was removed in later editions of the work, but in Lossing's estimation the damage had already been done. "If I were going to get up the book according to my own notion," he wrote, "I would have *every picture new, and all uniform.* Let it be an *original book.* It would thus so much the more command itself to the public, that the difference in the cost would be more than made up."[69]

Such remarks on illustration reflected the struggle Lossing and other pictorial historians experienced in adjudicating between the desire to report the war with visual and literary accuracy and the need to obscure or embellish aspects of it for the sake of popular taste. Lossing's personal preferences were for realistic renderings, but he was not interested in recreating visually the bloody realities of the battlefield nor was he averse to sentimentalizing on occasion in the name of patriotism and loyalty to Union. In terms of public perceptions of the war Lossing seemed to understand that a residual impulse to romanticize war was still evident among Americans, but he was not willing to make too many concessions to this tendency out of lifelong commitment to objective reporting. He concluded his third volume with a reflection on the future of the Republic that was revealing of his compromises in these matters. Noting that as late as 1868 some

Americans were "still agitated by the throes of the Civil War" and continued to demonstrate a perverse attachment to the maudlin residues of war, he believed nonetheless that there were strong signs that the nation was moving on toward "a new and more glorious era."[70]

If anything Lossing may have underestimated the power of this recuperative movement because, ironically, it helped explain why readers were less interested in his volumes in the late 1860s than they might have been five years earlier. The war was a bitter and painful memory that some sought to repress, others to forget, but most to overcome. By the end of the war decade, therefore, Americans were less favorably disposed than Lossing would have liked to taking a long, hard, realistic look at the war. Significant histories of the Civil War were written throughout the late nineteenth century and beyond, of course, but all of the most popular works on the Civil War were produced during the conflict itself by authors who rarely published anything on the subject after the fighting was over. Although six popular histories of the Civil War were listed as best-sellers during the war itself, for instance, not a single such work earned that distinction after 1866.[71] Sadly for Lossing, the late timing of his Civil War volumes meant that none of them ever came close to achieving best seller status.

In addition, the failure of Lossing's *Pictorial History of the Civil War* did little to assure realist historians that their understated and nonsentimentalized visions could have a discernable impact on the popular book market. Americans were too discerning to accept unquestioningly the melodramatic descriptions offered by giftbooks prior to the war, Lossing discovered, but they were not yet willing to embrace the kind of dispassionate realism characteristic of the *Pictorial History of the Civil War*. Referring to "all the merit and all the blemishes of Dr. Lossing as a historical writer," Moses Coit Tyler alerted audiences several years later to the peculiarities of his realist system. "He takes great pains to gather all the facts; he studies all the facts with serious and candid attention: and then, with perfect fidelity, he relates all the facts, caring far more for exact truth than for epigrammatic smartness," Tyler noted of Lossing. And yet, he added with concern, "no one has ever claimed for him that he is a philosophical historian, or the master of a powerful historical style. He narrates; he does not philosophize. He tries to tell his story in a plain, honest fashion; and seems satisfied with doing that, without ever trying to be brilliant." This lack of intellectual ambition made Lossing's works less useful and his status as a historian more marginal in Tyler's estimation. "He lacks, indeed, the generalizing grasp, the sympathetic imagination, the infinite learning, the dainty culture, the faculty of expression at once copious, luminous, swift and poetic, which are necessary to a historian of the highest order."[72] In overreacting to the sentimental excesses of Jesse Spencer or to the journalistic distortions of Frank Leslie and Fletcher Harper, Lossing exposed the vulnerabilities of the realist program so far as the popular imagination was concerned.

The Impress of Newspapers

Some reviewers of Lossing's *Pictorial History of the Civil War* found in it strong indications of the extensive and accurate research they had come to expect of the self-taught historian. The *New York Herald* called volume 1 of the series "the first conscientiously written history of the war that has been given to the world since its close."[73] *Godey's* also praised the book's accuracy, noting that "from its pages a stranger to the great contest might readily gather all that is necessary to the comprehension of the causes that brought about rebellion, and the motives of the Southern

leaders. . . . We do not doubt that the succeeding volumes will justify the high expectations to which this first has given rise."[74]

But those who disapproved of its derivative style and unimaginative realism also attacked Lossing's pictorial history in the press. An anonymous reviewer for the *New York Round Table* claimed that there was "nothing that may properly be called history in the volume" and lumped it in with the many mass-produced pictorial histories of the war in which narrative was secondary to uninspired pictures. The "evident object" of the text "is to serve as a frame for the four hundred and odd pictures which decorate its pages," noted this critic, who condemned the volume as a mere "picture-book." As a popular, illustrated history "it is fully as successful as could have been expected, even more so than the author's previous books, whose popularity shows the demand existing for such productions," he wrote. Yet even here, the *Round Table* critic condemned the kinds of pictures chosen by Lossing to carry the burden of his historical argument. "The pictorial department . . . bears the impress of the newspapers as distinctly as the literary," the reviewer noted, "an all-pervading atmosphere of *Harper's Weekly* and Frank Leslie impregnating the neatly executed wood-cuts no less palpably than 'our own correspondent' appears in the text." He claimed that 131 of the illustrations in volume 1 of the *Pictorial History of the Civil War in the United States* were "newspaper 'portraits' wherein a successful rendering of a single feature contents the artist." The reviewer also condemned the principles of selection at work in such "Newspaper art." "Mr. Lossing has attained the full quota of his four hundred pictures by delineating flags suggested and adopted, postage stamps, confederate money, a specific and a generic cannon ball, General Anderson's sword, a carpet-bag in which a rebel mail was carried, and other objects whose

preservation was of singular importance," the critic complained. "From the precedent thus afforded," he added with sarcasm, "we may look with hope to find embalmed in the continuation of the work such celebrated articles as Governor Brown's cabbages, General Bishop Polk's prayer-book, Jeff. Davis's bootjack, the carpet-bags which contained phosphorous for the destruction of New York, and the lamp-posts upon which Negroes were hung during the draft riots."[75]

To the extent that the reviewer for the *Round Table* acknowledged Lossing's literary efforts, he rejected them as the unoriginal work of a counterfeiter. Noting that Lossing had been "anticipated by Mr. Abbott and other narrators of about the same grasp of mind and range of ideas as himself," the reviewer condemned the field book historian for having "trod in their beaten track of relying on newspapers; of estimating the importance of events by the attention they happened to receive at the time when they transpired and of detailing them in the microscopic fullness of a reporter; thereby producing a book which, so far as its reading matter goes, is—anecdotes, doggerel rhymes, puffs, and the rest of it—but the essence of the New York dailies."[76] Lossing incurred the full wrath of the *Round Table*'s expressed editorial policy, which declared that "so long as there are bad books to be exposed, unprincipled publishers to be remonstrated with, corrupt society to be scathed, silly and extravagant fashions to be denounced," the paper would remain active.[77] Noting that others had done sooner and better what Lossing unfortunately chose to do later and less expertly, the reviewer concluded with contempt that the *Pictorial History of the Civil War in the United States* "is scarcely a work which gentlemen will care to preserve among the standard histories of their libraries." Although the volume was "certain to remain popular until it is worn out with the large class among whom the pictures will be possessed of the

deepest interest, and be thumbed so long as they are discernable," the *Round Table* could not recommend it for serious students of the military conflict.[78]

Lossing was incensed by this very damaging review when it crossed his desk in the summer of 1866, especially because it impugned his capacities as a realist. Although he claimed a personal disdain for addressing his critics directly, he wrote immediately to the editors of the *Round Table,* noting with thinly veiled anger that his "reverence for truth, candor and justice" required him to respond.[79] He pointed out that no reader who had "actually read" the *Pictorial History of the Civil War in the United States* and who was "acquainted with its subject" could say in good faith that it was "mostly made up from newspapers." Citing his "numerous references to authorities" and his use of private letters and diaries, he condemned the charge of shameless adaptation as "both untrue and unjust." With regard to the illustrations, he took special umbrage at the suggestion that his work was copied almost exclusively from *Leslie's Illustrated News* or *Harper's Weekly.* "The writer speaks of the portraits having *all* been copied from newspapers," Lossing retorted. "Only *two* of the whole number (Magrath and Simons) were copied from the pictorial papers; and they were copied because, after diligent search I could not, as I had done in *all* the other cases, procure photographic and other likenesses whose fidelity was attested." Condemning the hurtful irony of a literary review that attacked a man's accuracy with inaccurate assertions, Lossing requested that the editors of the *Round Table* supply him with the name of the reviewer so that he might challenge him directly. "I have an exulted idea of a true critic, which implies a person of generous and very extensive culture, large and varied experience, and a conscience that has as much divinity in it as that of a true apostle of Christ," he concluded. "The writer of the notice alluded to has evidently failed to so qualify himself for the office of a Critic; and he has sinned against the *Round Table* and its readers by making it the vehicle of positive untruth and injustice."[80]

The editors of the *Round Table* provided Lossing with the name of his attacker, and he was shocked to discover that the reviewer was none other than Henry Dawson, editor of the *Historical Magazine* and longtime associate of Lossing's in their mutual campaign to promote realism in historical study. Feeling betrayed by one he assumed a friend, Lossing wondered how Dawson could have perceived the *Pictorial History of the Civil War in the United States* as anything other than an example of the very principles of fidelity and fact they both professed. "I take this occasion to say that I have been told that a notice of the first volume of my *History of the Civil War* which appeared in the *Round Table* of the 16th of June was from your pen," Lossing wrote directly to Dawson. "I tell you frankly that I do not believe it."[81] There is no evidence that Dawson ever responded directly to Lossing, but in similar exchanges with other authors whose books he had attacked, Dawson revealed himself to be a somewhat heartless and unrepentant critic. One acquaintance of the editor noted that Dawson "was no gentleman," because "he spoke 'far too strongly for good taste,' and his conclusions were 'too severely given.'"[82] For his part Dawson defended his acerbic reviewing style by noting in the editorial pages of the *Historical Magazine* that "what is known to be historically untrue, the *Historical Magazine* will fearlessly expose and condemn, no matter by whom it may have been uttered."[83]

Elsewhere Dawson attacked the methodologies used by Lossing in his pictorial histories of other American wars. Noting that the field book author "too often sacrifices his fidelity as a historian for the sake of rhetorical effect," Dawson accused Lossing of pan-

dering to the popular prejudices of the day in order to sell books. Inferring that Lossing had distorted historical material to suit a personal thesis, he accused him of the very kinds of manipulation against which Lossing had campaigned during the war. "It is well, sometimes, to be quite sure of the value of one's authorities before undertaking to write *history*"; Dawson wrote, "when writing *romance* one needs take less trouble." Noting the field book historian's affiliation with the Republican Party of Lincoln, he alleged a political purpose to the work as well, arguing that Lossing's "pen was stayed in its holy work of bearing testimony to the Truth, because of the injury which it might do to the temper or the reputation of a dominant political party." Because Lossing worked from a preconceived theory about the righteousness of the "controlling political party" of Lincoln, the critic added, he operated "in defiance of the authorities on which historians delight to lean" and in "sad disregard, too, of his reputation as a faithful historian."[84] Referring to the "laughable blunders" of Lossing, Dawson condemned his histories as nothing other than "wretched romance."[85]

By the 1870s, then, two competing schools of critical thought surrounded Lossing's pictorial works, each representative of a distinctive outlook regarding the proper uses of history and its accompanying visual images. One group, represented by uncompromising idealists such as Moses Coit Tyler, viewed Lossing as a seeker after minutia, as a compiler more than a theorist, and as an antiquarian who shied away irresponsibly from the need to provide moral guidance to a nation in transition. A second group, led by arch-realists such as Henry Dawson, dismissed Lossing as a mere popularizer, a propagandist who twisted the facts of history in order to serve partisan and personal needs. They denounced the inaccuracies of Lossing's historical research, the "picture-book" qualities of his illus-

trations, and the generalizing tendencies of his literary efforts. Lossing was sensitive to both types of criticism, although Dawson's remarks hurt him most of all because they were made by a former friend who insinuated that Lossing had abandoned their mutual commitment to authenticity in exchange for popularity among casual and unsophisticated readers.

Both schools of criticism affected the sales of Lossing's *Pictorial History of the Civil War.* So unsuccessful was the first volume in 1866, in fact, that George Childs abandoned the project, leaving Lossing to scrape about for a new publisher for the second and third volumes. Childs's abdication suggested that by 1868 the market for Civil War histories had already been saturated and that the pictorial format of Lossing's work was not the novelty it had been twenty years before when the *Pictorial Field-Book of the Revolution* had been published. As was his habit, Lossing blamed his misfortune on irresolute and uncourageous publishers such as Childs, but the failure of the volumes may have had as much to do with changes in the pictorial market as with the timing of the publisher's withdrawal. As Harold Mahan has noted, Lossing's decision not to publish any of his work before the war's end "left his herculean research and writing efforts unrewarded. As in other episodes, Lossing displayed a real if naive desire to offer a serious work but insufficient business sense to recognize the slimness of his resultant chances for commercial success."[86]

Lossing's frustrations with his inability to satisfy either of the camps of critics coalescing around his works was tempered in part, however, by two ironic opportunities that presented themselves in the early 1870s and provided a small measure of vindication against both groups. In the first instance Henry Johnson decided to update Jesse Spencer's recently enlarged four-volume *History of the United States* to in-

clude a fifth volume in anticipation of the 1876 centennial celebration. Discouraged by the failure of the fourth volume in the series, however, Spencer was not interested in the task, so Henry Johnson approached Lossing about completing the work. On first glance, one puzzles at the choice; the idealist Spencer and the realist Lossing would seem to make such odd bedfellows. But an inspection of the explanatory note later appended to the centennial edition of Spencer's history reveals that Johnson was looking more for a compiler than a theorist, and Lossing fit the bill. "In giving an outline history" of the period from the close of the Civil War to the centennial, Lossing wrote, "I have endeavored to conform to the general plan and spirit of Dr. Spencer's labors, so that the work may present an unity in design and equal truthfulness and fairness in its execution." This outline history proved to be little more than a series of notes adopted from other general histories of the United States with which Lossing was preoccupied in the 1870s. Ignoring the high tone of Spencer, who submitted his earlier portions of the history "in the hope that its merits . . . may give it favor in the eyes of all good and true men, and all honest lovers of our highly favored land," Lossing viewed the labor as so much piece work undertaken primarily for the purpose of gathering materials for future histories and for the small compensation offered by Johnson.[87]

In the second instance, Lossing seized an opportunity to wrestle away control of the market for historical periodical literature from the uncharitable Henry Dawson and the *Historical Magazine*. In March 1871 Lossing received a letter from the journal's publisher, John E. Potter, representing "a number of literary gentleman" in Philadelphia who were "dissatisfied with the manner in which the *Historical Magazine* under Mr. Dawson's control has been conducted" and were interested in "establishing here a periodical of similar

character which shall be free from the offensive criticisms and rebel eulogisims that have become a marked feature of the former." Noting that it was necessary to procure the services of "some person of competent historical attainments to exercise editorial supervision," the publisher offered the job to Lossing with the flattering comment that "there is no historical writer in this country more highly appreciated or universally read."[88] Later the next year Lossing was appointed editor of the newly created *American Historical Record* with a modest yearly salary of twelve hundred dollars but with a bonus for increased subscriptions.[89] Lossing "took the editorial position at a low salary," noted a biographer, and because "he loved the subject and wanted to foster the growth of such a magazine" as a way of cutting into Dawson's market. When subscribers were slow initially to rally to the new periodical, Lossing blamed "the Dawson mismanagement" of the *Historical Magazine* for the generalized suspicions of would-be patrons of such periodical literature. Subscriptions for the *American Historical Record* increased over the next three years, however, and by 1874, Dawson, who suffered from the competition, was having trouble meeting bills for the *Historical Magazine*. In 1875 he was forced to cease its publication altogether when reductions in subscriptions prompted the local postmaster to deny the publication second-class mail status.[90]

If Lossing took any personal satisfaction in Dawson's demise, he was too much the gentleman to indicate as much in the pages of the *American Historical Record*. Instead he dedicated himself to three goals: to publish documents "which have an intrinsic and permanent historic value, and which have never been printed, or are almost as rare as manuscript"; to facilitate "discussions of important historical questions, in brief shape, and in the spirit and form of inquiry only"; and to provide "brief records of the most im-

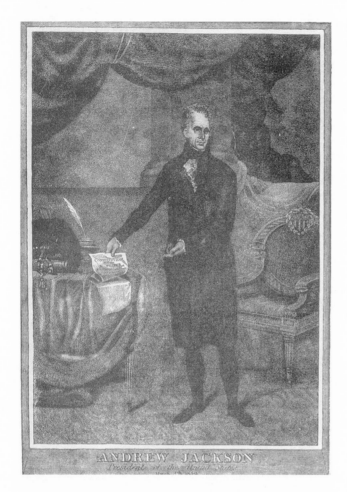

Figure 48. "Andrew Jackson," 1875, *Potter's American Monthly*, vol. 5, no. 47

portant proceedings of the historical and kindred societies of our country." As editor Lossing claimed the right "to prune or condense all contributions; and also to so modify all expressions that might be considered offensively personal, as to make the work absolutely free from provocatives of irritating controversy." In contrast to Dawson, Lossing announced that a new tone of civility would characterize the editor's chair. "The Editor's business is to edit, and not to assume the office of censor or umpire in discussions, uninvited," he wrote, and "to give his own views of questions as the peer of his correspondents when-

ever, in his judgment, occasion may seem to require it to be done."[91]

Among a select group of scholars, antiquarians, genealogists, and librarians with a "keen appetite for historical disclosures," the *American Historical Record* filled an important void in the publication of obscure archival materials.[92] For editor Lossing, the magazine also satisfied his realist's desire to be affiliated with an enterprise devoted to the collecting, arranging, and presenting of verifiable factual information. But the *American Historical Record* proved little more successful than its bankrupt predecessor,

Figure 49. "Mrs. Rachel Jackson," 1875, *Potter's American Monthly*, vol. 5, no. 47

the *Historical Magazine*, in attracting or retaining sub-scribers. Readers were increasingly drawn to the his-torical literature appearing in the more flamboyant, mass-produced popular journals of the day such as *Harper's Monthly* or *Scribner's Monthly*. Lossing tried to find a paying clientele among the group of scholars who would one day organize themselves into a pro-fessional association for the study of history, but he was premature by a decade or so in this search, and he could not draw enough interest from popular readers of competing journals to justify even his small salary.[93]

In 1873 the price of the *American Historical Record* was raised from three to four dollars a year, and the editor introduced a series of incentives for potential buyers, including the offer of free copies of the *Pic-torial Field Book of the Revolution* (also not moving well) for anyone attracting ten new subscribers to the maga-zine.[94] In January 1874 Lossing received a letter from J. Parker Norris, an agent at Potter's, expressing the company's "strong desire to see you personally in re-lation to . . . the business management of the 'Record.'" Norris hinted that the agenda of the meet-ing would be the *Record*'s financial solvency and edi-

torial control of the magazine. "In view of the heavy loss I have already sustained in keeping this work above water," Norris wrote, "it will be necessary during this year to practice the closest economy consistent with the production in the *most attractive and interesting manner possible*, to the end that it may be firmly established and acquire a self supporting basis at least."[95] An announcement was made later in the year that "THE RECORD" would be "ENLARGED AND IMPROVED!" with "many new and attractive features" designed to win "the cordial support of the public." Among these features was a new format and grander illustrations, as well as a change in name to "POTTER'S AMERICAN MONTHLY: An Illustrated Magazine of History, Literature, Science and Art." A radical expansion of the subject matter was also anticipated, including the introduction of fiction "in the form of first-class Serial Novels, and short, sparkling Stories" as well as "fresh and varied Articles on Literary and Social topics; sketches of Travel; Discussions upon Books and kindred themes; Poems, by representative poets; impartial criticisms of recent publications; and a general Review of the world of Literature."[96]

Lossing balked at these changes, complaining to Potter that such modifications went too far toward the "popular" to be acceptable to scholars of history. He was especially concerned with the illustrations, whose authenticity he often questioned. Potter tried to persuade him that the utmost was being done to ensure the credibility of the images. "I feel more than usually confident of your approval of the July number," he wrote his skeptical editor, who had expressed reservations about the accuracy of the cover illustrations. "I have endeavored to do honor to the National Month by making the number peerless. You will find several original cuts engraved in Mr. Jere. Rea's best style, and, better still, you will find a goodly number of excellent papers—at least I think so, and hope you will." But al-

ready concerned with the effect the broadening of the journal's subjects would have on its reputation for accuracy, Lossing took little comfort from the publisher's added cautions about the frontispiece to the July issue. "I am a little afraid of the leading cut—that of Nassau Bank," he wrote. The illustration had been produced from a sketch of which the artist was "so confident that it was correct that I yielded to his desire to work from it—but it does not show the edifice as I recollect it."[97]

Lossing eventually stepped down as editor of the periodical in protest against Potter's expansionist policies. Reviewers of the newly revised journal commented on the further descent of the art department after Lossing's resignation. The *Mercury* noted in a review of the November 1875 issue of *Potter's* that the "letter-press of this magazine is excellent, its articles well selected and readable, but in its illustrations it is vastly inferior to the magazines of the day." It judged the portraits of Andrew Jackson and Mrs. Jackson as "simply abominable," noting that "'Old Hickory's' wife looks like a mulatto, dreadfully pitted with the small pox, and the General himself has not been flattered by the engraver" (figs. 48 and 49). Arguing that a popular magazine must be inviting in its pictorial format to be successful, the reviewer for the *Mercury* hoped that "the publishers will recognize the necessity of an improvement in their illustrations ere the Monthly can become a first-class magazine."[98] Lossing confidant Samuel Atlee approved of his friend's decision to leave the periodical, noting that in changing the title of his magazine, Potter "manifested more vanity than discretion. The *Monthly* is losing its distinctive American character," Atlee commented, because "pictures and tiresome sentimental stories occupy all its columns. I doubt its longevity."[99] Subscriber Hiland Hill agreed, noting, "I was well satisfied with the *Record*, but under the Potter management it diminished, rapidly in my estimation."[100]

Lossing's decision to vacate the editor's seat of *Potter's* revealed in miniature the larger historical issues with which he had been dealing since the Civil War, namely, how to pictorialize history sufficiently without compromising his commitment to accuracy and realistic detail. Potter's efforts to expand the subject matter of the past helped enlarge the potential readership of the journal, but it also cost him those subscribers who had turned to the *American Historical Record* for reliable documentation and scholarly identity. At issue was whether history in the realistic vein could attract popular audiences in the same manner that romanticized or sentimentalized books had done before and during the Civil War. The question faced by publishers and historians alike was, How much realism is too much realism?

The disappointment of the *Pictorial History of the Civil War* and the demise of the *American Historical Record* suggest that popular readers at least were not yet ready for Lossing's acute literary realism. Although the Civil War made it difficult to consider a return to the sentimental, chest-thumping nationalism of Spencer's history, readers in the 1870s still insisted on a more heightened tone than Lossing provided in his literary and pictorial narratives. Compendia of historical facts were not sufficient to hold the interest of the average citizen, and matter-of-fact, reportorial illustrations were only acceptable when supplemented with occasional battlefield gore. As much as Lossing disapproved of the alterations in format that led to the more flamboyant *Potter's American Monthly,* he had to admit that such enhancements sold subscriptions in a way that his *American Historical Record* or Dawson's *Historical Magazine* had not. These features of the popular periodical marketplace alerted Lossing to the need to package history in ways more appealing to consumers and more attentive to the business end of selling the past. Popular books, especially pictorial ones, had the potential for vast sales in a market in which greater numbers of literate readers had more disposable income to purchase a wider variety of volumes at significantly reduced prices. Lossing hoped that although the marketplace had been saturated with works on the Civil War, there were still numerous opportunities to produce lucrative books in the area of general history, and he experimented endlessly with differing formats in order to capitalize on these possibilities. Some of these efforts came to fruition in the rich fields of opportunity for historians provided by the nation's centennial, and Lossing and others took advantage of changing visual preferences and improving technological capabilities to market new, more visually competent pictorial histories.

"A String for the Pearls"

The Centennial Celebration and Humanizing History

The centennial celebration of 1876 provided an important opportunity for Americans to reassess their national priorities and to reinvent themselves in light of the personality-shattering tragedy of the Civil War. It also gave historians a distinct chance to reflect on their special roles as cultural image makers, suggesting how, as arbiters of the past, they might use history in the service of cultural revitalization.[1] Pictorial historians who participated in this "reconstruction" effort were concerned naturally with the best and most appropriate ways to use illustrations to reinvigorate the nation. Before the Civil War, any such debate over the most suitable form of pictorial presentation was limited by constraints in the field of illustration that restricted substantially the range of alternatives available to illustrators. In the period after the Civil War, however, the preference of Americans for visual learning was encouraged by a proliferation of pictorial products generated by techno-

logical innovations in lithographic reproduction. The 1870s witnessed an explosion of inexpensive print materials, including album cards, political broadsides, sheet music, and art prints, many of which were devoted to the study of history through pictures. Currier and Ives advertised their 13½-×-17¾-inch prints of American scenes at six images for a dollar, a rate that corroborated their claim to deliver the "Cheapest and Most Popular Pictures in the World." The firm produced more than 500 portraits of famous Americans and more than 250 prints "depicting the highpoints of American history" by such famous lithographers as Napoleon Sarony, Henry B. Major, and W. K. Hewitt. If not always "precisely historical" in terms of accuracy, these images were an important source of historical consciousness in an age given over increasingly to an "illustration-mania."[2]

"History Illustrating Itself by Example"

As it became easier in a technical sense to illustrate history from a wider range of perspectives, the question of whether sentimental or realistic strategies were better suited to telling the story of the past became more meaningful. In addition, concerns about the proper relationship between images and words seemed of greater consequence. The centennial represented an occasion for publishers of pictorial histories to experiment with various formulas in an effort to find the most useful and remunerative pictorial approaches to the past. At stake was not only the financial solvency of the historians and publishing companies involved but also the stability of the nation's self-image.

Some participants in this debate over proper pictorial form believed that history should be allowed to tell its own story; that is, that the historian as narrator of events should give way to the narrative voice in-

herent in the events themselves. One of the leading advocates of this strategy in the centennial book market was R. M. Devens, whose *Our First Century* attempted to provide a "popular descriptive portraiture" of the one hundred "great and memorable events" in the history of the country. Although advertised as a bona fide work of pictorial history, Devens's book was more an annotated list of significant episodes in America's past than a scholarly narrative of causal connections among such episodes. As Devens noted, storytelling was not his intention; the task of writing "that transcendent Chapter" on the first one hundred American years "in the Volume of Human History" must be left to a Bancroft or a Motley.[3] Rather, his goal was to present a volume that could provide "a panoramic view of those wonders and prodigies, both men and events, which peculiarly reflect the patriotism, taste and genius, the exploits, tragedies and achievements, of the Century." Believing such a digest to be "the almost universal preference of the PEOPLE" as compared with "the works of simple chronological summary with the usual comments and discussions," Devens emphasized "the more diverse range—the wide scope—of attractive subjects here collected, and which are adapted to meet so fully the *average* taste and need." He referred to his methodology in conspicuously pictorial terms as "HISTORY ILLUSTRATING ITSELF BY EXAMPLE," the past as it were painting its own "tableaux" on the "canvas of national life" and bringing "into striking relief *the prevailing spirit or excitement of the period marked by its occurrence.*" Purposefully avoiding "diffuse comments" or "philosophical reflections," Devens claimed that in *Our First Century* the "'plain unvarnished tale' is allowed to stand by itself, teaching its own lesson, and suggesting its own commentary."[4]

Such a calculated reduction in the role of the historian as narrator might have threatened Devens's

volume with the same obscurity experienced by many strict realists who had eschewed the "subjective presence" in their pictorial histories of the Civil War save for the fact that the events selected for inclusion in *Our First Century* were all chosen for their "*romantic, stimulating [and] instructive*" content. Announcing the "EXCLUSION OF ALL DRY TOPICS AND DETAILS" in his work, Devens listed among the one hundred greatest and most memorable events in American history to be illustrated in his volumes not only standard episodes of noteworthiness, such as the signing of the Declaration of Independence or the firing on Fort Sumter, but also more sensational and obscure occurrences, such as the appearance of a sea serpent off the Atlantic coast, the murder of millionaire George Parkman, the musical tour of Jenny Lind, and the "sublime" meteoric shower of 1833. Contemptuous of the "too common plan of presenting rivulets of fact in meadows of verbiage," Devens also privileged images over words, allowing the "pictorial adornments" in his "complete *Picture Gallery of the National Century*" to make their own case for inclusion in the master narratives of the American past. In this visual capacity Devens relied heavily on "the unrivaled illustrated journals of our great cities" such as *Harper's Weekly* and *Frank Leslie's Illustrated Newspaper,* whose "life-like pictorial descriptions" left "nothing unprovided" for the "future historian." Because he desired to "avoid microscopic details" of the sort that had bogged down so many works, such as those of Lossing, Devens promised "to fuse the vital facts and racy incidents" of these popular newspapers "in such a manner as would body it forth to the reader in judicious fullness and complete unity."[5] As the large number of copies of *Our First Century* in antiquarian booksellers' shops today testifies, readers responded well to these strategies, "buying into" the marketing tactics of peddlers and book agents who argued persuasively that "pictures" such as those in Devens's work "have now become a necessity" and are priced "so low, that everybody can afford to buy them."[6]

Not to be outdone by competitors such as Devens appropriating his materials (in some cases without permission) for their pictorial histories, Frank Leslie published his own history of the centennial in 1876, *Frank Leslie's Illustrated Historical Register of the United States Centennial Exposition,* a richly illustrated, oversized volume that was advertised at a price "within the reach of everyone."[7] Leslie had been appointed a commissioner for the state of New York to the American Centennial Commission, and the illustrated newspaper mogul used his authority as an officer of the exposition to construct on the fairgrounds a "Frank Leslie pavilion," where he promoted his newspapers, periodicals, and especially his *Historical Register.*[8] Offered as "an intelligent and discriminating friend" with which readers "might perfect . . . the memory of happy days passed at Fairmount, and of the wondrous exhibition of human development in skill, industry, and intelligence there displayed before them," Leslie's volume was by its own description "conscientiously undertaken" on a "scale of liberal consideration" for the "presumed requirements of the public." As such, it drew on many of the devices perfected earlier by Leslie in his pictorial newspapers. For instance, the book was formatted as a tabloid with oversized newspaper pages (eleven by fourteen inches), bold-faced headers, and a columnar orientation, giving readers the illusion that they were perusing up-to-date newspaper accounts of ongoing events. A sense of participation in the events of the centennial was also achieved by Leslie's use of journalistic descriptions documenting the celebration in "process," such as depictions of the transporting and unpacking of exhibit materials, the lunch breaks of fairgrounds laborers or the construction of the circular railway that sur-

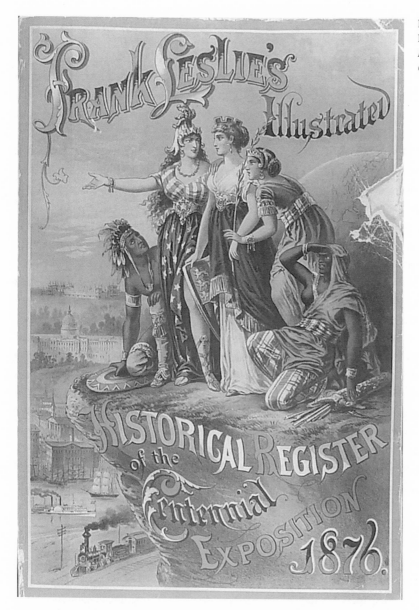

Figure 50. Frontispiece to Frank Leslie's *Illustrated Historical Register of the Centennial Exposition, 1876*

rounded the park. Finally, the volume was lavishly illustrated in the manner of Leslie's papers, suggesting the publisher's understanding of the preferences of nineteenth-century readers for visual markers in their pursuit of public memory.[9]

Leslie's Historical Register is a fascinating catalogue not only of the events of significance associated with the Centennial Exposition itself but also of the historical proclivities of Americans deliberating between sentimental and realistic versions of history. Leslie's

history fell squarely into the sentimental category, being essentially escapist in character. Throughout the *Historical Register* there are occasional allusions to the bloody fratricidal conflict of the Civil War— Joaquin Miller's tributes to the "mighty men who fought and fell" in the "Song of the Centennial," for instance—but these are the exception to the rule. The more typical sections deal with the history of previous expositions, with sketches of early American industry, and with historical analysis of the opening remarks by President Grant to the visitors to the fairgrounds. In this sense Leslie's compendium evidences realism of detail but not of national mood. War themes and sectional divisions give way to unifying discussions of family values and the bright future for American business as reflected in the exposition itself. Nearly all of Leslie's chapters are adorned as well with sentimental portraits of small children gazing in awe at the exhibits or sliding joyously on the sleekly designed playground equipment into the outstretched arms of adoring parents. Illustrations and articles celebrating the virtues of labor or the promise of American ingenuity supplemented these powerful affirmations of the Victorian cult of domesticity. In very few of these literary or pictorial depictions are there any acknowledgments of the contentious politics of the Reconstruction or the deep racial divisions affecting American life. Instead we find images of a regenerated people attracted to visions of themselves as unified and progressive in historical outlook.

The frontispiece to *Leslie's Historical Register* provides a good example of the sentimental character of its creator's unifying impulses (fig. 50). Representatives from ancient civilizations surround a female personification of Liberty (the Columbia figure) on a mountaintop and reveal to her the panoramic majesty of the future of American commerce. A supplicating Indian points west (significantly) toward a sequential

display of innovations in transportation and communication, including the clipper ship, the steamboat, the telegraph, and the train. Leslie's use of the convention of elevated perspective, deriving from the epic poetry of Joel Barlow and before that the Bible, indicated his sincere belief in the transcendence of the American experience as well as his more calculated manipulation of symbolic figures associated with the lingering role of allegory and sensationalism in the American historical imagination. Leslie exploited such iconographic images by using them in colorful posters scattered throughout his pavilion as well as in an ingenious souvenir lottery ticket system to sell subscriptions to the "sumptuously illustrated" *Historical Register*. He did a brisk business in this pictorial trade, too, until he was shut down by a commission agent who viewed such blatant huckstering as an improper use of Leslie's authority as New York's state commissioner.[10] An ensuing disagreement over Leslie's rights in the matter led to a libel suit in which the plaintiff won a decision against the publisher, contributing to the "significant loss" Leslie eventually experienced in connection with the *Historical Register*.[11]

Concerns about Leslie's self-promotional methods went beyond legal disagreements over his advertising techniques. To some Leslie's vision of a unified centennial culture was as irresponsible as it was inaccurate, because it was based on false and misleading assumptions about the solidarity of American life. Accused as he had been earlier of having more interest in selling papers than in documenting events precisely, Leslie was linked to an insidious "new pictorialism" that was condemned by its critics as "too sudden, too comprehensive, and too appealing" for popular readers to resist.[12] Whereas the use of visual allegory had been accepted in the 1850s as a legitimate device for conveying the moral value of the past, by the 1870s it was viewed by some as a surreptitious way

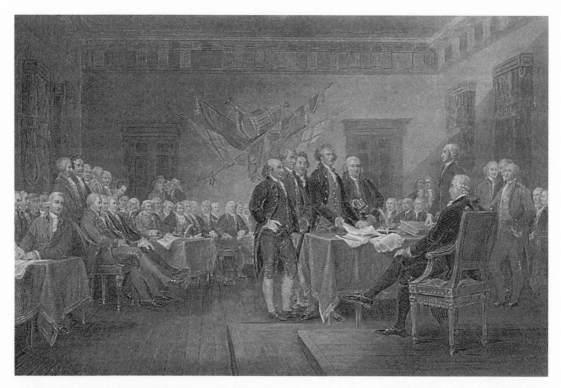

Figure 51. "The Declaration of Independence," 1876, engraved by W. Greatbach from the painting by Jonathan Trumbull for James McCabe's *Centennial History of the United States*

of entrapping vulnerable readers into a naïve historical complacency. Allegorical images were still acceptable when they were used in the cause of political satire, as in the cartoons of Thomas Nast, but heavy-handed sentimentalism of the blindly nationalizing sort in which Leslie dabbled bothered critics who wished to confront more directly the post–Civil War tension between "the comforting convenience of amnesia" and "the imperative of remembering."[13] What was needed in the estimation of this group was a more frank and sophisticated understanding of the meaning of the recent war and a greater willingness to confront in pictures and print the sometimes-brutal realities of life in the last quarter of the nineteenth century.

One of Leslie's strongest rivals was James McCabe, a writer and publisher who contributed two works to the genre of illustrated centennial histories, both produced by the National Publishing Company. McCabe was a Virginian who was not afraid to find faults with Southern leadership during the Civil War, especially with Jefferson Davis, whom he blamed for the downfall of the Confederacy. In both the *Illustrated History of the Centennial Exhibition* and the *Centennial History of the United States,* McCabe lashed out as well at sentimentalists such as Leslie who employed "unsatisfactory" methods in their efforts to "popularize the story of the nation." Dedicated to neglecting "nothing that could in the least contribute to a clear and comprehensive understanding of the subject," Mc-

Cabe marketed his histories as honest assessments of the virtues and faults of the nation. Like Leslie, McCabe endeavored "to write from a broad national standpoint" and to cultivate in his readers "a feeling of national patriotism"; but unlike Leslie he urged the "fairness and accuracy" of his narrative.[14] "Old, Incomplete and Unreliable *Histories of the United States* are being circulated," McCabe warned would-be purchasers of centennial histories, urging them to buy only those summaries of the nation's first century that exhibited "strict fidelity to truth," as he believed his own did.[15] He was especially cautionary in his pronouncements on illustrations, imploring readers to avoid any volumes that did not "admit the truthfulness of the picture herein presented."[16]

McCabe was less successful than either Devens or Leslie, however, in attracting a wide audience to his centennial books, a circumstance that raised again the question of whether realism was a literary strategy that could ever be popular. In speaking frankly to the American people about the urgent need for "the settlement of our national troubles," McCabe overestimated perhaps their willingness to engage in a dialogue of self-recrimination as encouraged by the frank political assessments in the *Centennial History of the United States*.[17] McCabe's text also failed because of the modest literary abilities of its author. His volumes were bland in comparison with the competition and redundant with respect to each other, and despite his claims to accuracy, McCabe made little effort to identify his sources or verify his authorities. The illustrations were also rushed and inadequate, Estelle Jussim describing those in McCabe's *Illustrated History of the Centennial Exhibition* as "crude" and unfocused, with details "largely abandoned to a symbolic, generalized, and schematic rendition." Jussim condemned in particular the "hack work inflicted on Eastman Johnson's 'Old Kentucky Home,' or Alma Tadema's 'The Vintage

Festival'" by the National Publishing Company's engravers and complained about the "low standards" of their reproduction of Trumbull's *Declaration of Independence* (fig. 51). In this overdrawn image "the codes are so conspicuous that almost every surface is rendered in crosshatched, parallel diagonal lines of high visibility," she wrote.[18] Illustrations of the Philadelphia Exposition recycled from earlier McCabe volumes were inappropriately placed throughout the text as well. Hence, the author's discussion of the organization of North American Indian tribes in the seventeenth century was paired inexplicably with a picture of the International Exhibition in the centennial grounds (with German subtitles, no less!), borrowed from a foreign edition of the *Illustrated History of the Centennial Exhibition*.[19]

The recycling of images in McCabe's volumes also called into question whether or not even the most "realistic" depictions were trustworthy when taken out of context. If McCabe viewed the "objectivity" of his pictorial histories as a necessary corrective to the sentimentality of those by Devens or Leslie, he could not have been reassured by the use made of his prose and images in derivative books published later by the National Publishing Company. Hoping to capitalize on the southern market for pictorial volumes on the centennial, for instance, National convinced former vice president of the Confederacy Alexander H. Stephens to write a *Pictorial History of the United States* using McCabe's volumes as explicit models. The publishing firm and Stephens hired six secretaries to create the spin-off volume, appropriating numerous format features from McCabe's *Centennial History* such as chapter titles, footnotes, and illustrations to facilitate the transition. In addition Stephens borrowed specific literary passages from McCabe's texts, altering their bipartisan perspectives and occasionally their content in a manner so indiscriminate as to discredit both

works.[20] Hence, the discussion of the coming of war in chapter 26 of Stephens's pictorial history ("The Administration of James Buchanan") mirrors paragraph by paragraph McCabe's treatment of the same evolution of events in his chapter 40 (also titled "The Administration of James Buchanan"), with the important exception that Stephens attributes the Civil War to misunderstandings about slavery, whereas McCabe adopts a more conventional political assessment of the dangers of radicalism. Stephens argued that Southerners were forced to secede from the Union by "Northern agitators" such as Horace Greeley, who, in "control of the ablest paper of the anti-slavery party of the United States, the New York 'Tribune,'" used "the most exciting, extravagant and incendiary language" to bait those south of the Mason-Dixon line into war. This discussion was accompanied by a curiously flattering engraving of a portrait of Greeley, an incongruity explained by the fact that the illustration was borrowed from McCabe's *Centennial History*, where the author had used it to supplement his description of the editor as a "generous" and "intellectual" editor who was a "true gentleman at heart."[21]

Similar incongruities emerged from other misappropriations of engravings and texts between the two volumes. To illustrate incidents from the Civil War, for instance, both Stephens and McCabe relied on battlefield sketches from pictorial newspapers such as *Frank Leslie's Illustrated* and *Harper's Weekly*. A sketch such as Alfred Waud's "Battle of Gettysburg," celebrating the breaking of the Confederate lines by Union forces on the last day of fighting in July of 1863, was integrated easily into McCabe's narrative on the "decisive victory" of General Meade at Gettysburg. The same pro-Northern illustration proved inappropriate, however, when National Publishing recycled it for use in Stephens's pro-Southern volume celebrating the invincibility of Confederate troops at Gettysburg.[22] Ad-

mittedly, the publisher was handicapped somewhat by the lack of pictorial depictions of the war from a Southern perspective, but his decision to use Waud's engraving without alteration created a jarring discrepancy between word and image in the *Pictorial History of the United States*.[23] Stephens resented this dependence on Northern sources as well, and whenever he was forced to rely extensively on such works, he apologized for their inclusion, undercutting the authority of volume in the process. Convinced by his editors of the need to quote at length from John Laird Wilson's Unionist narrative, the *Pictorial History of the Great Civil War*, for instance, Stephens did so begrudgingly. "We here omit some sentences in Wilson in this connection," Stephens noted in one such passage concerning the Battle of Gettysburg, "because we do not think he deals with his usual accuracy in details, especially in reference to the North Carolina forces under Pettigrew. It is due to the memory of these brave men that it should be recorded that at this juncture, when the brunt of the battle for a time fell mainly upon them, and after their ranks were decimated and their gallant commander wounded and borne from the field, few troops ever met the tide of unequal conflict with more valor than they did."[24]

These discrepancies point out that pictorial histories published during the centennial employed a wide array of word/image combinations for narrating the past, ranging from the minimalist approach of Devens to the flamboyance of Leslie to the politicized propaganda of McCabe and Stephens. Each of these works was marred in one way or another by the failings of their authors, illustrators, and/or publishers. Yet the sheer number and variety of such illustrated books confirmed the popularity of the pictorial form. No longer needing to convince readers of the efficacy of using pictures to tell the story of the past, the challenge for publishers was now to find the pictorial

strategies best suited to avoiding the inadequacies of form that blemished many illustrated volumes. Devens, Leslie, Mccabe, and Stephens all recognized the need to eschew the high sentimentality of the pre–Civil War period and to rely on more subdued forms of realism in their graphic and literary representations. Yet each also understood that a mere collection of facts, no matter how competently and clearly presented, would not be acceptable as history to audiences requiring narrative and pictorial prompts. History as a discipline had become self-conscious enough to guard against overreliance on sentimental effusions, but at the time of the centennial readers demanded still that concessions be made to their preferences for visual literacy. Given these conditions of readership, it is not surprising that the best selling of all centennial histories was one in which an author and an illustrator merged sentimental and realistic forms into a new hybrid of pictorial presentation. What is surprising, however, is that it was Benson Lossing who accomplished this task first and most thoroughly.

A Story with a Dash

The opportunities presented by the centennial for making money and establishing a literary reputation were not lost on Benson Lossing, who continued to tinker with the pictorial form throughout the 1870s. Some of his efforts were purely derivative and seem to have been motivated solely by pecuniary needs. Hoping to pour old wine into new skins, for instance, Lossing petitioned several publishing companies for the chance to produce updated centennial editions of his preexisting works. In 1874 he convinced Sheldon and Company to adapt for the centennial market *An Outline History of the United States, for Public and Other Schools,* which he had written in the 1850s. His emen-

dations were largely visual, the publishers noting in their advertising circular that the new edition was marked by an "elegance of appearance and copious illustrations of the text, both by pictures and maps." Young readers in particular were assured that in Lossing's works "ideas are not smothered in words" but rather are presented in attractive visual packages that facilitate learning. Lossing's historical assessments were more "easily comprehended by an ordinary effort of memory" in the present version, Sheldon's marketers claimed, because the "impress of vision" gave the mind a "powerful aid to the retention of facts." Because "the eye seldom forgets," the circulars added, students of American history could expect to "learn more effectively."[25]

In other cases Lossing sought commissions for original publishing projects, including a history of America to the centenary with special attention to the activities of the Philadelphia Centennial Exposition. This idea came to fruition when a Philadelphia firm, Porter and Coates, approached Lossing about writing and illustrating a volume to be titled *The American Centenary.* This innovative publishing house, best known for its later publication of the popular Horatio Alger novels, sought to secure an "official endorsement by the Centennial authorities" for the projected work as early as 1873 and solicited Lossing's services as primary author several years later. "Knowing that you will not despise the position of *official* historian of the country's Centenary," Porter and Coates appealed to Lossing's vanity, "it is our purpose to make the work a credit to all concerned & we should be glad to have your assistance there- in."[26] Lossing agreed to take on the work, despite the fact that he was involved in several other centennial projects as well, including a *Centennial History of the United States* for the Belknap Press of Hartford.[27] Such work obligated Lossing to a rigorous writing schedule, and in-

sofar as he illustrated the majority of these pictorial histories as well, he was kept busy both at his writing and drafting tables until the very eve of the celebration. By his own account he worked fourteen hours a day, seven days a week for seven solid months, a pace he later claimed took a toll on his health and his pocketbook.[28]

If Lossing hoped for adequate compensation for his efforts, he was disappointed, because these centennial works proved far less successful in either financial or intellectual terms than he had expected. Readers perceived correctly that such histories were largely repackaged versions of earlier works, one reviewer calling the Belknap volume "a popular subscription book along old lines" with "no especial feature of merit aside from the profuse illustration." The constant recycling of words and images in Lossing's texts branded him "superficial."[29] In addition, Lossing's style of illustration had not changed appreciably since the publication of the *Pictorial Field-Book of the Revolution* twenty-five years earlier, his literalness threatening him with obsolescence at a time when the power of the visual was increasing. Finally, there was something missing in these and many other of Lossing's histories (with the possible exception of the *Pictorial Field-Book of the Revolution*); namely, the human element. Overcommitted to realism as a literary strategy, Lossing seemed too detached and objective to readers who had grown dissatisfied with sentimentality but who still required some emotionalism in their historians.

Nothing if not determined, Lossing refused to withdraw from the centennial market despite the failures of his Belknap, Sheldon, and Porter and Coates volumes. Indeed, while he was at work on these projects, Lossing also contracted for a three-volume centennial history with Henry Johnson titled *Our Country: A Household History for All Readers.*[30] Having been impressed with Lossing's diligence ten years earlier in his work on the updated version of Spencer's *History of the United States*, Johnson now proposed a new pictorial format that he hoped would bring substantial financial remuneration to both author and publisher. In Johnson's estimation the failure of most centennial works was that history could not "illustrate itself by example," as Devens had hoped, but must be helped along in its task by original artwork that went beyond the mere embellishment of texts to an active engagement in the themes and story lines of historical narrative. In this sense Johnson desired to find an artist for the project who was as much a storyteller as any writer, one who could interact with his author in a thoroughly collaborative manner and who could use pictorial images both to depict and dictate to the text at appropriate times. The distinction was between illustrating only in response to the prior literary assertions of the historian and illustrating in advance of them. In one sense Benson Lossing had come closer than anyone to realizing such a thoroughly collaborative arrangement when he combined the functions of author and illustrator in his field books, but Johnson now sought a pictorial presence with a wider appeal to the masses than Lossing had enjoyed, one that could move the stark realist in directions more closely related to the middle-class needs of late-nineteenth-century audiences. Instead of culling secondhand illustrations from previously printed sources or relying on workers in "Chappel's factory" to redraw from established historical paintings as he had in the Spencer volumes, therefore, Johnson hired an illustrator who would contribute not just a new style of art but a new relationship between author and illustrator. This artist, F. O. C. Darley, was commissioned to produce five hundred original line drawings that would complement and anticipate Lossing's prose work in revealing ways.

Figure 52. "The Legend of Sleepy Hollow," 1849, by F. O. C. Darley for the American Art-Union

In selecting Darley to illustrate *Our Country*, Johnson chose one of the most highly regarded American artists of the 1870s. Like many other prominent illustrators before and after him, Darley was from Philadelphia, where his parents, both actors, exposed him to literature and the arts at a young age. A precocious reader and drawer as a child (his parents dubbed him "a junior Michelangelo"), Darley developed a reputation for depicting "climactic moments of the stories and novels that he was later commissioned to illustrate."[31] Self-taught, he received appointments to illustrate while he was still in his late

teens, including a contract to produce pictures on Indian subjects for several of John Frost's pictorial works. He was hired soon after to produce a series of black and white line drawings of Indians used in several "Mercury Stories," "tawdry sensational" volumes that were precursors to dime novels, and to illustrate a series of folk tales for the *Library of Humorous American Works* after the vernacular manner of William Croome in the Crockett almanacs.[32] Unsophisticated and overly theatrical though these illustrations were, they revealed a commitment to precise anatomical form that was highly valued at midcentury. Darley

often used family members or even his "life size 'lay doll' or wooden model" (named Dorothy) to lend precision to his figural drawings.[33]

Darley's success in these early efforts put him in greater demand for work in the field of book illustration, and in 1848 he moved from Philadelphia to New York, where he set up a studio in the heart of the book publishing district at 102 Twelfth Street. One of his first commissions in New York was from the American Art-Union to illustrate in black-ink-line technique two of Washington Irving's most popular tales, *Rip Van Winkle* and *The Legend of Sleepy Hollow* (fig. 52).[34] He performed this task admirably, revealing in his "outline sketches" the rudiments of a linear style that would become his trademark as a mature illustrator. On the strength of these results, G. P. Putnam asked Darley soon after to elucidate the text of *Knickerbocker History of New York*, published in 1850. Irving was delighted with the product, explaining to his brother Pierre that of all those who had attempted to capture the sardonic essence of the narrator Knickerbocker, only Darley "hit it." John Wesley Jarvis "tried but failed to embody my conception of Diedrich Knickerbocker," Irving noted; Robert "Leslie also." But Darley understood that Knickerbocker was "profoundly impressed with the truth of his own history" and depicted him appropriately as a self-important meditator on the philosophical meaning of the American past.[35] A reviewer for the *London Athenaeum* agreed, proclaiming that Darley's Knickerbocker illustrations were inspired by pictorial genius and revealed "a relish of what we have so long desired to find—a national manner." A uniquely American way of seeing was evident in Darley's illustrations, he argued, the artist's "figures and fantasies . . . referable to no other than the text which they illustrate." Less satisfied with the "mannerism" of the "handwork of the interpreting engravers," the British reviewer exonerated Dar-

ley of responsibility for the errors of these copyists, concluding that the original drawings were as precise and inspired as any viewer could desire.[36]

By the early 1850s Darley's reputation for pictorial excellence had increased substantially enough to garner him an invitation to membership in the Century Club of New York, where he mingled with Cooper, Irving, and Bryant.[37] Darley's acceptance into the club was in recognition not only of his immense talent but also of the growing credibility of the graphic arts in the intellectual world of the mid-nineteenth century. As a result of these associations, Darley received numerous commissions for illustrating the works of club members, such as the complete works of William Gilmore Simms or Nathaniel Hawthorne's *Scarlet Letter*, the latter of which he undertook despite its reputation for being a novel difficult to illustrate due to Hawthorne's concern with "inner rather than with outward things" and in which "spiritual development was of more concern than situations or events."[38] A still bigger break came for Darley when he was asked by W. A. Townsend Company to illustrate the collected works of James Fenimore Cooper.[39] Darley's special skill with Indian subjects and his growing reputation as an authority on historical figures made him a natural choice as illustrator of Cooper's works, which were themselves declared "A Monument of National Art." If some have gone too far in claiming that Darley's illustrations actually made the literary reputations of writers such as Irving, Simms, Hawthorne, and Cooper, there is substantial truth to the argument that "Darley brought good fortune to the writers whose work he illustrated." There can be no denying that the writings of America's best authors, "when linked with Darley's drawings, interested more readers than when Darley was absent from their pages."[40]

Commissions for illustrations of historical fiction by Darley led eventually to requests for pictorial elu-

cidations of nonfiction subjects as well. The firm of W. H. Holbrooks, for instance, contracted with the artist to draw scenes of the American Revolution, including *The Massacre of Wyoming, The Battles of Lexington, Concord, and Bunker Hill, The Last Words of Captain Nathan Hale, The First Blow for Liberty,* and *The Triumph of Patriotism.*[41] These illustrations were sold as independent lithographs and were often reproduced in pictorial histories. A reviewer of *The Triumph of Patriotism* noted that the representation of Washington was not only the "crowning achievement of Darley's pencil but is generally conceded to be, also, the best of Washington yet produced."[42] The growing number of companies specializing in lithography, including not only Currier and Ives and Holbrooks but also Endicott and Company and Louis Prang and Company, provided steady work for Darley and other lesser artists specializing in works adaptable to the illustrated book market. Like Lossing and Chappel, Darley did some illustrating of battle scenes during the Civil War as well, although he did not often go into the field as "Special Artists" had done, choosing instead to work from verbal accounts of battles and anecdotes of war. An admiring reviewer of one such studio-generated illustration of heroism at the Battle of Fredericksburg wrote, "It is remarkable evidence of Darley's skill that this effective scene was designed entirely from the verbal description of a newspaper correspondent; and yet so true in detail to fact is the drawing, that we have heard the young hero himself, when beguiling his convalescence after the loss of his limb, by examining a photograph of the sketch, attest the accuracy with which the artist's imagination has caught and embodied the local and personal facts."[43]

Perhaps the strongest indication that Darley had made it as an illustrator and artist was the fact that Henry Tuckerman featured him in his *Book of the Artists* (1867), a work celebrating the achievements of America's premiere portrait, genre, and historical painters. "We have had nothing in this style of art to compare with the exquisite and impressive drawings in which Darley has embodied his sense of the beauty, power, and truth of that remarkable fiction," wrote Tuckerman, who admired especially the "facile power" and the "original and vivid sense of the humorous" in Darley's work. Darley "tells a story with a dash, reveals a character by a curve, and embodies an expression with two or three dots," he added, noting that the artist was especially well suited to the depiction of American historical subjects. Darley's decision not to study in Europe but to focus his attention on American historical genre scenes was, in Tuckerman's estimation, "not less wise than it was patriotic" because his talents "have been in constant requisition" by his countrymen, "his progress regular and rapid, and his prosperity assured."[44] In fact, Darley's work earned him substantial financial returns, certainly the highest commissions paid to an American illustrator after the Civil War. In the 1840s Darley received only about seven dollars an illustration for original compositions, less than Croome or Lossing received; by 1861 he was getting forty-five dollars per design for illustrations requiring little original thought. He was so much in demand as an illustrator that he had the rare luxury of being able to work free-lance, juggling projects in accordance with his own schedule and changing intellectual interests.[45]

Darley's affiliation with Lossing began in the late 1860s, when he was asked by Belknap to do a few illustrations for the *Pictorial History of the Civil War.* Although these pictorial representations were not distinguished, they spawned a professional relationship between Lossing and Darley that crystallized when Johnson hired the latter to illustrate *Our Country.* The publisher had good reason to expect that Lossing and Darley would collaborate well, because they shared so

many assumptions about the writing and illustrating of history. In the preface to the work, for instance, Lossing paid tribute in pictorial language to the mutual respect he and Darley had for historical accuracy in depicting the past. "In the preparation of this work I have availed myself of all new revelations concerning the history of our country made by recent investigations, which have fallen under my observation," he wrote, "and I have endeavored to make it a faithful picture of the republic in all its phases, without any exaggeration in outline of coloring. In this labor I have been only seconded by Mr. Darley, the eminent American artist, who has, in every drawing illustrative of the text, consulted the best authorities for the portraiture and costume, and followed their teachings. His spirited sketches of a vast number of events in our history, are, therefore, stamped with the insignia of truth, and are positively useful, not only on artistic embellishments, but as safe instructors." Lossing and Darley even broke ranks with other illustrated historians by praising mutually the labors of those engravers who translated Darley's images onto the block. "To these gentlemen, and to the generous liberality of the publishers in bringing out the work in a style of great elegance and costliness, the reader is largely indebted for the pleasure and instruction which these volumes may afford," Lossing wrote.[46]

Yet Darley's association with *Our Country* was not without its strains for Lossing, and vice versa. The fact that he had always illustrated his own works had been a source of pride for Lossing, and the compatibility of words and images that derived from that consolidation of tasks long had been a selling point for his volumes. Having an artist such as Darley illustrate *Our Country* meant not only a separation of these functions but also an admission on Lossing's part that his own work as an illustrator was not sufficient for attracting readers. Because Lossing had been largely

self-taught, he was sensitive to the criticism that he was not a "trained artist," but his failures in this area were perhaps less a function of preparation than of an inability to adjust his reportorial style to the demands of readers for more exuberant pictorial formats. As Lossing explained to Evert Duyckinck, Darley's "very spirited" pictures eclipsed those of any contemporary illustrator, including himself, and justified his decision to put down his sketching pencil and graver in favor of the historian's pen.[47]

The danger to Lossing of relinquishing the role of illustrator in *Our Country* to someone as prominent as Darley was the risk he ran of losing control of his own project. By the 1870s editors at publishing houses that produced weekly and monthly pictorial magazines were often more familiar with illustrators than they were with authors, and in making decisions about the size and scope of pictorial works, they often consulted the former before the latter. In some cases they treated the author as completely subordinate to the illustrator, as when publishers hired Darley to create illustrations for texts that had not yet been written. Inverting the customary relationship between producers of words and producers of images, such a prioritizing required authors to conform their literary imaginations to the visual precepts of the artist, an arrangement writers were often reluctant to accept. In still other cases Darley's visual depictions so overshadowed an author's narrative as to undercut the reputation of both writer and artist. For instance, Henry Tuckerman argued that Darley's drawings for Sylvester Judd's novel *Margaret: A Tale of the Real and the Ideal* "would have [had] a world-wide celebrity" if they had not thrown into such high relief by their own magnificence the glaring inadequacies of Judd's writing.[48] And sculptor John Rogers dismissed the idea of creating a plaster grouping based on *The Legend of Sleepy Hollow* because he did not feel

he could compete with the powerful visual images Darley had fixed in the popular mind. "Darley seems to have illustrated it so completely that I am afraid I can make nothing original out of it," he wrote.[49] A reviewer for the *Democratic Review* summarized this intimidating presence by noting that the narrative texts of any works pictorialized by Darley must be presumed to be only "a string for the pearls" that were Darley's illustrations.[50]

Lossing was not one to stand idly by spinning the string for someone else's pearls, of course, but he accepted Darley's presence from the start of the enterprise as a concession to the new and unavoidable obligations of diversification of function in the pictorial history market. Johnson expected that the two might prove compatible in their work on *Our Country*, as both had considerable experience with historical narration and illustration and both had incentive for the project to work. Indeed, the earliest in-house transmissions between publisher and editor indicated high optimism for a smooth relationship. "The copy of the MSS [chapters 4 and 5] has just been finished," Johnson noted, and "we have a number of blocks ready for Mr. Darley, whom we expect in town next week." The key, Johnson foresaw, would be in coordinating the timetables of writer and illustrator, because the serialized format for the volumes required a regularized schedule of production—sixty sections of exactly thirty-two pages each illustrated with a uniform number of drawings. Despite the challenges that such a precise arrangement presented, the publisher expressed optimism about the chances of Lossing and Darley functioning well. "We feel assured that both Author and Artist will work harmoniously and effectively together," Johnson wrote at the outset of the project.[51]

But difficulties emerged from the beginning of the project, mainly due to Darley's schedule. The artist was even busier than Lossing in the mid-1870s, and he was slow to complete his drawings for the early chapters. Having been commissioned to produce more than five hundred illustrations for *Our Country*, Darley found the task too ambitious for the time allotted, and he requested several extensions. Continuances were granted, and still Darley delayed, missing meetings and generally frustrating the editorial staff at Johnson's.[52] When Lossing complained about the postponements, he received the following advice from an engraver on the project who understood well the temperamental nature of illustrators who dictated more and more to publishers and writers: "I have your letter of the 31st March, and regret more than I am surprised at Mr. Darley's failure, to keep his appointment," wrote Gouverneur Kemble. "All artists are apt to be fitful in their movements and the weather in January was sufficient reason to keep a nervous man at home, but now that the snow is vanishing into the ground without a trace behind, if he promised at all, I think we may look for him. I shall therefore leave the door latch on the outside, to be ready when you come day or night, you will find the house open."[53] By December 1874 chapters 9 and 10 of the first volume were done and circulars had gone out to advertise the work, but still the illustrations were lagging. "We have received no fresh drawings from Mr. Darley since our last communication to you," Johnson wrote, "but expect another lot very shortly. The general impression among those who are informed of the new Book is that it will be a timely and very successful venture," he noted, although in lieu of the completed illustrations he added guardedly, "We shall see."[54]

By late May 1876 the troubles in coordinating the schedules of Lossing and Darley led to some urgent requests from the publishers. Both author and artist had asked for a delay in their work schedules to go to Philadelphia for the centennial celebration, and Johnson rankled a bit at the further suspension of work.

"We shall have ready in a few days impressions of cuts for two more chapters (35 & 36)," the editor wrote Lossing, "and as S & McD [the electrotypists Smith and McDougall] are right on our heels, we would propose that you take the MSS of above chapters with you to Philad. and we can forward the impressions to you there when you can arrange them and return them to us—In this way we can keep S & McD. moving."[55] Meanwhile, Darley was distracted by the need to complete two paintings he was exhibiting at the Philadelphia Exposition as well as by Johnson's demand that he use more rapid techniques of illustration with which he was not completely comfortable.[56]

For most illustrated book projects, Darley produced preliminary pencil or pen studies from live studio models that he then refined in subsequent black and white renditions, and only the most polished of these would eventually be translated to a wood block or steel cylinder by a skilled engraver. If one compares the few preliminary sketches still extant of historical subjects created by Darley with the finished illustrations produced in a work such as *Our Country*, it is clear that as an artistic draftsman Darley had an exceptional sense of proportion and line. But the sheer volume of the illustrations for *Our Country* and the accelerated pace of publication required him to draw some of his images, in reverse, directly onto the woodblock surface rather than on the sketchpad. This was a somewhat faster way of working, eliminating as it did the obligation of the engraver to reproduce the artist's sketches faithfully, but this direct-drawing technique diminished the freedom of Darley's pencil, constrained as he was by the scale and the surface of the actual block. Not only did he have less opportu-

nity to make changes to his images on the block, but his drawings were effectively "destroyed during the engraving process," leaving no opportunity for later alterations.[57] Such "on-the-block" work was not easily accomplished even when Darley was at home in his studio in New York; it was nearly impossible while the artist was on the road or in Philadelphia. The result was further delays.

Even when Darley had the time to return to his studio to complete his on-block drawings, he was still handicapped by the many details that needed to be conveyed to the engravers working on the project. Proofs of wood engravings from *Our Country* that have survived indicate that Darley provided engravers with detailed instructions regarding every facet of the process. "I wish [the engraver] would make the upper part of these men much lighter," he noted of one such illustration. "Reduce the size of the head to where I have marked it. Take out the upper line of both eyebrows." On another sketch he commented with niggling attention to detail: "Put in the lights on the pupils of the eyes as I have marked them."[58] In other instances he required engravers to make last minute changes after the etching process had been completed nearly, noting where an area was inappropriately cut and recommending a "plug" where a passage of the illustration was particularly rough.[59] And Darley was very direct with publishers about which engravers he preferred to see complete the majority of the illustrations in the text. Pleased with the work of A. Bobbett in engraving "Thanksgiving Before the Image of the Virgin," Darley wrote Johnson, "This is the best engraved so far and quite satisfactory. I should like the engraver of this to do as many of the larger blocks as possible" (fig. 53).[60] So diligent was Darley in these matters, in fact, that the publishers felt obliged to check nearly all alterations with the artist personally, causing further delays in production.

As difficult as Darley was, Lossing proved no less challenging to his editors. Apart from the distractions of working simultaneously on an *Outline History of the United States* and *The American Centenary*, Lossing was unusually slow about getting the manuscript of *Our Country* to Johnson. Part of the delay came from his decision to compose more original prose for this volume rather than to rely so heavily on recycled materials from earlier volumes. This resolution obligated him to a more arduous research and writing schedule, and he continued to scour libraries and archives for information long after the investigative phase of his work ordinarily would have been completed. In addition Lossing made constant revisions to his text, often at the last minute and in unsystematic ways. As one beleaguered archivist later put it in describing the anarchy of Lossing's papers related to the project,

Lossing's MSS, comprising some 20,000 pages of minute & much patched writing, offer mute evidence as to the intelligence and long suffering patience of the nineteenth century printer. This author, who must have worked with scissors and paste pot always at hand (at least for revised editions) performed miracles of cutting, piecing, and inserting. Often single octavo sheets are pasted end to end, sometimes reaching a yard or more in length and are then rolled or folded. To such a roll may be added footnotes, which usually are written in a smaller script with colored ink on small scraps of paper tacked on here and there, with the utmost abandon. Lossing was a master also in the elaborate use of the arrow and caret.[61]

Despite all these challenges, however, Lossing and Darley were able to coordinate their schedules sufficiently to finish the three-volume edition of *Our Country* by 1878. And the advanced sales of the work were highly encouraging, justifying Johnson's faith in the Lossing-Darley team. Door-to-door salesmen found American consumers more than anxious to subscribe to a project of such noticeable high standard, selling in sixty parts at reasonable price of twenty-five cents

per installment.[62] In a letter to a personal friend Lossing noted with unbridled enthusiasm that the "publisher (Mr. Johnson) came up and spent a Sabbath with us not long ago, when he told me that they had between 40,000 and 50,000 subscribers to the work, and the number is continually increasing. Other publishers consider the sales most extraordinary at this time."[63] By September 1877 estimates were running well over fifty thousand, and by March of 1878 Lossing revealed that Johnson had printed over seventy thousand copies, "apparently knowing they could dispose of them."[64]

These exceptional sales figures raised some interesting questions about *Our Country* and the genre of pictorial history. What sold these volumes and why were they more successful than other competing centennial histories Lossing and others had produced? Was it Lossing's fresher prose? Darley's skillful illustrations? Or Johnson's aggressive advertising? In some ways, the success derived from a combination of all three of these forces coalescing in the development of a new hybrid form of pictorial history.

Humanizing History

Pre-publication brochures and the salesman's dummy for *Our Country* issued by Johnson to his agents (complete with snippets from Lossing's preface and samples of Darley's illustrations) gave the public its first exposure to an emerging model of historical realism. Lossing had long ago rejected Jesse Spencer's brand of sentimentalized history in which the historian "portrayed incidents of actual or fictive history involving significant identifiable personages" in a manner "large in scale, lofty in tone, noble in expression, and didactic in intention." His preferred alternative was to emphasize the historicity of the past, and he grounded his narratives in the language of "objective truth" and "ac-

curacy in the details."[65] He agreed with realists such as Henry Dawson that historians "must be accurate to a gaiter-button of a fibula" when describing artifacts like George Washington's uniform, "small accuracies" serving "as guarantors somehow of the truth, metaphors for the concept of historical objectivity itself."[66] This trend toward realism that swept through nearly every branch of literature in the late nineteenth century was especially noticeable in the field of history, where a growing belief in scientific positivism encouraged historians to make "objectivity" their mantra. Realist writers were presumed to make better historians than most other authors because they shared in common with students of history a commitment to the supplanting of "the world of chimeras and fantastic forms by a world of stiff, stubborn, angular facts" that one could "neither bend nor mold."[67]

Dawson and Lossing were part of a larger movement within the field of history dedicated to proving that the literature of "veracity and realism" was a "healthy alternative" to the "intellectual impotence and intellectual inebriety" of sensational writing. Although they had strength of conviction in these matters, their concerns about the addictive qualities of sentimental prose proved insufficient to assure the commercial success of an alternative historical literature in the high realist vein. Ironically, in fact, the realists who feared the emotional experiences associated with "enthusiastic" reading often undercut their own potential for popularity by rejecting the very dependencies that drove a profit-motivated consumer book culture. The dilemma for historians was that the pursuit of sober accuracy in the name of realism might doom a work to obscurity among readers more accustomed to the historical romances of Sir Walter Scott than the monographs of Henry Dawson. With self-righteousness, Dawson rejected the "set of pleasures" associated with sentimentality and with terms

such as "romance, adventure, and even history"; but it was Scott who sold volumes to American readers.[68]

One solution to overcoming this dilemma was the creation of a new style of realism that acknowledged the needs of readers for more than overwritten depictions of glorious historical events or exaggerated portraits of luminaries such as Washington and Lincoln. Lossing and others gradually came to recognize that American readers wanted stories and illustrations about people like themselves who acted in mortal rather than Olympian ways. Realism in this case meant realizable. This appreciation for the everyday life of average Americans, particularly the daily triumphs of the middle-class citizens who made up a large portion of the reading public, mirrored larger market forces at work in the general culture and represented an important turning point in the history of pictorial works understood as consumer items. In the wake of this recognition among historians, grand assumptions gave way to "smaller, more easily comprehended areas of one's own backyard," as regional idioms and local history increased in importance. The pictorial historian's greatest challenge became to depict average people in "unmonumental acts of living," investing history with "emotion without indulging in sentimentalism." The goal, in short, was to humanize the past.[69]

A pamphlet provided to book agents marketing *Our Country* titled *Biographical Sketches of Benson Lossing, LL.D., Author, and Felix O. C. Darley, Artist* gave important insights into how this new humanistic realism would be achieved. Recognizing that the family was the most basic social unit in America and the one to which the average American could best relate, Henry Johnson centered his advertising around portraits of Lossing and Darley as family men with interests in domestic values. Lossing was described as a sensitive "*pater familias*" whose book would be "es-pecially valuable to parents" because it was "calculated to inspire a love of reading" in children while "re-establishing the waning patriotism of the age and implanting in the minds of our youth the stirring incidents of our history." Evoking the memory of Samuel G. Goodrich, Johnson's ad men noted that "no writer since the days of Peter Parley has so completely won the hearts of the young" as Lossing. And Darley was celebrated as an artist whose name was itself a "household word," Johnson's brochure noting that "it would be difficult to find a homestead into which the light of his genius—in book, magazine, sketch or picture on the wall—had not entered and found a genial welcome."[70]

The text of *Our Country* reaffirmed these familial values, Lossing structuring his history around themes of ancestral legacy, generational relations, and domestic tranquility. In Lossing's narrative, colonies succeeded or failed depending on the strength of their family structures. Settlers in Jamestown sought "private adventures, or commercial associations, with no higher aim than the acquisition of wealth," not realizing that the "prime element of a permanent state—the family" was a necessity. Thomas Weston's corrupt colony at Wessagusett, whose members boasted that they were not "weakened by many women and children," was saved by the Plymouth people, who were led to America by "better men, with more exalted motives" and with families. And in Dutch New Netherlands, "homes," "firesides," and "family altars" were proclaimed "the purest and strongest elements in the foundations of a virtuous and prosperous state."[71] In these "happy homes," Lossing added, children were taught to lead clean and proper lives, enjoying the "fashionable parties" that "began at three o'clock in the afternoon in winter" but always leaving "at six, so that all the members of a family might be ready for evening devotions and bed at seven."[72]

Children were not just important subjects in Lossing's narrative; they were also objects of his campaign to widen the readership for his history. In nearly all of his earlier works Lossing had avoided the kind of dramatic episodes featured typically in juvenile historical literature on the grounds that such sensationalizing distorted history. But in this latest history, he relinquished some of his stark realism in favor of greater theatricality. In the Belknap edition of his pictorial history, for instance, Lossing had made only a feeble attempt to depict Columbus's physical demeanor, noting merely that he was "tall and commanding."[73] In *Our Country*, however, he expanded this modest profile into a fully rendered dramatic portrait of the Admiral of the Ocean Sea worthy of John Frost. Columbus had now become "tall, well-formed, and muscular; long visaged; a face of fair complexion, a little freckled and usually ruddy, but now pale and careworn in expression; an aquiline nose, rather high cheek bones, eyes a light gray; his hair thin and silvery, and his whole demeanor elevated and dignified," wrote Lossing with assurance.[74] In the Belknap edition Lossing noted simply that Columbus "was received with great honors" when he returned to Barcelona with news of his discovery.[75] In *Our Country* this return was transfigured into a triumphant march of Irvingesque proportions, complete with richly dressed Catalonian guards, bejeweled "dusky natives of the West Indies," and "birds of strange and brilliant plumage from the tropical islands."[76]

Such embellishments were supplemented by strong pictorial metaphors used by Lossing throughout *Our Country*. Reminding young readers that the "ingredients of the [discovery] story are highly picturesque," he called their attention to numerous additional "passages which give life and color to the less attractive details, making the whole a fascinating drama." To increase the dramatic effect of his writing,

Lossing experimented more freely with the pictorial mode, employing chiaroscuro and other devices in ways that far exceeded even their usage in his earlier pictorial field books. Lossing also recounted sensational events that would have escaped his stilted pen in years previous, including "wild tales" of "dreadful reefs and stormy headlands stretching far out to sea"; of "a fiery climate at the equator which no living thing, not even whales in the depth of the ocean, could pass because of the great heat"; and of places where "the waves rolled in boiling water upon the fiery sands of the coasts, and that whoever should pass beyond cape Bajador would never return." And in a manner consistent with Devens's *Our First Century*, Lossing focused on the power of nature as a reflection of culture, elaborating on how natural disasters presaged the destruction of European world dominance and suggested the way for American ascendancy. "These were all considered, and made dark shadings to the brighter pictures which faith and hope created" by the discovery of a New World, he concluded.[77]

Such striking literary adjustments reveal the degree to which Lossing was willing in the mid-1870s to expand the form of his work to accommodate a wider array of popular readers. In an effort to accomplish "the difficult desideratum of making American history attractive and winning to children," Lossing even borrowed from some of the promotional conventions of the giftbook tradition while continuing to condemn the excesses of such fancy picture books.[78] He consented to the printing of several deluxe versions of *Our Country*, for instance, including an oversized edition with a lavish embossed cover. He also allowed Darley's illustrations to occupy more space on the printed page for greater visual effect than had been his custom in the pictorial field books. Most significant, he agreed to abandon the scholarly apparatus char-

acteristic of his major works. For the realist who took such great pride in the scholarly rigor of his volumes, it was doubtless hard for Lossing to eliminate the footnotes and concordances that had accompanied his earlier narratives, but he did so to encourage families to read the history together aloud to find in its pages a reflection of themselves. In addition, Lossing softened and simplified the tone of his prose, abandoning the staid and complex realism of his earlier volumes for a lighter, less pretentious style. He dedicated *Our Country* to "the households of our country, wherein private virtue sustains the fabric of our free institutions," adding that his history had been written "in language so plain and in form so simple, that whole households may be interested and instructed by the reading of it."[79]

In increasing the dramatic tone of his history, however, Lossing wanted it understood that he was not writing merely for effect. Drama was inherent in the factual record, he argued, or it was not useful to the historian. "The simple outline picture, when drawn from nature with fidelity, possesses marvelous interest to the student of human nature," wrote Lossing in the introduction to *Our Country*. "The imagination may not conceive incidents more romantic than those which sober truth reveals in the career of men and women who came from Europe to explore and make homes in the wilds of America." Ever the realist, Lossing argued that the impulse to present history in a "more attractive shape" to young readers must be tempered by the need to "produce a faithful picture of the Republic in all its phases, without any exaggeration in outline or coloring." Hence, throughout *Our Country*, Lossing repudiated the assertions of those witnesses to history who distorted the past for the sake of sensation. French chronicler and explorer Father Hennepin, for instance, was too "much given to romancing" and too prone to "permitting the crea-

tions of imagination to be expressed as realities" to warrant much attention from Lossing. Longfellow used too much poetic license in his treatment of the Pilgrims in "The Courtship of Miles Standish" to be accorded the status of a historical poet, Lossing noted, adding that "history gravely tells" a different story of seventeenth-century New England. And as he had in the *Pictorial Field-Book of the Revolution*, Lossing challenged the myth of Jane McCrea, debunking consciously the "tale of romance and horror, concerning the manner of her death," which made for such great storytelling but not for "truth in history." The pattern Lossing adopted in dealing with all these sources was to balance honestly the desire for dramatic literary representation with the need for accuracy of historical detail.[80]

If Lossing made mild concessions to the romantic needs of readers by moderating the harshness of his realist doctrine, then Darley met him halfway by tempering his theatrical tendencies in drawing. Samples of images circulated in the pre-publication literature for *Our Country* suggest the illustrator's broad intentions for the pictorial history. On the one hand, like Lossing, Darley clearly wished to excite readers with titillating visions of dramatic episodes from the past, especially in dealing with conflicts between whites and Indians. The American public knew Darley primarily through his black-line drawings of Irving's Knickerbocker tales and by his dramatic illustrations of Cooper's collected works, and doubtless they expected a similar measure of sensational depiction in the illustrations for *Our Country*. In one sense they were not disappointed. For instance, Darley appropriated material from a scene in Cooper's *Last of the Mohicans* depicting the hideous murder of a baby ripped from her mother's arms and dashed against a tree for use in an engraving in *Our Country* of the gruesome massacre by Indians of paroled English soldiers

from Fort William Henry during the French and Indian War. Cooper's account was based loosely on the historical record, so the inclusion of Darley's adaptation from the novel was not completely inappropriate, but because so many readers were familiar with Darley's prior visualization of the text, its appearance in *Our Country* lent undeserved authority to the fictionalized version of the massacre as described by Cooper. The "pencil of the artist" has been employed with "greater prominence than usual" in detailing "the romance of our history" for young readers, Lossing explained of these concessions, "who, as *readers* only, prefer such literature in this more attractive shape rather than in the stately figures which engage the *student*."[81]

On the other hand, most of Darley's proposed illustrations were subdued genre scenes in which historical events were "narrated in incidental, personal and informal terms" rather than under dramatic or heroic conditions. Like many artists of his day, Darley had "lost confidence in the hortatory power of narratives that depicted the single-handed ability of historical figures to communicate didactic lessons," and increasingly after the Civil War he "depicted history instead as genre like situations involving historical personages" or as commonplace scenes among undistinguished Americans who serve as "types or representatives of social ordering."[82] The success of such genre scenes (sometimes called "comic scenes, low subjects, cabinet pictures, domestic scenes, familiar life, and scenes of everyday life") depended "on the humbler, less noble social relationships" of the middle-class patrons who bought books such as Lossing's *Our Country*. "Unlike history painting, which called for the expression of intellectual principles and high thoughts, there was nothing necessarily intellectual or elevating in scenes of familiar life," Elizabeth Johns notes. "History painting elevated the privileged

and relatively secure patrons and their institutions to an ideal past with mythological or literary or allegorical scenes," whereas genre painting "constructed aspects of the scene at hand and offered newly arrived patrons—not quite elite but not lower class either—the possibility of sorting out their place in it."[83] The goal for Darley in *Our Country* was to make history rousing not by overdramatizing events but by humanizing them. His was a characteristically democratic form of illustration, designed to appeal to that growing mass of middle-class readers frustrated with a clichéd didacticism and in search of a realism that transcended the minutia of facts.

One way to understand this form of new realism is to compare the illustrations of Darley to those of Alonzo Chappel. Late in their respective careers both artists illustrated the Stratford edition of the *Complete Works of Shakespeare*, and the contrasts between their styles caught the attention of the volumes' editors, William Cullen Bryant and Evert Duyckinck. In his annotations on the illustrations for *King Lear*, Bryant commented on the fact that both Chappel and Darley had chosen to illustrate the same dramatic moment—act 3, scene 2—in which a defiant Lear is out in the heath in a raging storm with his fool (figs. 54 and 55). "It is interesting to note how differently and yet with how great a purity of vigor and genuine feeling, the same scene has been treated by Mr. F. O. C. Darley and Mr. Alonzo Chappel," Bryant wrote. Although Bryant admired the melodramatic tone Chappel brought to the scene, he praised still more highly the "figure of Lear in Mr. Darley's picture," who is "full of life and intensity, the face being strong and noble through all its wild insanity." Darley's figure of Lear's companion was also thought by Bryant to be more realistic and less highly stylized than Chappel's, the "poor fool" feeling "that pelting rain drenching him to his very bones" and desirous of finding "shelter for

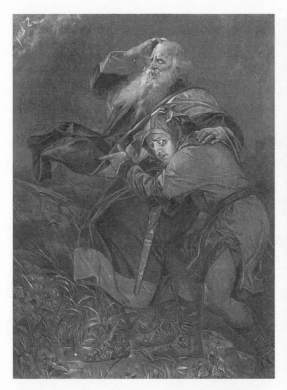

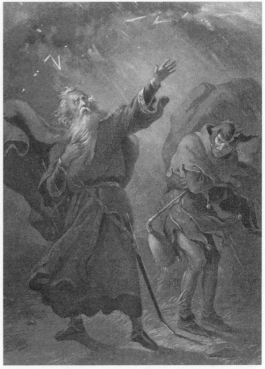

Figure 54. "King Lear," 1888, by Alonzo Chappel for *The Complete Works of Shakespeare,* edited by William Cullen Bryant

Figure 55. "King Lear," 1888, by F. O. C. Darley for *The Complete Works of Shakespeare,* ed. By William Cullen Bryant

the material man even though his soul is occupied with concern for his loved and grief-stricken master." Chappel's illustrations were sound in execution and sensational in impact, Bryant implied, but Darley had captured better the human and emotional side of the drama of Lear as intended by Shakespeare.[84] This distinction between the heroic and the humanized Lear underscored an important shift toward realism in pictorial taste at midcentury, a movement with profound implications for pictorial histories as illustrated by both Chappel and Darley.

Darley's illustrations for *Our Country* reaffirmed these distinctions. They were "outline illustrations," generally, characterized by "simplified settings and primitive perspective."[85] Most depicted "uplifting scenes of everyday life" filled with playful children and domesticated dogs. They amounted to assemblages of common things, human trompe l'oeil, which disclosed what Henry James termed a "delightful realism" of "cohesive families, distinguished men, attractive women, joyous children, pleasurable outdoor recreations, and picturesque city scenes."[86] By relying almost exclusively on simplified, outline illustrations rather than "finished pictures," Darley was not trying merely to reduce the costs of production, although that was one happy consequence of his style from his publisher's point of view. Instead, he worked from a distinct philosophical commitment to the "crude"

Figure 56. "The American Troops at Valley Forge," 1878, engraved by A. Bobbett from the original sketch of F. O. C. Darley for Benson Lossing's *Our Country*

Figure 57. "Valley Forge—Washington & Lafayette," 1858, by Alonzo Chappel for Jesse Spencer's *History of the United States*

sketch as the preferred method of visual representation, one that attracted audiences to "the action in drawing" and by association to the action of history. "Many finished pictures are like many printed sermons," wrote one nineteenth-century supporter of the outline form—"beautiful but lifeless." Just as "most sermons to be effective must be accompanied

with the voice," so most illustrations needed to betray the hand of the artist in process.[87]

Although many of Darley's drawings were less dramatic than those of Chappel, they reflected nonetheless a distinct ideology referred to as the "politics of everyday life." Illustrations in *Our Country* demonstrate that it is a misnomer to assume that complex

political messages cannot be derived from simple genre forms.[88] In depicting the hardships of Valley Forge, for instance, Darley chose not to focus on the struggles of Washington as so many artists had done before him but rather on the trials of anonymous soldiers huddled around insufficient camp fires enduring the bitter cold of winter (fig. 56). Although such a vantage point was clearly less grandiose and heavy-handed than those in images such as Chappel's "Valley Forge—Washington & Lafayette" (fig. 57), there was nonetheless an unmistakable political point expressed in Darley's scene—namely, that wars were fought by common men who suffered deprivations in ways that officers rarely did. Such a modest illustration as Darley's "Soldiers at Valley Forge" reaffirmed in an understated and yet profound way that the Revolution was a popular enterprise that must be told in a literary and visual language that the people could understand and appreciate.

Darley's representations of Indians also suggested the subtle ideologies at work in the genrification of his art. Although Darley was capable of depicting melodramatic images of bloodthirsty Indians slaughtering women and children, *Our Country* is filled with pictures of "noble savages" engaged in daily acts of sensitivity and kindness. In "The Little Captive," for instance, Darley portrays a small, vulnerable child being cuddled and comforted by her "savage" captor (fig. 58). In a Victorian culture obsessed with the welfare of children Darley's depiction of Indians as nurturing figures (even while engaged in the contemptible act of kidnapping) was significant in establishing a political tone of reconciliation between whites and Indians. This pictorial effect supplemented what Lossing had noted about Native Americans as a greatly misunderstood, family-oriented people. The "spoils" of a colonial attack on Indian fortifications "were more than three hundred Indian widows and orphans," Lossing

noted of one instance of white aggression, confirming the sad fate of savages who were too often viewed as "foreigners instead of citizens" or as "children having no legal rights." According to Lossing, Darley's illustrations were intended to help readers recognize that "our barbarian brethren are capable, not only of civilization, but of becoming orderly and valuable citizens." Treat the Indian "as a *man* and a *citizen*, and wars and unprofitable expenditures on his account will cease," Lossing counseled.[89]

Additionally, Darley was an expert at producing small, multifigured arrangements of historical actors, achieving through such sculptural groupings the kind of storytelling naturalism of genre sculptor John

Figure 58. "The Little Captive," 1878, by F. O. C. Darley for Benson Lossing's *Our Country*

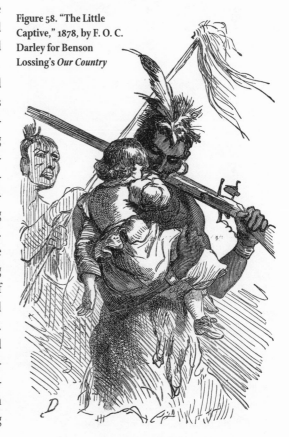

Rogers. Modeled but not allegorical, Darley's characters appeared in "light, linear outlines" that emphasized dramatic human action without the distractions of baroque setting.[90] Darley was also adept at drawing ordinary people with few traces of the physiognomic codes that characterized much news and narrative illustration, creating a form of realistic depiction in strong contrast to the detailed and elaborate steel engravings of Spencer's volumes based on traditional history painting. Hence, Darley's illustration of "Wolfe Mortally Wounded" in *Our Country* avoided the excesses of Benjamin West's oft-

Figure 59. "Wolfe Mortally Wounded," 1878, by F. O. C. Darley for Benson Lossing's *Our Country*

Figure 60. *The Death of General Wolfe*, 1776, by Benjamin West (Courtesy of the William L. Clements Library, University of Michigan, Ann Arbor)

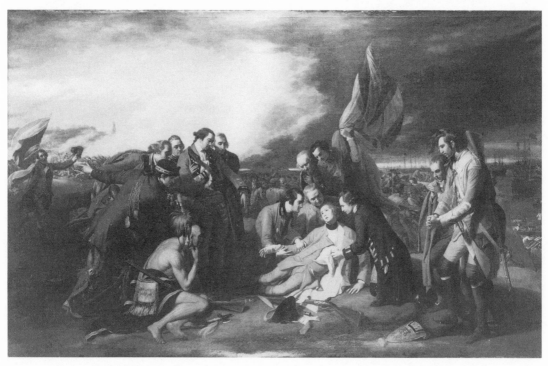

reproduced image of the Battle of Quebec, depicting the general in a very personal and human moment of struggle with death rather than as an actor in a universal morality play (figs. 59 and 60). Darley's decision to reimagine the event on more simplistic terms allowed for fewer distractions and less diffusion of meaning and gave viewers a sense of participation in the event. In this sense Darley's figural compositions drew some inspiration from the tableaux vivants that were popular in his day—"living pictures" in which common people assumed the positions of figures from noteworthy paintings as a way of sharing in the historical themes depicted in the composition. Darley's humanizing style lent itself nicely to the empathy implicit in such tableaux vivants and promoted a visual calculus in which "the image no longer merely formed the viewer's character by instruction but offered a dramaturgical means of performing the self."[91]

Even the physical layout of the images in *Our Country* contributed to the overall humanizing effect of the work. Members of the art department at Johnson's publishing house proved themselves wonderfully adept at employing a "vignette form" of page configuration in which images were interspersed among blocks of writing throughout the text rather than confined to separate pictorial pages. Using sophisticated techniques "to fade the image into the page, to dovetail engraving and text, and to place word and image in a graphic dialogue that enhanced the meaning of both," these page designers succeeded in commingling the visual and literary elements of *Our Country* in ways that made them more accessible to average readers, especially children. When images appeared on separate flyleafs or were disassociated from the texts they embellished, they lost some of their power to serve as visual counterparts to the narrative. Detached illustrations required viewers to "construct" their own interpretations of events, a dangerous practice for the uninitiated. When texts were used to frame images, however, their visual meanings were more firmly anchored, preventing them from "float[ing] away" or being interpreted in ways unrelated to the stories being told. Darley's relatively unambiguous pictures in *Our Country* clarified rather than obscured the meaning of Lossing's narrative and were, as Asa Bullard of *Well-Spring* magazine noted of a similar text, "propaedeutic to reading, bearing a legibility that led to textual literacy."[92]

Lossing and Darley were not always in agreement on the proper levels of dramatic content and realistic detail to bring to bear on historical subjects. In general Darley was more willing to sensationalize the past than was Lossing, who, as a realist historian, felt an obligation to balance polemic with more sober and even-handed assessments. Although in Lossing's estimation the intolerances of the Puritans represented "a dark stain upon the annals of New England," he still supported their condemnation of certain fanatical groups that had taken the concept of individual liberty too far. Like Spencer, Lossing was especially hard on the Quakers, whom he described as "absolute fanatics [who] sometimes became lunatics in their religious views and actions" and were utterly unlike the "sober, mild-mannered members of that society today." Condemning their "wildest extravagancies" and their abuse of the "the liberty of speech," Lossing intimated that there was little the Puritans could do to protect from the gallows a people who sought so conspicuously martyrdom as an honor.[93] Darley's accompanying illustrations in *Our Country*, however, evoke more sympathy and pathos for the Quakers than Lossing's text, suggesting a victimization model for heroines such as Mary Dyer, who refused to adhere to the terms of her lifetime banishment from the Puritan community and died at the gallows in pursuit of the right to follow her own religious beliefs (fig. 61).

Many of Darley's other illustrations exposed a discrepancy between the toned-down rhetoric of Lossing's text and the animated visual imagery of Darley's illustrations.

A similar contradiction was evident in the incongruous depictions of slavery presented by Lossing and Darley respectively. Lossing, who had once been criticized for not taking a strong enough stand against slavery in his school histories, was not shy in *Our Country* about condemning the institution.[94] He noted with deep regret that on a fateful day in 1619 the arrival from the coast of Guinea of "a strange cargo of living creatures for sale" introduced "the system of negro slavery in our country," a "stain" that had to be "washed out with blood almost two centuries and a half afterwards."[95] Yet Darley's illustrations of the institution of slavery were even more condemnatory than Lossing's prose, centered as they were on the physical abuses of the system. In several instances Darley featured slave women pleading unsuccessfully for protection from the stinging lash of brutal over-

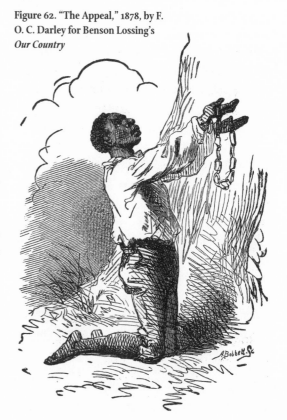

seers, tapping into Victorian revulsions toward violence against women. In other cases Darley showed careworn slaves struggling to work under the arbitrary supervision of lazy, Southern plantation owners, feeding well-developed late-nineteenth-century anxieties about the abuse of labor and the calcification of classes within society. In one memorable illustration Darley portrayed a chained slave making an ardent appeal to heaven to be freed in a manner consistent with the most dramatic emancipatory sculptures of the postwar era (fig. 62). These heart-tugging expressions of what might be called sentimental abolitionism did more than supplement the substance of Lossing's repugnance for slavery expressed in the pages of *Our Country;* they also introduced a pathos that intensified and even politicized the institution in ways that suggested the potential power of illustration over the written word to evoke pity and anger.

Discrepancies also emerged between Lossing's literary and Darley's visual depictions of battle. As was the case with his field books, Lossing was reluctant to describe in much detail the horrifying sights and

Figure 63. "Death of a Brave Leader," 1878, by F. O. C. Darley for Benson Lossing's *Our Country*

Figure 64. "Barbara Frietchie's Defiance," engraved by A. Bobbett from the original sketch of F. O. C. Darley for Benson Lossing's *Our Country*

Figure 65. "Destruction of Custer's Command," 1878, engraved by A. Bobbett from a sketch by F. O. C. Darley for Benson Lossing's *Our Country*

Darley also translated into pictorial images the frustrations of the very old, as in the refusal of Barbara Frietchie of Frederick, Maryland, to remove a Union flag from her window on the approach of Stonewall Jackson's troops (fig. 64). Lossing had sketched the Frietchie home for his *Pictorial History of the Civil War*, but revealingly, he had included only the physical structure in that trilogy, avoiding the drama and politics of the human element.[97] Depictions such as those of Clem and Frietchie in *Our Country* suggested the heroic contributions of women and children to the war cause, but they also condemned tacitly the disturbing tendency of war to implicate the very young and the very old in a bloody familial conflict.

Darley's illustrations of more recent events in American history also suggested his willingness to find dramatic potential in stories not yet delineated fully by the pens of historians such as Lossing. At the time of the publication of the last volume of *Our Country* (1878), for instance, Custer's defeat at the Battle of Little Big Horn had begun to capture the American literary imagination, but very few satisfactory prose accounts had emerged. Lossing described Custer's demise somewhat feebly with reference to the "cupidity of frontiersmen" who had in mind the "final dispossession" of Indian lands. But Darley elevated Custer to the status of a quasi-hero by placing him at the center of a battlefield landscape with the focus on the desperation of his defense (fig. 65). The doomed general in Darley's drawing is more victim than violator and is less in control of events than controlled by them.[98] This powerful illustration also suggests the growing potential influence of Darley's visual medium over Lossing's literary means for affecting the American historical imagination. Although "a scholar's prose account of a historical event, no matter how painstakingly researched and scrupulously accurate in detail, usually proves something less than

sounds of war. On occasion he did acknowledge screaming shells crashing through forests and bullets whistling through tents or the specter of troops "fighting desperately, driving half-dressed and half-armed troops before them, and dealing death and terror on every hand."[96] But these gory depictions were the exception to the rule. By contrast Darley's artwork illustrated to a much larger degree the startling horrors of war. In "Death of a Brave Leader" Darley depicted the macabre death struggle of Union colonel Edward D. Baker, whose bodily contortions and gruesome expression suggest the violent realities of death on the battlefield (fig. 63). The insidious effects of war on the very young were also demonstrated by Darley's portrayal of the actions of a twelve-year-old Michigan drummer boy, John Clem, who at the Battle of Chickamauga became the youngest participant in the bloody business of war by shooting a Confederate colonel.

deathless," one authority noted of such representations, "a picture of the same event may linger in the viewer's mind and leave a lasting impression. This proposition is demonstrably true in the case of Custer's Last Stand."[99]

Hence, comparisons between Darley's images and Lossing's words reveal a subtle shift in the balance of power within the genre of pictorial history. Given the responsibility for embellishing a historical record that could not be counted on to "illustrate itself by example," Darley's triumphs of art reflected the degree to which visual culture was coming to dominate its sister art, literature, by the 1870s. In relinquishing control of the pictorial element in *Our Country*, Lossing had given tacit approval to Darley's strategies of illustration, but his text struggled at times to compete with the powerful presence of the artwork. When asked by a friend to what he attributed the success of *Our Country*, Lossing noted, "My publisher and others think the success is largely owing to the name of the author," but "I am satisfied, that it is due, in a large degree to Darley's illustrations & probably to whatever excellence may be found in both of us."[100] Because advanced subscribers to the work had only the reputations of writer and artist to go on, and because Lossing's name had not been sufficient inducement in the past to garner the kind of high pre- publication sales the work experienced, it was logical for the author to assume that Darley was responsible for the success of *Our Country*. It was no coincidence, Lossing recognized, that Darley's name had been given billing alongside his own in the sample bindings carried by book agents for Johnson.[101] Such an unprecedented acknowledgment of the role of the artist as collaborator in a pictorial history suggested a new relationship between the shapers of words and the creators of images in the illustrated book industry.

The Retributive Verdict of History

Whether Lossing was sensitive about sharing the marquee or not, any bruising of the ego he might have experienced in his competition with Darley was doubtless soothed by the recognition that *Our Country* achieved the highest sales of any work he had produced to date in his now lengthening career. In terms of finances the high pre-sales of the work validated the enterprise even before it was published, but it was the continuity of sales throughout the 1880s and into the 1890s that proved most gratifying. It is estimated that *Our Country* may have sold as many as two hundred thousand copies, eclipsing all competitors in the centennial market as well as any books Lossing had written in his long career.[102] Intellectually the volumes were also a success. Lossing and Darley took justifiable pride in reviews that declared *Our Country* a rich compendium of American history and a readable addition to any home library.[103]

There were some complaints about the techniques of Lossing and Darley, of course, as one would expect with shifting priorities in a volatile pictorial book market. Some found a disdainful political motive in *Our Country*, especially in the latter chapters on the ascendancy of the Republican Party and the secessionist movement in the South. Democratic Party journals such as the *New York World*, an affiliate of the *Round Table*, took direct aim at Lossing, condemning the "retributive verdict" of his history. "I see no reason why Mr. Lossing should make glaring misstatements as he does in many places," wrote a southern professor of history and English, James Mitchell, who was disgusted by the numerous "examples of false statements from Mr. Lossing's book."[104] Another southern reader argued that Darley's pictorial treatment of Barbara Frietchie's refusal was skewed, charging the artist "with falsehood 'in fact' and 'in purpose'" and with obtaining subscriptions by "false pretense." Lossing re-

sponded to the writer with injured pride and spirited impunity on behalf of Darley. "Sir: Your letter of 27th June to Messrs Johnson and Miles, publishers of 'Our Country,' concerning a picture in that work of the patriotic act of old Barbara Frietchie is before me," he wrote. "With a conspicuous departure from the rules of courtesy which govern the actions of true gentlemen," he added, accusations had been made "before you have read a word of what I have written on the subject." Claiming that Darley's treatment of the Frietchie incident in *Our Country* was "honorable to the head and heart of 'Stonewall Jackson,'" he added with righteous indignation, "If you ever read what I have written on the subject, in 'Our Country,' you will regret your indecency in making the false charges, if you have a spark of justice in your nature. If you shall address me in language such as one gentleman would use toward another, I may give you some facts in the case of which you are evidently ignorant."[105]

Despite Lossing's spirited defense of Darley, comments like those concerning the Frietchie illustration underscored the incongruities that could occur between words and images in pictorial histories. These disparities remind us that the author and illustrator of *Our Country* were also beholden to their publisher, Henry Johnson, whose editorial staff made final determinations as to the proper balance between realistic and sensational approaches to the past. In an age in which growing literacy and the need for patriotic reconciliation spawned a rash of nationalistic publications, such publishers assumed even more responsibility in the literary and visual processes of pictorial bookmaking than they had even two decades before. In the 1850s Johnson had promoted the sweeping sensationalism of Spencer's idealistic vision, but in the 1870s he succeeded more grandly by endorsing the muted drama and humanistic realism of Lossing and Darley. In emphasizing the personal and human side

of history in their publications, publishers such as Johnson billed themselves as conveyors of national history to the private homes of citizens in ways that benefited the nation, its citizens, and, importantly, the publishers themselves.

And yet with this vogue of humanistic realism came a loss of the sense of historical exceptionalism for which William Gilmore Simms and others had argued so strongly a generation earlier. If history was the tale of unspectacular events experienced by mundane people, then what set it apart from mere chronicle? How might historians distinguish the important from the unimportant, the sacred from the profane? Without guidelines for discriminating among materials, some feared, historians would become victims of their own generous standards, swamped by the relativist's habit of accepting everything as historically viable. The threat to agreed-upon principles for determining what was significant about the past and what was not impacted heavily on realists such as Lossing, because it forced them to admit their own limitations in an expanding historical and pictorial universe. The humanizing tendencies of illustrations such as those by Darley—celebrating the triumphs of middle-class life in America—health, home, and happiness—encouraged a democratization of the arts that adopted the "common" as the standard for the evaluation of what matters in history. Such a simplified, nearly reductionist approach sold volumes, but it also worried those who believed that proper history demanded greater distinctions between the "real" and the "ideal." Some critics of Darley's "outline" style looked to the restoration of the written word as a way of protecting against the leveling qualities of "humanized" history. These detractors were quieted, however, by the introduction of another innovation in the packaging of pictorial images that extended the life of pictorial history as a genre: color lithography.

Part Three

The Tyranny of the Pictorial

Challenges to the Visual, 1890–1900

"Colors That Do Not Fade"

Chromos and the Professional Attack on Illustrated Histories

The "golden age" for the genre of pictorial history in America was the last two decades of the nineteenth century, when illustrated formats dominated nearly every type of print media. During these decades, there was an explosion of pictorial works, as small companies specializing in particular varieties of illustrated history texts competed with larger houses producing more generalized works for nearly every imaginable reader. In the years between 1840 and 1880 several dozen books had been published with some variant of the "Pictorial History of the United States" in the title, but in the two decades that ended the nineteenth century, many times that number were issued, centered on specialized topics targeted at specific regional or generational markets.[1] In some cases houses such as the History Publishing Company of Philadelphia kept themselves viable financially by producing books on contemporary topics, staying "current" as it were by employing artists to sketch

history "as it happened."[2] In other cases publishing houses remained competitive by revising old but still popular pictorial histories, such as those by Frost and Lossing. Still others, such as the Perry Pictures Company of Boston, supported themselves by publishing compendiums of pictorial images of American history without the burden of accompanying narratives. Whether creating fresh products for new readers or recycling old ones for tested audiences, the writers, artists, and publishers associated with the booming illustrated book industry had good reason to believe that the genre of pictorial history had established itself as a permanent part of the literary landscape.[3]

"History Made Visible"

There were a number of reasons why the genre of pictorial history experienced an explosion of interest after nearly half a century of steady but slow growth. First, the abilities of publishers to reproduce images in illustrated texts had improved tremendously due to photographic technologies. The development of the "photograph-on-the-block" in the 1880s allowed highly complex paintings and drawings to be translated to the printed page without the intermediary of an engraver. For centuries engravers had been needed to transcribe visual messages from the artist's hand to the printed page, but now it became possible to transfer original pictorial images directly to the surface of a wood block by means of a photographic negative. The halftone employed a grid that acted as a screen between the lens of a copy camera and a photosensitive copper plate coated in a light-sensitive gelatin film. When a photograph was taken through the grid, a series of small dots imprinted on the plate that was then bathed in acid, resulting in an etched surface in negative relief that could be inked to produce a positive image.[4] This technique allowed publishers to replicate almost any visual image they desired without experiencing the problems of textual differentiation and modeling that had long plagued engravers. Pictorial histories became more unrestrained and experimental in style as a result, reproducing in their pages "the subtle chiaroscuro of oil paintings, or the crisp washes of watercolor, or the chalky freedom of crayon drawings."[5]

Later practitioners of the halftone process applied the same techniques to more durable metal plates as a means of photographic reproduction by exposing a light sensitive emulsion on the plate "to an original viewed through a finely apertured screen."[6] In terms of information transfer the results of this halftone innovation were considerable, because the technique not only allowed publishers to recycle images used in earlier histories without redrawing or reengraving, it also changed inexorably the way historical images were created by artists in the first place. When F. O. C. Darley produced illustrations for Benson Lossing's *Our Country*, for instance, he drew with the limitations of wood-block engravers in mind. Now artists depicting historical events could work in nearly any style or medium they chose, assured that the codes of photographic transmission were accurate enough to allow for precise duplication of artistic intention. Publishers also knew that they could get multiple uses out of virtually any image, a technical advance that allowed them to justify spending more for original productions by artists. This was a sad development for engravers, of course, who since the days of William Croome had played a crucial role in the pictorial process. But the advantages of the halftone process were so substantial to the freeing up of the illustrator and the reducing of costs to the publisher that this loss was easily rationalized.[7]

Second, and perhaps most important of all for the continuance of pictorial history as a genre, was the de-

velopment of techniques for colorizing illustrations that increased dramatically the visual impact of pictures in books. A few books in the 1850s were hand-colorized, using a laborious assembly-line process borrowed from print makers. Workers would apply a single pigment to all appropriate areas of an illustration, passing it along to the next colorist who would in turn apply a different color to other areas before transferring it to other artisans down the worktable. A senior colorist would eventually evaluate the final product, performing any touch-ups necessary and smoothing out transitions among areas of color where inconsistencies occurred. This tedious technique was only suitable for limited editions of selected works. The colorization of mass-produced historical texts had been in limited use since midcentury, when Lossing featured a three-color lithotinted frontispiece in the *Pictorial Field-Book of the Revolution,* a technique that required rolling inks of different hues through stencils on a single lithographic stone. These early colorizations were difficult to design and expensive to execute, however, because they required a separate plate impression for each color represented and a printer specially trained in the multiple-step process. In addition, the colorization of illustrations generally demanded larger and more simplified drawings by artists, because broad areas for printing were needed to avoid the bleeding together of colors.[8]

Given these limitations, the primary use of colorization in pictorial history texts was in maps and four-color scheme synchronic charts designed to teach history through timetables. These latter visual aids derived from the techniques of Polish general, Josef Bem, who devised elaborate diagrams "listing all the significant events in the history of the world" as a way of teaching the lessons of the past to military students.[9] The idea was to associate specific periods in history with selected colors, which, when arranged

properly, would give readers a quick visual reference scheme for periodizing the past. John Clark Ridpath was among the first to use this technique in a pictorial history of the United States, introducing each major section of his *Popular History of the United States* with an idiographic vision of history. Long blocks of color constituted significant periods in the development of the nation, and like shades implied closely aligned events, some of which overlapped into amalgamated hues corresponding with transitional historical phases. It was "History Made Visible," as one proponent of synchronic charts advertised them.[10]

Although designed originally for adults, the effects of color were thought to be especially beneficial to children in learning history, because the vividness of their pigmentation created a more "instantaneous impression on the minds of the youth of our country" than did monochromatic images, "leading them to read and realize events and scenes recorded and described in the marvelous Story of [America]."[11] Not all children responded well to the system, however. Julian Hawthorne recalled squirming through his Aunt Lizzie Peabody's demonstrations of the color-coded strategy, testing her "inexhaustible patience many a sad hour" with his "most inapt and grievous" recitals of the colorized system, which he believed obscured rather than elucidated the important historical insights his father had taught him. "To this day I cannot tell in what year was fought the battle of Marathon, or when John signed Magna Carta," Julian noted with embarrassment late in life of the failed Bem method.[12] Historian William Sloane referred to these charts in equally contemptuous tones when he remarked in 1895, "Middle-aged and older men will remember with some amusement the amazing historical charts which used to adorn the walls of schoolrooms, and resembled nothing so much as rainbow-colored rivers vaguely rising at the top, and wandering in viscid

Figure 66. Cover of *The History of the United States, Told in One Syllable Words*, by Josephine Pollard, 1884

streams more or less vertically, according to the law of gravitation or the resistance of the medium, until absorbed one by the other, or lost in the ferule at the bottom."[13]

Advances in chromolithography (in which individual colors were printed from separate lithographic stones) and later in color halftone processes (in which a "color-record negative" was used to translate pigments to the printed page) improved the effectiveness of colorized illustrations. Eventually bookmakers per-fected duotone relief plates to produce three-color halftone blocks for illustrations that revolutionized the way readers received visual impressions.[14] Publishers of children's books led the way in this revolution, the juvenile work *The History of the United States, Told in One Syllable Words* by Josephine Pollard demonstrating in its bindings and its illustrations the effectiveness of extensive colorized technologies (fig. 66).[15] The vivid pigments employed in the work by the McLoughlin Brothers of New York were designed to "sell history"

to America's youth in the same way that chromolithography was used by Louis Prang and others to market posters, sheet music, and art reproductions. The McLoughlin Brothers blended colors and overlapped images to create three-dimensional effects on the covers of their works, illustrations leaping out as it were to grab young readers, and the pictorial representations in the texts were designed to suggest an equivalence between the richness of graphic embellishment and the colorfulness of the American past. Publishers such as McLoughlin argued that colorized pictures would "soften the harsh features" of pictorial images, not only reducing the visual effect of the "bareness of harsh angles" typical in black-and-white illustrations but also smoothing the rough edges of a sometimes jagged and violent national history as well.[16] Because color images still required special paper for printing and had to be "tipped in" to a book on separate insert pages, black-and-white drawings continued to dominate in-text representations, but most major pictorial histories of the 1890s advertised "chromos" as the most salient feature of their visual package.

The four-hundredth anniversary of Columbus's first voyage as celebrated at the 1893 Chicago Columbian Exposition provided a perfect opportunity for the marketing of colorized history books for Americans of all ages. Popular historians such as Lossing and McCabe had capitalized on the nationalizing impulses surrounding the 1876 Philadelphia Exposition, but the improvement of colorized technologies allowed a much larger contingent of writers, artists, and publishers to compete for the buyer's "eye" in the competitive commemorative historical book market.[17] These quadri-centennial books had few of the literary pretensions of the more expansive histories of Spencer or Lossing; they were instead less ambitious projects devoted more narrowly to the themes of the anniversary celebration. Pictorial histories sold in and around the Chicago fairgrounds, for instance, frequently focused on Columbus as a representative American figure, a characterization requiring some mental gymnastics, given the aforementioned recognition that Columbus never set foot on any land that was part of the United States in 1893. A typical strategy employed by publishers anxious to avoid these uncomfortable historical points was to recycle old and accepted historical narratives of Columbus as the prototypical American but to distract readers with new, eye-catching, colorized illustrations that depicted the discoverer in a multiplicity of roles and guises.

The Royal Publishing House of Philadelphia, for instance, put out a richly illustrated volume, *The Discovery and Conquest of the New World* (1892), which was advertised as a fresh, new look at the "world's grandest drama" but proved to be little more than a quickly sewn together compilation of various sources, including excerpts from Washington Irving's *Life and Voyages of Christopher Columbus*, an account of the "Conquest of Mexico and Peru" by English historian W. W. Robertson, and a compendium of snippets from the works of Bancroft, Fiske, Blaine, Grant, Sherman, and Johnston.[18] The introduction to the volume was written by Murat Halstead, identified on the title page as a "Columbian student of both Americas" but in reality a literary jack-of-all-trades who wrote popular books on topics as diverse as the Boer War in South Africa and the reign of Queen Victoria in England.[19] One of America's most prolific authors, Halstead was reputed to have written more than one million words annually for forty years, prompting a contemporary to speculate that "he has probably written more copy for printers than any other man living."[20] As a historian, he had earned a reputation for composing with the "vigorous and forceful" style of a journalist rather than with the care and patience of a scholar, and he was considered by his peers to be "naive and garru-

lous" in his work.[21] Anxious to submit the quadricentennial to his popularizing pen, Halstead admitted that his task of welding together the radically different evaluations of Columbus presented in *The Discovery and Conquest of the New World* was at first "so stupendous as to be absolutely appalling." But as he had with so many of his hurried popular works, he rallied quickly to the literary cause, producing a narrative of discovery and colonization that was rivaled in his humble estimation only by "the story of the savior" in its power to stir the emotions.[22]

Halstead had high hopes that the profuse illustrations adorning the text of *The Discovery and Conquest of the New World* might increase the emotive power of his holy tale. "Such magnificent possibilities for the brush of the painter, the pencil of the artist, have not been neglected," he noted in the introduction to the work. "With eager eyes and inspired souls has the genius of the Old and New World embraced the subject, portraying with wonderful exactness and fidelity each scene in the career of Columbus which has been so pregnant with momentous results to the Anglo-Saxon race." Copies of "masterpieces of art" have been made with "care, judgment, and unparalleled patience," he remarked, the engravers having secured a "careful adjustment of each illustration, to add vividness to the original compositions." Comparing the "interest and affection" engendered by his pictorial work to that commanded by an illustrated work such as *Harper's Illuminated Bible*, Halstead argued that the story of Columbus should be among "the most valued treasures of the future electors of the Union," having always "inculcated and enlivened the spirit of patriotism in the hearts of the young, by presenting in a realistic manner the sufferings, sacrifices, and sorrows of those who bequeath this land of freedom to them." Raising the artist to the level of a moral arbiter, he added that "the most famous, brush and pencil in hand, hasten to perpetuate the events and incidents of every phase of the conquests of Cortes and Pizarro with unfailing fidelity to the facts, registering each act of cruelty inflicted by the invaders upon the inhabitants of the New World." Even the most callous observer of the national scene must "become inspired by thoughts of national glory when reading such a record," Halstead noted somewhat grandiosely, especially when illustrated by "gems that would do credit to an Angelo or Raphael." In a highly stylized copyright page, the publishers of *The Discovery and Conquest of the New World* reminded readers that they had spent more than twenty-five thousand dollars in procuring the resplendent drawings and engravings that solidified these points for visually oriented students.[23]

Despite these blatant self-promotions, the text and the visual depictions in *The Discovery and Conquest of the New World* betrayed the inconsistencies of a hurriedly produced compilation history. In addition to a wildly varying tone, alternating from the highly sentimental to the starkly realistic, the illustrations were inconsistent with respect to each other in both content and form. In some of the pictorial representations Columbus is tall and lanky; in others he is short and stocky. Often he is bearded, but on occasions clean-shaven, and in some cases he has a full shock of hair, whereas at others times he is nearly bald. The greatest contrasts appear with regard to the discoverer's age. In some of the pictorial illustrations of the embarkation moment Columbus is depicted as youthful and sprightly; in others he is aged and sedate. As controversies over the Parmigianino-likeness of Columbus in Frost's pictorial history demonstrated, there was little agreement on a "true" portrait of the explorer, so these variations may have reflected an understandable diversity of opinion regarding what Columbus might have looked like. But the inclusion of so many contradictory Columbuses in a single text suggested the lack

of any consistent editorial point of view on the part of Halstead's publishers. "If [Columbus] resembled all the pictures published of him," one critic of such a compilation technique noted, "he must have been exceptionally accomplished in 'changing his face.' If one of those pictures is accurate, the others cannot be," he added, a discrepancy that "to say the least, certainly must be confusing to the student."[24]

Under these compromising circumstances, what made the illustrations in Halstead's history acceptable (even memorable) to readers was the innovative use of color. Even today, a century after their publication, these pictures command attention because of the luscious brilliance of their four-color scheme and the expansiveness of their double-page formats. Because luminous colors draw the eye to the surface of a picture plane, they accentuate the decorative or ornamental qualities of images, giving them an abstract, even expressionist quality. Color also flattens illustrations, calling attention to the contrasts among superficial shapes rather than the depth of modeled forms. Whereas Darley's simple, monochromatic style emphasized the three-dimensionality of space and the contours of figure and ground, the illustrations in Halstead's history were more two-dimensional in appearance and more impressionistic than representational in disposition. These features of colorized illustration were acceptable to Halstead, because it mattered less to the author what Columbus looked like in a formal sense than what his discoveries implied in the abstract for the history of the world. But publishers certainly understood that colorized illustrations presented special problems for bookmaking, because the limitations of space on the printed page made it difficult to reconcile the expansive requirements of ornamental art with the more precise and restrained needs of historical literature. Often it was the distracting colors rather than the causes or char-

acters of history that dominated texts such as Halstead's.

The majestic colorized illustration of the controversial John Smith–Pocahontas incident in Halstead's volume provides a good example of the overwhelming power of these pictorial representations and the corresponding inadequacy of the literary texts that accompanied them. Based on a reproduction of an original oil painting by V. Nehlig titled *The Renowned Pocahontas*, the illustration in *The Discovery and Conquest of the New World* depicts a swirl of action around the dramatic death-moment of Smith, when a mature and provocatively bare-breasted Pocahontas places herself between the intended victim and the tomahawk intended to shatter his skull (fig. 67). Nehlig emphasized the communal quality of this poignant event by painting small vignettes in which individual groups of Powhatan Indians watch the drama of deliverance unfold before them. It is a complex and highly nuanced scene, worthy of William Gilmore Simms and implying complicated relationships between chiefs and subjects, men and women, whites and Indians. An art critic for the *New York Herald* congratulated Nehlig and by indirection Halstead for choosing a subject that represented "one of the few striking romantic incidents which relieved the correct, but somewhat dull, foundation of the infant republic."[25] Yet reviewers were quick to note that when reduced in scale for publication in illustrated histories, such paintings were too busy to be comprehended easily and too all-consuming to allow for meaningful literary amplification. The literary account of the Smith episode in *The Discovery and Conquest of the New World*, for instance, is not up to the rich complexity of Nehlig's work. Nowhere is there any treatment of the considerable skepticism associated with the tale or the suspicion, shared by nearly all historians of the 1890s, that Smith manufactured the

Figure 67. "The Renowned Pocohontas [sic], Daughter of Powhattan [sic], Saves the Life of Captain John Smith," 1874, after the drawing by V. Nehlig for Murat Halstead's *Discovery and Conquest of the New World*

episode as a way of bolstering his own self-image with readers. Indeed, so condensed is the discussion of colonial affairs in *The Discovery and Conquest of the New World*, that the Jamestown settlement receives only one line, and the name Pocahontas does not appear in the text at all. The inclusion of Nehlig's painting in the absence of any substantial discussion of the Smith-Pocahontas incident confirms that producers of popular histories such as the Royal Publishing House were less concerned with the literary consistency of their texts and more with their dramatic visual appeal.[26]

The theatricality of colorized illustrations was clearly the reason for the success of another popular history venture associated with the quadri-centennial, *Columbus and Columbia: A Pictorial History of the Man*

and the Nation, published in 1892 by the Dominion Publishing Company of Seattle Washington.[27] Bright, luminescent colors in full-page depictions of "Columbus Taking Possession of the New World" or "Columbus' Return from the New World," for instance, demonstrated the stimulating capabilities of the chromolithographic technologies (fig. 68). Printed on one side of specially prepared paper to avoid excessive "showing-through," these illustrations used vibrantly colored inks to evoke a sense of the brilliance of Columbus's act of discovery, style recapitulating theme as it were. Unlike the tightly organized figure and ground studies in most steel-line engravings, the pictorial representations in *Columbus and Columbia* featured looser compositions and more abstract forms. The publishers of such volumes advertised

Figure 68. "Columbus' Return from the New World," 1892, for *Columbus and Columbia: A Pictorial History of the Man and the Nation*

their works as patriotic celebrations of the most "colorful" episodes in the nation's history, arguing that their special interest in the "salient points" of history justified a reliance on only the most "magnificent colored plates of thrilling battles and events" available.[28] Some such promoters went so far as to proclaim that the inescapable vibrancy of chromolithography made it the ultimate vehicle for bringing art "within the reach of all classes of society," implying that the use by publishers of colorized illustrations that had been "republicanized and naturalized in America" was the highest expression of democratic values.[29]

Despite these determined attempts to justify the colorization of texts, the illustrations in *Columbus and Columbia* reveal many of the incongruities evident in

Halstead's pictorial miscellany. As with the illustrations in *The Discovery and Conquest of the New World*, the pictures in *Columbus and Columbia* are formatted in a style and scale that causes them to overwhelm the text and to distract the reader. In some ways this was a calculated effect, of course, because such colorized images were intended to serve as both storytelling pictorializations and advertisements for the illustrated books in which they appeared. But the result of this double-duty was a frequent incongruity between word and image in the volume. The illustration "Indian Warfare During the Revolution" suggests the ways in which color affected visual comprehension by influencing perceptions and depth in the picture plane (fig. 69). The illustration is a standard image of

Figure 69. "Indian Warfare During the Revolution," 1892, for *Columbus and Columbia: A Pictorial History of the Man and the Nation*

a besieged home on the frontier, but here the requirements of separation and balance of color create an action plane that is too extended to be easily comprehended. The telescoping that might have been accomplished with a black and white line drawing through a tighter and more controlled space is lost as the viewer's eye is forced toward the edges of the illustration by the decorative surface and the ornamental quality of the coloring. The figures are rendered cartoonlike by the exaggerated effects of scale and dispersed action created by color technologies, suggesting a lack of depth that extended to the superficiality of texts as well. The inclusion of such illustrations in texts such as *Columbus and Columbia* suggests that publishers such as Dominion were will-

ing to reduce standards of drawing and execution under the assumption that colorized schemes would still sell their volumes.

Less drastic efforts were made by other publishers to capitalize on these new trends by colorizing the black-and-white illustrations in their older texts. In 1901 the National Publishing Company rereleased McCabe's 1876 *Centennial History of the United States* under a new title, *Pictorial History of the United States*, with additional commentary by the "well-known historian," Henry Davenport Northrop, and new colorized frontispieces and inserts. On first inspection this experiment in color adaptation would seem to have been a failure, because many of the original crude illustrations were rendered more coarse by in-

accurate registration of color and a noticeable lack of understanding of the harmonic relations of one color to another. Estelle Jussim has noted that the untidy effects of these "grab-bag" methods of illustration in Northrop's *Pictorial History of the United States* were borne of a desire on the part of the National Publishing Company to exploit a "certain 'antique' desirability" in older engraved images by recycling those appearing in McCabe's original volume.[30] The company certainly had an incentive to reuse materials it had close at hand, making small concessions to contemporary readers by gilding a few selected pages with colorful adornments. In this sense color was employed as a restorative, bringing new life to old, worn-out illustrations and in the process revitalizing an antiquated past for contemporary audiences, although often without the commitment to accuracy of presentation that many historians required.

The Historical Publishing Company of Philadelphia introduced its own version of color adaptation, embossing the cover of John Clark Ridpath's *People's History of the United States* with icons of American culture and repeating those images in single printing-ink colors on the inside panels of the volume, generally

Figure 70. "Confirming a Treaty Between Whites and Indians," 1895, for John Clark Ridpath's *People's History of the United States*

Figure 71. "Ending the Revels at Merrymount," reproduced from Alan C. Collins's *Story of America in Pictures*, 1935

red or blue depending on the edition.[31] Ridpath also borrowed and altered many images recolorized in competing popular histories. Although this kind of reappropriation was not unusual, the particular misuse the publisher made of such adaptations was noteworthy, even among pictorial histories. For instance, one illustration titled "Confirming a Treaty Between Whites and Indians" and used by Ridpath to elucidate the relationships between the United States government and Indian tribes in the Ohio Valley during Monroe's presidency (fig. 70) was in fact a cropped version of a sketch produced originally in a nineteenth-century periodical to depict the maypole revelries of seventeenth-century renegade Thomas Morton of Merrymount (fig. 71). The use of this image by Historical Publishing was not only inconsistent with the characterization of the solemnity of the Monroe treaty as described by Ridpath in the text of the *People's History*, it also transposed out of context by nearly two full centuries pictorial evidence that had been created for the purposes of illustrating a very different time and place. The only possible explanation for such a misappropriation of visual material was the unwillingness of the publisher to incur the expense of commissioning an original drawing where adaptable images (no matter how unsuited) presented themselves for use. If recropping or recolorizing images proved cost effective, then publishers of illustrated histories had an incentive to become pictorial scavengers rather than the initiators of original visions.

The variety of work being produced in the 1880s and 1890s under the rubric of pictorial history suggested the ways in which the parameters of that field were expanding to accommodate demand for chromos and halftone process pictures. No less distinguished a leader and historian than Theodore Roosevelt praised pictorial historians for their willingness to bring "color" in both a figurative and literal sense to the telling of the heroic story of the nation's past. "The immense importance of full knowledge of a mass of dry facts and gray details has so impressed" some historians, Roosevelt complained, "as to make them feel that the dryness and the grayness are in themselves meritorious." But true history was in his estimation that which was written by "artists" who "illustrated" the past with the "vivid" quality of a "Rembrandt." Historians must be able to arise "from his study of a myriad of dead fragments" to "paint some living picture of the past," Roosevelt claimed, proving themselves able to "convey vivid and lifelike pictures to others . . . whose secrets he has laid bare." Because conventional historians seemed unable to "paint in colors that do not fade," he noted, popularizers must take up brush and palette and fill the nation's canvas with vibrant images that were strong and lasting. Certainly publishers of volumes by Halstead, Northrop, and Ridpath felt they were accomplishing just such a painterly task when they submitted their colorized pictorial histories to the avid readers of popular books.[32]

Mere Picture Albums

Despite the enthusiastic endorsement of Theodore Roosevelt, not everyone was convinced of the potential benefits of the new pictorialism. Complaints about the corrupting influence of illustrations had increased throughout the nineteenth century in direct relation to the numbers of illustrations feasible in a standard-length book.[33] In the 1840s, when John Frost began his experiment of introducing crude black-and-white woodcuts into the text of his pictorial history, limited technologies made it impossible for illustrations to play more than a restricted, supporting role in the production. By the 1870s skilled artists such as F. O. C. Darley had begun to demonstrate that books could be sold with a profusion of in-text illustrations,

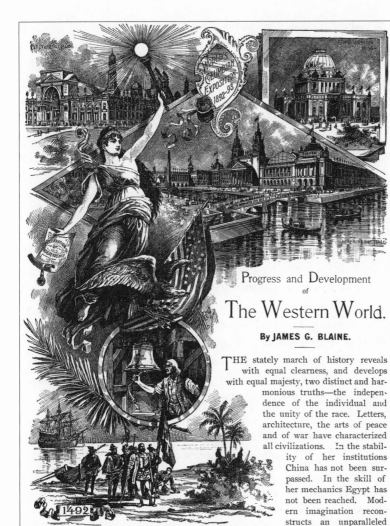

Figure 72. "Progress and Development of the Western World," 1892, for *Columbus and Columbia: A Pictorial History of the Man and the Nation*

Progress and Development
of

The Western World.

By JAMES G. BLAINE.

THE stately march of history reveals with equal clearness, and develops with equal majesty, two distinct and harmonious truths—the independence of the individual and the unity of the race. Letters, architecture, the arts of peace and of war have characterized all civilizations. In the stability of her institutions China has not been surpassed. In the skill of her mechanics Egypt has not been reached. Modern imagination reconstructs an unparalleled splendor from the ruins of Assyria. Nineteen centuries have not added to the grace of the Greek column or to the strength of the Roman arch. No proverb has supplanted the

(35)

although the potential impact of pictures in *Our Country* was reduced in part by constraints of size and graphic detail inherent in the limitations of the conventional engraving process. But by the 1880s and 1890s, when photographic technologies allowed for the intermingling of text and image in increasingly sophisticated ways, the potential for pictorial excesses was real. Consequently, critics of illustrated literature at the end of the nineteenth century complained with increasing frequency about the misuse of illustrations in historical texts and their corrupting influence on readers of popular history.

Some of the complaints in the field of pictorial history had to do with the tendency of publishers to reduce a book or magazine "to a mere picture album" by squeezing text out to make room for pictures.[34] The

proliferation of images over words on the printed page was contributing to a "growing aversion to reading" among Americans noted a concerned writer for the *Nation*, who added that the visual preferences of readers represented a "distinct reversion to barbarism" and a "recurrence to the picture-writing and sign-language of savages."[35] What was an untrained reader to do, the argument went, when illustrations such as those in *Columbus and Columbia* encroached so aggressively on the written word as to confine the historian's assessments to less than one-quarter of the page at the bottom right-hand corner (fig. 72)? The literal infringement of illustrations on the printed page had its figurative equivalent in the tendency of pictures to crowd out or preempt the imagination, thus precluding anything other than the most superficial and clichéd responses to historical texts. A writer in *Harper's Weekly* condemned such "over- illustration," warning that "our world is simply flooded" with pictures that "lurk in almost every form of printed matter." Under such unhealthy circumstances created in the interest of profits by unthinking publishers, "we can scarce get a sense of what we read for the pictures," he noted. "We can't see the ideas for the illustrations."[36]

Many writers in the new age of pictorialism also complained about having their prose overillustrated, not trusting in the ability of artists to reproduce with fidelity in visual form the subtleties of their nuanced literary depictions. Henry James, for instance, took issue with the tendency of publishers to "graft" or "grow" a "picture by another hand on my own picture," and he confessed to a certain "literary jealousy" at the prospect of fruits emanating from a "garden" the cultivation of which was accomplished "by other hands." James warned authors against "anything that relieves responsible prose of the duty of being . . . good enough, interesting enough and, if the question be of picture, pictorial enough, above all *in itself*." Au-

thors who allowed publishers to overillustrate their literary works were subject to what James called the "lawless" character of the "picture-book," an unfortunate propensity to which "contemporary English and American prose appears more and more destined, by the conditions of publication, to consent."[37]

Far from the kindred spirits they had once been presumed, then, literature and the arts were viewed increasingly by some in the late nineteenth century as mutually exclusive enterprises. The author of a *New York Times* article titled "Meaningless Illustrations" advanced this line of thinking when he noted that pictorial records "appealed mainly to those unreachable by words," those "unable to feel and appreciate the inward spirit of the writer," or those too lazy to take the time to actually read what was written on the printed page. Concessions made by publishers to "readers" of this sort corrupted the intentions of authors by allowing illustrations to compete with rather than enhance the author's literary meaning. "It was useless 'if not absurd,'" Bret Gyle wrote derisively, "to illustrate such works as Dickens, when the author takes chapters to bring an image before us. Should our ideals, formed under the guidance of a master hand, be crushed or perverted by the conception of another?" he asked. The genius of Dickens illustrator George Cruikshank notwithstanding, the answer was a defiant "Surely not." In the estimation of this critic, "the spread of illustration endangered individual thought by reducing all literary images to an inappropriate shorthand and prohibiting readers from shaping their own personalized mental pictures" of a scene.[38]

The issues raised by the proliferation of pictures in historical works were also aired in newspapers such as the *Literary News*, which periodically ran antipictorial diatribes such as "The Pictorial and the Literary Art" excerpted from Johnson's *Elements of Literary*

Criticism. This article suggested how far the distance traveled had been from the tightly argued theory of the pictorial mode in the 1840s to the loose-fitting pictorial philosophies of the 1880s. The central thesis of Johnson's column was that illustrations should rarely be used in any other than children's books. From his point of view, most illustrations were artistically incompetent, and those that were adequate in terms of artistic merit still corrupted vulnerable readers by encouraging "a sluggish habit of mind." Certainly no one cares to read an illustrated Shakespeare, Johnson wrote, unimpressed apparently with the Stratford edition of the playwright's *Complete Works*, edited by William Cullen Bryant and illustrated by Chappel and Darley. "It is not of the slightest consequence how Romeo looked, nor what was the height or weight of Caliban," he noted. "Such matters are the affair of the Painter" who shares little in common with the writer, because the "visions one sees crowd out the visions the other sees." Unless artist and author "chance to be spiritual duplicates, or unless the writer be dominant and the illustrator wonderfully receptive," Johnson argued, the only way for a working relationship to develop between them "is for both of them to look at the subject-matter from the same conventional standpoint, and relegate the higher and more individual qualities of the imagination to the background." Such a suppression of personal creativity might have worked for a pair such as Benson Lossing and F. O. C. Darley or author-illustrators such as Thackeray and Du Maurier. But even in these cases one might well ask, as Johnson did, "Is Du Maurier's text much more than an explanation of his pictures, and would not Thackeray have been greater as a writer if he had not amused himself with drawing?"[39]

The genteel and elite writers from whom much of this criticism emanated blamed the greediness of publishers for the pictorial excesses of their works. Al-leging a profit motive for the overabundance of illustrations in American literature, one exasperated writer to the *New York Times* asked, "Why do publishers insist on illustrating everything? Are they trying to pauperize our imagination, or do they think the public hasn't any?"[40] In the minds of these critics the pictorializing of texts had become synonymous with cheapness and an erosion of standards. The use of colorized methods came under particular attack by those who wished to protect literature from the corrupting influence of the visual. Chromolithography in particular was attacked for its encouragement of a "packaged 'pseudo-culture' that 'diffused through the community a kind of smattering of all sorts of knowledge' and gave people the false confidence of being 'cultured.'" For editorialist E. L. Godkin, the term "chromo" became indistinguishable from "ugly" or "offensive" and was responsible for the emergence of what he called derisively a facile "CHROMO-CIVILIZATION."[41] With the colorization of illustrations, he argued, pictorial history seemed to have returned to its crude, vernacular roots in the Crockett almanacs, signaling a decline in literary and cultural standards. Charles Congdon of the *North American Review* agreed, although he had greater faith than Godkin that the materialistic excesses of illustration-happy publishers would betray them eventually with American readers. Congdon encouraged critics such as Godkin to look forward impatiently to the day when "chromo-lithography was carried on to such an extent that at last the popular stomach revolted."[42]

There is no question that much of the criticism of pictorial histories in the last decades of the nineteenth century was justified. No inference could be drawn from a perusal of these overembellished works than that historical prose was secondary in importance to decorative elements. Designed to be seen as much as read, derivative volumes such as *Columbus and Co-*

lumbia encouraged publishers to rely in an unwholesome way on "fixed symbolic forms," eschewing "originality and initiative" for the "easier and more remunerative" paths of "imitation and fixed formulas."[43] The question was, what could be done about it? One strategy was to encourage publishers to recruit writers with established literary reputations who had sufficient name recognition to sell volumes in their own right, independent of the artists who might embellish them. This technique was evident in the pictorial histories issued between 1876 and 1898 by popular writers such as William Cullen Bryant, Edward Eggleston, and Julian Hawthorne.[44] Such narrative-minded texts distracted readers from the addiction of visual stimulation by refusing to allow "tawdry," fanciful pictures to carry too much the burden of historical proof, although there were complaints from reviewers that even these works trafficked in pictorial extravagance.[45] According to Charles Congdon, however, overillustration was "a fashion" that would not survive once publishers convinced themselves and others of the virtues of unadorned realism. The key was to restrain the forces of materialism at work in historical literature by calling readers back "to the good plain letterpress, to quiet binding and to mere frontispieces," with the inclusion of a portrait or two as a way "to gratify a reasonable curiosity" only.[46]

For their part, publishers sometimes saw themselves more as victims than as victimizers in the process of pictorial overindulgence. A few defended themselves against the charge of materialism, for instance, by pointing to the financial responsibilities incurred by publishers who chose to reproduce numerous illustrations in their works. As was the case with Lossing's *Our Country*, powerful illustrators such as Darley dictated the circumstances of their workplace by capitalizing on the growing authority of the visual. Frustrated at their loss of control at the hands of mere

"picture-makers" (some of whom demanded the respect and the salaries accorded "artistes"), publishers sought to reestablish their influence by increasing the role of the verbal in their pictorial histories, sometimes at the expense of the visual. Editorialist Edwin Carlile Litsey defended such decisions, asking pointedly in the columns of the *Critic* why illustrators should "be given the right of way above their fellow artisans who labor with letters and words."[47] Written language was more accurate at conveying the kind of complex meanings associated with lessons about the past than pictures, noted another observer from the *Nation*, who wondered why those "who come to scoff at history in uninteresting type" might "remain to pray over history tricked out with all the charm of the illustrator's art." This writer, Rollo Ogden, complained that illustrated histories were responsible for a "growing aversion to reading," especially among children, who demonstrated a disturbing "fondness for labor-saving and the thought-saving graphic representation."[48]

Publishers also noted the rising expenses associated with pictorial volumes. The cost ratio of pictorial to printed pages in illustrated histories was higher than many presses could afford, forcing some to reduce the number of illustrations in their works as a cost-cutting measure. Henry Johnson had shown in *Our Country* that extensive illustrating of pictorial histories could be popular and profitable, but the commissioning of more than five hundred illustrations by Darley had required a major investment at the outset of the project, a risky outlay of advanced funds that many presses could not afford to make. Publishers of illustrated books also found it increasingly hard to compete financially for the services of the best illustrators. Many artists preferred to work for magazine editors rather than book editors, because illustrators were paid generally by the size of their images as they

appeared on the printed page, and magazines were far more likely to use oversized pictorial formats than books. In addition, artists discovered that large magazine illustrations were adapted more easily to the rising print market than were smaller "book pictures." Periodicals with the widest circulations monopolized the time of artists such as Frederic Remington, who earned far more in a year as magazine illustrators than they did as book illustrators. "Fred has as firm a grip on Harpers & The Century as any artist in this country," Eva Remington wrote of her husband's preference for magazine work. "He has all he can do," she noted, and "Harper takes all he can make & asks no questions & gives him from $75 to $125.00 per page."[49]

In addition, the reception of pictorial history by popular audiences was influenced by the illustrated formats employed by periodicals. As magazine literature gradually dominated the marketplace, periodicals hired artists who could best accommodate the requirements of columnar arrangement and dual-page printing. When an artist such as Remington sat down at his easel or drawing board, more often than not he conceived his work in the format and layout of the periodical page.[50] Under the conditions created by these new circumstances, free-lance artists who worked for multiple publications in a wide variety of styles gradually replaced illustrators such as F. O. C. Darley who remained committed to a signature style appropriate mainly to conventional book formats. Most of the pictorial histories of the 1880s and 1890s were illustrated by artists who worked simultaneously for the historical projects of rival magazines.[51] The value of their pictorial work was judged and compensated in accordance with its suitability to the particular design needs of the periodical that commissioned it. Writers of history were also influenced by these tendencies, as historians found themselves needing to respond to

the orientation of magazine layout and design, the "multiple columns, decorative mastheads, ornaments, display type, and varying sizes of type" all creating special obligations on the part of the writer to compose with the "graphic" in mind.[52]

The adaptation of magazine formats to pictorial histories, though cost effective for publishers, rarely satisfied either illustrators or authors. Despite Edward Eggleston's claim in the introduction to *Household History*, that "the drawings have been mostly made under the personal supervision of the writer, and have required no less thought and care than the text itself," the pictorial elements in his history were borrowed mainly from the periodical images of artists such as Frederic Remington, who expressed disappointment at the quality of the translation.[53] All the illustrations in Eggleston's *Household History* were black-and-white wood engravings, and Remington, who worked best in color on the printed page, found that the engravers at Appleton's and elsewhere constrained his freedom. "Do not misunderstand me," he wrote of the breed in general, "I have no quarrel with the 'good' engravers of the block, the men who are as much artists as those whose drawings they interpret. But those clumsy blacksmiths turned woodchoppers, who invariably made my drawings say things I did not intend them to say—those were the fellows who made my youthful spleen rise up and boil."[54] Remington disapproved of the way that engravers at Appleton's and elsewhere tried to copy lines as a way of reproducing tonal values and mistranslated color into inappropriate gradations of black and white or hatchings. As a result of these compromises with technique, Remington viewed the work he did for Appleton's and other illustrated histories as substandard, and he eventually abandoned book illustrating to concentrate on his paintings and his sculpture of Western themes.[55]

Remington was not the only one critical of the pic-

Figure 73. "The Ships of Columbus," 1888, by Allegra Eggleston for Edward Eggelston's *Household History of the United States and Its People*

torial representations in the *Household History*. Others complained that the illustrations were inaccurate and unhistorical, suitable for tabloids but not histories that might be used by school children. A reviewer in the *Florida Times-Union* wrote of Eggleston's history, "In the plain truth we find lots of errors in the language; facts distorted, and even at a superficial examination the illustrations are, to say the least, left-handed abortions. In the first full page picture, while the *Santa Maria* of Columbus is running dead before the wind under the mainsail and crossjack, the *Pinta* is hove-to under the sprit sail—a thing she could not do; and the *Nina* is only an open jolly boat sailing to-

wards the *Santa Maria* right in the teeth of the wind, as if she was a steamer without any canvas" (fig. 73). In addition, the reviewer complained that illustrations of a "Scotchman" and "Scotchwoman" were inappropriate because "there is no such word neither in the Scottish nor English language as a Scotchman." As for the dresses, he wrote, "I have seen pictures of the Scottish people dating back hundreds of years, but I never saw any like these." A piper of a Highland regiment was depicted with his bagpipe under his right arm, "when it is always played with the left," while he carried a flag with a St. George cross on it in ignorance of the history of that pennant. "Just think of a High-

lander flying the St. George cross!" he noted with exasperation. "No one ever saw or heard tell of it."[56] Such misapplications of images, common to magazine literature where less rigorous editorial standards prevailed, were not acceptable in works of history. "Has not the time come to demand that the pictures introduced into works on social and cultural conditions be subjected to the same investigation which is given to other testimony?" asked an exasperated writer for the *Dial*.[57]

Over reliance on illustrations of any kind led some publishers and writers to conclude that pictorial works were contributing to the "deverbalization" of culture.[58] So grave was the threat of excessive illustration to the sanctity of the written word, in fact, that the strictest of antipictorialists questioned whether pictures should be included at all in history texts. The central concern was that the idealizing tendencies habitual in nearly all pictorial representations of unobserved events could undercut the realist mission of the historian. Although a literary text could be adapted reasonably well to the realist's goal of recovering the factual record of the past, illustrations of those facts often bled too freely into the imaginary or the ideal. Realism in the arts meant concern for the textured surfaces of objects and for the mimetic qualities of accurate reproduction, but these features had little relevance to past events not "pictured" in the literal sense. Some tried to safeguard against the idealizing tendencies of the pictorial by downplaying the role of illustrations, emphasizing the superiority of the written word over the graven image. A radical few even called for the abandonment of illustration in histories altogether, declaring them incompatible with the historian's ambition to tell the story of the human past with unquestioned honesty. For such extremists, the visual was only "a lifeless and meaningless mass of material" that was forever dependent on and must never distract from the "magic touch of the pen." As C. Edwards Lester put it on behalf of the sovereignty of words over images, "The empire of the pen can never be broken."[59]

Had Lester's position regarding the supremacy of the pen over the graver been taken to its illogical extreme, of course, it would have spelled the end of pictorial history, which by definition required the presence of illustrations. That late-nineteenth-century publishers did not take seriously his absolutist suggestion indicated the persistence of the visual in the historical imagination. Despite concerns about the potential for their misuse, pictorial representations were perceived by bookmakers as too necessary to historical understanding to be abandoned on intellectual grounds, too crucial to the selling of books to be forsaken for financial reasons. Unquestionably readers relied on visual cues for historical comprehension, and although it is sometimes hard to separate cause from effect in determining what sells books, bestseller lists from the late nineteenth century suggest that illustrations were a prerequisite to success in every corner of the literary marketplace. Some publishers made a conscious effort to use only those illustrations that they presumed complemented the literary goals of their authors. The key was to find visual formats that did not contradict the authenticating intentions of historically minded writers who relied primarily on nonvisual sources. This was not always easy, however. Many illustrators had followed their literary associates into the realist movement, but they faced special challenges in representing historical events "as they had really occurred." Realist painters abandoned allegorical and timeless subjects in order to depict the "palpable truths" of the here and now, for instance, but such prioritizing biased their works in favor of contemporary topics. In addition, the "forthright mimetic approach" of realists often felt

uncomfortable to historians who were accustomed to searching for "concealed meanings, unconscious motives, symbolic insinuations, and higher purposes" in the historical record.[60]

William Dean Howells's important 1890 realist novel, *A Hazard of New Fortunes,* engaged many of the dilemmas faced by marketers of pictorial histories. Howells's work centered on the travails of an editor, March, who proposed to a publish a periodical without illustrations on the grounds that pictures tended to "ensnare the heedless and captivate the fastidious." In making this bold recommendation to his publisher Fulkerson, March claimed that he hoped to exclude illustrations "not because I don't like them, but because I like them too much. I find that I look at the pictures in an illustrated article, but I don't read the article very much. It was different," he argued, "when the illustrations used to be bad. Then the text had some chance"; but in the heyday of pictorial refinement, words were undeniably at the mercy of images. Although the publisher of March's periodical agreed with his editor in principle that pictures distract, he could not ignore the imperatives of the bottom line. "My dear boy! What are you giving me?" Fulkerson responded to March's suggestion. "Do I look like the sort of lunatic who would start a thing in the twilight of the nineteenth century *without* illustrations?— Come off!"[61] Given the expectations of most readers for pictorial embellishment of one sort or another, publishers could not in good conscience purge their popular histories of illustrations even if they found visual representations troublesome to select and expensive to produce.

As exaggerated as some of the jeremiads against illustration were, they indicate that the triumph of the word celebrated by eighteenth-century intellectuals had given way in the late nineteenth century to the cult of the image. To those scholars trained primarily in the Enlightenment tradition of verbal analysis, the loss of preeminence for the written word spelled disaster, especially for "young mind[s]" that could "scarcely be likely to do any original thinking" when "overfed pictorially."[62] Although there had always been resistance to the pictorial among these linguistic critics, their attacks intensified in the late nineteenth century as the capabilities of illustrators increased. Lamenting that the "emblematism" of pictorial histories such as Josephine Pollard's had decreased the abilities of young people to articulate ideas about the past, they called for an overturning of the modes of historical thought that had allowed a "childish view of the world" to be "on top."[63] How could readers appreciate the verbal or articulated text, it was asked, when they were faced with a bombardment of icons and symbols? Such questions provoked petulant answers from antipictorialists such as Sydney Fairchild of *Lippincott's,* who warned that the reading public had gone "picture-mad" during an era in which the "highest thought, the deepest truth, the most exquisite bit of description, poetry, dialogue, love, tragedy, humor, realism of any kind, all are subjected to the tyranny of the pictorial."[64]

The Empire of the Pen

Among the most vocal critics of the "tyranny of the pictorial" were members of a new cadre of scholars, professional historians interested in establishing codes of intellectual behavior on behalf of an independent academic discipline of history. As Thomas Haskell has noted, although professionalization occurred in many scholarly fields in the late nineteenth century, history was a leader in this movement, in part because the developmental theories central to the rationalization for autonomous disciplines were grounded in evolutionary and historical principles.[65] Such profes-

sionalism had been anticipated by Henry Dawson and others influenced by German historical scholarship just prior to the Civil War. By the 1880s historians associated with American universities and colleges began to draw distinctions between their own "scholarly" work and the unreliable methods of popularizers of history.[66] In 1884 forty- one of these self-identified "professionals" gathered together in Saratoga Springs, New York, to establish the American Historical Association (AHA), the first professional organization in the nation devoted to the study of history.[67] One of their first orders of business was to extend invitations of membership to another 120 "well-known students of American history," none of whom had made a reputation in the pictorial book market.[68]

If these "professional" historians shared a common methodological goal, it was to bring scientific regularity to the study of the past. The *Boston Herald* commented in an advanced notice of the first meeting that the "organization of the American Historical Association at Saratoga next Tuesday . . . is understood to mean an attempt to give historical studies in this country a larger scope and purpose, and to place them upon a scientific basis."[69] The first papers presented at the conference reaffirmed this scientific bent. Andrew D. White's paper "On Studies in General History and the History of Civilization" advocated the strong "union of close scientific analysis with a large philosophic synthesis," recommending the establishment of guidelines for objectivity and scholarly detachment.[70] At the December 1890 meeting Professor R. H. Darby asked the question "Is History a Science?" and answered his own query with a firm yes. Students of history must employ "a far stricter and more critical spirit . . . into the investigation of the mere facts of history," he noted, than was the case with the "long cherished" "delusions" of popularizers who allowed the "obstructing rubbish" of legend to interfere with

the honest presentation of the past.[71] Henry Charles Lea agreed in his 1903 AHA presidential address, adding that in all their writings, professional historians should be as "purely objective" as possible. "We all of us have our convictions—perchance our prejudices—and nothing for the historian is more vital than to be on his guard against their affecting his judgment and coloring his narrative," he warned. Above all, he added, the historian "should cultivate the detachment which enables him soberly and impartially to search for and to set forth the truth."[72]

C. M. Andrews described the AHA in these early years as "the accepted promoter of historical work, giving point and direction to historical achievement, and acting as a clearing-house for historical ideas and enterprises." In search of "accepted standards or principles to which historical writing is expected to conform," professionals tried to introduce "higher canons of criticism and interpretation, better balanced judgments, and more rational methods of presentation." Writers of popular history who had been satisfied merely "to entertain their readers with sprightly and dramatic narrative, rich in style and glowing with color," he remarked, were being replaced by professionals who believed that the "historical concoctions" of amateur historians were "as injurious to the mind that absorbs them and believes in them as were injurious to the human body the old-time frauds and adulterations with which the apothecaries of the past filled the stomachs of their patients." Opposed to the excesses of "literary hacks" such as Frost or the visual chicanery of those such as Halstead, Andrews offered in exchange the profile of the academic historian whose work "corresponds to the experiment in the laboratory, where the investigator is at all times in touch with the problems and workers in the field and is able to make his results known to his brother scientists through the medium of the scientific publica-

tions." Such scholarly rigor was essential to the integrity of historical studies in America, Andrews argued. "The historian cannot be a free lance to write as he pleases, for he must play the game according to the accepted rules, and it is one of the outstanding marks of the progress which the study of history has made in this country that there are accepted criteria accompanying historical research and presentation and accepted standards—constituting a code not dreamed of in older days—to which the writer of history must conform."[73]

Of all the things that worried members of the American Historical Association most about popularizers, none caused more concern than the heavy reliance on visual content in popular histories. Scholars campaigned actively to disabuse readers of the notion that an illustration could convey meaning more directly and accurately than the written word. A picture might be worth a thousand words, but if they were the wrong words, then illustrations were counterproductive to the historian's mission. French historian Jules Champfleury summarized the position well: "There are some men and women whose natures are so strangely constituted that they are more impressed by painting than by print, by a picture than by a book." These were odd fellows who believed that the "stroke of the pencil teaches them almost as much as history," he concluded. Deploring the simplemindedness of such visually oriented readers, Johan Huizinga added, "The fantasies of those who claim to be able to read in a picture the complete character of some individual, in all its mysterious depths and in all its most subtle psychological nuances, are well enough known. This is dangerous rhetoric of no use to history," he concluded, arguing that illustrations seduced readers in ways that had hampered severely the power of scholars to make history an effective tool for learning.[74] This growing distrust of the visual

threatened the reputation of all pictorial histories among scholars who warned that the "mass of inexpensive, sometimes sensational illustrations that took up increasing space" in such picture books was contributing alarmingly to the "degeneration" of the literary imagination.[75]

Professional historians cautioned each other about the abuses of pictorial histories in meetings of the AHA and in professional journals devoted to the scholarly pursuit of the past. In an article in the *History Teacher's Magazine* titled "Pictures: Their Use and Abuse in History Teaching," Dr. Edgar Ames admit-

Figure 74. "Escape of Benedict Arnold on the British Sloop-of-War 'Vulture,'" by Howard Pyle for *Harper's Magazine* 93 (July 1896)

ted that some illustrated materials were useful in educating young minds about the past, provided they were historically accurate and capable of arousing interest in pursuit of truth. Ames singled out Howard Pyle's "Escape of Benedict Arnold" (fig. 74) as an example of an illustration that "tells the whole story" of a historical episode in a reliable pictorial narrative, depicting "better than any words can do" the "sneering looks of the officers who receive" Arnold and the "lifelong agony of self-contempt and the hatred of the world" he incurred. "I have never known a class to look at ["Escape of Arnold"] without that hush of feeling and understanding that we so desire and so seldom have, that tells us an historical truth has been understood," he noted. But Ames added that most illustrations in pictorial history books were "of no value whatever." A work like the endlessly reproduced *Washington Crossing the Delaware* was harmful to the historical sensibilities of students, he argued, because Leutze "failed to realize that in a picture a deeper sentiment may be aroused by a simple truth of representation than by a display of mock heroics." Ames also rejected the tendency of history teachers to instruct from the "great many ordinary pictures cut from magazines" and adapted for use in classrooms and textbooks. The creators of such "penny pictures" felt little obligation to record history accurately, he argued, and their illustrations in pictorial histories did virtually nothing to elucidate for students "the personages who move across the historical horizon" or "the life, manners and customs of the people." Illustrated textbooks should be filled with "good copies of famous historical paintings," such as Rembrandt's *Syndics of the Cloth Guild*, Ames concluded, "pictures with figures" that "occupied without acting" and "speak without moving their lips." In lieu of such expressive and responsible pictures, students would be better off without any illustrations at all.[76]

Scholars also complained to each other in professional bibliographic works about the "perils of pictorialism."[77] One such important source of admonition was J. N. Larned's *Literature of American History*, an annotated guidebook that condemned works of history demonstrating too strong a tendency toward pictorial effect. Of Hamilton Mabie's *Popular History of the United States* a reviewer for Larned remarked contemptuously, "There are many illustrations. Of these a considerable number are fanciful, and some are exceedingly sensational." Charles Morris's *History of the United States of America* was characterized as a careless composition without "special merits," filled with "illustrations that are merely imaginative" and display "neither originality nor a knowledge of modern methods of instruction."[78] But Larned reserved his most critical commentary for Joel Dorman Steele and Mrs. Esther B. Steele's *Popular History of the United States* (1899), singling out specific illustrations such as

Figure 75. "Execution of a Spy at Kingston, New York," 1885, for Joel Dorman Steele and Esther Baker Steele's *Popular History of the United States*

Figure 76. "Assassination of President Garfield," 1885, for Joel Dorman Steele and Esther Baker Steele's *Popular History of the United States*

"Execution of a Spy at Kingston, New York" and the "Assassination of President Garfield" for special denunciation (figs. 75 and 76).[79] "There are a great many illustrations, but many of them are badly executed, and the subjects of a considerable number are sensational, and for youth distinctively unhealthy," Larned argued.[80] Concerned by the capacity of evocative images to subvert the uplifting intentions of words, *Literature of American History* rejected the Steeles's use of sensationalized depictions of death, echoing Anthony Comstock's argument in *Traps for the Young*, that such sources could be the cause of emotional, passionate and even murderous behaviors in children.[81]

Not all professionals rejected illustrations out of hand. Some, in fact, supported their use, even in scholarly works. In the 1886 meeting of the AHA, for instance, Albert Bushnell Hart defended illustrations in remarks titled "Graphic Methods of Illustrating History." According to the secretary's notes, Hart began "by briefly speaking of the value of illustrations which appeal to the eye, as arousing and holding the interest of listeners, and making clear complicated details." But early in the presentation, it became obvious that Hart had a very limited scope in mind when he referred to useful illustrations, confining his remarks primarily to "the practical methods of making large-scale maps and diagrams."[82] Justin Winsor was equally restrictive when he reported to the Executive Committee of the American Historical Association on the progress of his *Narrative and Critical History of America* (1889), an eight-volume scholarly compendium of the history of America since the Age of Discovery. "The graphic illustrations are to be very numerous," Winsor noted, but he qualified the remark by adding that "nothing in the way of imaginary or idealized pictorial designs is to be allowed." Relying only on facsimiles of documents and maps, materials whose physical presence could be verified, Winsor rejected "fanciful" drawings that presumed to imagine what had happened in a historical epoch. "There is a necessary sympaty between the graphic illustrations belonging to a period under observation and the progress of its events," he wrote, and "a certain wrong is done to the critical sense if other pictorial associations are established."[83]

Hence scholars inside and outside the American Historical Association rejected pictorial histories for a variety of reasons having to do with the lack of objectivity, rigor, and authenticity in such volumes. Illustrations of history were not intrinsically bad, Charles Henry Hart noted in a special report to the AHA titled "Frauds in Historical Portraiture, Spurious Portraits of Historical Personages." The inability of publishers to differentiate responsibly between good and bad pictorial representations, however, made their works inferior to literary treatments of the same material regulated by trained professional authorities.[84]

The question in the minds of these critics was whether it was ever possible in using illustrated formats to improve the reliability of historical depictions. If objectivity was such a priority, then what technologies could be used to increase the reliability of illustrated material, they asked? How could the usurping vision of the artist be reduced or eliminated to allow the "matter" of history to retain its integrity independent of the distortions of the packaging? These questions were debated endlessly both inside and outside the historical profession in the late nineteenth century, with the proposed solutions having profound implications for pictorial history as a genre and for pictorial historians as a publishing community.

"Of Rembrandt Rather than of Rubens"
A good way to demonstrate the commitment of professionals to the antipictorial campaign is to focus on their reaction to one of the most popular illustrated historians of the turn of the century, Woodrow Wilson. Because of his political prominence it is easy to forget that Wilson was trained first as a historian and was best known in the 1890s as the author of various popular historical pieces in widely circulating periodicals. Born in Virginia five years before the outbreak of the Civil War, he was raised with a keen sense of regional identity and sensitivity to the historical significance of the South. Wilson studied history and law at Princeton and earned his doctoral degree under Herbert Baxter Adams at Johns Hopkins University. He became a college professor of history, teaching and serving in administrative capacities at Bryn Mawr and Princeton and was later active in the AHA. His graduate-student colleagues at Hopkins included future leaders in the profession, among them C. M. Andrews and Frederick Jackson Turner. His first books on congressional and state government were praised

as models of "scientific scholarship," and by the 1890s he was acknowledged as one of the best of a new class of professional historians occupying important positions in the newly emerging university system.[85]

Wilson loved historical scholarship and pursued his research agenda aggressively, but almost from the beginning he had nagging doubts about the relevance of the professional monographs he produced. In his most candid moments Wilson admitted that he had ventured into history as a way of satisfying repressed political urges, and by the 1890s he had begun seeking public uses for his scholarship and teaching. "I love history and think there are few things so directly rewarding and worth while for their own sakes as to scan the history of one's own country with a careful eye and write of it with the all-absorbing desire to get its cream and spirit out," he wrote Frederick Jackson Turner. "But, after all, I was born a politician, and must be at that task for which, by means of my historical writing I have all these years been in training." His interest in writing history "was less in knowing what had happened," he admitted to his friend, "than in finding out 'which way we were going.'"[86] Such confessions, hard to make as they might have been for a dedicated scholar such as Wilson, freed him to participate in the essentially political exercise of finding new techniques of presenting historical evidence to wider public audiences. To this end, Wilson experimented with two related literary forms in the 1890s— the illustrated periodical and pictorial history—in an effort to increase the scope and serviceability of historical research for American citizens.

Wilson's public profession of his politicized philosophy of history was an 1895 article on historical methodology titled "On the Writing of History," first published in the Century Illustrated Monthly Magazine. Noting that his own graduate training was inadequate to the task of presenting history to the masses, Wilson

condemned the dictum fashionable among university-trained scholars: "Give us the facts, and nothing but the facts." Such feigned objectivity, he noted, produced a false sense of authority among professionals and a lack of proper perspective on the past. As an alternative, Wilson called for historians-in-training to develop "a very catholic imagination" by which truths behind the facts could be brought to life. Too many historians wrote "colorless histories," in Wilson's estimation, "so passionless and so lacking in distinctive mark or motive that they might have been set up out of a dictionary without the intervention of an author." Wilson claimed that scholars were too reluctant to acknowledge their personal (even political) agendas, too unwilling to reveal the "chronicler underneath the chronicle." The consequence of this detachment was that the true "form and color" of history were often lost. Using an extended pictorial metaphor, Wilson noted that the historian "must look far and wide upon every detail of the time, see it at first hand, and paint as he looks; selecting as the artist must, but selecting while the vision is fresh, and not from old sketches laid away in his notes." Like an impressionist watercolorist, the historian must always paint "direct from the image itself," using his "knowledge of the great outlines and bulks of the picture" as a guide and restraint for the "individual strokes of his work."[87]

In proclaiming the virtues of an impressionistic perspective, Wilson aligned himself more with popular historians than with the professionals among whom he worked, although he acknowledged that some pictorial historians had been guilty of sacrificing truths in pursuit of the sensational. Noting that the "picturesque writers of history have all been right in theory" and "wrong only in practice," he argued that "it *is* a picture of the past we want" in our histories, complete with "express image and feature," but it must be "the true picture and not simply the the-atrical matter—the manner of Rembrandt rather than of Rubens." According to Wilson, melodramatic historians such as Frost and Spencer discredited themselves by putting "false or adventitious colors" into their narratives, forgetting that although "all life may be pictured . . . not all of life is picturesque." Historians like these "who select an incident merely because it is striking or dramatic" were but "shallow fellows" in Wilson's mind. "They see only with the eye's retina, not with that deep vision whose images lie where thought and reason sit," he argued, adding that the "real drama of life is disclosed only with the whole picture." This necessary holism was appreciated only by "the deep and fervid student" of the past, whose mind "runs always to the authentic colors of nature, whose art is to see and to paint what he sees." Noting that the historian needs "imagination quite as much as he needs scholarship, and consummate literary art as much as candor and common honesty," Wilson concluded that even imperfect pictorial historians approached more nearly his ideal of historical scholarship than did most scholars in the historical profession, because errors of amateurs were failures of degree rather than of kind.[88]

It is not coincidental that Wilson chose to announce his nonconformist philosophy in an illustrated periodical magazine such as the *Century*, because he viewed such publications as important vehicles for the conveyance of historical lessons to public audiences. In turn the periodical format influenced greatly the kind of history Wilson could tell. Periodicals had a significant impact on the reception of ideas about literature, art, and popular history in the late nineteenth century, because these publications allowed for a more diverse range of political and artistic expressions and gave voice to the special configurations of memory and nostalgia that came to dominate the late nineteenth century. The best-selling

journals in the country, such as *Harper's, Scribner's*, the *Century, Collier's*, and *McClure's*, featured each month dozens of articles about every aspect of history; muckraking historical investigations, genealogical studies, antiquarian pieces, articles on the Constitution, queries about the lingering influences of the Civil War, and speculations on the history of American technology. The serialized format of many such periodicals also offered greater flexibility and adaptation to historians anxious to vary the presentation of their material over time. Although the segmented qualities of serialized magazines created the potential for fragmentation of meaning and disruption of narrative flow, they allowed historians such as Wilson to make timely alterations to texts in accordance with the most current public events. Turn-of-the-century readers were more comfortable with such disjuncture than had been their predecessors, Wilson's impressionistic style appealing as it were to an emerging aesthetic of the "modern" and challenging to the rigidities of established antiquarian forms.[89]

The pervasive influence of the periodical form is best evidenced in a pictorial history of the United States begun by Woodrow Wilson in the mid-1890s. As a southern professor of history and political science at a northern university, Wilson had long desired to publish a meaningful history for students written from a southern perspective. Works such as Alexander Stephens's *Pictorial History of the United States* were not suitable, Wilson noted, because they were too partisan in their sectional affiliations to be marketed to a national audience. He began thinking seriously about writing a more balanced history after so many "men of influence" in the South encouraged him that it "came to look like a sort of public duty."[90] By 1898 he had completed enough of the introductory material for such a work to warrant some preliminary discussions with *Century* editor Richard Watson

Gilder about publishing the manuscript in serial form.[91] Gilder liked the initial chapters of Wilson's project instantly, but he doubted their "magazine-ability" and offered instead to publish them as a book.[92] Charles Scribner also approached the professor about a book contract.[93] But in the spirit of public obligation with which he conceived the assignment, Wilson informed both publishing houses that he preferred to release the work in "some twenty-four historical essays for publication throughout a couple of years in a magazine" where it would gain broad exposure among the American people. In addition, he announced, "he planned a heavily illustrated history, and spreading its parts over two years would afford the time for the selection of illustrations 'which would themselves be vehicles of history.'"[94]

Friends such as Walter Page urged Wilson to accept either the Gilder or the Scribner book offer on the grounds that a standard published volume of history would be more useful to his growing professional portfolio than illustrated magazine articles. "Down at the bottom of my immortal soul I have a prompting to ask," Page wrote Wilson. "Why publish a history as a serial at all?" Writing for periodicals, Page implied, would create obligations of content and form that no professional scholar could in good conscience accept.[95] But Wilson dismissed Page's concerns, reaffirming his commitment to the general public rather than professionals.[96] He also hinted that finances were a concern, as periodicals were offering good money for successful serializations. In this latter regard Wilson's patience paid off, because Harper and Brothers eventually paid him twelve thousand dollars for the serialized history, a staggering thousand dollars for each of twelve articles to be published over several years.[97] In addition, Harper and Brothers dangled the prospect of a lucrative book contract before Wilson if the public reception to the articles justified one.[98] Like

many, Wilson worried a bit about the commercial taint associated with publishing his ideas first in an illustrated periodical format. "The editors of the popular monthlies offer me such prices nowadays that I am corrupted," he admitted to J. Franklin Jameson, who had expressed his concerns about pictorial monthlies. But Wilson assured his friend and consummate professional that he would not compromise the scholarly quality of his work "to suit the medium."[99]

From the beginning, Wilson took an active role in all aspects of the publishing process. He wrote numerous letters to his editor at Harper and Brothers, Henry Mills Alden, asking for details about the layout, electrotyping, and advertising for the series.[100] Wilson also played an important role in decisions regarding the illustration of his installments. Harper and Brothers had promised to spend as much as ten thousand dollars pictorializing the twelve segments, and Wilson made frequent suggestions about how to allocate the budget.[101] First he asked Alden to secure the services of painter Frederick Coffay Yohn, whose historical illustrations Wilson had admired for their "dramatic quality" and fidelity. When Alden reported that Yohn was on assignment in Europe for Scribner's preparing sketches for political rival Theodore Roosevelt's serialized biography of Oliver Cromwell, Wilson admitted to being "deeply disappointed" with the news and refused to give up on the prospect "of getting a picture or two from him at long range."[102] Eventually Wilson succeeded in securing a few works from Yohn, but he had far better luck with an artist from Wilmington, Delaware, Howard Pyle, who had illustrated numerous popular works for Harper and Brothers. Pyle had been raised on a steady diet of illustrated English periodicals—Punch, Illustrated London News, Once a Week, Churchman's Family Magazine—and these works of the pictorial press inspired him to illustrate books for children such as The Merry Adventures of Robin

Hood (1883) and a later edition of Diedrich Knickerbocker's History of New York. Also interested in history, Pyle produced dozens of illustrations for pictorial works, including books by Benson Lossing and Julian Hawthorne. "Full of meticulously researched detail, based on life studies or on photographs of models in costume," Pyle's illustrations were "in the history-painting tradition of the English and French academics, continuing the idea of representation of history as an enactment on a stage." The "You-are-there" quality of his "Colonial pictures," noted one reviewer, separated him from the average illustrator of historical subjects. It was Pyle's verisimilitude and attention to detail that first attracted him to Wilson.[103]

Fiercely independent and able to take advantage of the stylistic freedoms provided by new graphic technologies, Pyle emerged in the 1890s as the premiere exemplar of a new unfettered generation of book illustrators. He averaged more than 150 magazine and book illustrations a year between 1890 and 1895, and he supplemented this work for periodicals with exhibitions of historical paintings in oil at places such as the World's Columbian Exposition in Chicago.[104] After 1895 Pyle distinguished himself further as an illustrator of historical scenes in a series of colonial sketches in Century's Illustrated Magazine and in a traveling exhibition of works by American book and magazine illustrators. Of this work the New York Times reported, "Howard Pyle leads all the rest with his paintings of the 'Fight on the Common, Lexington,' two of the series of twelve paintings of the 'Battle of Bunker Hill,' of which the remainder are to appear, and of 'Jefferson Writing the Declaration of Independence.'"[105] Samuel Isham's later proclamation that Pyle was "the only man who seems to know thoroughly the colonial and Revolutionary epoch" explained further Wilson's conviction that Pyle must be Yohn's replacement.[106]

Wilson was attracted not only to Pyle's artistic vision but also to his philosophy of history. Like Wilson, Pyle believed that historians had an obligation to the facts as filtered through an active historical sensibility. "While painting a battle scene, the artist should be able to smell the gun smoke," Pyle wrote, adding that as an illustrator "one must live in the picture."[107] Pyle had demonstrated his commitment to this dictum by photographing relevant scenes for an 1895–96 serialized biography of Washington by Wilson, a successful collaborative work that justified hopes for a still more successful Harper and Brothers history. "I was delighted when Mr. Alden wrote me that you had consented to take part in illustrating my history," Wilson wrote Pyle, "not only because you are easily the first of illustrators" but because "we jump so together in the matter of the illustrations, and have such a natural community of taste."[108] Flattered by the suggestion of their mutual commitments to a common set of beliefs, Pyle promised to accelerate his efforts to bring their mutual philosophy of history to the attention of the American public. "I remember in our work upon the History of the Life of Washington you specified your subjects and I upon my part after carefully reading the manuscript was allowed to give my ideas concerning them from the standpoint of an illustrator," Pyle wrote Wilson.[109] In keeping with that established format, Wilson proposed to outline specific subjects for illustration derived from the manuscript and asked Pyle to execute preliminary sketches based on those suggestions as talking points for further refinement. If all went according to plan, Wilson predicted, the *Short History of the United States* for Harper and Brothers would provide Americans with "a real history of [their] national development" of sufficient "literary and artistic value" to withstand the erosions of time and place.[110]

The installments of the *Short History of the People of the United States* that appeared in *Harper's Magazine* for 1901 confirmed Wilson's sense of the value of an impressionistic philosophy of history. Arranged in segments of roughly ten to twenty magazine pages each, his "essays" presumed that readers of serialized works could not be counted on to have perfect recall—or perhaps any recall—of themes and descriptions established in earlier installments. Each article was written to stand independently, therefore, assuming only a vague association with the others in the series. This formatting of the serial allowed Wilson to jump from topic to topic without too much concern for narrative flow and permitted readers to pick up the story at any juncture. Hence, in the opening paragraphs of the first installment of the series, Wilson skated effortlessly from the "sober, contentious seventeenth century" back to the "breathless, eager stir of the Elizabethan age" and on to the "an age of commerce and organization." He presented materials on Marco Polo alongside those on the Reformation, and when limitations of space required brevity, he exhibited remarkable talents for compression. Although the history of the American Revolution stretched out over one hundred pages, Wilson collapsed the period between 1715 and 1754 into a few terse paragraphs.[111] Letters between Wilson and Alden reveal that although both author and editor were pleased with the general presentation of the pieces, the apportionment of space for topics was a problem because it disregarded scholarly conventions concerning the proper periodization of the past. They convinced each other, however, that readers would tolerate such difficulties if the historical judgments and political messages of the articles were sound.[112]

The larger question, perhaps, was how readers would receive the illustrated format. As both artist and author doubtless understood, readers of *Harper's*

Magazine were probably at least as attracted to the series by Pyle's illustrations of American history as they were by Wilson's rehearsals of historical debates. This knowledge emboldened Pyle to imagine that, as an untrained but earnest student of the colonial period, he could take an active part not only in the creation of the illustrative material for the series but also in the shaping of its intellectual content. In this regard the relationship between Pyle and Wilson was very revealing of the new directions evident in the genre of pictorial history. In their first work together, the biography of George Washington, Pyle felt free to question Wilson about his source of information for a meeting of patriots at a tavern in Raleigh, doubting the veracity of "a picture of the room in the Raleigh tavern in Lossing's Field Book of the Revolution" on which the description was based. In addition, Pyle challenged Wilson on the accuracy of his assertion that two British inspectors were on board a vessel bound for the colonies to incorporate Virginia into the Commonwealth.[113] At first Pyle was decorous and self-effacing in his suggestions, as when he confessed to Wilson, "I did feel very much the impertinence of criticizing your article, and I only came to the conclusion that the two commissioners, representing the Provinces, were not aboard the Parliamentary frigate when I came to study into the matter more closely with the idea of illustration in my mind."[114] Later, however, the artist became bolder in his advice, as when he disputed Wilson's assertions about the place of Washington's wedding (correctly, as it turns out).[115]

Wilson was almost always open to Pyle's suggestions, as evidenced by his willingness to defer to the artist even on matters of historical content. "By all means make the selection of illustrations for No. VII in accordance with the scheme you suggest," he wrote his illustrator. "You know a great deal better than I do what will lend itself to picture-making, and, since this is the No. which, alone perhaps, lends itself to the carrying out of a scheme of illustration, I hope that you will make the sort of selection you propose." Wilson trusted Pyle's historical instincts and research and viewed the artist as a collaborator in a collective enterprise. "You understand the objects I have in view quite as sympathetically as I do myself," he told the illustrator.[116]

Some of the most meaningful discussions between Pyle and Wilson involved which topics were suitable for illustration and which were not. A number of the episodes Wilson proposed for pictorialization in the *Harper's* series had potential as literary subjects, Pyle noted, but, because they were not "exactly susceptible to illustration," they might "fall altogether flat as . . . picture[s]." For instance, Wilson had proposed to his editor that the article on Nathaniel Bacon be illustrated either by a portrait of the rebel demanding his commission in the House of Burgesses or one of Bacon threatening the Governor at the head of his troops. Pyle was dubious about the pictorial feasibility of either suggestion and prevailed on Wilson to accept an alternative. "In regard to the two Bacon pictures, I feel that while both of them are very dramatic from a literary standpoint, they may not be so easy to make clear in an illustration where the words must necessarily be omitted," Pyle wrote Wilson. "It seems to me that a much better illustration would be the burning of Jamestown with Bacon's tatterdemalion army marching through the wide Colonial street or road."[117] Pyle won the day in this matter but acquiesced in others, as when Wilson rejected his request to illustrate "Washington refusing the offer to make him a King" on the grounds that "it was really an incident of correspondence" than of verifiable reality. Calling it "dangerous, historically" to dramatize a scene that never physically took place, Wilson

warned, "I should fear that, in making a picture of it, we should be in danger of putting in too large an imaginative element."[118]

Generally Pyle's suggestions for illustrations were intended to heighten the drama of Wilson's narrative that the artist found occasionally dull and repetitive. For instance, in the fifth segment of the *Harper's Magazine* manuscript, Pyle rejected a proposal from Wilson for an illustration of the surrender of New Netherlands in favor of a more sensational and (in Pyle's estimation) more "popular subject,—of a farmer plowing his clearing and an Indian watching him in ambush—or some such typical subject of the war of civilization and savagery for the possession of the Continent."[119] On the same grounds Pyle had strongly recommended that Wilson include a dramatic depiction of "the supreme and crucial test of that terrible winter at Valley Forge" in his biography of Washington, an illustration more akin to Chappel's depiction of that brutal season than Darley's. "Not only is it a very sublime subject," Pyle noted, "but there are no doubt instances of individuality displayed by Washington at that time that would be very dramatic."[120] In such cases Wilson often accepted Pyle's suggestions but insisted on a departure from sensationalized or clichéd formats. "I can agree very heartily to an incident taken from Valley Forge, if only you hit upon something that took place there which dramatically reveals the man, and not merely the new conventional subject of the sufferings of the troops from cold and privation."[121]

The lone exception to Pyle's rule of theatricality was his suggestion that Wilson abandon a request for a depiction of the swashbuckling Captain Phips of Massachusetts raising a Spanish galleon. Although "very picturesque," it "is hardly historical," Pyle wrote, adding his preference for a more "typical" treatment of family life in a cave home in rural Penn-sylvania. The illustrator explained, "There are several accounts of how these caves were made, and I think I could make an image of it so as to let the reader see pretty clearly what they looked like."[122] Wilson acquiesced on the cave illustration, but he urged Pyle not to abandon the Phips drawing altogether. "I am very loath to give up Phips and the Treasure Ship," he wrote, as the incident was "perfectly historical" and unusually charming. "There is so little that is romantic in our national story that I greatly value these too infrequent touches of the picturesque," he admitted.[123] Pyle conceded the point. "I did not mean to question the historic accuracy of the story of lifting the Spanish treasure," he apologized to Wilson, "I only meant that it was a personal history rather than a national history and was, perhaps, not so pertinent to your book."[124]

In addition to the obvious impact Pyle had on the selection of illustrations for Wilson's history, the artist also had an important influence on the intellectual content of the work. This effect derived in part from Wilson's habit of beginning segments of his manuscript only weeks before they were due at the editors, forcing Pyle to guess at the proper tone to assume in illustrating the subjects on which they had agreed in advance. "I suppose it would be rather risky to go on with the illustrations for the Fifth Washington Article until the paper is finished," Pyle had written during the production of their first collaborative work. "But I am very sorry, for I foresee a great deal of inconvenience unless the articles are pushed through with a rush."[125] Because of Wilson's delays, Pyle was compelled often to produce illustrations independent of the text, hoping that he could anticipate Wilson's historical intentions.

Pyle accepted this arrangement not only as a practical expedient in his busy work schedule but because increasingly he came to view his illustrations as au-

tonomous works of art that were only secondarily embellishments of a text. In an interview in *Pearson's Magazine* for September 1907 Pyle explained that in his conception, the art of illustration did not mean "the making of diagrams of the text." Rather, he argued, "a work of true art must be independent and superior to the text."[126] Hence Pyle took stronger and stronger initiatives in the articles as time went on, writing Wilson that as an artist he was comfortable working independent of the written manuscript if circumstances necessitated. "As for your article, I dare say we can manage to make the illustrations for it even without having the text fairly in hand," Pyle assured Wilson. "If you will let me know what point you intend to treat in the second article, I will look up authorities and make a sketch or two which I will send you so that you may see that they will agree with the text."[127] For his part, Wilson was accepting of most of Pyle's strategies and philosophies, even approving the inclusion of illustrations of events he had not referenced in the history, events he presumed could "be got in without a text."[128] Sometimes such approval was adopted as the path of least resistance by Wilson, even though it led to some odd disjunctures and compromised the professional standards of relevancy and accuracy under which he had been trained. "It seems to me perfectly safe for you to go ahead with the illustrations," Wilson wrote in one instance, because "of none of the scenes you expect to draw does my narrative contain any detail; text and drawings cannot clash."[129]

Occasionally Pyle's preliminary sketches arrived even before Wilson had made his intentions for a subject clear. This arrangement meant that Pyle was at times in a position to influence the way Wilson conceived of his subject prior to its articulation on the written page. In such instances the historian deferred modestly to the artist, acknowledging that Pyle's illus-

trations set a higher standard for excellence than he expected to be able to meet as a writer. Kidding the illustrator about his significant role in the production of the biography of Washington, Wilson wrote, "I shall be extremely interested to see your sketches. I expect to like them a great deal better than I like the text."[130]

But Wilson was not always so accepting of Pyle's intrusions into the text, especially when the illustrator's visualizations threatened to contradict his announced objectives for the history. A case in point was Pyle's series of preliminary illustrations on the American Revolution for the Washington biography that emphasized the very military side of the war Wilson disavowed in his narrative. Wilson pointed out the contradiction to Pyle, but the latter was persistent in trying to make his sketches work, urging Wilson to accept them in the spirit of artistic counterpoint.[131] "It seems to me (unless I altogether misunderstand your motives)," Pyle wrote, "that a pictorial suggestion relating to the war might enforce in the minds of your readers the very fact that you [are] refraining from speaking of it. I find very often that the writer's periods are enforced by my not illustrating them too directly."[132] At his boldest moments, Pyle even proposed alterations to the literary text to accommodate illustrations of his choosing. Anxious to include a representation of the battle of the *Serapis* and the *Bonhomme Richard* in Wilson's *Short History*, for instance, Pyle suggested emendations to the manuscript that otherwise was silent on the inadequacies of the U.S. Navy. "I think there is nothing in the paper referring to the very insufficient navy of the Revolutionary period," he wrote Wilson. "Do you think it would be feasible for me to slide a sentence into the text that I could pin such a picture to? I know this sounds like a great piece of assurance on my part, but it seems to me that such a subject would much embellish the number."[133]

Figure 77. "Phips Recovering the Sunken Treasure," 1902, by Howard Pyle for Woodrow Wilson's *History of the American People*

Figure 78. "Landing of Negroes at Jamestown from a Dutch Man-of-War," 1902, by Howard Pyle for Woodrow Wilson's *History of the American People*

The illustrations that finally appeared in the *Harper's* series suggested how thoroughly collaborative the relationship between Wilson and Pyle was and gave hope to both historian and illustrator that they had demonstrated the value of pictorial formats to professionals and the public alike. In some instances Pyle's recommendations clearly won the day, as in the inclusion of "The Fight Between *Bonhomme Richard* and *Serapis*" with accompanying text. At other times, Wilson's preferences prevailed, evidenced by the late addition of "Phips Recovering the Sunken Treasure." Although Wilson was successful in

lobbying for most of the illustrations he desired, it was ultimately Pyle who controlled the artistic content of the history, as he was responsible to Alden for the execution of the pictorial element. The Phips drawing, for instance, was certainly not the "dramatic" rendering for which Wilson had hoped (fig. 77). As accustomed as Pyle was to illustrating works on pirates and sunken treasure, the lackluster portrayal he submitted of the Phips incident suggested an insufficient commitment on his part to subjects of Wilson's choice. He was more accommodating of Wilson's request that the military side of the Revolution

not be overdone, illustrating the war from a distance by removing viewers from direct contact with the blood and guts of the fighting. Sometimes this detachment was achieved, as in "Washington and Rochembeau in the Trenches at Yorktown," by providing a behind-the-scenes view of military actors before the great battle. At other times, visual distance was accomplished by manipulating the angle of vision, as in "Viewing the Battle of Bunker's Hill," in which the bloody massacre on Breed's Hill is sanitized by the rooftop perspective of distanced colonials who look more like spectators at a sporting event than witnesses to a tragedy. And then there were the illustrations that exceeded Wilson's expectations and confirmed Pyle's reputation as the premiere illustrator of his time. Wilson had hoped that a depiction of the first slave ship in North America could be commissioned for Appleton Clark of *Scribner's* because he specialized in such scenes, but Pyle's "Landing of Negroes at Jamestown" proved so masterful that the depiction was used as the first full-page illustration in the series by *Harper's* (fig. 78).[134]

Finally, Wilson and Pyle shared a common commitment to an impressionist style of presentation.

**Figure 79. "Loading Ships in Albemarle Sound,"
1902, by Howard Pyle for Woodrow Wilson's
*History of the American People***

The periodical format of the original *Harper's Magazine* series allowed Wilson to indulge his penchant for jumping from topic to topic without dependence on a strong master narrative driven deliberately through installments of the series. Pyle enjoyed a similar freedom, translating the creativity of Wilson's literary expressions into a graphic medium in which traditional representational forms gave way to growing abstraction. After 1895 Pyle came under the influence of Spanish impressionist Daniel Vierge, who specialized in "the transitory effects of sunlight and motion in his drawings." Many of Pyle's illustrations in the *Short*

History of the American People convey a similar "impression of atmospheric effects by contrasting black shadows with complex patterns of flickering lines and by leaving some portions of the white paper blank."[135] In "Loading Ships in Albemarle Sound," for instance, Pyle did not allow light to flow evenly across the picture plane; rather, he developed a diffused, luminist sensitivity to the play of light on the surface of water, borrowing his sense of modeling from the washes of modern watercolorists (fig. 79). In "Governor Sloughter Signing the Death Warrant of Leisler" Pyle created a similar effect for an indoor scene by

Figure 80. "Governor Sloughter Signing the Death Warrant of Leisler," 1902, by Howard Pyle for Woodrow Wilson's *History of the American People*

manipulating candlelight and shadow in order to dramatize human intrigue (fig. 80). In both instances the illustrator moved away from traditional dependence on representational form and toward the modernist fascination with spiritual essence. Wilson appreciated this forward-looking perspective and congratulated Pyle on the avant-garde quality of his illustrations that gave their collaborative projects the sort of fresh pictorial identity he desired for it. "They heighten the significance of the text, not only, being entirely in its spirit, but are themselves, besides, perfect in their kind," he noted approvingly.[136]

The collaboration between Pyle and Wilson was not typical necessarily of the relationship between historians and illustrators in their work on pictorial histories; comparable teamwork had not been evidenced since the partnership of Darley and Lossing on *Our Country*. Reviewers of their joint efforts, such as historian William Sloane, noted that the general rule in pictorial histories was for incompatible writers and artists to be of "two minds which are frequently inharmonious and sometimes at war." Pyle was an exception as an illustrator, Sloane argued, because he was himself "a charming writer" and "the illustration of his own books has clearly given him a thorough understanding of the true relations between pictures and text in a book which deals with a single important theme." The reader of volumes produced by Pyle and Wilson, he added, "will find no friction between the conceptions of author and illustrator. Mr. Pyle is in his aims a kindred spirit with the true man of letters, his technique is clever, his fidelity to truth very high. It was a fine idea to bring the two men together in a performance of this character."[137] From a visual standpoint, at least, the collaborative "performance" was so good in the case of the magazine series that both author and illustrator had high hopes of achieving popular fame and some of the emolu-

ments that went along with it when the *Short History of the People of the United States* was published in book form. They were disappointed in some of these ambitions, however, by the reactions of professional historians who viewed the Wilson-Pyle history as just another sad example of how pictures corrupted texts and words subverted illustrations.

"The Edition of Looks"

Part of the disappointment Wilson and Pyle ultimately felt with regard to the *Short History of the People of the United States* was a result of the reaction to its periodical format. Wilson had been under contract with Harper and Brothers to produce twelve installments that traced the history of the United States from beginning to end in one year of serialization, but even with a stingy economizing of words he managed barely to finish fighting the American Revolution when the run was completed. As early as February of 1901 Alden had held preliminary discussions with Wilson about truncating the study at the Reconstruction period, but even this abridgment meant that "some trespass on next year's space" would be "inevitable in order to secure completeness."[138] Brief conversations ensued about publishing a few independent articles beyond the serialized numbers if Wilson failed to meet his deadlines or space limitations, but such emendations never materialized. Eventually *Harper's Magazine* discontinued Wilson's history altogether on the convenient editorial grounds that no serialization could hold the interest of readers much beyond a year. Wilson was disappointed with the curtailing of the series, of course, but he was forced to admit that his "middle-sized creature" had grown too monstrous in its proportions to be contained any longer by the serialized format.[139]

Wilson's disappointment over the termination of

the project was lessened by Harper and Brothers' promise to publish the work in book form as soon as a complete manuscript was available. Unfortunately, editor and author could not agree on the desired format. Wilson wanted his history to be sold by subscription to agents, as had been the practice with many earlier pictorial histories. "There is, I believe, practically only one single volume, popular history of the United States on the market, that of Ridpath, which, because carried everywhere by agents, has sold up into the hundreds of thousands, in spite of its manifest crudeness and inadequacy," Wilson informed Alden.[140] Harper and Brothers, however, tried to dissuade him from a subscription format, warning that the net return on subscription sets was not as large as Wilson seemed to think, because publishers "must pay agents, commission and expenses, must pay expenses of collection of accounts running over a year, [and] must bear the inevitable losses occasioned by failure to continue payments." But eventually the firm agreed to market three editions of the history: a subscription edition at twenty-five dollars for a five-volume set, a fancy alumni edition at forty dollars for a five-volume set, and a trade edition of five volumes at seventeen dollars.[141] Candid about his desire to "make a considerable amount of money out of a book," and hoping to gain as wide a circulation for his ideas as possible, Wilson agreed to a royalty-based contract for all three versions.[142] The historian had strong hopes for the sale of the subscription editions (especially as Harper and Brothers had agreed to include a free one-year subscription to either *Harper's Monthly* or *Harper's Weekly*), but it was the seventeen-dollar popular edition— dubbed the "edition of looks"—that he expected would sell best.[143] In this expectation he was correct.

Wilson's five-volume trade edition of the *History of the American People* (renamed from the periodical version in recognition of its greater length and published finally in 1902) was composed of the chapters already serialized in *Harper's Monthly* with slight editorial changes and supplemented by material covering American history from the Revolution to the end of the nineteenth century. The new chapters, roughly constituting volumes 3, 4, and 5 of the history, had a different tone and substance than the original articles in the *Harper's Magazine* series, and these changes affected the way audiences responded to its images and texts. Although the earliest volumes had a "finished" and picturesque style characteristic of serialized articles, for instance, the new chapters were less thoroughly illustrated and more saturated with historical detail. Wilson's scheme for the covering of recent events in the latter volumes also suggested a more rapid, even hurried, treatment of nineteenth-century experiences. Of the 1,848 pages in the entire work, 819 were devoted to the colonial period, most of these appropriated directly from the original serialized work. Although the American Revolution received 106 pages of treatment, therefore, events given short shrift in the magazine version were underrepresented in the trade edition of the book, the Civil War meriting only 54 pages, 16 of which were pictures. Wilson's latter volumes also showed a marked preference for political events and administrations, especially incidents that demonstrated the worthiness of the author's emerging political agenda. This politicization of the text caused one reader to ask why the historian had abandoned the more neutral cultural and social approaches evident in the serialized version of the work. "Mr. Wilson's title promises 'a history of the people,'" he wrote, "and yet it is but a history of the politics of the people."[144]

Outspoken and politically opinionated as some of his latter chapters were, they did not dampen the public enthusiasm for the *History of the American People* when the five-volume set was marketed in 1902. Wil-

son's friends wrote him congratulatory letters, some praising the soundness of his historical argument, others acclaiming his "courage" and honesty in evaluating American politics.[145] A number of acquaintances from the South thanked Wilson for setting the record straight on the states' rights issue and for providing some needed perspective on the southern view of the Civil War.[146] But the most ardent praise was expressed for the literary quality of the volumes. William Pulsifer of D. C. Heath regarded the history "as the best in the English language." He wrote Wilson that it was "for the ordinary reader, better than Bancroft, for it is written in such an attractive style as to hold the attention like a romance from beginning to end."[147] George McLean Harper, longtime friend and associate of Wilson's, agreed with this assessment of the literary worth of the volumes, noting that "one rises from reading them with a clear sense of having observed a drama unroll, of having heard a high argument pleaded. These are not books merely to put on the shelf for reference, but they are books to read, if it may be, in a day or a week of complete absorption."[148] And the public-minded Wilson took special satisfaction in the comments of family friend, Jenny Davidson Hibben, who saw past the politics and the polemics to the work's inner literary strength. "I am deeply interested in your History & I think I am reading it in exactly the right way," she wrote. "I mean for my own pleasure & benefit."[149]

Some of those responding most positively to the trade edition of Wilson's work acknowledged the special value of the illustrations, although there were concerns about the consistency of its visual elements. The earliest volumes in the set were profusely illustrated with pieces from the original magazine series, featuring the works of Pyle, and these were supplemented with other graphic ornamentation provided by Harper and Brothers' artists. The later volumes of the history, however, revealed noticeable changes in the pictorial strategies of the editors. Among other things, there were no illustrations by Pyle in volumes 3, 4, and 5 of the work because the illustrator's formal affiliation with the project had ended with the completion of the periodical serialization. The termination of the relationship was motivated by financial concerns on the part of Harper and Brothers, because the publisher could no longer afford to pay Pyle's rates for illustrations not doing double duty in the magazine as well as the history. But the severance also suggested the frustrations artists such as Pyle felt at the contaminating influences of the periodical format on their own work. Tired of illustrating for periodicals and books when, in fact, he viewed himself as a "fine artist" who should be "working only toward the creation of individual, nonrepeatable works of art," Pyle forsook the function of copyist on projects such as the *History of the American People* to pursue a career as an independent painter and teacher. "Of course, I have to earn my living," he noted, "but it is rather hard to be limited to illustration."[150] After 1902 Pyle produced relatively few illustrations for books other than those he authored himself; instead, he worked on exhibition pieces and concentrated on teaching his trade to the many students who gathered near his Wilmington studio.[151]

In lieu of illustrative material from Pyle, the pictorial embellishments in volumes 3, 4, and 5 of the *History of the American People* were primarily reproductions of drawings from old prints or photographic images engraved for earlier editions of *Harper's Weekly, Harper's Monthly,* and *Harper's Encyclopaedia of United States History.* In Pyle's absence Wilson feared that Harper and Brothers might scrimp on illustrations, an anxiety he had experienced once before when the first proof pages of his biography of George Washington arrived without any illustrations from

the original serialized periodical articles. "Is it possible that you mean to print the book without the illustrations that accompanied the articles in the Magazine?" Wilson asked incredulously of his editor on that occasion. "I sincerely hope not. Mr. Pyle's drawings, particularly, added so much to their value that they will be sadly missed, and I had hoped to see the text even more fully illustrated than before."[152] Harper and Brothers assured him that all of Pyle's illustrations would be "tipped in," along with many others, too, as in fact they were, but that incident prompted Wilson to keep a vigilant eye on the process in the case of the *History of the American People*.[153] In a notation to himself during the editing process, Wilson wrote, "Shall ask for a few more [illustrations], but especially for a few different—full- page portraits in best possible style. Superb or nothing."[154]

One point of concern for Wilson was the lack of colorized illustrations in his popular history. The original illustrations in *Harper's Magazine* were black-and-white halftones in keeping with the monochromatic format of the periodical, but Wilson's publisher could have provided a more vivid presentation of Pyle's images in the *History of the American People* because the originals were full-sized canvases in color. Given the obsession of popular readers with chromolithographs and duotone illustrated periodicals, the decision by Harper and Brothers not to include colorized illustrations must have been seen by Wilson as an unworthy attempt to cut corners in production costs. Although Wilson acquiesced in the matter of colorized visualizations, he did not capitulate when it came to the quality of the black-and-white images for which he was forced to settle. When Harper's submitted substandard engravings, like a crude one of Cyrus McCormick, for instance, Wilson protested, petitioning the inventor's family for a more worthy likeness. "I am very much dissatisfied with the portrait they have reproduced (which I saw for the first time yesterday)," Wilson told McCormick's son, who was so moved by Wilson's concern for authenticity that he sent a more appropriate image directly to Harper and Brothers' art department at his own expense.[155]

Among the most numerous illustrations in the remaining volumes of the history were those that Harper and Brothers culled from its old files of earlier illustrated histories. A humorous sketch by F. O. C. Darley was recycled from *Harper's Weekly*, two Frederic Remington paintings were adapted from illustrated magazines, and several sketches from Benson Lossing's *Pictorial Field-Book of the American Revolution* were pressed into duty to illustrate midcentury events. These secondhand borrowings, some of them upward of forty years old, were not redrawn for Wilson's history but rather photographed on the block, producing convenient but often imprecise copies. There is a lack of crispness and clarity in almost all of these illustrations, which, when compounded by the inaccuracies attributable to the deficiencies of the originals on which they were based, made for some curious visual inadequacies in the *History of the American People*. In addition, pictorial drawings (whether new or old) were the exception to the general rule in the last volumes of the history. Volume 4 consisted almost entirely of portraits that were reproduced from engravings in works such as Duyckinck's *National Portrait Gallery* or from studio photographs. Many of these reproductions lost whatever value they might have had as communicators of character because they were reduced so drastically in size as to be indistinguishable in detail. Because illustrations originally designed for periodicals had to be reduced to conform to a book format, many of Pyle's most elegant renderings lost much in the translation to the printed book page by virtue of unsatisfactory compression ratios. The subscription edition was formatted for a

larger page to avoid such problems, but the popular trade edition was a standard seven-by-four-inch size, and its cramped pages confirmed fears at Harper and Brothers that "the drawings would suffer if much reduced."[156]

The shortcuts taken by Harper and Brothers in the matter of illustrations concerned Wilson, who worried about how the compression of images would affect the reception of his volumes among professionals. There were indications even during the preparation of the manuscript that Wilson was having doubts about the publication of an illustrated "edition of looks" altogether before a more scholarly version had been printed. In a reflective notation to himself of April 1901 Wilson revealed that he had flirted with the idea of publishing a scholarly, "unillustrated" edition of his history first, but that he had deferred to the "*commercial* judgment" of Harper and Brothers in favor of a prior pictorial issue.[157] The decisions made by the art department for this illustrated edition, almost all of which were intended to heighten visual impact while curbing costs, did little to calm Wilson's fears about how professional historians would receive his work. "It was of course my earnest wish, as all who know me must know that it would be, to have the first form of the book a single volume without illustrations, and wait for an illustrated edition until the book had won some standing,—if it is to win it," Wilson wrote defensively to Frederick Jackson Turner. "But, alas! what is a man as against his publishers!"[158]

Adopting the persona of a victim (one not necessarily justified by his correspondence with Harper and Brothers), Wilson tried to deflect the professional criticism he anticipated for his "edition of looks" by blaming its visual deficiencies on the materialism of publishers. "Once sign a contract and you have signed away the right to have any choice as to the visible form of your book," he wrote Turner. Referring to his book

manuscript as "this poor modest child of mine," he bemoaned the fact that it would appear first "tricked out in five sumptuous subscription volumes," making its authorial parent appear "the most pretentious of mortals." Wilson hoped that the "Lord" would have "mercy on" his too-flamboyant offspring and that his scholarly friends would "detect the imposition" inflicted by his publisher and not "misjudge him" for it.[159] Frederick Jackson Turner tried to console Wilson with the assurance that the periodical version of the work had secured already the book's reputation among scholars. "In spite of what you wrote of its illustrations, I am sure that no amount of picturesque effort on the part of the artist can interfere with its being the important work which the chapters which I have read in the magazine indicate," his friend comforted.[160] But Wilson felt compelled to warn Turner nonetheless that it was "not the book you and I talked over in the delightful days when talk between us was possible."[161]

Wilson's apologetic confessions to Turner were prompted by his anticipation that although popular readers would tolerate (even welcome) illustrations borrowed from periodical literature, professional reviewers of his volumes would find such adaptations inappropriate. Ever interested in cultivating a public persona, Wilson's chief goal in producing the *History of the American People* was to serve the needs of the general reading public, of course; but as someone who held a doctoral degree, as a former professor, and now as a college president, Wilson was also concerned with the scholarly reputation of his work, and he was chagrined by the tone of many of the earliest scholarly reviews, which dismissed the history as no better than the illustrated works of Halstead, Ridpath, and Northrop. Carl Van Tyne, instructor in history at the University of Pennsylvania, for instance, complained that Wilson and Harper and Brothers had padded out

the *History of the American People*, rendering "it far more imposing than it really is." The five volumes could easily have been reduced to two, he wrote, adding that "the heavy paper, the deep margins, a wilderness of injudiciously chosen pictures, for which Mr. Wilson is not responsible, and a sumptuous binding, produce a volume so ponderous as to be unwieldy."[162]

In addition, scholarly reviewers complained about "an unfortunate predominance of fancy pictures rather than representations of real historical objects" in the *History of the American People*, noting that many of the illustrations were "works of the imagination, and while doubtless historically accurate, [were] nevertheless open to the criticism of the careful student who prefers a contemporary print." Historian William MacDonald asked why "fancy pictures . . . could not have been excluded" altogether. At the very least, he noted "a fuller indication of origin" for visual material should have been given other than that "afforded by the oft-recurring ascription, 'from an old print.'"[163] Others complained that Harper and Brothers had not done a particularly good job of integrating Pyle's original pictures into Wilson's now-expanded text. Many of the illustrations "have nothing to do with the text and some are inserted without regard to their proper place as adjoining the matter they illustrate," noted C. M. Andrews.[164] Hence, in volume 2 an illustration of the Plains of Abraham was inserted inexplicably into a description of Braddock's campaign of 1756. In the same volume the picture of Washington and Rochambeau at Yorktown "precede[d] by twenty pages the account of the operations depicted," whereas a picture of Carpenter's Hall, Philadelphia, was set into the opening pages of volume 4, although the text related to the beginning of Jackson's administration. Still worse, an illustration by artist Jeannie Chambers of the Dunker Church,

"where John Brown preached the night of the raid," proved a "curious lapsus," wrote William MacDonald, "since the incident referred to did not occur."[165]

An occasional scholar wrote appreciatively of the illustrations in Wilson's text, as did Francis Shepardson, who complimented Harper and Brothers on the "great collection of nearly eight hundred illustrations, scattered unevenly throughout the volumes and combining to give powerful aid to the narration." Yet even Shepardson regretted the inclusion of certain profane pictures in the *History of the American People*, especially the portraits of assassins John Wilkes Booth and Charles Guiteau, whose pictorial visages Francis Shepardson believed "the American people do not care to perpetuate." Still more, Shepardson was critical of Wilson's text, which he felt was too political in tone and would render "the History a disappointment" for most readers "after the pleasure of examining the pictures is past."[166] Carl Van Tyne agreed, arguing that Wilson's "interests are with men and their political activities," and that although "in the portrayal of these he proves himself an artist," the remainder of the text was aesthetically displeasing and substandard. Suspicious of Wilson's reliance on "secondary histories" for treatments of the legal, religious, and social events about which he knew less than politics, Van Tyne rejected Wilson's "canon of selection," which was valuable "only to the artist" focused narrowly on the political.[167] In a review for the *Critic*, colonial historian George Louis Beer spoke of the misplaced "courage" Wilson displayed in opposing "the current of scientific thought" in favor of political narrative and of Wilson's unfortunate decision to adopt a "life-like and vivid" literary style more "closely akin to the epic, drama, and romance" than to science and appealing primarily to "the emotions, and thus only mediately, to the intellect."[168]

Within six months of its publication, professional historians affiliated with the American Historical Association had brought the weight of their previous attacks on pictorial histories to bear on Wilson's now beleaguered illustrated volumes. Van Tyne took Wilson to task for citing sources in an unprofessional manner. "In the summary treatment of the several historical periods, the specialist recognizes that the facts often lie behind opinions and comments, but the untrained reader is not permitted to see them," he noted. "This method of writing is Mr. Wilson's ideal of historical production," he added, the reader having "only to accept the results, while the historian does the work, which is satisfactory enough if one is simply interested in conclusions and generalizations and could be sure that the data of the field had been well considered." That format was sufficient for periodical literature, Van Tyne acknowledged, but in the case of a five-volume book series, the "size of the undertaking" suggests "that the data have not been well considered. The original matter that must have been consulted in order to warrant such generalizations is too vast," he concluded.[169] Historian William MacDonald shared these criticisms, noting that the student "who is searching for a concise and comprehensive narrative of historical events, a careful marshaling of facts and weighing of evidence, or a bringing together of tested and assured information from monographs and documents, will not find any of these things" in Wilson's *History of the American People*.[170]

Not every professional historian condemned the book, of course. Indeed, Wilson received support from some unlikely professional reviewers, foremost among these Charles McLean Andrews, who had been so outspoken in his condemnation of popularizers like Ridpath and so zealous in outlining the rules for scholarly conduct in the writing of history. Andrews praised the regional balance of the volumes and Wilson's abilities to see behind the historical portraits of Americans the broader "changes in governmental theory and practice and to explain the conditions attending the great crises of colonial and national history." Andrews also applauded the optimism of the book, an uplifting tone missing in some popular and professional assessments of American life. "The history is, therefore, wholesome, the sort of work that will make a man sleep better," he noted. "There is nothing pessimistic or chicken-hearted here, and if there be 'anti-imperialists' still abroad they will find nothing in this history to support their warnings of evil to come."[171] But Andrews's positive review may be explained in part by the fact that he and Wilson were close friends from graduate school and because Wilson helped Andrews secure his former teaching post at Bryn Mawr College when he vacated the spot for a position at Princeton.[172]

Even the boon of friendship did not prevent some of Wilson's professional colleagues from attacking his history in the press. Perhaps the most devastating review of all came from his friend, Frederick Jackson Turner, who wrote a critical assessment of Wilson's history for the *American Historical Review*, the official organ of the American Historical Association. Disappointed as were many scholars with the false advertising associated with the title of Wilson's work (which purported to tell the story of the American people), Turner argued that Wilson was unfortunately "more at home in characterizing political leaders and the trend of [political] events than in dealing with the deeper undercurrents of economic and social change." If one accepted Wilson's political bias, Turner noted, there was still much to dislike in the history. For one thing, the narrative was too hurried, Wilson's "picturesque" treatment of the French and Indian Wars and the Revolution "obscur[ing] the other facts of this important era of Americanization,"

and his "over-heroic compression" of the Jacksonian period necessitating the exclusion of many crucial details of its history. Some of Wilson's political facts could not be trusted either, Turner added. "It is certainly a mistake to say that there is no doubt that Texas was a part of the Louisiana purchase, as recent students of Spanish claims to the region have shown," he complained, and Wilson's characterization of the rigidity of state sovereignty in the South was unfounded in Turner's estimation because it was "too monolithic" in conception. Turner admitted that the *History of the American People* was "often brilliant in style" and acknowledged that "the author has read widely and has aimed rather to fuse the facts of American history into artistic literary form than to make investigative contributions to the facts of our development." But in the end, the reader is left with only casual "interpretation," Turner concluded, not sound, professional, historical scholarship.[173]

Revealingly Turner rejected as well the "ornate and bulky form in which the publishers have presented the work." Despite his earlier assurance that readers would appreciate anything Wilson wrote despite the "picturesque effort" put forth by artists, the profusion of highly diverse illustrations in the five volumes became a source irritation to Turner. Far from elucidating the themes of the author, he wrote in his review, such pictures undercut the important historical messages Wilson wished to convey. "The effect is that the stream of the narrative too frequently runs like a rivulet between the illustrations," Turner noted. "The excellence of most of these pictures must be recognized, although the process of artistically redrawing old prints and portraits is objectionable to the critic who is sensitive in the matter of the inviolability of sources; but even when the pictures are above reproach in this respect, and when they are appropriately placed, they continually distract attention from

the narrative." Turner also protested that some of the illustrations were completely irrelevant and others were utterly distracting. "Why Alexander Stephens should look out from the narrative of Jackson's war on the bank; why Cyrus McCormick should intrude in a discussion of the independent treasury; while Whittier's gentle smile plays above the story of McCormick's invention of the reaper; and why many similar incongruities exist," he complained, was a question only some "'expert' in the composing-room" could explain. "We should like every young man to read all that is contained in these volumes, and wish that after the publishers have reaped their due reward they may find it possible to issue a single volume without the paraphernalia of pictures, at a relatively cheap rate," Turner advised.[174]

These negative reviews cut Wilson deeply, especially Turner's criticism. As many psycho-biographers (including Freud) have noted, Wilson was overly sensitive to criticism, and he reacted poorly to the snubbing he received from his old friend.[175] Wilson and Turner continued to correspond and maintain the semblance of a relationship after the review of the *History of the American People* was published in 1903, but Turner later told his personal secretary that "the severance of the warm friendship of many years between Woodrow Wilson and him was caused by adverse comments in his review."[176] Wilson could take some solace from the fact that the early sales of the volumes indicated that they were popular with the very audience they were intended for—the American people. Indeed, he received a hefty check from Harper and Brothers for $7,039.75 as an advance on the royalties for the first six months' sales.[177] But these financial returns were small compensation indeed for a historian with the enormous aspirations of Wilson. Among other things, he was desirous of demonstrating the fruitful intersection of popular, political, and

professional visions of the American past, and in this ambition he had largely failed. The negative reviews by Turner and other scholars confirmed Wilson's own suspicions that, as Ray Allen Billington has noted, the *History of the American People* would be viewed as nothing more than "a commercial venture, prepared for the popular market, and sadly lacking the refinements expected by his professional colleagues."[178]

What did the rejection of the *History of the American People* by scholars mean to Wilson's career and to his chances for advancement? In one sense it did not hurt much. The popularity of the "edition of looks" certainly helped the future president in his political aspirations, putting his name before the public in a manner sufficient to delight any campaign manager or publicist. In another sense, however, the renunciation did a great deal of damage to the outlook of a man who desired to be both a great scholar and a great leader. Wilson never fully recovered from the shunning he received at the hands of professional historians, and he maintained a defensive attitude toward the *History of the American People* the remainder of his life. Throughout his important political career, he never failed to react when opponents used passages from the history to condemn his biases and to challenge his claims as an objective thinker. In the election of 1912, for instance, Wilson bristled when quotations from the fifth volume of the *History of the American People* were taken out of context in his opinion by his rivals, quotations that described immigrants to the United States from eastern Europe as "men of the meaner sort . . . , men out of the ranks where there was neither skill nor energy nor any initiative of quick intelligence."[179] Complaining of the unfair and politically motivated tendencies of readers to twist his historical narrative, Wilson lashed out at those making "malicious attempt[s]" to misrepresent him. "My history was written on so condensed a scale," he wrote

one critic, "that I am only too well aware that passages such as you quote are open to misconstruction, though I think their meaning is plain when they are fairly scrutinized."[180]

Although few professional historians engaged in overt politics in their reviews of Wilson's illustrated history, the sense of betrayal at the work's inadequacies that many of them expressed was especially keen because they numbered Wilson as one of their own. Trained at one of the best institutions of higher learning in a scientific tradition that should have protected him from the deficiencies of pictorial history, Wilson had sold out to commercial and political interests. In his most honest moments of reflection on the *History of the American People*, Wilson knew many of his professional critics were right about the failures of his volumes. Half a decade after the publication of the *History of the American People*, Wilson admitted that his motives for writing the popular work had been personal, political, and perhaps selfish. "I was guilty myself of the indescretion [*sic*] of writing a history," Wilson told an audience at the University of North Carolina in 1909, "but I will tell you frankly, if you will not let it go any further, that I wrote it, not to instruct anybody else, but to instruct myself. I wrote the history of the United States in order to learn it. That may be an expensive process for other persons who bought the book, but I lived in the United States and my interest in learning their history was, not to remember what happened, but to find which way we were going."[181]

And what effect did the rejection by scholars of Wilson's illustrated volumes have on the genre of pictorial history? Again, in one sense, not much, because the work sold well enough in the literary marketplace and suggested that there was still a place for visual pedagogy in the study of the past. In another sense, however, Wilson's blatant politicization of the past caused some to question the

efficacy of exposing Americans to popular literary and pictorial images. Those who were not sympathetic to Wilson's self-indulgences or who wished America to move in a direction other than outlined in the *History of the American People* raised doubts as to whether it was possible ever to develop a pictorial format for history that could avoid the perversion of images and the politicizing of words. For promoters of a genre under fire from professionals trained in specific rules of scholarship and from scholarly reviewers increasingly in control of the apparatuses of critical evaluation in the history book market, the issue was more than just philosophical. Some worried that the economic solvency of producers of illustrated texts could be jeopardized if the perception persisted that pictorial works were antithetical to the goals of objectivity and scholarly rigor. In the 1890s the popularity of pictorial formats was still substantial enough for publishers of illustrated histories to withstand these attacks; after all, professional historians were not then (and are still not now) sufficiently strong to dictate completely the reading habits of American audiences. But the financial repercussions of the challenges by scholars were serious enough to compel publishers to continue to search for alternative ways to satisfy both popular and professional audiences. Inevitably the doubts introduced by scholars compelled marketers of illustrated books to consider one nagging question above all others: Could techniques of visualizing history be developed that did not distort the past, or must pictures always corrupt the historical record?

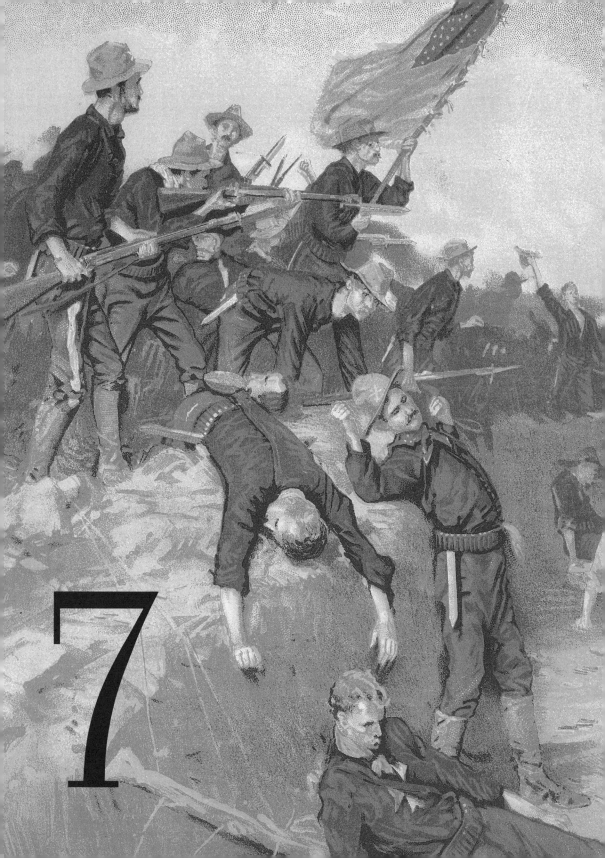

7

"The Subjective Eye and the Conventionalizing Hand"

Photography and Realism

By the turn of the century pictorial history was a genre in transition. On the one hand general readers continued to appreciate and to "consume" histories presented in pictorial formats. The wide variety of innovative illustrated histories that emerged in the 1890s certainly suggested the resiliency of the industry and the staying power of its primary images. The visual retained much of its importance as a vehicle of cultural information because of its undeniable adaptability to the conditions of the marketplace in a world of mass production. The ease with which pictorial representations were made to serve as emblems of material culture ensured that in late Victorian advertisements, at least, visual images would remain dominant over texts "as the primary bearer[s] of meaning."[1] The commercialism implicit in the pursuit of visual literacy, however, was not always easily reconciled with the disinterested, scholarly imperatives of the newly emerging dis-

cipline of history. Attacks by professionals against visual adornments were damaging to the pictorial cause, and these assaults increased in furor and potency as the technological capacities of publishers for pictorial embellishment increased throughout the decade. Ordinarily the complaints of scholars would not be sufficient to influence popular book markets substantially, and few publishers of pictorial histories acknowledged that their industry had much to fear from sanctimonious professionals. Yet the fact remains that after 1900 there was a greater drop-off in sales of illustrated histories than of works in any other pictorial category and a simultaneous increase in the production of scholarly historical monographs.[2] What accounts for these changes?

Part of the explanation for the decline in pictorial history after 1900 relates to changes in the public mind as to the very definition of what constituted past reality and history. As we have seen, a new cult of objectivity crept into every aspect of American social and intellectual life after the Civil War, and its successful challenges to romantic sensibilities forced many to reconsider the very epistemological roots of "truth." What was the past, really, and what relationship did it bear to the here-and-now? Once time had elapsed, could it ever be recovered in the formal sense? Or must history always remain an imaginative reconstruction?[3] The crisis of historical understanding conditioned by these uncertainties impacted the formal study of history in general and caused many professionals to redouble their efforts at producing an agreed-upon set of scholarly standards for historical work. Whereas history as a literary pursuit had once been inclusive enough in scope to encompass the romantic fiction of Scott and the sentimental excesses of Spencer, now it constituted a "discipline" whose operative rules were more highly restrictive. Conventional pictorial treatments such as those of Frost,

Lossing, and even Woodrow Wilson were branded as "not history," and illustrated history books were condemned as unreliable purveyors of the past.

Producers of pictorial histories felt these attacks more than those working in other areas of popular history because the rise of a skeptical realism raised especially dispiriting doubts about the validity of "artistic truth" in relation to the past. A writer for the *New Path* noted that "in this modern day, when all things are brought under the reign of science," the primary function of art should be the accurate "representation of things." The problem was that few trusted the ability of traditional visual art to accomplish this mimetic task. Among the most profound skeptics were those who argued that visual representations had done little to aid in the historian's mission of recording the past "as it had actually occurred." Distrusting the pictorial mode, these critics argued that even illustrators in the "realist" tradition were not free of the "subjective notions of order and significance" that "repeatedly intervened in their efforts to represent visual reality." True worshipers of the "real" imagined art as a "simple mirroring of the external world," but as the illustrations of Remington, Pyle, and others had demonstrated, "reality was not so matter-of-fact as it seemed" because artists' impressions and emotions were always insinuating themselves on the illustrated page. The distinction "between duplicating life *as is* and representing life *as perceived*" was at the heart of the problem, and an increasing number of historians found the latter artistic intention incompatible with the historian's aspirations for the former. The "noble dream" of the turn-of-the-century intellectual, Charles Beard noted, was to achieve near perfect objectivity in the documenting of history rather than the mere impressionistic representation of past experience as encouraged by the purely pictorial. To this end, some called for the

purging of all visual art from any text wishing to be called legitimate history.[4]

"A History from Which There Would Be No Appeal"

Not everyone agreed that history needed to be divorced from art, of course. Some insisted that the new scientific age was innovative and "progressive" enough to provide its own visual tools for the recovery of historical memory. Indeed, such a scientific instrument was already in common usage among Americans who were busy creating reliable visual records of their personal pasts: the camera. Literary and art critic Kenyon Cox proclaimed photography the greatest invention of the nineteenth century and likened its power for historians to that of the printing press in the fifteenth century. "The invention of printing was the discovery of a method for the preservation and multiplication of the record of human thought," he noted, whereas "the invention of the photograph was the discovery of a method for the obtaining, the preservation, and the multiplication of records of fact." Indeed, from his point of view, the camera had eclipsed the printing press as a conveyor of historical reality because of its ease of use, its reasonable costs and its ability to reproduce images that exceeded the reach of the pen. Whereas printing "can only record what man knows or thinks," he noted, "photography can record many things which man does not know and has not even seen, much less understood." In a realist age enamored of "facts, facts and more facts," the camera suggested to Cox an evidentiary tool of the highest order.[5]

Photography had been employed in limited ways in the pictorial book market in the late nineteenth century, as we have noted, but primarily as a means for translating engravings and painted images to the printed page through photography-on-the-block. It had also been used to record historical events themselves, such as the aftermath of Civil War battles, but its application in these documentary capacities was restricted by the cumbersome nature of photographic equipment and by the complexities of the developing process. By the 1890s, however, new cameras with faster shutter speeds and easier portability made it possible to preserve a wider range of objects and events of interest to historians, including details of battle scenes, large public gatherings, and natural disasters. In addition, the development of the halftone process allowed photographs themselves to be the images transferred to a screen or plate via photographic processes. The camera's dual capacity as both recorder and transmitter of historical images also increased dramatically its potential usefulness to historians in their scholarly pursuit of the objective past, promising a way of controlling "the subjective eye" and the "conventionalizing hand" of the artist by substituting the unfailing perception of a "mirror with a memory."[6] The age's new faith in the power of photography inspired not only fresh commitments to the use of the visual in historical accounts but also new visual epistemologies for the historian. It implied "a magical new means of enlarging the realm of the visible, and thereby helped to redefine public perceptions of reality."[7]

For true believers in the expansive ocular power of the camera, the photograph stood for more than an approximation of reality; it "stood for the thing itself." Taking for granted the ubiquitous quality of the camera's lens, a photograph came to represent "what we could see if we were uniformly sensitive to everything that light imprints upon our retinas, and nothing else." Some even claimed that the device was an improvement on the human eye, overcoming as it did the "predisposition 'not to see some of the things be-

fore us, and to see others which are not there.'" Because photography came to be thought of as "a mechanical medium of vision which surpasses the human eye in accuracy and impartiality," advocates of the camera noted its superiority to the eyewitness accounts of historians such as Lossing, previously thought to be the closest visual approximations of historical reality. They agreed in principle with Walt Whitman's comments to Mathew Brady in a much-quoted exchange regarding the failures of traditional, pre-photographic imagery. "How much better it would often be, rather than having a lot of contradictory records of witnesses or historians—say of Caesar, Socrates, Epictetus, others—if we could have three or four or half a dozen [photographic] portraits—very accurate—of the men," Whitman noted. That would be "a history from which there would be no appeal."[8] The agency of photography would allow future students, "in turning the pages of history," to look "on the very skin, into the very eyes, of those long since mouldered to dust, whose lives and deeds he traces in the text," Whitman's contemporaries believed.[9] Such optimism in the power of the camera led many to accept the idea that the photograph was not merely "a message about reality, but as reality itself somehow magically compressed and flattened onto the printed page, but, nevertheless, equivalent to, rather than symbolic of, three-dimensional reality."[10]

One indication of the widespread faith in the power of photography to capture objective reality was the alacrity with which pictorial historians took up the camera as a solution to the criticisms leveled against them by professionals. As early as 1893 popular historian John Clark Ridpath published a *Portfolio of the World's Photographs* in which he noted that photography had become the "leading adjunct of modern historical and scientific research" and the new form in which the results of innovative methods of historical

inquiry would be recorded in the future. Noting that photography provided more accurate reflections of reality than did traditional literary descriptions, Ridpath echoed Cox in declaring that the camera would replace the pen for supremacy in the historian's arsenal. "Strange it is that the *picture* should have come back and insinuated itself in the place of the *word*," he wrote, predicting that "the age of pictures is to succeed the age of words." It is as though "the hieroglyphics of antiquity should have returned to contest with language and printing the empire of the world!" he remarked. "Nor should we, in this connection, fail to remember that while most of the written and nearly all of the spoken languages of ancient times have perished from the knowledge of mankind, the old picture-writings of Egypt still stand out clear and bright as in the morning of their creation." For those who worried that the photograph was a threat to the literary imagination, Ridpath argued that the camera was both an inducement to and a check on the intellect because it made "all men travelers" and allowed them to verify information "wherever travel is impractical, wherever the mountains and seas divide the eager mind from the objects of its longing and search." Wherever physical limitations have made it difficult for citizens to experience far-off places or events, Ridpath added, "there the lens, with its quick flash of light and swiftly-caught image of nature or work of man, has come in to supply the deficiency and to transmit to humble homes in distant lands the picture and vision of the reality."[11]

In Ridpath's estimation the camera was a useful instrument for collapsing not only geographic distances but also temporal ones. Through the agency of photographs, he noted, "the memory is traced with indelible images, and the imagination is lifted and borne away across continents and oceans. With the picture before us time and space are suddenly obliterated."

The idealistic works of historical painters and illustrators represented laudatory attempts at historical preservation, he argued, but they could not compete with the camera's indisputable powers of retention. In this regard photography not only aided in the recovery of the past but also contributed to the perpetuation of a culture's collective memory by allowing one generation to provide a visual record of itself for future generations. "The current civilization seems to be striving to perpetuate itself in authentic outlines by the device of light and shade," Ridpath wrote, substituting photographically derived visual images for less efficient memories preserved in literary or artistic form. He admitted that the great literatures and arts of the Roman and Greek empires had done much to help historians piece together what life might have been like in the classical world, but like Whitman, Ridpath challenged readers to consider how a "few photographs preserved from antiquity might change our whole concept of whole chapters in ancient history."[12]

Committed sketch artists and engravers also came to appreciate the power of the camera even as their careers were effectively ended by its inscrutability. Erstwhile illustrator Benson Lossing proclaimed photography the ultimate democratic medium, because it allowed any citizen with a camera to personalize history. In an 1891 lecture Lossing noted that the portable Kodak had done much to fulfill the ambitions of popularizers of history who wished to turn the common man into a "seeing man." Once dependent on illustrators and engravers like himself for visual documentation, he noted, the average American could presently put his own stamp on history by recording its passage in film. "The click of the Kodak button is now (1891) heard around the world," he noted, the inexpensive portable camera having "brought photography within reach of the general public" while deepening "popular interest in the wonderful art which is playing an all-important part in the drama of national life." Seconding Ridpath's assertions about the triumph of the image over the word, Lossing noted that the camera made even language subservient to its visual authority, the term Kodak having "attained to the dignity of a verb in speech," as in the "the historical event was kodaked." With its "profound secret" locked "in the heart of chemistry," the camera liberated middle-class Americans from former dependencies by encouraging them to take an active role in preserving the record of the history of their own day.[13] In recognition of the camera's restorative potential for altering the deficiencies of artists and engravers, Lossing's Civil War trilogy was reissued in a fiftieth-anniversary edition in which the original Lossing illustrations were replaced by Mathew Brady war photographs, a substitution that allowed the anniversary edition to outsell its predecessor by a good measure.[14]

Implicit in many of these assertions about the rejuvenating potential of the visual was the conviction that the camera did not lie. Given the strong objectifying abilities of photography, Ridpath, Lossing, and others believed that the camera could be used to preserve the past with greater fidelity than their earlier pictorial formats had allowed. The assumption was that history and photography were directed in principle at the same intellectual goal—the scientific verification of reality. The snapshot is "an accurate statement of what was," Cox asserted, and as such it represents "one of the most valuable of the tools of science, at once a means of research and an invaluable, because impersonal, record." Cox believed that the camera made history "something different in the future from what it has been in the past," because it provided a visual catalogue of history's most significant events in as impartial a manner as possible. "In photography" as in the discipline of history, he noted

confidently, "there is no personal equation."[15] Holding up photographs as a hedge against the distorting subjectivity of the "fancy pictures" of artists such as Chappel and Darley, Cox and others applauded the camera's ability to "expose" traditional visual reconstructions of the past for what they were, mere "deceptions" and "tricks played against the credulity of our eyes."[16]

Although not all publishers of pictorial histories were as zealous as Ridpath, Lossing, and Cox about the benefits of photography for depicting the past, many made efforts to incorporate photography into their formats where feasible. In a few cases, for instance, publishers invented fresh formats for their pictorial histories, marking transitions from the purely pictorial to the partially photographic.[17] In 1892 R. M. Devens, who had produced the popular, wood-engraved centennial publication *Our First Century*, marketed an innovative pseudo- photographic history titled *Our Land and Country: Its History, Treasures and Splendors: Four Hundred Years of American Progress*. This pictorialization of the first four hundred years of American development offered a "panoramic history of illustrations," some drawn and others photographed, with the text in all cases reduced to brief descriptive captions. Not only did the greater proliferation of visual images created by the camera make detailed texts unnecessary, Devens wrote, but the photographic revolution of the late nineteenth century demanded that the visual be given prominence over the written word as a recorder of objective truth. Adopting a photo-album format, Devens encouraged viewers to page through his publication in flipbook fashion. "To turn these alluring pages," he wrote in the introduction to *Our Land and Country*, "is to fix upon the minds of both Old and Young a cognizance of Places and Objects, more vivid and indelible than could be conveyed in volumes of print." What ensues,

Devens noted enticingly of his history informed by the new "science of the sunbeam," is a series of increasingly "realistic" depictions of scenes of significance to American history adjoined to a collection of photographs of the land and the people such as has never been set "before the American eye" and "revealing in such minutiae, the actual . . . appearance" of events, as to fall "only short of Life itself."[18]

In keeping with his professed "acquaintance with the public wants," Devens's publisher, C. A. Nichols, claimed to have spared no expense in pursuit of pictorial excellence in *Our Land and Country*. But like many popularizers, Nichols occasionally cut corners where finances dictated. Unable to secure a panoramic photo of Niagara Falls that could be reduced adequately for inclusion in his text, for instance, Nichols adopted a poorly rendered, hand-drawn illustration of the natural wonder, apologizing for the substitution by noting that, as the great naturalist Audubon said, "all the pictures one might see, and all the descriptions one might read, of these mighty falls, could produce in the mind merely the faint glimmer of a glow-worm compared with the overpowering glory of the meridian sun." The irony that photography was, after all, literally "writing with sun" was evidently lost on Nichols, who resorted to arguments about the elusive nature of Niagara as an explanation for the inadequacies of his images. Other photographs used by Devens proved equally deficient for reasons related to the susceptibility of the camera to manipulation. *Our Land and Country* featured a slow-exposure group portrait titled "Sioux Indians Grouped," for instance, in which several participants moved during the filming, blurring their features. Rather than discard the image, Nichols's artists "improved" the finished print by touching up several of the faces of the participants with India ink, producing a curious hybrid image—part drawing, part

photo. A decade before, such touch-ups would have been unnecessary, because the original photograph would have been used only as the basis for an engraving of the scene rather than as a visual source in its own right. But by the 1890s growing fascination with photographic evidence induced Nichols to reverse the relationship between artist and photograph; whereas previously engravers had used photos as accessories in the task of "finishing" illustrations, now illustrators had become "finishers" of substandard photos.[19]

The influence of photography was also evident in the apportioning of material in works such as Devens's *Our Land and Country.* Because the camera predisposes its users to accentuate "the exterior aspects of life," it privileges the observable data of the physical world over spiritual essences and internal reflections.[20] This exteriorizing sensibility encouraged pictorial historians enamored of the camera not only to fill their books with photographs of tangible objects but also to privilege contemporary events that were susceptible to photographic representation. Frost and Spencer devoted a disproportionate amount of space in their works to the colonial period because they believed that, in lieu of adequate physical and visual records of seventeenth- and eighteenth-century life, they had a responsibility to provide imaginative recreations of lost worlds. But in an age of realism, such unconfirmed images conveyed uncertainty, as did any sentimentalized pictorial representation not subject to photographic verification. Historians committed to the "values of literalism and objectivity" were increasingly uncomfortable with such ambiguity, as were publishers of pictorial histories, who pushed authors quickly forward in their narratives to depictions of the late nineteenth century where sound photographic recordings of events were available.[21] In this sense photography was viewed not just as the best source for realistic images but the *only* source, rendering almost any verifiable, contemporary image more valuable to historians than nonphotographic ones.[22]

Consequently, photography introduced a new brand of presentism into the works of pictorial historians that would not have been tolerated at the inception of the genre. Thousands of photographs taken of such events as the World's Columbian Exposition and the Spanish-American War found their way in inflated numbers into the pages of pictorial histories produced at the turn of the century, both as inspirations for pictorial illustration and as independent visual statements. Publishers justified the preponderance of contemporary photographs in their pictorial works by claiming that although history must be inclusive, it should be less concerned with "the past as a whole" than with "so much of it as accounts for the present."[23] Some even argued that the advantages photography afforded for the recording of contemporary events allowed historians to alter the social and political sensibilities of Americans, giving history a more useful reform purpose. In this sense the camera's influence on "ways of seeing" extended to areas later addressed by photojournalists such as Jacob Riis, who believed in the "special evidentiary power" of photography "to lay bare [the] hidden truths" of destitution and corruption at the heart of society.[24] In addition to its other virtues as an accurate recorder of historical events, that is, photography had the potential to enliven history for those previously reluctant to rummage among the "dead matter" of the past. In this resurrecting capacity the camera had become, as Baudelaire noted, "the public's new Messiah."[25]

A Discourse of Images

Among those who experimented most freely with the use of photographic evidence in pictorial histories was

Edward S. Ellis, a writer who made the transition from novelist to historian in the late nineteenth century. Ellis was a midwesterner, born in 1840 in Ashtabula County, Ohio, although at a young age he moved to New Jersey, where he lived his adult life. As had John Frost, Ellis got his start as a schoolteacher and later as a superintendent of education, although he is best known for the hundreds of dime novels he wrote over a forty-year publishing career. His most successful work was also his first, *Seth Jones; or, The Captives of the Frontier* (1860), which was published when Ellis was only nineteen and sold an estimated sixty thousand copies in its first week of sales.[26] "Released after a saturation advertising campaign that plastered New York billboards, barns, and newspaper columns with curiosity-stimulating advance notices," *Seth Jones* became the springboard for numerous other popular publishing ventures, including *The Youth's History of the United States* of 1880.[27] Borrowing from the Peter Parley tradition of Samuel Goodrich, the *Youth's History* was a low-budget operation, published on cheap, nearly transparent paper but richly illustrated with wood engravings and written in a style that suggested Ellis had not completely divested himself of the dime novel habit.[28] Its low price and readable style made the *Youth's History* an instant popular success in a marketplace dominated by history books for adults. "I regret very much that I did not have a book like Ellis's 'Youth History of the United States' when I was a boy," literary historian Albert Johannsen once wrote, "in place of a history that was simply a mass of names and dates and battles, as are, I am afraid, many of the modern school histories."[29]

Ellis's most important work in the field of pictorial history was an eight-volume *History of Our Country*, published in 1899 by the History Company of Philadelphia. Written as were most of Ellis's publications in a flurry of activity under the lash of an impa-tient publisher, the history reflects some of the impulsive showmanship of his dime novels and a good deal of their blatant nationalism as well. In the introduction to the history Ellis noted with overinflated rhetoric that none of the "great peoples . . . in the historical tableau of the world," neither the Egyptians, the Greeks of the Romans, had created "a historical product greater or more worthy of admiration than that magnificent result which history has brought as her trophy to the great American republic." Proclaiming himself a true patriot who believed "confidently" in "the institutions of his country," Ellis echoed the popularizers before him in writing with excessive zeal about the uniqueness and glory of the American experience.[30] Unlike these earlier popularizers, however, Ellis focused on contemporary experience as the most worthy historical setting for the explication of nationalist themes. Revealing a realist's interest in the immediate world around him, Ellis devoted three of his eight volumes to the most recent seventeen years of American history and the entire last two and a half volumes exclusively to the first McKinley administration, barely two years old when his work went to press. As Ellis's publishers advertised, this apportioning of space reflected the growing trend among historians interested in the "here-and-now" of national experience.[31]

In keeping with the announced contemporary slant of his history, Ellis's *History of Our Country* was illustrated primarily with recent photographs—hundreds of them, in fact. As we have seen, publishers of pictorial histories had employed photo-technologies for years as a means of reproducing engraved images. But Ellis's work was the first pictorial history of renown to draw extensively upon photos as artifacts for illustration in their own right. Considerable photographic attention was given in *The History of Our Country* to the Spanish-American War, for instance, Ellis making

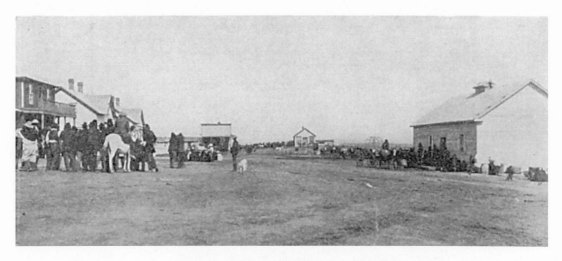

Figure 81. *Standing Rock Reservation,* photograph, 1898, for Edward Ellis's *History of Our Country*

good use of the many camera-generated images being sent home by journalists such as Frederic Remington, who had abandoned his painter's studio to "document" events in Cuba and the Philippines. Ellis also included dozens of photos illustrating aspects of the vernacular environment in the United States: buildings, frontier towns, marketplaces, street scenes, and Americans at work. Adopting some of the new social perspective advocated by Darley and others, Ellis used such images to awaken in readers a love of historical truth as revealed in the everyday lives of his countrymen and women. With their ability to capture in stark and accurate detail the routine conventions of American life, the photographs in Ellis's *History of Our Country* often proved superior to his words in conveying the commonplace lessons about American vernacular life that he wished to impart.

The photographs selected for use in *History of Our Country* were valuable as well as a way of celebrating the diversity of culture and of establishing visually the contrasts Ellis wished to emphasize between the optimistic and the more guarded assessments of Ameri-

can life. On the one hand a procession of celebratory camera images of American types and places in the history reaffirmed Ellis's belief in progress in the recent national experience. Volume 6 of *History of Our Country* featured photographic images of the Brooklyn Bridge, the Statue of Liberty, the Columbian World's Fair, and the White House, all symbols with strong associationalist qualities for patriotic Americans. On the other hand interspersed among these uplifting icons were more sobering images of those living outside the American Dream, including Indians on the Standing Rock Reservation in South Dakota (fig. 81). Noting with the candor of a Darwinian convert that "an inferior civilization coming into contact with a civilization that is superior is destroyed" always, Ellis introduced his photos of the wretched life of Native Americans on the reservation as a visual finale to the "piteous drama" that was the "red man's journey towards the 'setting sun.'"[32] The juxtaposition of this austere visual evidence with other more patriotic photos is revealing, because pictorial works of this era were generally more than just collections of

Figure 82. *Johnstown Flood,*
photograph, 1898, for Edward
Ellis's *History of Our Country*

independent photographs; they were characterized by an "internal dialogue" of images and texts and by an "external dialogue with their times." In this sense Ellis's habit of oscillating between highly iconographic images and less idealized ones created a "discourse of images" that suggested the discordance and complexity of contemporary American life at the turn of the century.[33]

The abundant use of photographs in *History of Our Country* also allowed Ellis to depict subject matter that

had long defied the powers of literary description. How might one best convey the horrors of the Johnstown Flood of 1889, for instance? The historian might describe them by traditional literary means as Ellis tried when he characterized the "appalling" velocity of the flood "at the moment of starting," when the "largest trees were snatched up by the roots, like so many straws, and flung into the air or hammered sideways into the ground"; when "rocks weighing hundreds of tons were rolled over and over like the

wheels of a bicycle, and hurled aside as a boy would throw a ball"; or when "houses were playthings, and trees, rocks, and dwellings were jumbled and churned together and carried resistlessly forward into the grasp of the current." But despite the palpable power of such literary descriptions, even Ellis admitted that the momentum of the flood was "terrific beyond conception" and that photos of the aftermath of the flood were the only real means to convey the horrors of the diluvian event (fig. 82). Hence Ellis cut short his narrative of the flood in order to make more room for evocative photographs culled from newspaper accounts of the tragedy. And how could one communicate best the rigors of the Klondike mining expeditions of the 1890s? The historian might quote firsthand testimonials from experts on Alaskan geographical expeditions, as Ellis did in his lengthy transcriptions from the journals of W. H. Dall. But by his own acknowledgment these descriptions paled next to the photographic evidence of vessels laboring in frozen waters, "steaming under difficulties" posed by the arduous climate and manned by frigid expedition members struggling to maintain body temperature in the extreme cold of the Arctic.[34]

In this sense, photographs were useful as a form of literal reportage in that they conveyed the realities of a scene in ways that no graphic art or narrative exposition could. The camera was especially effective in providing visual reports of events such as the Spanish-American War. If one compares Mathew Brady's images of the Civil War with those produced by Remington in the Cuban conflict and used by Ellis, the camera's new versatility as a recorder of war experiences becomes instantly apparent. *The History of Our Country* is filled with dozens of photos that depict all aspects of Cuban life both before and after the fighting, including images of cocoanut palms and Catholic cathedrals, of country villas and crude village huts, of

Figure 83. *A Hole in the Texas*, photograph, 1898, for Edward Ellis's *History of Our Country*

sugar plantations and Cuban bedrooms. There are snapshots of American soldiers embarking on battleships, of Cuban blockhouses, of thirteen-inch gun shells, and of naval maneuvers. Ellis included a number of genre photos of daily life of an American sol-

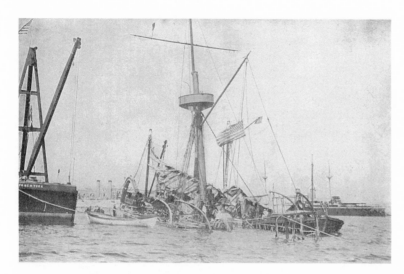

Figure 84. *The Wreck of the Maine,* photograph, 1898, for Edward Ellis's *History of Our Country*

dier as well, such as those with titles like *In Camp— Washing Clothes, In Camp—Cooking, In Camp—A Field Post Office, A Bugler,* and so on. In the interest of objectivity and balance he also secured images of Spanish forces in camp, of Spanish artillery exercises, of Spanish cavalry, and of Spanish generals. An occasional photo went beyond reportage to include artistic perspectives, as in the playful and fortuitous symbolism of a sailor peeping his head out of a new porthole created by a shell during a naval engagement in *A Hole in the Texas* (fig. 83). And a few of the photographs reproduced in *History of Our Country* were political in nature, having played a role in the promulgation of United States war policy, as had *The Wreck of the Maine,* whose original publication had been the inducement for the declaration of war against Spain itself (fig. 84). But more often than not, the photographic images Ellis assembled were intended to relay information directly in the manner of documentary reportage, without political overtones and "unencumbered" by artistry and symbolism. The assumption on the part of Ellis's publisher was the same as shared by Kenyon Cox—that photography would in-

crease rather than diminish the historian's power to record the past with fidelity to the truth.

It is not surprising to discover, therefore, that when Ellis and his publishers wished to produce an "artistic effect" in *The History of Our Country,* they used conventional pictorial illustrations rather than photos to accomplish their task. This substitution was especially evident when Ellis desired to depict action of a sort still not accessible to cameras, as in portrayals of active battle scenes during war. Although photographers in the 1890s secured images of battle far more precise and revealing than had their predecessors during the American Civil War, these camera-toting recorders were still no matches for artists in depicting the battlefield and the action of war as it occurred. Hence, Ellis made extensive use of the work of artist J. Steeple Davis, whose *Defense of Camp McCalla* or more famous *Battle of San Juan—Charge Up the Hill* were drawn on the scene for use in newspapers and periodicals (fig. 85). In such cases the effectiveness of the reproduction was determined by the adaptability of the original magazine illustration to the book format and by the compatibility of the drawings with the photos and text sur-

rounding it. In one or two instances Ellis's publishers created disconcerting ambiguities by pairing full, double-paged, colorized illustrations, such as Gilbert Gaul's "In the Trenches Before Santiago," which dramatized and sentimentalized the battlefield, with more mundane photographic representations of the ennui of camp life (fig. 86). Such traditional, bombastic illustrations as Gaul's stood independent of the written text, literally detached from it by insert, and dictated inordinately to the narrative and photographic evidence in its proximity by dint of its resplendence and largesse. For some readers the introduction of romanticized pictures into a text given over primarily to photographic realism was undesirable, because, as one reviewer of historical picture books for adults put it, "the photograph renders recent history much less romantic than that portrayed by graphic art" and naturally "raises the question of whether history should be romantic" in the first place. The art staff at the History Company recognized, however, that the camera's frightening ability to assure a "nearness to events" meant that al-

Figure 85. "The Battle of San Juan—Charge Up the Hill," 1898, from the original drawing by J. Steele Davis for Edward Ellis's *History of Our Country*

Figure 86. "In the Trenches Before Santiago," 1898, by Gilbert Gaul for Edward Ellis's *History of Our Country*

Figure 87. *The Astor Battery,* 1898, photograph, for Edward Ellis's *History of Our Country*

Figure 88. "Astor Battery Going into Action," 1898, from the original drawing by J. Steele Davis for Edward Ellis's *History of Our Country*

most "any *truthful* portrayal of contemporary happenings" generated by photographs would be startling in its frankness. Therefore, Ellis's book designers introduced pictorial idealizations as mitigating devices to offset the harsh realities of photographic evidence.[35]

The mixing of old and new typologies created some strange contrasts in *History of Our Country* between photos and illustrations of the same scenes. The understated photograph of the Astor Battery on page 2059 of the eighth volume, for instance, seemed incongruous with the pictorial illustrations by J. Steeple

Davis of the same battery "Going into Action," on page 2087 of the same volume (figs. 87 and 88). In the photograph scale is a problem, as is the loss of three-dimensional form that accompanies the compression of most photographic images. Because Davis was less concerned with literal realism than pictorial effect, his depiction captures the arduous struggle that is war, as animated soldiers labor to move heavy artillery through the jungles and mountains of Cuba.[36] The contrast is also evident in corresponding photographic and pictorial depictions of war heroes such as Theodore Roo-

Figure 89. *Col. Theodore Roosevelt, U.S.V. (as a Rough Rider)*, photograph, 1898, for Edward Ellis's *History of Our Country*

Figure 90. "Storm and Battle at San Juan," 1898, for Edward Ellis's *History of Our Country*

sevelt. On page 2148 of *History of Our Country*, we find a photograph of a rather prosaic-looking Roosevelt perched unassumingly on his horse at an uneventful moment in camp (fig. 89). On page 1976, however, Roosevelt is represented pictorially amid the "Storm and Battle at San Juan," a heroic figure poised for vigorous action (fig. 90). The History Company's scheme was simple enough. Photography was the favored instrument for conveying the realistic details of the behind-the-scenes aspects of war, whereas graphic illustrations were called on less regularly to recreate war's fury and stereotyped glory. This prioritizing reflected more than just the natural comparative advantages each medium evidenced for the depiction of certain kinds of activity. It also suggested Ellis's preference for a social history of war over a military one.

In this regard it is interesting to note that although all the pictorial illustrations in Ellis's text are signed and acknowledged by artists' names in the table of contents, not one of the more numerous photographs is attributed to anyone, implying that camera-generated images were not offered as monuments to the artistic genius of any individual photographer so much as testimonials to the cold historical facts as presented in visual form. This anonymity suggests that Ellis and his publishers were among those who believed that a photographic format would revolutionize pictorial history by eliminating some of the objections raised by critics concerning the subjectivity of pictorial evidence. If photographs were indeed more authentic as transcribers of reality, then advances in photo-technology might someday make the use of pictorial illustrations unnecessary. Readers of older pictorial histories were forced to accept (by the limitations of the graphic medium in use when they were published) certain distortions and inaccuracies in the visualizations of the past; indeed, they incorporated these limitations into their own restricted

expectations for the pictorial mode. In the mid-nineteenth century, pictorial embellishments were recognized as deliberate "historical fantasies" that by definition gave "to the subject an appropriate grandeur, majesty, and dignity, qualities that elevated and honored their subjects." But in the new age of photographic realism, such carefully managed "front performances" gave way to an interest in "back" images, "those unplanned, unstructured, informal occasions when defenses are down and people act without premeditation."[37] Ellis's photographic images of soldiers relaxing in camp and officers out of uniform were designed to do more than just fill out the pages of an already lengthy work; they were intended to suggest a revolutionary historical perspective that was at once more objective and more revealing of the true experiences of war.

So palpable was the feeling of participation created by many of the images in Ellis's *History of Our Country* that they evoked the memorable comments of Oliver Wendell Holmes about the "surreal" quality of photography. Holmes noted that the camera often produced images that were so real that "matter as a visible object is of no great use any longer, except as a mould on which form is shaped." A few good negatives "of a thing worth seeing, taken from different points of view" was all viewers needed, in Holmes's estimation, to understand the thing itself.[38] The most competent stereographs or photographs encouraged Holmes to argue for the "absolute reality" of the camera as a historical tool. For Holmes "photography was better than material reality, in fact; it was a substitute for the world as well as an incomparable delight, an education, an art."[39] Ellis shared this appreciation for the surreal quality of photography and held out the hope that it could salvage the reputation of a pictorial history industry under attack. For him the power of the almighty camera to reproduce historical events

signaled not only the expansion of the volume of visual materials available to the historian for corroboration of the historical record but also the emergence of a new and more authentic historical epistemology by which historians could evaluate the past.

The Mechanical Message Taker and Pictorial Photography

As much potential as the camera implied for the revival of the visual in historical narratives, it proved ultimately unsuccessful in protecting the genre of pictorial history from its harshest critics. If for Ellis photography held out the promise of a more accurate visual representation of the past, for others it seemed subject to many of the same problems that threatened the integrity of the pictorial depictions of illustrators. The presumed impartiality of the camera's lens posed difficulties for some historians, for instance, especially those who questioned the value of its neutral, dispassionate reports of the past. Because the camera's eye was believed to be a nondiscriminating recorder of all that passed before it, historical photos were condemned by these critics as passive records of events rather than organizers of them. The "machine-like exactness" and the "determinable, datable character of the photograph," noted one skeptic, meant that the camera "didn't take time to reflect; it didn't arrange; it merely recorded."[40] A photographic portrait of a famous American might render the superficial and surface qualities of that person's being, but it could never convey the "inner character" of the sitter the way a painter's portrait might do. "While the camera may be useful as an aid to drawing," artist William Page pointed out, "it is a 'misapprehension of the object of art' to think that 'reproduction of nature' by itself can achieve it. 'Soul' can 'never be made visible through a machine-rendered body, however perfect in its kind

that may become.'" Page rejected the camera as too authoritative and controlling in its presentation of cold, neutral observations to compete with the "imagination and thought" of the artist.[41] A similar argument had been made about the usurping quality of illustrations, of course, but in that instance the complaint had been with a fancy picture's tendency to dominate other competing imaginative visions. With photography, the danger was not so much the rivalry of opposing visual images as the ruthless elimination of all alternate representations in the face of the camera's uncompromising objectivity.

The camera's ability to produce and then reproduce images with clarity unrivaled even by the best engraving techniques raised renewed concerns about the deverbalization of culture as well. Publishers of magazines and books illustrated primarily by photographs often took advantage of the ease with which images could be manipulated to fill space, the visual material crowding out words in an unhealthy competition for control of the printed page. Sidney Fairfield complained in an 1895 edition of *Lippincott's* that "at least one of the magazines published in New York is almost wholly produced, as to its text, by three or four of its office-men . . . who 'write around' the pictures; that is, they supply the reading-matter for somebody's photographs." In Fairfield's estimation, there was no explanation for this shameless reversal of standard image/text configurations other than the desire of publishers to reassert their authority over the writers of words. The damaging effects of these power struggles were noticeable especially in the field of history, he implied, where the sanctity of the written word was compromised continually by the commercialism of manufactured visual images. "While we may deplore this Cheap-John literature masquerading in the guise of the best and the highest," he wrote sardonically, "we cannot but admire the business intuition

of those publishers who recognize the selling value of mere pictures." Part of Fairfield's tone can be explained by the fact that he was a writer who had been victimized himself (both financially and intellectually) by "the subordination of what is literary to what is pictorial," and he felt helpless to resist photography's sovereignty in the editorial decisions made regarding his own published articles. Resigned to taking "his medicine uncomplainingly," Fairfield advised himself and others like him to buy a camera for the developing of suitable photographic images for their articles and to hire "some professional sketch-artist" who could turn each "into a genuine masterpiece and affix his own name to with fitting artistic indistinctness."[42]

Although most acknowledged that photographs provided a level of realistic detail not possible in imaginary illustrations, some critics questioned whether camera images were, in fact, the pure, objective transcriptions of reality they purported to be. These doubters recognized that the camera was at its basic "merely a mechanical message-taker" and that "even the mechanical message-taker had defects of distortion" in its lenses, emulsions, and human operators.[43] By the 1890s photographers had been experimenting for more than fifty years with the manipulation of the medium, and many had become experts on altering perspective or angle of vision to achieve a desired effect. Tinkering in the developing process with the composition, texture, and tone of a camera-generated image was considered part of the photographer's "craft," and the "misty atmospheres, fuzzy surfaces [and] exotic tableaus" of numerous nineteenth-century photos testify to the capabilities of photographers for adjusting pictorial conditions to suit personalized needs. Indeed, by the turn of the century a new breed of "picture-takers" had emerged who believed that photography was "more than factual reporting," who argued that it was also "a potential art"

form capable of conveying "a personal expression of one's emotional reaction to life." These camera artists "strove to redeem the aesthetic reputation of their chosen medium by proving they could impose their desire, their artistic vision, upon the mechanism." As Alfred Stieglitz later put it, the camera, which had once been "slave, hand-maiden, or helping friend" to "research [and] science," had now become the liberating instrument of a new branch of "pictorial photography." Distinguishing between the documentary and artistic functions of the camera, Stieglitz noted that in evaluating the "objectivity" of historical images created by the camera, one must never forget the artistic presence of the photographer behind the lens.[44]

The problem with acknowledging the interpretive and artistic potential of photography was that such recognition changed irrecoverably the meaning of the camera as a historical tool. Some might value pictorial photography as a more controlled mechanism for exercising the imagination, but as a form of representational art it was still open to the criticism that it distorted in ways incompatible with the historian's commitment to objectivity. As we have seen in the case of Devens's images of Sioux Indians, portraits could be "improved" or "retouched" to produce effects bordering on illusory trickery. In addition, composite photos could be manufactured by attaching sections from different photographs to a single plate and rephotographing them, thus falsifying a scene by bringing together individuals and artifacts that did not coexist in the same temporal moment. Negatives were also capable of manipulation, as when opaque materials were used to block out areas of collodion film or when special pencils were employed to "abrade" the surface of the film. Photos could be "staged" to reflect false conditions as well, photographers obscuring purposefully certain details of a scene by altering angles of vision.[45] Sometimes illus-

trators even tried to give the illusion that photographic facsimiles were original works of art by recreating the texture of a painted surface or imitating the irregularities of canvas.[46]

Given the potential for manipulation and artifice in the production of the photographic images, it is no wonder that many questioned whether photos were really any more useful than pictorial illustrations had been in the pursuit of accuracy in the study of the past. In fact, some argued that photography was a less tenable medium than conventional pictorial illustration because its inflated claims to objectivity obscured the considerable subjectivity of the camera's work. At least with illustrations, the reader of pictorial works knew that "some interpretive recreation" was implied and that the illustrator of historical events acted self-consciously at some level as a representational artist. With the photograph, the assumption of objectivity gave observers the false security that they were in the presence of images that required no interpretation, when, in fact, the camera's seeming "impartiality" imposed more analytic demands than less. In the estimation of these critics, viewers of photographic evidence were forced to play a more "active role in searching out and constructing meaning" than were the examiners of illustrations, and they ran greater risks of misreading or misinterpreting images than did those engaged in reviewing overt allegorical treatments.[47]

Even if one assumed no manipulation of subject or instrumentation on the part of the photographer, the use of cameras to record historical events raised unavoidable questions about the standards for evaluating historical evidence. The camera begged responses to queries such as, What is reality after it has occurred? Is it the physical residue (visual or otherwise) of the events themselves? Or is it the idealized collective memory of the things represented by visual evidence like photos? And what of that reality not recorded by cameras? Most events of the past were not subject to photographic depiction, either because they predated the age of photography or because no camera was available to create a photographic record at the time of their occurrence. In our own age of constant surveillance, when video cameras have made possible the recording of nearly every important private and public event, it may seem hard to imagine a day when cameras were not in use at all times. Even photojournalists who made conscious efforts to be on hand for historically significant events (and who, not infrequently, endangered themselves in seeking to secure photos) could rarely claim to have achieved anything close to a complete or accurate perspective. Only an imaginary, ubiquitous photographer with an infinite number of cameras could give full satisfaction to historians that a complete record of an important incident had been made from enough conceivable angles of interest to be useful as a historical tool, and speculation about such a mythical camera operator thrust historians forcibly back into the realm of the imagination from which they had sought escape in the first place.

Even if such omnipresent photographers did exist, they would be restricted in their abilities to map complete visual accounts of historical scenes by the limitations of the nineteenth-century camera as a recording device. The hand-held, single-shot cameras in use in the 1890s were reasonably accurate at depicting "arrested time," Ellis's publishers recognized, but they were incapable of delineating "elapsed time" so crucial for the study of history. By the twentieth century the movie camera had solved this difficulty for the film medium, but the problem of how to transfer a sense of "duration over time" to the printed page remained.[48] The dilemma was ontological. In one sense the belief that a photo was an irrefutable representation of the "thing itself" resulted in a "cancellation of

history," because the assumption was that a camera-generated image could "shrink time" by transporting one back to a precise moment in the past. But how to move the viewer through time using photographic means or to encourage sustained historical reflection? These were greater challenges, ones that required the reconceptualization of history as a divide between the event and later studies of the event and that insisted on the reevaluation of visual evidence as a mediator between past and present.[49]

Edward Ellis and his editors at the History Publishing Company attempted one solution to the problem of conveying change over time by grouping like photos of the same event at sequential intervals throughout the text of *History of Our Country.* Hence, before-and-after shots of monuments under construction appear throughout the volumes as do juxtaposed images of early and later models of locomotives. As effective as this technique was at giving readers the impression that they were experiencing the passage of time, it still proved inadequate for the depiction of motion and action within a single historical episode. Indeed, artists-turned-photographers, such as Frederick Remington, argued endlessly with colleagues about the ambiguities raised by the "stop-action" of photography, engaging in lengthy debates on issues such as whether cameras could answer the age-old question whether horses ran with two feet or four feet in contact with the ground at any time.[50] Photos might capture the anticipation of action, such as the moment before a shell is to explode or the immediate aftermath of an explosion, but most nineteenth-century photographs of historical events had a posed, frozen quality to them. "Unlike a painting or a drawing, which conflates the duration of its making with the inner subjective time of the maker's memory and mental processes, the making of the photographic image occurs at once."[51] When one adds the technical difficulties the photographer might encounter in securing even these individual before-and-after images (bad lighting, inclement weather, inadequate exposure time, etc.), the chance of obtaining a wholly satisfactory photographic image of a historical event over time decreased markedly.

Finally, some saw the ascendancy of the camera as part of a broader conspiracy on the part of publishers to undercut the authority of the artist as a preserver of the past. As an instrument for information transference, the camera had already made inroads into the once-noble profession of engraving by introducing photography-on-the-block; now some felt the sacred role of pictorial artists as depicters of history was threatened altogether by insistence on images that "standardized and sterilized artists in a fashion to delight a prohibitionist."[52] A writer for the *Atlantic Monthly* complained in 1891 that the "element of cost" was at the heart of many publishers' decisions to choose photographic imagery over pictorial representations in their texts, a disposition of the "publishing mind" that accounted for the "degree of slovenliness" and lack of imagination in most pictorial histories based on photographs.[53] Many publishers employed photos indiscriminately, they argued, adapting camera images made for one purpose for use in alternative applications with little thought to the photographer's original intentions.[54] Some were so concerned by the intrusions of photographers into the pictorial arts that they encouraged the revival of the lost art of engraving. Various periodicals that had long championed the wood engraver, such as *Scribner's Monthly* and *Century's Illustrated Magazine,* for instance, awarded annual prizes in wood engraving after 1890 as a way of preserving the art form for a generation subjected to the usurping qualities of the camera. "At this time when photography charms the mob by the mechanical fidelity of its reproductions, it is necessary to en-

courage an artistic trend in favor of free caprice and picturesque fantasy," *Century*'s editors explained.[55]

This nostalgia for the day of pre-photographic illustrators informed the reviews of many pictorial histories in the 1890s, establishing an evaluative standard by which some praised and others condemned works such as Ellis's *History of Our Country*. The range of these critiques mimicked the literary discussions in Philip Gilbert Hamerton's article "Book Illustration," in which "imaginary dialogues" among artists recreated conversations about how illustrators and writers "were faring under the new reign of photo-technology." In one such exchange, an opponent of the camera explained why he would rather have illustrations than photographs in his pictorial books. The photograph "does not detach one thing from another as a skillful artist can," the imaginary critic noted. "The artist can take what the reader wants, and that only, and he can make the needed facts very plain and intelligible, whilst in a photograph they may be entangled with many other details that are not wanted." Just as the traveler composing a travel book "largely uses this power of selection in writing an account of what he has seen and done, so the illustrations of an artist are better in harmony with his work than the photograph can ever be." In fact, "a pure photograph from nature is out of place in any book whatever," the critic argued, because it could never anticipate or replicate the way a particular traveler might interpret the natural or historical landscape.[56] This same logic was used by some to condemn the tendency of publishers such as the History Publishing Company to use substandard photos of natural scenes to convey the sublimity of American Nature. Ellis's photographic views of Niagara Falls or the western frontier in the *History of Our Country* were so reduced in scope as to be virtually unidentifiable without captions, a condition that severely limited their powers as conveyers of

historical meaning. In such instances, the critics averred, Ellis would have been better served to have included traditional pictorial illustrations of these locations, tolerating their picturesque excesses in order to underscore for readers the importance of landscape and natural beauty in the American historical experience.[57]

Other critics noted that Ellis's supposed "objective" photographs were used routinely in the service of causes, rendering them nothing more than intellectual camouflage for partisan ideologies. An outspoken opponent of the labor movement, for instance, Ellis had written in the text of *History of Our Country* that, despite efforts on behalf of working men in the 1880s and 1890s, "strikes continue, with the destruction of property, the paralysis of business, and often with violence and loss of life." The right to strike "is as clear as the right to breathe," he noted, "but the wrong is committed when the strikers, as is nearly always the case, use violence to prevent others from taking their places. Not only that," he added, "but they pillage and destroy property, and some of the desperate persons among them (quite often criminals who are the worst enemies of the strikers) commit atrocious misdeeds." To make his point Ellis included a pictorial illustration titled "Types of Strikers" (fig. 91), which equated disgruntled laborers with criminality by presenting them in the fashion of police mug shots.[58] These images were consistent with those of nineteenth-century phrenological journals "dedicated to typologizing national and racial characters and linking them, with a demeanor of scientific certainty, to moral character, national features, and corresponding systems of government."[59] As if warning these miscreants about the dangers of misguided actions, Ellis moralized in the text: "One momentous truth should be borne in mind. A powerful mob may defy the authorities for a time; it may hold an entire city at its mercy," but "back

of the military and the regular army would rally ten millions of free men, who would grind the rioters to powder. The safety of our country lies in the fact that we are, have always been, and always will be a law-abiding people."[60] By way of contrast to this hand-drawn rogue's gallery of irresponsible laborers, Ellis offered a photograph of a uniformed militia group staging a reenactment of its breakup of a labor strike. Clearly a contrived performance in both its grouping of figures and in its depiction of elapsed time, *Charging the Strikers* provided a classic example of the ways

in which photography could be used to support a political point of view (fig. 92).

These uses and misuses of photographs remind us that, as with pictorial illustrations, the context for the transfer of visual information is crucial to an understanding of its meaning. Put simply, "photographic images do not become history automatically." They must be selected first by a historian or a publisher, who, in placing them in a text, affects irrevocably their message.[61] In addition, they are "read" differently by different readers, so that no purely objective or deter-

Figure 92. *Charging the Strikers*, photograph, 1898, for Edward Ellis's *History of Our Country*

minable viewer response is ever evident. For some purchasers of Ellis's *History of Our Country*, the numerous photographs of native Cuban villages and street scenes in Santiago provided a meaningful backdrop for discussion of the human element of the Spanish-American War. For others, such as critic Edwin Sparks, photos were a colossal distraction, published too extensively in a text in which the "subject matter is quite secondary to the illustrations."[62] Sparks and others disapproved of what historian Robert Taft later referred to as the incongruity created when "trite, trivial, superficial, tawdry, salacious, morbid, or silly" photographs were paired with the interesting, the significant, and the important. Frequently camera images were scattered in works such as Ellis's "in such numbers and in such confusion as to form a totally indigestible mental meal," Taft noted, adding contemptuously that "many times the publisher's only principle of selection appears to be '*Any* photograph is better than no photograph.'" The abuses of the History Publishing Company in these areas, which were substantial in the estimation of its critics, were magnified by the indiscriminate mixing of formal portraits, casual photos from travel books and sensationalized tabloid photographic illustrations.[63]

These questions about the legitimacy of photos as historical sources pushed the genre of pictorial history toward a crossroads of sorts. By the first decade of the twentieth century it was becoming obvious to some that both illustrations and photos were "symbolic reports" and that "both stand for, but do not replicate or duplicate 'concrete events.'"[64] This knowledge meant that either one could accept all pictorial representations as subjective renderings and live with the consequences or one could reject visual culture altogether and fall back on whatever objectivity might be found in words. In an age of scientific realism in which historical literature was judged by its ability to objectify reality, producers of illustrated histories found their publications dismissed more and more as something other than "true history." Some publishers of pictorial histories were perfectly willing to accept this characterization, because they recognized that their visual texts continued to be appreciated by a certain class of readers whether the images in them were historically accurate or not. But the charge that

they were producing something other than history convinced a number of publishers to advertise their works as "popular literature" rather than as "pictorial and photographic *histories*," suggesting the affinity of their works to best-selling fiction and essays rather than to bona fide history. In making these subtle changes publishers admitted tacitly that the "new visual sensibility" of the photograph implied "a product whose power and efficacy owed [more] to its status as a commodity" in the popular book market than to its reputation as the embodiment of objective fact.[65]

As convenient a rationalization as the switch in nomenclature provided for the ongoing publication of texts illustrated by engravings and photographs, it represented an undeniable declension of sorts for the genre of pictorial history. Clearly history that was not really history had lost something vital to its self-identity. Some publishers of "visualized history" continued to argue for the integrity of their images as historical artifacts, but most admitted to the distorting qualities of visual evidence and accepted the limitations that such knowledge implied for the historical value of their works.[66] In this sense photography had become a victim of its own successes. So thoroughly had the camera discredited other competing systems of illustrating the past, that when it proved itself vulnerable to manipulation, neither it nor its pictorial competitors could recover from the fallout. The solution for some was to avoid photographic material altogether, lest their publications come to resemble "the comic almanacs" of old in their misplaced enthusiasm to illustrate without proper protection against distortion.[67] Others continued to include pictorial material in their works but apologized for their imperfections in long, confessional introductions to their works. Far from being an unimpeachable aid to historical understanding or memory formation as conceived in the 1840s and 1850s, then, the visual had become a dis-

tracting and even counterproductive element in the search for historical truth. The variability of interpretation created by the camera's internal mechanisms for manipulating perspective meant that photographic evidence could not escape the ambiguities of its own creation.

Gone to the Junk Shop

Although pictorial history as a genre suffered noticeably in the early 1900s from the strangulating constraints of its own internal ironies, it was helped along in its demise by an ongoing campaign on the part of professionals who redoubled their efforts to support only those "legitimate" modes of historical study sanctioned by the academy. Pictorial history, traditionally defined, had never been history at all in the estimation of these scholars. As early as 1896 Harvard professors Albert Bushnell Hart and Edward Channing noted in their *Guide to American History* that, despite the considerable work of popular historians over the last six decades, there was no adequate "comprehensive history of America from the discovery to the present time." Hart and Channing dismissed the pictorial histories of Lossing and Stephens as either too shallow or too polemical, and they ridiculed the lack of scholarly standards in works by Ridpath and Halstead.[68] So disturbed were these scholars about the inadequacies of the popular illustrated histories available for sale that they brought their concerns before the American Historical Association and urged its council to "take up the matter," soliciting "countenance and support" for an alternative professional history of the nation. A committee was formed within the AHA to consider such a comprehensive history, and a preliminary report was prepared by such eminent scholars as Hart of Harvard; Charles Francis Adams, president of the Massachusetts Historical So-

ciety; Herbert Baxter Adams of Johns Hopkins; W. A. Dunning of Columbia; John B. McMaster of the University of Pennsylvania; and Professor Moses Coit Tyler of Cornell.[69]

The call for an alternative to the inadequate pictorial histories of amateurs was discussed in several annual meetings of the AHA at the turn of the century and representatives from the leading universities agreed on general principles for such a work, including a strong commitment to the values of scientific proof and objectivity. The association eventually decided not to fund the enterprise on the grounds that such a comprehensive work might not "pay for itself." This admission was revealing for what it suggested about the continuing dominance of popular histories in the literary marketplace, but it by no means signaled a lack of commitment to the long-range goal of undercutting that presence.[70] Refusing to abandon the field to inadequately trained popularizers who seduced the public with fancy pictures, Hart pitched to Harper and Brothers in 1901 the idea of a privately published comprehensive history.[71] The publishing firm had just begun marketing Wilson's *History of the American People* at the time, but because distinctions were now being made between professional and popular initiatives, its editors evidently felt that one project would not undercut the other and agreed to produce the *American Nation* series as a professional initiative under the directorship of Hart. The proposed series was to include twenty-seven volumes written by several dozen professionals for the purpose of contributing "an intelligent summarizing of the present knowledge of American history by trained specialists" and providing a "complete work, written in non-technical style, which shall serve for the instruction and the entertainment of the general reader." On the surface such goals seemed little removed from the ambitions expressed by the earliest

popularizers such as Lossing; namely, thoroughness and readability. But Hart emphasized that his scholarly series would differ from works "encyclopaedic, uneven, and abounding in gaps" because it would outline not only the events that "inspired the imagination of contemporaries, and stir[red] the blood of their descendants" but also the more sober forces of the past that were the true stuff of history.[72]

It is highly significant that in negotiating his contract with Harper and Brothers Hart insisted that illustrations not be included in the series, with the exception of a single portrait of an eminent figure at the front of each volume and a series of maps throughout. The assumption on Hart's part was that only a few such embellishments were necessary, because, in his estimation, most subjects did not benefit from presentation "in graphic form [rather] than in print."[73] The doubts about illustrations that Hart raised with his editors echoed the more restrained observations he had made earlier in his presentation "Graphic Methods of Illustrating History," suggesting the distance he continued to put between himself and the pictorial excesses of his amateur predecessors. He was especially critical of those works "prettily illustrated" with which the *American Nation* series might have to compete, those "crude and unreadable" volumes whose authors sought to distract readers with glitzy pictures and photographs.[74] Maps and charts were acceptable in histories, Hart argued; indeed, he spent a good deal of time as editor of the Harper and Brothers series managing the details of colorized maps that were later collected in a supplementary historical atlas.[75] But he disdained illustrations that were merely ornamental, and he advised agents for the *American Nation* series to "dwell upon the fact that this is a scientific work, by writers every one of whom has already published something good" without the smokescreen of pictorial embellishment.[76]

In leveling his attacks against the use of visual culture in histories, Hart was especially vigilant in the rejection of photos of the sort used by Ellis. He shared the objections of Frank Weitenkampf and others that Ellis's faith in the photographic image had encouraged a new generation of Kodak-toting Americans to imagine that they could be historians, too. If every man could be his own historian (to paraphrase Carl Becker), then amateurs might privilege their own images over those gathered and analyzed by professionals. The camera threatened to trivialize the past and thereby to reduce the authority of scholars dedicated to upholding its standards.[77] The enfranchising of the people as "their own image-takers" by the introduction of the "snapshot" technologies had not had a salutary effect on historical study in Hart's estimation. "Photography democratized pictures, and it also democratized history," perhaps, but this was a process that many professionals feared nearly as much as they did the pictorial excesses of engravers, whose lack of standards in representing the past had encouraged the rise of professional associations of elite scholars in the first place.[78] In rejecting historians such as Ellis, Hart may also have had in mind a larger critique of the commercial motivations behind many pictorial histories. Although Hart was not immune to the need to reach popular audiences, he rejected the blatant materialism of pictorial texts like Ellis's that justified a reduction of standards by the ostensible need to reach the democratic masses. Revealing some of the intellectual elitism characteristic of many professional associations, Hart and others took delight in the failings of those who substituted shallow pictorial evidence for reliable analytical research. When the Boston publishing firm of J. Osgood was forced to close its doors in 1885 because of fire, the uncharitable George Townsend remarked that such a disaster at least "calls a halt upon so much sensuousness in our literature." Instead of producing "strong books and strong meat for the mind," he noted disapprovingly, Osgood and publishers of his ilk had been guilty of "giving us decorative books, all bursting with illustrations . . . that catch the eye and do not minister to the soul. You cannot make a literature . . . with pictures," he asserted, callously implying that the J. Osgood publishing company had gotten what it deserved.[79]

Hart was not alone among professionals in his efforts to bring more scholarly rigor to a comprehensive study of the past. In the early 1900s a rival project to Hart's emerged at the Johns Hopkins University under professor Guy Carleton Lee titled *The History of North America* series.[80] Like Hart, Lee identified the lack of a comprehensive history of the United States as a massive failing in the American historical enterprise. The works of Frost, Lossing, and other popularizers, he noted, could not be described as either "comprehensive" or "accurate"; they were "unworthy of serious consideration" at all as works of history. Most such histories, he argued, "were confessedly sketchy, and, with only two exceptions, they have not been written by men of standing among scholars." In these two instances, probably the works of Edward Eggleston and Woodrow Wilson (both members of the AHA), Lee noted that "the authors have been handicapped by the limits of space and by the fact that no one man is able to write from his own knowledge of the details of American history in the whole, and within limits imposed by the commercial necessities of publication." Because such writers had had to "depend on secondary authorities" of inconsistent quality, Lee added, the tendency had been for even these men of standing to incorporate "most of their errors along with their correct statements of fact." Those like Ellis not adequately trained in universities were still more susceptible to the dangers of unrestrained ambition in their multivolume productions. "No more glaring

example of this fallibility of historical writers attempting a task too large can be found than in a recent pretentious general history in the compilation of which the author was obliged by the circumstances of production to depend largely on secondary authorities, with the result that more than five hundred errors have been discovered in a single volume," Lee concluded in judgmental fashion of amateur works.[81]

Although Hart and Lee had similar objectives for their scholarly series, the latter differed from the former in his willingness to consider a pictorial format for his comprehensive history. "Determined in the present instance to follow a radically different plan" from that of Hart, Lee convinced his publishers at George Barries and Sons of Philadelphia to include "all the illustrative material that was necessary to give prominence to the points of the text or to elucidate them." Lee's intention was to show that pictorial evidence was not incompatible with professional standards, and he boasted that *The History of North America* would be "more satisfactorily illustrated than any work of like nature" and yet would have "the unique distinction of being the one work in which not a picture has been selected for decorative purposes, but all have been chosen because of their value as historical data."[82] Using mainly photographic evidence, Lee's twenty volumes included hundreds of depictions of natural scenes, technological wonders and international dignitaries. Circulars for the series declared it "elaborately illustrate[d]" in a manner consistent with the highest tenets of scholarship and professionalism.[83]

The announcement in literary publications of the forthcoming publication of Lee's *History of North America* series prompted a decidedly unprofessional response from Hart. The Harvard professor undoubtedly resented the competition the Hopkins volumes created for the *American Nation*, but the form these jealousies took was a tirade against Lee's claim

that a responsible history of the United States with illustrations could be published. The decision to pictorialize *The History of North America* confirmed for Hart what he had already suspected, that the Lee project was a commercial rather than a scholarly undertaking and was the work "of men entirely unknown to the profession."[84] Condemning Lee as a "thorough-going charlatan" and his Hopkins editor as "a proved fraud," Hart warned would-be readers that the time had come to recognize that illustrations were by definition idealizing and were therefore incompatible with the goals of authentic history. The image veneration of the nineteenth century, rooted as it was in an appreciation of the rhetorical capacity of illustrations to interest readers in the texts that accompanied them, had now given way to revelations about the distorting romantic underpinnings of visual evidence. Indistinguishable from the profit motive that they served, images were in Hart's mind the very essence of what later became known as the "cultural construction of consumer desire," the literal manifestations of a romantic imagination that turns "things into objects of desire that can be consumed."[85] Put differently, illustrations had become synonymous with the fetishizing of history.

When the first volumes of Lee's *History of North America* appeared on the market, Hart felt confirmed in his fears about the perverting quality of its images. He took special aim at the scandalous quality of some of the photographic evidence Lee included in the series, especially illustrations like that of bare-breasted Hawaiian women.[86] The normally restrained Hart was outspoken as well about the fancy colorized brochure circulated by Barries and Sons, which the staff at Harper and Brothers characterized as "a good specimen of bluff" derived from the advertising excesses of popularizers.[87] Hart speculated that Lee's books might "appeal strongly to librarians, who are not in

general a discriminating class and are easily taken by showy promises," but he hoped that more discerning readers would recognize the volumes for what they were, "a poor thing so far as any literary or historical value goes."[88] Noting that the twenty volumes of *The History of North America* were to sell for $120 dollars (as compared to $40 for the *American Nation* series), he argued that Lee's series was not even a good value as measured by the commercial gods it served so slavishly. Given these failings, Hart predicted somewhat uncharitably that "Lee and his volumes" would soon be "gone to the junk shop."[89]

Lee had his defenders, of course, especially among those accustomed to having their written accounts supplemented by visual images. Some argued that scholars had gone too far in their insistence that pictorial texts be purged of abstractions. Julian Hawthorne among others clung persistently to the notion that histories could and should be illustrated. "There are no illustrations," he complained in a review of a pictureless volume, *The Transit of Civilization*, by Edward Eggleston, the erstwhile pictorial historian who had become president of the American Historical Association. The lack of pictures "is surprising in this age, and it seems to me regrettable," Hawthorne noted; "there ought surely to be pictures of old things and customs which would have shed additional light upon the subject."[90] Yet even Hawthorne admitted that the efforts of the last half-century to combine verbal and visual representations had often had disastrous effects on both strategies of historical explanation. Like many others pictorial historians, Hawthorne had experienced the critical fallout from the seemingly unavoidable incongruities between images and words. Reviewers of *Hawthorne's United States*, such as Edwin E. Sparks, complained that the "entirely imaginary" illustrations were distracting, amounting to little more than "stock illustrations."[91] Such comments left

Hawthorne dispirited, suggesting to him that his carefully crafted words were secondary to the stylings of the artists who embellished and the designers who marketed them, rendering his books objects to be owned for their external appearances but not literary masterpieces to be read and savored.

In addition, Julian Hawthorne suffered the criticisms of reviewers who complained about the "principle of convenience" used by his publisher, P. F. Collier, to juxtapose the images and text in *Hawthorne's United States*. Hawthorne had painted a highly flattering portrait of the humble, happy Dutch, for instance, noting that as a people they were so "rich in character and color" that "their story lends itself to picturesque and graphic treatment" of the sort at which Washington Irving excelled, a treatment whose "sympathetic and creative insight" proved the axiom that "the caricature of a true artist gives a better likeness than any photograph."[92] In such descriptions Hawthorne emphasized what Alan Trachtenberg called the "interior reality" of his subjects, penetrating through the "external surface of persons" in search of "signs or expressions of inner truths."[93] To accentuate the charming qualities of this literary portrait of the Dutch people Hawthorne's editors accompanied the text with an illustration by Victor Perard titled "Scene in New Amsterdam" depicting a convivial, pipe-smoking, liquor-drinking Dutchman reposing in a lively, festive village marketplace (fig. 93). On the surface, the image would appear to be compatible with the narrative, implying a perfect synergy between pictures and words. Closer inspection of the image, however, reveals the degree to which Perard altered the original artist's intentions for the illustration by softening the realities of seventeenth-century Dutch life. Discerning readers of periodical magazines, for instance, would have recognized that Perard's quaint illustration was adapted from a far

Figure 93. "Scene in New Amsterdam, 1660," 1900, by Victor Perard for Julian Hawthorne's *Hawthorne's United States*

Figure 94. "The Choicest Pieces of Her Cargo Were Sold at Auction," 1895, by Howard Pyle for *Harper's New Monthly Magazine* 90 (December 1894–May 1895)

more austere series of pictorial representations of the Dutch that appeared in *Harper's New Monthly Magazine* for 1895. Produced originally by Howard Pyle for Thomas Janvier's article "New York Slave-Traders," these prior illustrations were intended to debunk the Irvingesque portraits of the Dutch by pointing out the cruelties of the active slave trade in which they participated.[94] Comparing Perard's "Scene in New Amsterdam" with Pyle's "Choicest Pieces of Her Cargo," we notice the same portly Dutchman situated under an identical tavern sign, but missing from Perard's

adaptation is the trading block, the auctioneer, and, most of all, the luckless slave (fig. 94). The elimination of these gruesome accessories of the slave trade obscured a considerable flaw in the Dutch character and revealed a somewhat shameless effort on the part of Collier to make pictorial evidence conform to literary stereotype. The Perard adaptation also cost Hawthorne a chance to use the Dutch in his otherwise strong attack against the institution of slavery in colonial America, an opportunity Edward Eggleston did not lose in the unillustrated *Transit of Civilization*.[95]

Lee's twenty-volume illustrated history used pictorial evidence more responsibly than Hawthorne, perhaps, but it bore little resemblance to the pictorial sophistication that had defined the genre just a decade before. It was a nicely packaged series with the look and feel of a reference guide, but it was not nearly as inviting to the eye as the works of Spencer or Darley had been. Consequently, in the competition among professional rivals Hart's *American Nation* series outsold Lee's *History of North America* by a good measure.[96] Whether this was a result of the reduced price of the former or the weight of his arguments against illustration, it was clear that the market for comprehensive histories of the United States had changed perceptively to the advantage of scholars such as Hart. The *American Nation* series was praised in the press as a fresh, new departure from a depleted and exhausted tradition, a "boon" to the general public, as one reviewer put it, "which have too long been at the mercy of the hobby-rider and the sensation-monger."[97] The suggestion was that the reading public needed a dose of scholarly rigor in its historical diet and that Hart's series supplied it in a way that Lee's pictorial works could not. The failure of the Johns Hopkins project may also have confirmed what Hart suspected, that "the feeling against photography" ran deep, some viewing it as a mere "vehicle for mimicking rather than creating art," others ridiculing it as a "fine art" of little use to historians.[98] A new class of iconophobes had settled on photography as the most recent target in the ongoing battle over the proper use of images in historical texts, and, along with Hart, they rejected works such as *The History of North America* on the grounds that camera images violated the exacting evidentiary standards established by the new profession of history.

Regardless of the causes of the poor sales of Lee's series, one thing seems clear: its failure signaled a triumph of the word over the image in the specialized market that was now history. As pictorial histories became more and more hackneyed and clichéd in their visual forms, they lost credibility with professionals who campaigned effectively to convince readers that history required different evidentiary standards for truth than amateurs such as Ellis allowed. This is not to say that pictorial histories like Ellis's or Lee's disappeared from the marketplace; but increasingly professionals viewed these histories as something "other" than legitimate history. Assuming authority over the public debate concerning what constituted history, professional historians introduced new, more restrictive definitions of what methods and devices should and should not be employed in the study of the past. The illustrated books by Frost, Spencer, Lossing, and others that had dominated the popular book market in the mid-nineteenth century were still purchased and read, but they were now categorized as mere travelogues, moral diatribes and pseudo-histories. As a result of the efforts of those like Hart, pictorial historians went into partial retreat, writers such as Ellis abandoning the field to a new breed of less flamboyant, monograph-wielding professionals. Whether this abdication was ultimately in the best interests of history as a discipline could be debated. But Hart at least viewed his victory over new pictorialism as absolutely justified, signaling the successful culmination of a campaign for the "triumphant appropriation of the whole span of American history by professional historians." In the words of noted intellectual historian, John Higham, the publication of the *American Nation* series marked for Hart and for the publishing world "the end of [one] epoch" of historical writing and the beginning of another.[99]

Epilogue

Endings

With the commercial failure of Lee's *History of North America*, the genre of pictorial history came full circle. Begun in the 1840s as an experiment in embellishing texts with crude woodcuts, it had moved through several phases marked by the growing sophistication of illustration and a proliferation of historical material from which to construct literary narratives. Throughout its life cycle, the genre had been characterized by a struggle among authors, illustrators and publishers as to the proper balance between visual and literary ways of conveying historical knowledge. In the early history of the cycle, writers had the dominant hand over illustrators and publishers, the latter of whom were compelled to serve as copyists of one sort or another for the former. In the 1850s it was possible for a historian such as Benson Lossing to assume control over the writing and illustrating phases of the same work, although he was obligated to his publishers at Harper and

Brothers for formatting and promotion. During the heyday of the pictorial form in the 1880s and 1890s, technology allowed for the mass-production of more artistic, less strictly encoded images, and individual artists began to achieve notoriety on a par with the authors of popular texts. In some instances artists such as Howard Pyle and Frederic Remington exercised enough influence to determine what topics authors chose to address or how much space they allocated to historical subjects. Illustrators also asserted their authority with publishers at the expense of writers by dominating page design, their sprawling pictorial layouts literally crowding out words in preference to images. Colorized illustrations enhanced further the authority of artists, the decorative and ornamental qualities of their work often distracting readers from literary texts. The power of artists waned only when questions were raised about the accuracy and objectivity of their illustrations and when still newer technologies, primarily photography and the halftone process, made pictorial representations of any kind other than photos seem illegitimate. The cult of the camera reaffirmed the power of the visual by substituting the photographer for the artist as the primary historical image maker, but it also renewed the authority of publishers, who regained control of the printed page through the capacity to manipulate the size and placement of camera images.

If by the turn of the century publishers seemed to have retained the upper hand in the complex relationship between authors, illustrators, and themselves, it was an incomplete victory at best, because the entire genre of pictorial history was jeopardized as much as aided by the emergence of photographic images in books. Not only did photos overshadow all other forms of pictorial representation, especially hand-rendered imagery, but they also introduced a form of visual skepticism and altered in both figura-

tive and literal ways the manner in which people viewed the past.[1] Unwilling to trust even their own personal memories of previous events without verification on film, many historians dismissed all pre-photographic depictions of history as only so much fanciful embellishment. Eras for which no photographic evidence existed were discounted as somehow less historically significant, and the works of early illustrators such as Croome, Chappel, and Darley were denigrated or ignored as irrelevant. When even photographs proved themselves "arranged" and capable of manipulation with regard to light, tone, perspective, and color, however, the entire enterprise of visualizing past events seemed at risk. If photography was as much interpretive art as evidentiary record, then it too was vulnerable to the shortcomings evidenced in the work of illustrators. Given the usurping role of photographs in pictorial texts at the turn of the century, writers had little choice other than to accept the cheaply imitative and falsifying qualities of pictorial photography or to reject the pictorial form altogether, as professional historians such as Albert Bushnell Hart chose to do.

Not that visual culture had lost its power to inspire—quite the contrary. Although illustrated publishing across all disciplines declined somewhat in the early twentieth century, book illustrations remained in high demand in most areas of popular literature. The appeal of pictures was undeniable, especially in children's markets, where it had been accepted as doctrine since Samuel Goodrich's day that visual literacy was a necessary precondition to the ability to read and understand the written word. Various publishers of children's histories had success with visual formats in the early to mid-twentieth century, including marketers of the successful Landmark and Signature series of juvenile biographies and period chronicles. These works operated on the assumption that the

"story of the past can be deadly dull unless so told as to make the visualization of the scene possible." Directing readers to the more habitual presence of visual representations in children's books, Claude Bowers noted that although "it is easy to forget the details of what one reads, one never forgets the details of what one sees."[2] But many historians refused to accept even these restricted uses of pictures; in fact, some volumes in such series were ridiculed as "visual propaganda" by critics who condemned them for doing a disservice to American youth by encouraging an unhealthy reliance on unreliable images.[3]

In the category of "professional history," there was little room for visual embellishment in books published after 1900. The precipitous drop in pictorial histories in the new century had to do largely with the special ambiguities created by the use of illustrations in a subject area defined increasingly by rigorous standards of objectivity. Pictorial elements had been acceptable when history was characterized primarily by the storytelling qualities of narrative, but as the positivistic aspects of the past were emphasized at the turn of the century, the overuse of illustrations increasingly disqualified pictorial works from serious consideration as history. The failures associated with the efforts of pictorial historians to be both "illustrative" and "accurate" suggest that historians had lost faith in the power of the former to achieve the latter, viewing images and texts as mutually exclusive. The original pictorial form conceived by Frost, Goodrich, and Spencer as an aid to the historical imagination had been stretched and pulled almost beyond recognition as twentieth-century authors and editors struggled unsuccessfully to make new priorities conform to old formats. Increasingly, illustrations in works of history were made to serve the subordinate role that they had played in the 1840s; that is, "scattered pictures" were used to "scantily illustrate" texts rather than the mere "thread of a text" explaining the pictures.[4] After 1910 so few books with the erstwhile designation "pictorial history" met the conditions established by literary periodicals for inclusion in the category of history that the label was dropped from most reference guides as anachronistic and even oxymoronic.[5]

Some noble efforts were made to sustain the genre into the twentieth century. Illustrated journals like Leslie's Weekly persisted, using cameras "that do not lie" to produce a record "in pictures" of World War I in much the same self-promoting fashion as earlier correspondents had used pens to illustrate the Civil War.[6] In 1925 Yale historian Ralph Gabriel served as editor for The Pageant of America series, a fifteen-volume pictorial survey of the United States that was illustrated extensively with thousands of reproductions of engravings and photographs. Gabriel claimed to be enchanted with the pictorial format, but he admitted as well that "visual aids . . . have definite limitations." In his "Notes on the Pictures," Gabriel reminded readers that "pictures of the imagination . . . remain what they are intended primarily to be," works of creative art that "should be studied more for what they suggest than as literal renderings of the facts."[7] Amateur historian James Truslow Adams offered a similar multivolume series in 1944 for Charles Scribner's Sons entitled Album of American History and with the same cautions. "No amount of verbal description, however accurate or vivid, can make us visualize the life of the past as can pictures of that life," he wrote. "But the pictures must be authentic; they must be the delineation of that life as seen by those who lived within it, not the interpretation of those who lived long afterward and could only see the earlier life through the spectacles of their own."[8]

In the category of adult literature, only American Heritage magazine, with its glossy illustrations, its ex-

tensive use of archival images, and its two hundred thousand subscribers, seemed to have transferred nineteenth-century pictorial formulas successfully into twentieth-century popular culture. But even here, looks could be deceiving. As with Hart's *American Nation* series, the original plan for the illustrated magazine had been submitted to the American Historical Association for sponsorship, but that organization rejected the proposal on the suspicion of "a commercial taint to the enterprise." After its successful launching through an alternative publishing concern, members of the AHA continued to reject its mission to popularize history through pictures. *American Heritage* "has revealed its limitations," wrote John Higham several years after the magazine's first publication, proving "to have a great appeal, high technical finish, and no intellectual challenge at all." Higham argued that, as with the nineteenth-century pictorial projects on which it was based, the "sharpness, freshness, and variety of its historical vignettes" could not conceal "its studied avoidance of controversial issues. Evading analysis, desiring always to please and never to dare or disturb," he argued, *American Heritage* was characterized by a "blandness" borne of its commercial "compromise between nostalgia and realism."[9]

Although the publishers of *American Heritage* might dismiss Higham's criticisms about the overuse of seductive illustrations as petty professional jealousy, they could not ignore as casually his charge that the magazine's "search for a 'mass' audience necessarily homogenizes it, reducing the actual diversity of tastes and interests to the most common denominator of 'human interest.'" The typical historian employed by *American Heritage*, Higham noted, was "encouraged to write for everyone who will take some instruction along with entertainment" and thereby "addresses no one in particular." The readers in turn were "encouraged to accept a passive role, discover what they have in common with one another (i.e., their 'heritage'), instead of exercising their capacity to discriminate."[10] This characterization of the dilemma at the heart of mass culture recapitulates the problems that pictorial historians faced at the turn of the century in their efforts to be both popular and professional. Illustrations had always been costly enough to require a certain return on the investment, and in order to assure that enough readers could be attracted to pictures to make them pay for themselves, publishers of illustrated histories felt obliged to appeal to the widest readership possible. Not only did the necessity of this outreach require history to be reduced to standardized forms that compromised history as an investigative enterprise, but it also commercialized the past in unsatisfactory ways. Using the profit motive as their standard of judgment rather than the tools of scientific verification, pictorial historians had disqualified themselves as valid guardians of the past in Higham's estimation.

To the extent that the visual has maintained any association with history in the twentieth century, it has done so through the medium of television, "through which millions of Americans now see the drama of history unfolding before their eyes."[11] Putting aside the considerable debate that rages today about what television has done to the cultural and historical literacy of Americans, there is no question that it has changed the way we "see history." It allows for the near-instantaneous transmission of images of events destined to become "historical," even providing collateral instruments such as video-recording devices for preserving and reexperiencing past moments. But this immediacy has also altered the way visual evidence is processed. Whereas pictorial histories of the nineteenth century were understood to be but fragmentary and distanced recreations of ephemeral events, television purports to circulate virtually unim-

peachable visual images of actual historical episodes as they are occurring.[12] Television is susceptible to some of the kinds of manipulations we discussed with regard to photography, of course, but in a very real sense it fulfills most of the documentary functions of reportage once aspired to by some pictorial histories and with much greater claims to accuracy. What it lacks is the studied contemplation of many nineteenth-century illustrations and access to the naïve but unquestioned acceptance of the pictorial mode that those illustrators assumed. Cable television's History Channel may well be the nearest equivalent we have today to the popularizing impulses and visual aspirations of pictorial historians such as Frost, Lossing, and Spencer, but it operates according to philosophical assumptions concerning what constitutes history that are different from those of a century before and that alter perceptions about the role of the visual in human understanding in perhaps irreversible ways.

In the transition from pictorial print culture to televised and cinematic visual formats, silent films assume a special intermediary role. Reliant on captioned titles to convey certain elements of narrative plot sequencing and conversation, silent films represented one of the last venues for the mixing of literary and visual texts. Efforts were made in the first decades of the twentieth century to transfer the lessons learned in pictorial histories to the silver screen by producing feature-length films on American history. The most famous example of such efforts was D. W. Griffith's silent movie The Birth of a Nation (1915), a thinly veiled racist film based on an adaptation of the best-selling novel by Thomas Dixon, The Clansmen.[13] The movie was controversial not only for its endorsement of the Ku Klux Klan but also because it made use in its captions of passages from Woodrow Wilson's History of the American People. Wilson, president of the United States at the time of the film's release, had been a classmate of Dixon's in the doctoral program at Johns Hopkins and, on the strength of that relationship, consented to review Griffith's movie, declaring it "History written with Lightening!" This statement, which infuriated the African American community but assured the success of the film, implied Wilson's sanction of the use of his words and images from the History of the American People in a new and less regulated historical format. Alleging a political motive for the "misappropriation" of one form of historical inquiry in an alternative context, Wilson's enemies condemned him for blurring the distinctions between the literature, art and history.[14]

Toward the end of his career Edward Ellis also tried to make the transition from pictorial history to film. At the time of his death in 1915 he was in the process of contracting with the Edison Company "to supply for moving pictures a complete scenario of United States history from the settlement of Jamestown down to 1915."[15] Although upstaged by D. W. Griffith in his desire to be the first to tell the story of American history through "moving pictures," Ellis had strong hopes that the translation of visual images into the medium of film could bring to life those pictorial and photographic conceptions of America that he had offered in his History of Our Country. Ellis's aspirations were achieved in part after his death by silent filmmakers who produced screenplays based on spin-offs from his grand cinematic scheme, including one released in 1916 by Pallas Pictures (later Paramount) entitled Davy Crockett. Ellis had written a popular biography of Crockett in the late nineteenth century, and historical assessments such as his formed the basis of the heroic characterization of the frontiersman as revealed in the film's intertitles.[16] The film centered on the relationship between Crockett (played by Dustin Farnum) and his love interest Eleanor

(Winifred Kingston), and it featured a poignant scene in which Eleanor reads to Davy from a book of poetry just prior to her departure for Europe, offering to leave the volume with him for further perusal. Davy, of course, can't read, and the revelation of this fact is the moment of psychological crisis in the film. A narrative version of the screenplay, published in *Motion Picture Magazine* in the September 1916 issue, notes that the "blood in the boy's cheeks" rose at the exposure of his illiteracy. Crockett "stooped, picked up his gun, and set his teeth hard," and when he finally spoke, his voice was curt: "I reckon I kin *l'arn*" to read, he declared. A week later, we are told, "Davy went to the schoolmaster and asked to be taught his letters."[17]

This exchange between Davy and Eleanor recalls the discussion of literacy engaged in by Crockett and Ben Harding in the Crockett almanacs of the 1830s. In that earlier dialogue the issue was whether pictures could serve as useful interpretive devices for conveying narrative meaning to unschooled readers who wished to reconcile the dialogues of two illiterate spokesmen from vastly different folkloric worlds. Ben Harding's voice was so coarse and foreign to Crockett and the editors of the almanacs that they resorted to sketching its outlines in graphic form as a way of lending concrete shape and meaning to it. A similar practice was undertaken by the makers of the silent movie *Davy Crockett*, whose actors spoke in words that were not understandable to viewers except as translated into graphic pictograms in the movie's intertitles. In this sense the figures on the screen performed a sort of visual pantomime for moviegoers, and the important moral lessons to be drawn from the film were clarified by written prompts in the form of titles. In both the Crockett almanacs and Paramount's film, "pictures" played a central role in the conveying of historical meaning, although film represented a substantial advancement over Croome's woodcut engravings in terms of conveying action over time. Indeed, in making the transition from pictorial history to film, those like Ellis were attracted doubtless to the additional air of authenticity conveyed by early films shot on historical location. In this vein a reviewer for *Variety Film* praised *Davy Crockett* for its admirable and trustworthy scenery and its spectacular action scenes.[18] The capacity to "move" genuine pictures of landscapes and figures past the eyes of viewers allowed "movies" to simulate visual reality in ways unimaginable to an earlier generation raised on crude illustrations in almanacs.[19]

And yet, in another sense, these early films failed more spectacularly as agents of the historical than had even the Crockett almanacs of the 1830s. As numerous film historians have noted, the potential for the cinematic manipulation of history was enormous, especially as techniques for cutting, selecting, and editing materials improved. The *Variety Film* reviewer of *Davy Crockett*, for instance, complained that the filmmakers had taken unjustified liberties with the historical record to produce a "drawn out and padded story."[20] Even documentary films purporting to tell history "like it is," could not conceal their editorial priorities nor their political biases. In addition, the introduction of "talking pictures" or "talkies" removed the last pretense of literary responsibility on the part of the writers and viewers, threatening to make history a visual and aural exercise without association to the printed word. The "kindred spirits" of literature and art, once the primary channels of transmission for historical meaning, were now estranged. The historical "image" had not lost its power to persuade as a result of the growth of the movie industry; the opposite, in fact, was true as the popularity of film as medium suggests. The genre of pictorial history was threatened by cinematic presentations, however, because the visual imagery of films was so monstrous and controlling as to

obscure the literary elements of explanatory narration that had coexisted with the pictorial for centuries in the storytelling function of history.

As professional historians moved to define their discipline with reference to the precise rules of scientific verification expressed in monographs and other literary treatises, suspicions about the role of usurping images increased. The fear on the part of practicing historians was that the traditional relationship between images and texts, in which pictures were used to "elucidate" the meanings of words, had been reversed by arrogating visual devices such as photographs or movies that now privileged the rhetoric of the image over the figurativeness of language.[21] One could argue, of course, that the written word is no less vulnerable to manipulation than the visual image, but historians of the early twentieth century were not ready to travel down that philosophical road. They knew only that images corrupted texts and "true history" must protect against the perversions of engravings, chromolithographs, photographs, and movies by purging itself of all but the least contentious of visual cues. Popular uses of pictorial images in the name of history persisted throughout the twentieth century, as they do today in the twenty-first. But to the extent that professionals succeeded in establishing the "objective rules" and permissible forms by which historians defined themselves and their work at the turn of the twentieth century, they were responsible for the decline of the genre of pictorial history as a serviceable tool in the pursuit of historical understanding. In the case of pictorial histories produced in the 1900s, that is, "form" no longer "followed function" so much as betrayed it.

Notes

Introduction: "I Can Read Pikturs to a D———n"

1. John Seelye, "A Well-Wrought Crockett: Or, How the Fakelorists Passed through the Credibility Gap and Discovered Kentucky," in *Davy Crockett: The Man, the Legend, the Legacy, 1786–1986*, ed. Michael A. Lofaro (Knoxville: University of Tennessee Press, 1985), 31–33.
2. Ibid., 33.
3. Ibid., 33–34.
4. Ibid., 33.
5. Neil Harris, *The Artist in American Society: The Formative Years, 1790–1860* (New York: George Brazillier, 1966), 2, 47, as cited in Susan S. Williams, *Confounding Images: Photography and Portraiture in Antebellum American Fiction* (Philadelphia: University of Pennsylvania Press, 1997), 3.
6. Williams, *Confounding Images*, 10. For more on ekphrasis as a concept, see W. J. T. Mitchell, *Picture Theory: Essays on Verbal and Visual Representation* (Chicago: University of Chicago Press, 1994), 151–81.
7. Mitchell, *Picture Theory*, 114–15.
8. Francis Haskell, *History and Its Images: Art and the Interpretation of the Past* (New Haven, Conn.: Yale University Press, 1993), 14.
9. M. H. Abrams, *The Mirror and the Lamp: Romantic Theory and the Critical Tradition* (New York: Oxford University Press, 1953), 33–34, 50–51.
10. Haskell, *History and Its Images*, 53.
11. For more on the manufacturing and marketing of these almanacs, see Michael A. Lofaro, "The Hidden 'Hero' of the Nashville Crockett Almanacs," in Lofaro, *Davy Crockett*, 46–79.
12. On the vernacular style in these almanacs, see Joshua C. Taylor, *America as Art* (Washington, D.C.: Smithsonian Institution Press, 1976), 86–94.
13. Mitchell, *Picture Theory*, 325.

14. Alexander Cruden, *Concordance to the Old and New Testament* (1738), as cited in Mitchell, *Picture Theory*, 111.
15. David Tatham, *Winslow Homer and the Illustrated Book* (Syracuse, N.Y.: Syracuse University Press, 1992), x.
16. For more on this reading function, see Catherine Golden, "Reading Beyond the Lines: Victorian Art and Illustration," introduction to *Reading Beyond the Lines: Victorian Art and Illustration*, by Catherine Golden (Saratoga Springs, N.Y.: Skidmore College, 1996), 1–2.
17. On the economics of book publishing in the first half of the nineteenth century, see John Tebbel, *A History of Book Publishing in the United States*, 4 vols. (New York: R. R. Bowker, 1972–81), 4:203–30.
18. Benson Lossing, *A Pictorial History of the United States for Schools and Families* (New York: Mason Brothers, 1858), 5.

1. "An Aid to the Imagination": The Pictorial Mode and the Rise of Illustrated History

1. Estelle Jussim, *Visual Communication and the Graphic Arts: Photographic Technologies in the Nineteenth Century* (R. R. Bowker, 1983), 1–22.
2. Introduction to *American Book and Magazine Illustrators to 1920*, vol. 188, *Dictionary of Literary Biography*, ed. Steve E. Smith, Catherine A. Hastedt, and Donald H. Dyal (Detroit: Bruccoli Clark Layman, 1998), xiv–v, and Tatham, *Winslow Homer*, 8.
3. Ibid., xiv.
4. Mitchell, *Picture Theory*, 5.
5. Tatham, *Winslow Homer*, 2.
6. Golden, "Reading Beyond the Lines," 1–2.
7. John Harthan, *The History of the Illustrated Book: The Western Tradition* (London: Thames and Hudson, 1981), 8. For more on

the technical aspects of lithography, see Jussim, *Visual Communication and the Graphic Arts*, 40–41.

8. For more on iconographic treatments of Washington, see Barry Schwartz, *George Washington: The Making of an American Symbol* (Ithaca, N.Y.: Cornell University Press, 1987), 160–62, and Michael Kammen, *A Season of Youth: The American Revolution and the Historical Imagination* (New York: Alfred A. Knopf, 1978), 76–109. Trumbull's epic series included *Declaration of Independence, Resignation of General Washington, Surrender of Lord Cornwallis at Yorktown,* and *Surrender of General Burgoyne at Saratoga.*

9. Mitchell, *Picture Theory*, 130–31. For more on reactions to Trumbull's work, see Ann Uhry Abrams, "National Paintings and American Character: Historical Murals in the Capitol's Rotunda," in *Picturing History: American Painting, 1770–1930,* ed. William Ayres (New York: Rizzoli, 1993), 64–79.

10. Joshua Reynolds, "Discourses IV," in *Discourses on Art*, ed. Robert R. Wark (San Marino, Calif.: Huntington Library, 1959), 59.

11. Entry for 8 November 1854, *The Diary of George Templeton Strong*, ed. Allan Nevins and Milton Halsey Thomas (New York, 1932), 2:196–97, as cited in Kammen, *Season of Youth*, 12.

12. "Twenty-Sixth Exhibition of the National Academy of Design," *Bulletin of the American Art-Union, May 1, 1851,* as cited in Wendy Greenhouse, "The Landing of the Fathers: Representing the National Past in American History Painting, 1770–1865," in Ayres, *Picturing History*, 54.

13. Sydney Smith, "America," *Edinburgh Review* 33 (1820): 78–80.

14. David W. Noble, *Historians against History: The Frontier Thesis and the National Covenant in American Historical Writing since 1830* (Minneapolis: University of Minnesota Press, 1965).

15. Nathaniel Hawthorne, *The House of the Seven Gables*, vol. 2 of *The Centenary Edition of the Works of Nathaniel Hawthorne*, ed. William Charvat, Roy Harvey Pearce, and Claude M. Simpson (Columbus: Ohio State University Press, 1965), 182–83.

16. For more on the notion of transmitted sin and its influence on Hawthorne's view of history, see George Forgie, *Patricide in the House Divided: A Psychological Interpretation of Lincoln and His Age* (New York: W. W. Norton, 1979), 110–22.

17. For more on pictorial elements in Hawthorne, see "Hawthorne, Daguerreotypy, and *The House of the Seven Gables*," in Williams, *Confounding Images*, 96–119.

18. Judy L. Larson, "Dobson's *Encyclopedia:* A Precedent in American Engraving," in *The American Illustrated Book in the Nineteenth Century*, ed. Gerald W. R. Ward, Proceedings of the Fourteenth Annual North American Print Conference (Winterthur, Del.: Henry Francis du Pont Winterthur Museum, 1987), 22.

19. Greenhouse, "Landing of the Fathers," 45.

20. On nationalistic pictorial imagery and immigration, see Gail E. Husch, "'Freedom's Holy Cause': History, Religious, and Genre Painting in America, 1840–1860," in Ayres, *Picturing History*, 81–99.

21. For more on the creation of political unity through art, see Lil-

lian B. Miller, "Paintings, Sculpture, and the National Character, 1815–60," *Journal of American History* 53, no. 4 (March 1967): 696–707.

22. William H. Furness, "Fine Arts," in *The American Gallery of Art* (1848), as cited in Katherine Martinez, "'Messengers of Love, Tokens of Friendship': Gift-Book Illustrations by John Sartain," in Ward, *American Illustrated Book in the Nineteenth Century*, 96–97.

23. Haskell, *History and Its Images*, 94.

24. Nathaniel Hawthorne, *The American Notebooks*, ed. Randall Stewart (New Haven, Conn.: Yale University Press, 1932), 203. See also Nathaniel Hawthorne, "Twenty Days with Julian and Little Bunny, a Diary," AC8 H3188 904t, Hawthorne Papers, Houghton Library, Harvard University.

25. Charles Augustus Goodrich, *A History of the United States of America* (Hartford, Conn.: Barber & Robinson, 1822). The 1823 edition of the book does have engraved title pages.

26. Joel Myerson, "Samuel Griswold Goodrich," in *The American Renaissance in New England*, vol. 1, *Dictionary of Literary Biography*, ed. Joel Myerson (Detroit: Gale Research, 1978), 75–76. For more on Goodrich, see Daniel Roselle, *Samuel Griswold Goodrich, Creator of Peter Parley* (Albany: State University of New York Press, 1968).

27. Samuel G. Goodrich, *Recollections of a Lifetime; or, Men and Things I Have Seen*, 2 vols. (New York: Miller, Orton and Mulligan, 1856), 2:256–58.

28. S. G. Goodrich, *A Pictorial History of America; Embracing Both the Northern and Southern Portions of the New World* (Hartford, Conn.: House & Brown, 1848).

29. Goodrich, *Recollections of a Lifetime* 2:308–11.

30. The "juvenile" version of Goodrich's volume was titled *The American Child's Pictorial History of the United States* (Philadelphia: E. H. Butler, 1860).

31. Goodrich, *Pictorial History of America*, appendix, 4. For more on physiognomy and pictorial representation, see Alan Trachtenberg, *Reading American Photographs: Images as History Mathew Brady to Walker Evans* (New York: Hill and Wang, 1989), 21–70.

32. Goodrich, *Recollections of a Lifetime* 2:311–12. The rival to Peter Parley was created by a London publisher, who invented a "quaint, quiet, scholarly old gentleman, called Mr. Felix Summerly" to "woo back the erring generation of children to the good old orthodox rhymes and jingles of England."

33. Ibid. 2:292–307. See also *Parley's Cabinet Library*, 20 vols. (Boston: Bradbury, Soden, 1843–45).

34. Goodrich, *Recollections of a Lifetime* 2:311–12.

35. Hugh Murray, Esq., *Pictorial History of the United States of America* (Boston: Phillips, Sampson, 1850); John Warner Barber, *The Family Book of History* (New Haven, Conn.: Durrie & Peck, 1839); and John Howard Hinton, *The History and Topography of the United States* (Philadelphia: T. Wandel & I. T. Hinton [1830–32]). The Murray and Hinton works were illustrated in part by William Croome.

36. Alexis de Tocqueville, *Democracy in America*, ed. Richard D. Heffner, (New York: Mentor Books, 1956), 176–77.

37. Goodrich, *Recollections of a Lifetime* 2:279.

38. For more on these transitions, see Jussim, *Visual Communication and the Graphic Arts*, 11–44.

39. For more on didactic illustrated books, see "The Book Beautiful and After," in Harthan, *History of the Illustrated Book*, 244–47.

40. For more on the postheroic and national memory, see Forgie, *Patricide in the House Divided*, 13–53.

41. On the growing confidence of Americans in their literary output, see William Gilmore Simms, "Americanism in Literature," in *Views and Reviews in American Literature History and Fiction*, ed. C. Hugh Holman (Cambridge: Belknap Press, Harvard University Press, 1962), 7–29.

42. De Tocqueville, *Democracy in America*, 174.

43. Donald Ringe, *The Pictorial Mode: Space and Time in the Art of Bryant, Irving, and Cooper* (Lexington: University of Kentucky Press, 1971), 57, 13.

44. On the sister-arts, see Elizabeth Abel, "Redefining the Sister Arts: Baudelaire's Response to the Art of Delacroix," *Critical Inquiry* 6, no. 3 (Spring 1980): 363–84. Also see Mitchell, *Picture Theory*, 111–13, and Abrams, *Mirror and the Lamp*, 30–46.

45. William Gilmore Simms, "The Epochs and Events of American History, as Suited to the Purposes of Art in Fiction," in Holman, *Views and Reviews*, 30–127. For biographical information related to Simms's vision of history, see Clyde N. Wilson, "William Gilmore Simms," in *American Historians, 1607–1865*, vol. 30, *Dictionary of Literary Biography*, ed. Clyde N. Wilson (Detroit: Gale Research, 1984), 277–85.

46. Simms, "Epochs and Events," 31–32, 36, 38, 35, 37.

47. Ibid., 61, 76, 49, 54.

48. William Gilmore Simms, "Pocahontas: A Subject for the Historical Painter," in "Epochs and Events," 112–27.

49. Ibid., 115, 117. For more on Chapman's "Baptism of Pocahontas," see Abrams, "National Paintings and American Character," 71–75.

50. For more on those who questioned the Smith rescue episode, see Robert S. Tilton, *Pocahontas: The Evolution of an American Narrative* (New York: Cambridge University Press, 1994), 162–69, 173–75.

51. Wendy Steiner, *Pictures of Romance: Form against Context in Painting and Literature* (Chicago: University of Chicago Press, 1988), 20–21, 13–14.

52. Simms, "Pocahontas," 115–16.

53. Ibid., 117–20.

54. Ibid., 125, 121.

55. For more on the problems with circulation of visual images, see Harris, *Artist in American Society*, 90–122.

56. Simms, "Pocahontas," 121.

57. I have adapted this phrase from Michael Kammen, foreword to Ayres, *Picturing History*, 11.

58. John Langdon Sibley, *Collectanea Biographica Harvardiana: Being Obituary and Other Printed Notices of Harvardians Col-* *lected During the Preparation of the Last Twelve Triennial Catalogues of Harvard University, 1842–1875)*, vol. 2, n.p., as found in HUG 1791.14.10, Reel 1, Harvard University Archives, Pusey Library, Harvard University (hereafter cited as Harvard University Archives).

59. Ibid. Also see "John Frost, 1822, A.M. 1825," "Class Publications and Records," HUG 300 and HUD 222.00, Harvard University Archives.

60. For full citations to these works and their prices, see O. A. Roorbach, comp. and arr., *Bibliotheca Americana: Catalogue of American Publications Including Reprints and Original Works from 1820 to 1852*, ed. John D. Morse (New York: Peter Smith, 1939), 207–8.

61. See especially [John Frost], *Robert Ramble's Picture Gallery; or lessons on pictures and stories designed to exercise the powers of observation and memory in children* (Philadelphia, 1838).

62. Hellmut Lehmann-Haupt, *The Book in America: A History of the Making and Selling of Books in the United States* (New York: R. R. Bowker, 1951), 74–75.

63. For more on the publishing world in Philadelphia in the 1830s and 1840s, see Tebbel, *History of Book Publishing* 1:365–85. Peter C. Marzio, "American Lithographic Technology before the Civil War," in *Prints in and of America to 1850* (Winterthur, Del.: Henry Francis du Pont Winterthur Museum, 1970), 215–56.

64. John Frost, *The Pictorial History of the United States of America*, 4 vols. (Philadelphia: Benjamin Walker, 1844), 2:239, 97, 213; 1:148; 2:39, 102, 127.

65. For more on the use of pictorial devices by these historians, see David Levin, *History as Romantic Art: Bancroft, Prescott, Motley, and Parkman* (Stanford, Calif.: Stanford University Press, 1959), esp. 12–19.

66. Frost, *Pictorial History of the United States* 1:190, 2:199, 1:38.

67. Ringe, *Pictorial Mode*, 8, 6.

68. Henry C. Pitz, *The Brandywine Tradition* (New York: Weathervane Books, 1968), 20.

69. Sinclair Hamilton, *Early American Book Illustrators and Wood Engravers*, 2 vols. (Princeton, N.J.: Princeton University Press, 1968), 1:96.

70. Frost, *Pictorial History of the United States* 1:vii–viii.

71. Eli Bowen, *The Pictorial Sketch-Book of Pennsylvania* (Philadelphia: Willis P. Hazard, 1852), preface, as cited in Hamilton, *Early American Book Illustrators and Wood Engravers* 1:118.

72. Hamilton, *Early American Book Illustrators and Wood Engravers* 1:118. Hamilton calls Devereux's work "stilted and of no great value."

73. Franz Kugler, *Geschichte Friedrichs des Grossen* (Leipzig: Weber'schen Buchhandlung, 1840). The switch is noted in Hamilton, *Early American Book Illustrators and Wood Engravers*, on 97.

74. For more on this substituting process, see Haskell, *History and Its Images*, 74–78.

75. For more on the technical aspects of conveying three-dimensionality in two dimensions through engraving processes, see Jussim, *Visual Communication and the Graphic Arts*, 19–30.

76. For more on the role of engravers as copyists, see Pitz, *Brandywine Tradition*, 56–58.

77. Steiner, *Pictures of Romance*, 20–21.

78. Kammen, foreword to Ayres, *Picturing History*, 12.

79. For more on visual images of Carpenters' Hall, see George B. Tatum, *Penn's Great Town: 250 Years of Philadelphia Architecture Illustrated in Prints and Drawings* (Philadelphia: University of Pennsylvania Press, 1961).

80. For more on the illustration of flora and fauna in this period, see Georgia B. Barnhill, "The Publication of Illustrated Natural Histories in Philadelphia, 1800–1850," in Ward, *American Illustrated Book in the Nineteenth Century*, 53–88.

81. Frost, *Pictorial History of the United States* 1:vii–viii.

82. Barbara J. Mitnick, "The History of History Painting," in Ayres, *Picturing History*, 29–30.

83. Frost, *Pictorial History of the United States* 2:124.

84. On Croome's "flat, reportorial style" and his eventual liberation from it, see Hamilton, *Early American Book Illustrators and Wood Engravers* 1:xxxvi–xxxvii.

85. For more on the uses of these ornamental devices in nineteenth-century illustrated books, see Harthan, *History of the Illustrated Book*, 180–81.

86. For a similar reading of other wood-engravings and their pre-photographic codes of transmission, see Jussim, *Visual Communication and the Graphic Arts*, 23–26.

87. For more on Carlyle's "Great Man" theory and its impact on the writing of history, see Levin, *History as Romantic Art*, 10–11, 64.

88. As quoted in Trachtenberg, *Reading American Photographs*, 36.

89. Williams, *Confounding Images*, 42.

90. Frost, *Pictorial History of the United States* 1:vi.

91. Ibid.

92. For more on Parmigianino's portrait and its misidentification, see Sydney J. Freedberg, *Parmigianino: His Works in Painting* (Cambridge: Harvard University Press, 1950), 202–3.

93. For more on competing pictorial images of Columbus, see Barbara Groseclose, "American Genesis: The Landing of Christopher Columbus," in *American Icons: Transatlantic Perspectives on Eighteenth- and Nineteenth-Century American Art*, ed. Thomas W. Gaehtgens and Heinz Ickstadt (Los Angeles: Getty Center Publications, 1992), 11–32, and Claudia L. Bushman, *America Discovers Columbus: How an Italian Explorer Became an American Hero* (Hanover, N.H.: University of New England Press, 1992), 98–126.

94. Frost, *Pictorial History of the United States* 1:184–85.

95. For more on the pictorial representations of George III, see Vincent Carretta, *George III and the Satirists from Hogarth to Byron* (Athens: University of Georgia Press, 1990).

96. Frost, *Pictorial History of the United States* 4:239–40.

97. For a sample of such mixed reviews, see "Pictorial History of the United States, from the Discovery of the Northmen in the Tenth Century, to the Present Time, John Frost," *New Englander and Yale Review* 1, no. 4 (October 1843).

98. Pitz, *Brandywine Tradition*, 30.

99. For complete price lists, see F. Leypoldt, ed., *The American Catalogue: Author and Title Entries of Books in Print and For Sale (Industry Reports and Importations), July 1, 1876*, comp. Lynds E. Jones (New York: A. C. Armstrong & Son, 1880), vol. 1, pt. 1, p. 271.

100. For sale figures on Frost's *Pictorial History of the United States*, see S. Austin Allibone, *A Critical Dictionary of English Literature and British and American Authors* (Philadelphia: J. B. Lippincott, 1908), 1:639–40.

101. "Wood Engraving," *Cosmopolitan Art Journal* 1, no. 2 (November 1856): 53–54, as summarized in David Morgan, *Protestants and Pictures: Religion, Visual Culture, and the Age of American Mass Production* (New York: Oxford University Press, 1999), 66.

2. "Pictures on Memory's Wall": Visual Perspective and the Pictorial Field Books

1. For a complete listing of Croome's activities in this period, see Hamilton, *Early American Book Illustrators and Wood Engravers* 1:96–99.

2. See citations for Frost in *The National Union Catalogue, Pre-1956 Imprints* (London: Mansell Information/Publishing, 1972), 186:608–26.

3. On the relationships between illustrators and publishers, see Tebbel, *History of Book Publishing* 1:251–57; also see Cathy N. Davidson, "Books in the 'Good Old Days': A Portrait of the Early American Book Industry," *Book Research Quarterly* 2 (Winter 1986–87):33–64.

4. Pitz, *Brandywine Tradition*, 57.

5. Tatham, *Winslow Homer*, 8.

6. Pitz, *Brandywine Tradition*, 56–58.

7. Tebbel, *History of Book Publishing* 1:207; see also Madeleine B. Stern, "The Role of the Publisher in Mid-Nineteenth-Century American Literature, *Publishing History* 10 (1981): 5–26.

8. James T. Callow, *Kindred Spirits: Knickerbocker Writers and American Artists, 1807–1855* (Chapel Hill, N.C.: University of North Carolina Press, 1967), 11–29.

9. For details on Lossing's itinerary, see "Diary, 1848–1851," A. Ms. LS 1111, "Notebook, [c. 1850]," A. Ms. LS 1112, and "1851 Notebook," A. Ms. LS 1113, Lossing Papers, Huntington Library, San Marino, California (hereafter cited as Lossing Papers–Huntingdon).

10. For biographical information on Lossing, see "Autobiography," 1884, LS 1055, Lossing Addenda, Box 23, Lossing Papers–Huntington. See also J. Tracy Power, "Benson J. Lossing," in *Dictionary of Literary Biography* 30:163–68, and "Benson John Lossing," *Appleton's Journal* 8 (20 July 1872): 69–71.

11. For more on Joseph A. Adams, see Hamilton, *Early American Book Illustrators and Wood Engravers* 1:45–46.

12. "The Artist. Drawing. Letter I.," *Casket* 2 (5 May 1838): 12, as cited in Harold Mahan, *Benson J. Lossing and Historical Writing in the United States, 1830–1890* (Westport, Conn.: Greenwood Press, 1996), 20. See also "The Self-Made Men of Our Times—Biographical Sketch," GA-28, Box 3, Lossing Papers, Rutherford

B. Hayes Presidential Library, Fremont, Ohio (hereafter cited as Lossing Papers–Hayes).

13. "Engraving and Printing: An Address [c. 1850]," pp. 1, 5, LS 1111, Lossing Papers–Huntington.

14. Benson Lossing to Lyman B. Draper, 3 May 1854, Draper Correspondence, Wisconsin State Historical Library, Madison, Wisconsin (hereafter cited as Draper Correspondence). See also "Notes for Family Magazine [1843]," LS 1142, Lossing Papers–Huntington.

15. "Review of the Family Magazine, vol XIV—No. 45 [Time's Watchman]," Addenda 1, Box 29, Lossing Papers–Huntington.

16. "Art," as cited in *Independent Examiner*, 24 February 1855, GA-28, Box 3, Lossing Papers–Hayes, and "Art," 108–10, Addenda 2, Box 31, Lossing Papers–Huntington.

17. Ward, *American Illustrated Book in the Nineteenth Century*, 19.

18. "Art," as cited in *Independent Examiner*, 24 February 1855, GA-28, Box 3, Lossing Papers–Hayes, and "Art," 108–10, Addenda 2, Box 31, Lossing Papers–Huntington.

19. See "Introduction and Editor's Notes for Francis Hopkinson's 'A Pretty Story,'" LS 88, Huntington Library, San Marino, California. For more on works engraved by Lossing and Barritt, see W. L. Burroughs to Elihu Geer, 22 June 1842, Box 2, Folder 14, Book Trades Collection, American Antiquarian Society, as cited in Mahan, *Benson J. Lossing*, 48.

20. Samuel G. Goodrich to Benson J. Lossing, 8 September 1851 and 25 August 1855, GA-28, Box 1, Incoming Correspondence, Lossing Papers–Hayes.

21. Samuel Griswold Goodrich, *The Travels, Voyages and Adventures of Gilbert Go-Ahead, in Foreign Parts*, ed. Peter Parley (New York: J. C. Derby, 1856).

22. Benson J. Lossing, *Outline History of the Fine Arts, Embracing a View of the Rise, Progress, and Influence of the Arts among Different Nations, Ancient and Modern, with Notices of the Character and Works of Many Celebrated Artists* (New York: Harper, 1840); *The Lives of the Presidents of the United States; Embracing a Brief History of the Principal Events of Their Respective Administrations* (New York: H. Phelps, 1847); *Seventeen Hundred and Seventy-Six; or, The War of Independence; a History of the Anglo-Americans, from the Period of the Union of the Colonies Against the French, to the Inauguration of Washington, the First President of the United States of America* (New York: E. Walker, 1847); and *Biographical Sketches of the Signers of the Declaration of American Independence: The Declaration Historically Considered; and a Sketch of the Leading Events Connected with the Adoption of the Articles of Confederation and of the Federal Constitution* (New York: G. F. Cooledge, 1848).

23. *New York Review* 7 (July 1840): 251–52, and "Literary Notices," *New-York Mirror* 18 (27 June 1840): 7, as cited in Mahan, *Benson J. Lossing*, 34.

24. Lossing, *Seventeen Hundred and Seventy-Six*, preface, n.p.

25. Mahan, *Benson J. Lossing*, 34.

26. Samuel G. Goodrich to Benson J. Lossing, 27 April 1860, GA-28, Box 1, Incoming Correspondence, Lossing Papers–Hayes.

27. Benson J. Lossing, *The Pictorial Field-Book of the Revolution; or,*

Illustrations, by Pen and Pencil, of the History, Biography, Scenery, Relics, and Traditions of the War for Independence, 2 vols. (1850–52; reprint, New York: Harper & Brothers, 1855), vii.

28. The *Farmer and Mechanic* in *Blackwood's Edinburgh Magazine*, 2, as cited in Mahan, *Benson J. Lossing*, 45.

29. "Plans" for *Pictorial Field-Book of the American Revolution*, Lossing Misc. MSS, New York Public Library. See also Alexander Davidson, "How Benson J. Lossing Wrote His 'Fieldbooks' of the Revolution, the War of 1812 and the Civil War," *Papers of the Bibliographical Society of America* 32 (1938): 58.

30. Lossing, *Pictorial Field-Book of the Revolution* 1:viii, ix, viii.

31. For more on the contract with Harper and Brothers, see "The Pictorial Field-Book of the Revolution," Addenda 2, Box 33, Lossing Papers–Huntington.

32. With regard to Harper and Brothers and its marketing techniques, see Eugene Exman, *The Brothers Harper: A Unique Publishing Partnership and Its Impact upon the Cultural Life of America from 1817 to 1853* (New York: Harper & Row, 1965), 125–26. For contemporary and older accounts, also see, J. Henry Harper, *The House of Harper: A Century of Publishing in Franklin Square* (New York: Harper & Brothers, 1912) and [Jacob Abbott], *The Harper Establishment; or, How the Story Books Are Made* (1855).

33. "Pictorial Field-Book of the Revolution," Addenda 2, Box 33, Lossing Papers–Huntington.

34. These account books are collected in L1111, Lossing Papers–Huntington. For more on the relationship between Frost and Lossing, see Robert W. Johannsen, *To the Halls of the Montezumas: The Mexican War in the American Imagination* (New York: Oxford University Press, 1985), 223, 260–61. Mahan rejects the notion that Frost served as "Lossing's most important model"; see Mahan, *Benson J. Lossing*, 42.

35. Lossing Papers, L1111. Carefully enumerating the diverse categories for the nearly 1,100 engravings that appeared in the *Field-Book*, Harper and Brothers noted that there were "245 portraits, 475 autographs of eminent men, 182 celebrated buildings, 62 maps and plans of battles, fortifications, etc., 46 views of battle-grounds, 102 views of other historical locations, 96 sketches of curious historical objects, 26 facsimiles of manuscripts, 27 medals, seals, &c., 46 views of fortifications, sketches of 12 remarkable trees, 76 monuments, 24 old churches, 6 statues, 57 appropriate initial letters, and "about a dozen miscellaneous fancy sketches."

36. Mahan, *Benson J. Lossing*, 56.

37. Other prices included "two volumes, 8vo Muslin" for eight dollars; "Sheep, gilt" for nine dollars; "Half Calf" for ten dollars; "Morocco, gilt edges" for fifteen dollars. See "Great National Work," GA-28, Box 3, Lossing Papers–Hayes.

38. "Great National Work." For more on the policy of reselling books sold originally by subscription, see Tebbel, *History of Book Publishing* 1:218, 238–51.

39. "Great National Work," Harper and Brothers circular, GA-28, Box 3, Lossing Papers–Hayes.

40. See alterations in both title and subtitle, including the loss of the word "American" as suggested by "Plans," Misc. MSS, New York Public Library.

41. "Lossing's Pictorial Field-Book," Harper and Brothers circular, GA-28, Box 3, Lossing Papers–Hayes.

42. Lossing, *Pictorial Field-Book of the Revolution* 1:44, 72, 607, 333.

43. For more on the visual suggestions for history of "eyewitness" testimony, see Mitchell, *Picture Theory*, 104–5, 186.

44. Lossing, *Pictorial Field-Book of the Revolution* 1:ix, 88–89, 292.

45. Ralph Waldo Emerson, "Nature" in *The Collected Works of Ralph Waldo Emerson*, ed. Robert E. Spiller (Cambridge: Belknap Press, Harvard University Press, 1971), 1:3–45.

46. For more on Francis Parkman and his historical methodologies, see Robert L. Gale, *Francis Parkman* (New York: Twayne, 1973) and Samuel Eliot Morison, *Vistas of History* (New York: Alfred A. Knopf, 1964), 26–27.

47. Lossing, *Pictorial Field-Book of the Revolution* 1:614, 614–15.

48. Ibid., xv–xvi, 72.

49. Ibid. 1:339–40, 96.

50. Ibid. 1:104, 214.

51. Ibid. 1:129, 131, 105, 256–57.

52. Ibid. 1:212–13, 413.

53. For more on the "optative mood," see F. O. Matthiessen, *American Renaissance: Art and Expression in the Age of Emerson and Whitman* (New York: Oxford University press, 1941), 3–75.

54. Lossing, *Pictorial Field-Book of the Revolution* 1:viii. Other American historians, such as William H. Prescott, also complained of French visual culture: "I do not care for the sort of illustrations with which the French historical writers sometimes embellish their works, which seem to me better suited to romance than history." As cited in Haskell, *History and Its Images*, 298–99.

55. Lossing, *Pictorial Field-Book of the Revolution* 1:viii.

56. Jussim, *Visual Communication and the Graphic Arts*, 339. For more on electrotyping as a process, see Lehmann-Haupt, *Book in America*, 80–82.

57. Jussim, *Visual Communication and the Graphic Arts*, 31–38.

58. G. W. Davey to Benson J. Lossing, 3 April 1853, GA-28, Box 1, Incoming Correspondence, Lossing Papers–Hayes.

59. Haskell, *History and Its Images*, 14.

60. Jussim, *Visual Communication and the Graphic Arts*, 27–28, 31–34.

61. For a discussion of Lossing's research techniques regarding the portraits in this and others of Trumbull's paintings, see Lossing, *Pictorial Field-Book of the Revolution* 2:197 n. 1, 306 n. 1. See also Abrams, "National Paintings and American Character," 70–71.

62. Lossing, *Pictorial Field-Book of the Revolution* 1:406, 294–95. Although Lossing did not practice the popular pseudo–science of phrenology on his subjects, he used analogous techniques to discern their private characters, a fact not lost on the firm of "Fowler & Wells—Phrenologists and Publishers" that offered Lossing a coupon for a free examination "with a chart" in ex-

change for a review of relevant excerpts from the field book. See Fowler and Wells to Benson J. Lossing, 27 January 1853, GA-28, Box 1, Incoming Correspondence, Lossing Papers–Hayes.

63. "Catalogue of Autograph Letters and Historical Documents Principally Relating to the American Revolution, from the MSS Collection of Benson J. Lossing, 1890" and "Lossing Collection Auction, 1912," GA-28, Box 3-5, Lossing Papers–Hayes.

64. Reverend Francis Hawks, "Opinions of the Press," circular, GA-28, Box 3, Lossing Papers–Hayes.

65. John P. Kennedy, "Secretary of the Navy," GA-28, Box 3, Lossing Papers–Hayes.

66. *Baltimore Commercial Advertiser*, GA-28, Box 3, Lossing Papers–Hayes.

67. *New Orleans Delta*, GA-28, Box 3, Lossing Papers–Hayes.

68. *Home Journal*, GA-28, Box 3, Lossing Papers–Hayes.

69. "The Prize Question (No. 3) in Revolutionary Literature," *Publishers Weekly* 9 (15 April 1876): 494, as cited in Mahan, *Benson J. Lossing*, 53–54. For a discussion of the fire at Harper's and how it related to Lossing's field books, see Mahan, *Benson J. Lossing*, 63–64.

70. "Wood-Engraving," *Cosmopolitan Art Journal* 1, no. 2 (November 1856): 53–54, as cited in Morgan, *Protestants and Pictures*, 65–66.

71. George Bancroft, "Generous Complimentary Letters Received by the Author and Publishers," GA-28, Box 3-5, Lossing Papers–Hayes.

72. John Frost to J. W. Harper, 6 January 1853, Box 4 (Misc. Correspondence), Benson John Lossing Collection, Syracuse University Archives, Syracuse, N.Y. (hereafter cited as Lossing Collection–Syracuse).

73. Washington Irving to Benson J. Lossing, 12 January 1852, as cited in Edward Satterlee, "An Evening with Lossing," *Evening Post* (14 July 1877), "Euphemera," Addenda 1, Box 29, Lossing Papers–Huntington.

74. David Swain, "Opinions of the Press," circular, GA-28, Box 3, Lossing Papers–Hayes. See also Benson Lossing to David Swain, 23 September 1852, 18 December 1852 and 23 May 1853, Swain Papers, Southern Historical Collection, University of North Carolina, Chapel Hill.

75. William Cruikshank, "Lossing's Field-Book of the Revolution," *American Whig Review*, as cited in Mahan, *Benson J. Lossing*, 62.

76. Lossing to W. Cruikshank, 28 June 1852, Box 1, General Correspondence, Lossing Collection–Syracuse.

3. "Vulgar and Strict Historical Truth": Giftbooks, Sentimental History, and the Grand Manner

1. *New York Daily Times*, "Opinions of the Press," GA- 28, Box 3, Lossing Papers–Hayes.

2. *North American Review* 46 (April 1838): 476, as cited in George H. Callcott, *History in the United States, 1800–1860* (Baltimore: Johns Hopkins Press, 1970), 109–10. See also *DeBow's Review* 3 (April 1847): 293.

3. Anon., "History, Its Use and Its Meaning," *Westminster Review* 62 (October 1854): 229, as cited in Callcott, *History in the United States,* 211. See also anon., "The Aim of History," *Princeton Review* 29 (April 1857): 234; anon., "The Study of History," *Southern Quarterly Review* 10 (July 1846): 131–32; and William Greenough Thayer Shedd, "The Nature and Influence of the Historic Spirit," *Bibliotheca Sacra* 11 (April 1834): 371–75.

4. For more on the process of steel-line engraving, see Jussim, *Visual Communication and the Graphic Arts,* 31–34, and glossary, 339–47.

5. Martinez, "Messengers of Love," 90–91.

6. Samuel G. Goodrich, *Recollections of a Lifetime; or, Men and Things I Have Seen,* 2 vols. (New York: Miller, Orton, and Mulligan, 1856), 2:182, as cited in Martinez, "Messengers of Love," 93.

7. Martinez, "Messengers of Love," 96.

8. For more on the giftbook tradition as defined in a more limited way than I use the term here, see Ralph Thompson, *American Literary Annuals and Gift Books, 1825–1865* (1936; reprint, New York: Archon Books, 1967).

9. David Shi, *Facing Facts: Realism in American Thought and Culture, 1850–1920* (New York: Oxford University Press, 1995), 27, 24.

10. Benjamin Rowland Jr., "Popular Romanticism: Art and the Gift Books, 1825–1865," *Art Quarterly* 20, no. 4 (Winter 1957): 374.

11. Thompson, *American Literary Annuals and Gift Books,* 33.

12. For more on the collaborative nature of giftbook productions, see "Annuals and Gift Books," in *The Cambridge History of American Literature* (New York: Macmillan, 1931), 2:170–74.

13. Michael Ann Holly, *Past Looking: Historical Imagination and the Rhetoric of the Image* (Ithaca, N.Y.: Cornell University Press, 1996), 37.

14. Jesse Ames Spencer, *Memorabilia of Sixty-Five Years (1820–1886)* (New York: Thomas Whittaker, 1890), 7, 12, 16, 20, 21–22, 64, 107–9, 115, 120, 193–94.

15. Ibid., 134–35.

16. For more on Spencer's complaints with publishers, see "Jesse Ames Spencer," in *Dictionary of American Biography,* ed. Dumas Malone (New York: Charles Scribner's Sons, 1943), 17:448–49. See also Spencer, *Memorabilia of Sixty-Five Years,* 64–65.

17. For more on Spencer's activities during the period 1854–57 while he was at work on the manuscript, see Spencer, *Memorabilia of Sixty-Five Years,* 120, 134–35.

18. Martinez, "Messengers of Love," 89, 93.

19. For more on the relationship between publishers such as Johnson and their illustrators, see Tatham, *Winslow Homer,* 9–13, esp. 13.

20. "Elias Lyman Magoon," in *The National Cyclopaedia of American Biography* (New York: James T. White, 1907), 9:540. See also James Grant Wilson and John Fiske, eds., *Appleton's Cyclopedia of American Biography* (New York: D. Appleton, 1888), 174–75.

21. Johnson's relationships with Magoon and Chappel are described in David Meschutt and Barbara J. Mitnick, *The Portraits and History Paintings of Alonzo Chappel* (Chadds Ford, Pa.: Brandywine River Museum Publication, 1992), 13–14 and Appendix 2, 65. For more on Magoon as collector, see "Sketchings: Our Private Collections No. VI," *Crayon* (December 1856): 374. Much of the collection was later donated to Vassar College.

22. Meschutt and Mitnick, *Portraits and History Paintings of Alonzo Chappel,* 12. For more on Chappel's early career, see Herman H. Diers, "The Story of Alonzo Chappel," typescript, ca. 1940s, Chappel File, National Museum of American Art, Washington, D.C.; also see Robert M. Hyatt, "Mystery Man of Art," typescript, 14 May 1947, Alonzo Chappel File, New York Public Library and "Scrapbooks" (3 vols.) and card file, both undated, New York Public Library. For more on Chappel's later career, see also Oliver Ramsey, "Prolific American Illustrator and Painter of Historical Scenes in the Period 1855–1885," *Essay-Proof Journal No. 70* 18, no. 2 (Spring 1961): 50.

23. For more on history painting and the "grand manner," see *The Painted Word: British History Painting: 1750–1830,* ed. Peter Cannon-Brookes (Woodbridge, England: Boydell Press, 1991), esp. 23–25. The "tyranny of portraiture" quote appears on page 23 of this work.

24. Greenhouse, "Landing of the Fathers," 50.

25. Evert A. Duyckinck, *National Portrait Gallery of Eminent Americans,* 2 vols. (New York: Johnson, Fry, 1862).

26. For a discussion of one prototype for the work of Chappel and Duyckinck (Mathew Brady's *Gallery of Illustrious Americans,* [1850]) and the source of the quote, see Trachtenberg, *Reading American Photographs,* 48.

27. For more on Evert Duykinck, see Donald Yanella, "Evert Augustus Duyckinck," in *Antebellum Writers in New York and the South,* vol. 3, *Dictionary of Literary Biography,* ed. Joel Meyerson (Detroit: Gale Research, 1979), 101–9. I would like to thank Donald Yanella for his personal help in securing information about Duyckinck and his relevance to this study.

28. Bruce W. Chambers, "Painting the Civil War as History 1861–1910," in Ayres, *Picturing History,* 120.

29. Anna Douglas Ludlow [?], *A General View of the Fine Arts, Critical and Historical* (New York: G. P. Putnam, 1851), 42–43, as cited in William H. Gerdts, "On Elevated Heights: American Historical Painting and Its Critics," in William H. Gerdts and Mark Thistlethwaite, *Grand Illusions: History Painting in America* (Fort Worth, Tex.: Anon Carter Museum, 1988), 88.

30. Barbara Gaehtgens, "Fictions of Nationhood: Leutze's Pursuit of an American History Painting in Dusseldorf," in *American Icons: Transatlantic Perspectives on Eighteenth- and Nineteenth-Century American Art,* ed. Thomas W. Gaehtgens and Heinz Ickstadt (Los Angeles: Getty Center Publications, 1992), 155.

31. Azel Ames to John Shaw Billings, 29 March 1897, Alonzo Chappel File, New York Public Library, as cited in Meschutt and Mitnick, *Portraits and History Paintings of Alonzo Chappel,* 10. The prototype volume alluded to is James Barton Longacre and James Herring, *The National Portrait Gallery of Distinguished Americans,* 4 vols. (1834–39). For more on this volume, see Gor-

don M. Marshall, "The Golden Age of Illustrated Biographies," in *American Portrait Prints: Proceedings of the Tenth Annual American Print Conference*, ed. Wendy Wick Reaves (Charlottesville: University of Virginia Press, 1984). With regard to Ames's assessment of Chappel's "slapdash" technique, see an alternative view in David Meschutt, "Portraits by Alonzo Chappel," in Meschutt and Mitnick, *Portraits and History Paintings of Alonzo Chappel*, 20, 26, 28.

32. Reynolds, "Discourse IV," 59.

33. Duyckinck, *National Portrait Gallery of Eminent Americans* 1:vi–vii, 211.

34. David Alexander, "Patriotism and Contemporary History, 1770–1830," in Cannon-Brookes, *Painted Word*, 40.

35. Johan Huizinga, *Dutch Civilization in the Seventeenth Century and Other Essays* (London, 1968), 46, as cited in Haskell, *History and Its Images*, 493.

36. Meschutt and Mitnick, *Portraits and History Paintings of Alonzo Chappel*, 12, 44.

37. F. C. Adams, "Executive Document 315: Art in the District of Columbia," *Executive Documents Printed by Order of the House of Representatives During the Second Session of the Forty-First Congress, 1869–'70* (Washington, D.C.: GPO, 1870), 747, as cited in Mark Thistlethwaite, "The Most Important Themes: History Painting and Its Place in American Art," in Gerdts and Thistlethwaite, *Grand Illusions*, 51.

38. For more on lithographic technology and its effect on book illustration, see Jussim, *Visual Communication and the Graphic Arts*, 39–42.

39. Meschutt and Mitnick, *Portraits and History Paintings of Alonzo Chappel*, 15, 10.

40. See Ruth Soloman, *Artists of Suffolk County*, pt. 1, Exhibition Catalogue (San Marino, Calif.: Huntington Library, 1970) and Meschutt and Mitnick, *Portraits and History Paintings of Alonzo Chappel*, 68–84. For a listing of Chappel's paintings that were still extant as of 1937, see p. 359. A number were held in the private collection of William H. Duncan, a descendant of publisher Henry Johnson.

41. Charles Lee Lewis, "Alonzo Chappel and His Naval Paintings," *Proceedings of the U.S. Naval Institute* (March 1937): 359, 361.

42. For more on the pricing of Spencer's volumes, which cost as much as thirty dollars for the four-volume set in 1880, see Leypoldt, *American Catalogue*, vol. 1, pt. 2, p. 693.

43. Spencer, *Memorabilia of Sixty-Five Years*, 136.

44. J[esse] A[mes] Spencer, *History of the United States: From the Earliest Period to the Administration of James Buchanan*, 3 vols. (New York: Johnson, Fry, 1858), 1:iii, iv.

45. Ibid.

46. Ibid. 1:282.

47. Ibid. 1:223, 224, 377, 357, 455, 2:185.

48. Ibid. 1:302, 2:522.

49. On steel engraving and book illustration, see Jussim, *Visual Communication and the Graphic Arts*, 31–35. For more on the issue of scale in Chappel's paintings and illustrations, see

Meschutt and Mitnick, *Portraits and History Paintings of Alonzo Chappel*, 44.

50. Greenhouse, "Landing of the Fathers," 54.

51. Groseclose, "American Genesis," 17.

52. Ibid., 12, 21.

53. Abrams, "National Paintings and American Character," 77.

54. Greenhouse, "Landing of the Fathers," 50. The portion of the quote in italics comes from Mircea Eliade, as cited in Ann Uhry Abrams, *The Pilgrims and Pocahontas: Rival Myths of American Origin* (Boulder, Colo.: Westview Press, 1999), xv.

55. Abrams, "National Paintings and American Character," 77.

56. "Filling the Panels of the Capitol with National Pictures," *Literary World*, 20 November 1848, 385, as cited in Abrams, "National Paintings and American Character." It is not clear whether or not Duyckinck was the author of these comments.

57. Haskell, *History and Its Images*, 3.

58. *Anglo-American* (8 May 1847): 58, as cited in Gerdts, "On Elevated Heights," 95.

59. On Leutze and his impact on the American art scene in 1850, see Barbara S. Groseclose, *Emanuel Leutze, 1816–1868: Freedom Is the Only King* (Washington, D.C.: Smithsonian Institution Press, 1975), 41–47.

60. William H. Gerdts, "The Dusseldorf Connection," in Gerdts and Thistlethwaite, *Grand Illusions*, 125–65.

61. Mary Panzer, *Mathew Brady and the Image of History* (Washington, D.C.: Smithsonian Institution Press for the National Portrait Gallery, 1998), 118.

62. *Georgetown Advocate*, 6 April 1852, as cited in the preface to Ayres, *Picturing History*, 17.

63. Spencer, *History of the United States* 1:459.

64. "National Glory and the Arts," *Home Journal*, 23 August 1851, 2, as cited in Gerdts, "On Elevated Heights," 94.

65. Diers, "Story of Alonzo Chappel," 2, as cited in Meschutt and Mitnick, *Portraits and History Paintings of Alonzo Chappel*, 39. For information on Chappel's private library, which was extensive, see *The Library of the Well-Known American Artist Alonzo Chappel, Esq. With Addenda of Engravings, etc., to Be Sold by Auction, Monday, July 20th, 1885* (New York: George A. Leavitt, 1885).

66. Helmut von Effra and Allen Staley, *The Paintings of Benjamin West* (New Haven, Conn.: Yale University Press, 1986), 206–7.

67. Spencer, *History of the United States* 1:133.

68. For more on the emblem book tradition, see Harthan, *History of the Illustrated Book*, 104.

69. Spencer, *History of the United States* 2:481.

70. Ibid. 2:56.

71. Lewis, "Alonzo Chappel and His Naval Paintings," 450.

72. For a similar discussion of how engraving techniques contributed to the "molding" or "roundness" of form, see Jussim, *Visual Communication and the Arts*, 34.

73. Spencer, *Memorabilia of Sixty-Five Years*, 120.

74. Barbara J. Mitnick, "The History Paintings," in Meschutt and Mitnick, *Portraits and History Paintings of Alonzo Chappel*, 64 n. 27.

75. Spencer, *History of the United States* 1:52, 63.

76. *Bulletin of the American Art Union,* May 1849, as cited in Grose-close, *Emanuel Leutze,* 78.

77. For what little Spencer does say about Williams and the founding of Rhode Island, see Spencer, *History of the United States* 1:65–66.

78. For a detailed discussion of the painting and its historical credibility, see Adelaide M. Budde, "The Landing of Roger Williams by Alonzo Chappel," *Museum Notes* 2, no. 2 (February 1944): 12–14 (Museum of Art, Rhode Island School of Design, Providence).

79. Bradford Fuller Swan, "Chappel's Painting and the City Seal," *Museum Notes* 2, no. 2 (February 1944): 14–15 (Museum of Art, Rhode Island School of Design, Providence).

80. Panzer, *Mathew Brady,* 118.

81. Mark Twain, *Mississippi Writings/Mark Twain* (New York: Literary Classics of the United States, Distributed to the Trade by the Viking Press, 1982), 458.

82. Jesse Ames Spencer and Evert A. Duyckinck, *History of the World: Ancient and Modern* (New York: Johnson, Fry, 1869).

83. Preface to Ayres, *Picturing History,* 22.

84. Husch, "Freedom's Holy Cause," 98.

85. Greenhouse, "Landing of the Fathers," 62.

86. Spencer, *History of the United States* 3:75; 1:41; 3:88, 539–40, 522, 540, 454.

87. Ibid. 3:539–40.

88. Spencer, *Memorabilia of Sixty-Five Years,* 127.

89. Ibid.

90. Ibid., 134. For more on Spencer's reputation in his own day as a promoter of specific literary forms, see Evert A. Duyckinck and George L. Duyckinck, *Cyclopaedia of American Literature,* 2 vols. (New York: Scribner's, 1855), 2:630.

91. Spencer, *History of the United States* 2:187.

92. Ibid. 3:539–40, 524.

93. For more on this debate over moral authority in narrative voices, see Hayden White, *Metahistory: The Historical Imagination in Nineteenth-Century Europe* (Baltimore: Johns Hopkins University Press, 1973).

94. This phrase is borrowed from Barbara Gaehtgens article of the same title in Thomas W. Gaehtgens and Heinz Ickstadt, eds., *American Icons: Transatlantic Perspectives on Eighteenth- and Nineteenth-Century American Art* (Los Angeles: Getty Center Publications, 1992), 147–82.

95. *The Works of John Ruskin,* ed. E. T. Cook and Alexander Wedderburn, 39 vols. (London: George Allen, 1903–12), 5:50, as cited in Gerdts, "On Elevated Heights," 107.

96. Frederick William Fairholt, *Costume in England* 2d. ed. (1860), as cited in "The Recreation of the Past," in Cannon-Brookes, *Painted Word,* 55.

97. For more on Chappel's research habits, see Meschutt and Mitnick, *Portraits and History Paintings of Alonzo Chappel,* 20, 49.

98. "Historical and Literary Intelligence," in *Historical Magazine,* ser. 1, 2 (April 1858): 126–28.

99. For more on Dawson and his historical endeavors, see John A. Todd, "Henry B. Dawson," *New England Historical and Genealogical Register* 44 (July 1890): 235–48, and Robert E. Moody, "Henry Barton Dawson," in Malone, *Dictionary of American Biography* 5:152.

100. David D. Van Tassel, "Henry Barton Dawson: A Nineteenth-Century Revisionist," *William and Mary Quarterly,* ser. 3, 13, no. 3 (July 1956): 319.

101. For more on the genesis and principles of the *Historical Magazine,* see "First Prospectus of the Historical Magazine," ser. 1, vol. 1 (1857). Also see, Frank Luther Mott, *A History of American Magazines* (Cambridge: Harvard University Press, 1938), 2:175 and n. 110.

102. Henry B. Dawson to Lyman Draper, 16 July 1879, Draper Correspondence, as cited in Van Tassel, "Henry Barton Dawson," 334–35.

103. Henry Barton Dawson, *Battles of the United States, by Sea and Land* (New York: Johnson, Fry, 1858). Interestingly, Henry Johnson published this work by Spencer's rival.

104. "Historical and Literary Intelligence," 126–28. To verify Dawson's accusations, compare, for instance, 142–45 of James Thacher's *Military Journal of the American Revolution* (Hartford, Conn.: Silas Andrus & Son, 1854) with Spencer, *History of the United States* 2:23–25.

105. See for instance, Benson J. Lossing to Henry Barton Dawson, 1 July 1862, Dawson Miscellaneous Manuscripts, the New York Historical Society, New York, New York.

106. "Confidential Circular," [1858], Notes from Correspondence, File F-3, Benson J. Lossing Papers, Historical Society of Pennsylvania, Philadelphia (hereafter cited as Lossing Papers–Pennsylvania).

107. *Historical Magazine* 2 (April 1858): 127–28. The original *New York Times* "Letter to the Editor," appeared on 21 January 1858.

108. Ibid. The work on which Lossing based his corrections (and which Spencer failed to consult) was Charles Miner, *History of Wyoming: In a Series of Letters from Charles Miner to His Son William Penn Miner* (Philadelphia: J. Crissy, 1845).

109. Spencer, *Memorabilia of Sixty-Five Years,* 128.

4. "Eyewitness to History": Challenges to the Sentimental Form

1. W. Fletcher Thompson, *The Image of War: Pictorial Reporting of the American Civil War* (New York: Thomas Yoseloff, 1960), 7, 24, 29.

2. Evert A. Duyckinck, *History of the War for Union: Civil, Military and Naval. Founded on Official and Other Authentic Documents* (New York: Johnson, Fry, 1862).

3. For more on Chappel and his war service, see Barbara J. Mitnick and David Meschutt, "Biography," in Meschutt and Mitnick, *Portraits and History Paintings of Alonzo Chappel,* 17.

4. Shi, *Facing Facts,* 45.

5. Spencer, *History of the United States* 4:544.

6. Chappel's Civil War illustrations generally seem to derive from three sources, according to his biographers: (1) the written accounts of Evert Duyckinck for the *National History of the War for the Union*, (2) sketches made on the spot by other artists [including this one by Lovie], and (3) journalistic reports published by the press. For more on these composite sources, see Barbara J. Mitnick, "The History Paintings," in Meschutt and Mitnick, *Portraits and History Paintings of Alonzo Chappel*, 52. The prototype for "Battle of Wilson's Creek" appeared in *Frank Leslie's Illustrated Newspaper*, 31 August 1861.

7. Abrams, *Pilgrims and Pocahontas*, 60–61.

8. Shi, *Facing Facts*, 58.

9. Daniel Aaron, *The Unwritten War: American Writers and the Civil War* (New York: Knopf, 1973).

10. Shi, *Facing Facts*, 66.

11. *Frank Leslie's Illustrated Newspaper* 13 (7 December 1861): 35, as cited in William P. Campbell, *The Civil War: A Centennial Exhibition of Eyewitness Drawings* (Washington, D.C., National Gallery of Art, 1961), 23, 24–25.

12. Shi, *Facing Facts*, 96.

13. Ibid., 55. For more on this documentary function as it relates to the Civil War, see Trachtenberg, *Reading American Photographs*, 71–118.

14. Alexander Gardner, *Gardner's Photographic Sketchbook of the Civil War* (Washington, D.C.,: Philip & Solomons, 1866), n.p.

15. *Frank Leslie's Illustrated Newspaper* 13 (7 December 1861): 35, as cited in Campbell, *Civil War*, 23, 24–25.

16. Chambers, "Painting the Civil War as History," 122.

17. For more on the wet-plate process, see Campbell, *Civil War*, 95.

18. Hermann Warner Williams Jr., *The Civil War: The Artists' Record* (Boston: Museum of Fine Arts, 1961), 24.

19. Trachtenberg, *Reading American Photographs*, 94–95.

20. For more on difficulties associated with these developing processes, see Jussim, *Visual Communication and the Graphic Arts*, 51–52.

21. For more on Leslie and his newspaper, see "Frank Leslie," *Frank Leslie's Illustrated Newspaper*, 24 January 1880, 381–82; "A Tribute of Respect to the Memory of Frank Leslie, by the Employes [*sic*] and Former Employes [*sic*] of His Publishing House," *Frank Leslie's Illustrated Newspaper*, 31 January 1880, 403; Richard B. Kimball, "Frank Leslie," *Frank Leslie's Sunday Magazine*, March 1880, 369–72, 373, 376; "Frank Leslie," *American Mercury*, May 1930, 94–101; Budd Leslie Gambee Jr., *Frank Leslie and His Illustrated Newspaper, 1855–1860* (Ann Arbor: University of Michigan, 1964).

22. *Frank Leslie's Illustrated Newspaper*, 15 December 1860, as cited in Andrea G. Pearson, "*Frank Leslie's Illustrated Newspaper* and *Harper's Weekly:* Innovation and Imitation in Nineteenth-Century American Pictorial Reporting," *Journal of Popular Culture* 23 (Spring 1990): 87.

23. *Frank Leslie's Illustrated Newspaper*, 5 December 1857, 6, as cited in Pearson, "*Frank Leslie's Illustrated Newspaper* and *Harper's Weekly*," 107.

24. Including artists such as Frank Schell, Henry Lovie, William Crane, Arthur Lumley, Edwin Forbes, Eugene Benson and William Waud. For more on other special artists during this period, see David Tatham, "Winslow Homer at the Front in 1862," in "New Discoveries in American Art," *American Art Journal*, ed. J. Kuchna, vol. 11, pt. 3 (July 1979): 87; Frederick Ray, *Alfred R. Waud, Civil War Artist* (New York: Viking Press, 1974); and Frank Luther Mott, "Thomas Nast Pictures of Civil War Reporters," *Oldtime Comments on Journalism* 3, no. 1 (November 1959): n.p.

25. *Harper's Weekly*, 4 May 1861, as cited in Pearson, "*Frank Leslie's Illustrated Newspaper* and *Harper's Weekly*," 93.

26. Pearson, "*Frank Leslie's Illustrated Newspaper* and *Harper's Weekly*," 81, 89.

27. Thompson, *Image of War*, 87.

28. Orville J. Victor, *The History, Civil, Political and Military, of the Southern Rebellion* (New York: J. D. Torrey, 1861), v.

29. John Stevens Cabot Abbott, *History of the Civil War in America*, 2 vols. (Springfield, Mass.: H. Bill, 1863–66), 1:iv, as cited in Thomas J. Pressly, *Americans Interpret Their Civil War* (1954; reprint, New York: Free Press, 1962), 39. Mott lists the Abbott volume as a "better seller" rather than a "best seller" in this period; see Frank Luther Mott, *Golden Multitudes: The Story of Best Sellers in the United States* (New York: Macmillan, 1947), 321.

30. "Edwin L. Godkin to George E. Norton, 18 January 1865," as cited in David D. Van Tassel, *Recording America's Past: An Interpretation of the Development of Historical Studies in America, 1607–1884* (Chicago: University of Chicago Press, 1960), 144 n.

31. *Frank Leslie's Illustrated Newspaper*, 7 December 1861, 35, and 31 May 1862, 134, as cited in Pearson, "*Frank Leslie's Illustrated Newspaper* and *Harper's Weekly*," 90. The full citation to the Leslie history was E. G. Squier, ed., *Frank Leslie's Pictorial History of the Civil War* (New York: Frank Leslie's Publishing House, 1861–62).

32. *Harper's Weekly*, 3 June 1865, 339 as cited in Pearson, "*Frank Leslie's Illustrated Newspaper* and *Harper's Weekly*," 96. The full citation to the Harper's history was Alfred H. Guernsey, ed., *Harper's Pictorial History of the Great Rebellion*, 2 vols. (New York: Harper & Brothers, 1863–67).

33. *Harper's Weekly*, 30 April 1864, 277, as cited in Pearson, "*Frank Leslie's Illustrated Newspaper* and *Harper's Weekly*," 96.

34. *Frank Leslie's Illustrated Newspaper*, 12 April 1862, 366, as cited in Pearson, "*Frank Leslie's Illustrated Newspaper* and *Harper's Weekly*," 89.

35. *Frank Leslie's Illustrated Newspaper* 13 (7 December 1861), 35 as cited in Campbell, *Civil War*, 23, 24–25. See also "How a Battle Is Sketched," *St. Nicholas* 16, no. 9 (July 1889): 62.

36. Pearson, "*Frank Leslie's Illustrated Newspaper* and *Harper's Weekly*," p. 86.

37. *Harper's Weekly*, 3 June 1865, 339, as cited in Campbell, *Civil War*, 98–99.

38. This quote is from Harry V. Barnett in Walter Montgomery, ed., *American Art and American Art Collections* (Boston, 1889), 2:833–34, as cited in Campbell, *Civil War*, 18–19.

39. Campbell, *Civil War*, 50, 54–57.

40. Ibid., 58.

41. Thompson, *Image of War*, 89.

42. Ibid., 137.

43. Williams, *Civil War*, 24–25.

44. For more on the impact of the "Harper's style," see Morgan, *Protestants and Pictures*, 65–66.

45. Mott, *Golden Multitudes*, 321.

46. Benson Lossing to George Childs, 6 January 1862, GA-28, Box 1, "Outgoing Correspondence," Lossing Papers–Hayes.

47. Power, "Benson J. Lossing," 167.

48. "Notebooks, 1860," 5 vols., LS 1124–LS 1128; "Notebooks, 1863," 3 vols., LS 1129–LS 1131; and "Pocket Notebooks Kept During the Travels to the Battlefields of the Civil War, 1864–66," LS 47, Lossing Papers–Huntington. See also Benson J. Lossing to "My Darling," 31 May 1866, GA-28, Box 1, Lossing Papers–Hayes.

49. Benson Lossing to "My Dear Mr. Childs," 22 March 1866, GA-28, Box 1, Lossing Papers–Hayes.

50. "American Publishers' Circular," and "Testimonials to Lossing's Pictorial History of the Great Rebellion," Lossing Papers–Hayes.

51. "Information to Applicants for Agency to Canvass Lossing's Pictorial History of the Great Civil War," Lossing Papers–Hayes.

52. Ibid.

53. George Childs to Benson J. Lossing, 12 January 1862, LS 463, Addenda 1, Box 8, Lossing Papers–Huntington.

54. George Childs to Benson J. Lossing, 19 May 1862, LS 469, Addenda 1, Box 8, Lossing Papers–Huntington.

55. George Childs to Benson J. Lossing, 27 September 1864, General Correspondence, Box 2, Lossing Collection–Syracuse.

56. George Childs to Benson J. Lossing, 30 March 1863, LS 474, Box 9, Lossing Papers–Huntington.

57. Benson J. Lossing, *Pictorial History of the Civil War in the United States of America* (Philadelphia: George W. Childs, 1866), 1:5.

58. Mahan, *Benson J. Lossing*, 88–92. Mahan's work contains an excellent summary of the "timing" decisions made by Lossing in the matter of publishing the Civil War trilogy.

59. John Emmins to Benson J. Lossing, 23 May 1862, General Correspondence, Box 1, Lossing Collection–Syracuse.

60. Benson J. Lossing to Francis Lieber, 27 March 1862, as cited in Mahan, *Benson J. Lossing*, 87.

61. George Childs to Benson J. Lossing, 20 April 1863, LS 475, Addenda 1, Box 9, Lossing Papers–Huntington.

62. Benson J. Lossing to Francis Lieber, 27 March 1862, as cited in Mahan, *Benson J. Lossing*, 87.

63. Tho[mas] B. Fairchild to Benson J. Lossing, 2 April 1863, LS 640, Addenda 1, Box 9, Lossing Papers–Huntington.

64. Lossing, *Pictorial History of the Civil War* 1:3–4.

65. Ibid. 1:5.

66. Benson J. Lossing to Francis Lieber, 27 March 1862, as cited in Mahan, *Benson J. Lossing*, 87. On this issue of illustrating battle scenes, see an interesting letter from August Ford to Lossing, 21 December 1874, in which Ford asks Lossing to comment on the question "Can an author write a good description of a battle if he has not been a witness of, or participant in, one?" Addenda 1, Box 17, Lossing Papers–Huntington.

67. Lossing, *Pictorial History of the Civil War* 1:3–4.

68. Ibid. 2:627. The incongruous Grant/Pemberton illustration appears only in the first edition of Lossing's *Pictorial History of the Civil War*. Subsequent editions substituted "Farragut Entering Mobile Bay," by H. P. Stephens and Augustus Robin, although the tables of contents in these later editions do not reflect the change.

69. Benson J. Lossing to H. Phelps, 10 November 1854 and 24 November 1854, GA-28, Box 1, Lossing Papers–Hayes.

70. Lossing, *Pictorial History of the Civil War* 3:621.

71. These six "better sellers" were Frank Moore, *The Rebellion Record;* Joel T. Headley, *The Great Rebellion;* J. S. C. Abbott, *The Civil War in America; Harper's Pictorial History of the Civil War;* George Ward Nichols, *The Story of the Great March;* and Horace Greeley, *The American Conflict*. See Mott, *Golden Multitudes*, 321.

72. Moses Coit Tyler, "Review," *Christian Union*, March 1873, 208. The review was of Lossing's *Life and Times of Philip Schuyler*, vol. 1 (New York: Mason Brothers, 1860) and vol. 2 (New York: Sheldon, 1873). In a private letter, Tyler reassured Lossing that he had "tried to find a little fault" with the volume in making such comments, since an "unmitigated eulogy would have taken all value" from his praise, but even at his most naïve Lossing could not have misunderstood Tyler's profound disappointment with what the scholar viewed as a commonplace book. See Moses Coit Tyler to Benson J. Lossing, 18 March 1873, Addenda 1, Box 16, Lossing Papers–Huntington.

73. *New York Herald*, 29 May 1866, as cited in Mahan, *Benson J. Lossing*, 88–89.

74. "Literary Notices," *Godey's* 73 (October 1866): 357, as cited in Mahan, *Benson J. Lossing*, 88–89.

75. *The Round Table: A Saturday Review of Literature, Society and Art*, ser. 2 (16 June 1866), as collected in General Correspondence, Box 3, Lossing Collection–Syracuse. For more on the *Round Table*, see Mott, *History of American Magazines* 3:319–24.

76. *Round Table*, ser. 2 (16 June 1866).

77. *Round Table*, ser. 2, no. 4 (4 August 1866): 8.

78. *Round Table*, ser. 2 (16 June 1866).

79. For more on Lossing's professed preference for "shrinking from public discussion" and his "indisposition to 'rush into print,'" see Lossing to Mrs. Schuyler Van Rensselaer, 14 January 1887, Benson John Lossing 02867 01 L, Collection 1/5 MMC, Historical Manuscripts Division, Library of Congress, Washington, D.C.

80. Benson J. Lossing to Henry B. Dawson, 4 July 1866, General Correspondence, Box 3, Lossing Collection–Syracuse.

81. Ibid.

82. Edward F. DeLancey, "Westchester County in the Revolution," *Magazine of American History* 17 (1887): 343, as cited in Van Tassel, "Henry Barton Dawson," 319.

83. *Historical Magazine,* ser. 1, 10 (1866): 201–2.

84. *Historical Magazine* ser. 2, 7 (January 1870): 69–75.

85. Henry B. Dawson to Charles Deane, 15, 22 January 1880 and Lyman Draper, 29 March 1880, as cited in Van Tassel, "Henry Barton Dawson," 337.

86. Mahan, *Benson J. Lossing,* 91.

87. Preface to *History of the United States of America. By J.A. Spencer, Continued to July 4, 1876 by Benson J. Lossing* (New York: Johnson, Wilson, 1876), v.

88. Theodore L. Chase to Benson J. Lossing, 15 March 1871, "Correspondence," File F-6, Lossing Papers–Pennsylvania.

89. "Contract for Historical Record," 31 July 1871, Lossing Papers–Pennsylvania. Lossing was to receive fourteen hundred dollars yearly if the circulation of the monthly rose to four thousand and sixteen hundred dollars if it climbed to five thousand.

90. David D. Van Tassel, "Benson J. Lossing: Pen and Pencil Historian," *American Quarterly* 6 (Spring 1954): 33–44, esp. 43–44.

91. [Editor's Comments], *American Historical Record* 1, no. 1 (January 1872): n.p., as collected in GA-28, Box 5, Lossing Papers–Hayes.

92. "A Library of American History Without Cost," GA-28, Box 5, Lossing Papers–Hayes.

93. See John E[liot] Potter to Benson J. Lossing, 5 October 1874 and 13 November 1874 regarding proposed changes in the format of the *American Historical Record* to attract new subscribers. Addenda 1, Box 17, Lossing Papers–Huntington.

94. "A Library of American History Without Cost," GA-28, Box 5, Lossing Papers–Hayes.

95. J. Parker Norris to Benson J. Lossing, 19 January 1874, Incoming Correspondence, Lossing Papers–Hayes.

96. "Announcement for 1875! The Record Enlarged and Improved," Lossing Papers–Hayes.

97. J. Morris to Benson J. Lossing, 5 June 1875, Lossing Papers–Hayes.

98. This review is enclosed in a letter of 30 November 1875 to Lossing from Jo[hn A] McAllister, in which McAllister notes that "the experiment at illustrating 'Potter's American Monthly' seems not to have been a complete success." Addenda 1, Box 17, Lossing Papers–Huntington.

99. Samuel Yorkee Atlee to Benson J. Lossing, 31 January 1877, General Correspondence, Box 3, Lossing Collection–Syracuse.

100. Hiland Hill to Benson J. Lossing, 16 July 1877, Addenda 1, Box 18, Lossing Papers–Huntington. *Potter's American Monthly* lasted until 1882.

5. "A String for the Pearls": The Centennial Celebration and Humanizing History

1. Pressly, *Americans Interpret Their Civil War,* 101–26, 139–47.

2. Walton Rawls, *The Great Book of Currier and Ives' America* (New York: Abbeville Press, 1979), 65–67.

3. Bancroft had just completed his monumental work, *History of the United States from the Discovery of the American Continent to the Present Time,* 10 vols. (1834–75), after nearly four decades. It was used throughout the remainder of the century as the new standard by which to measure the worthiness of all historical publications, including popular ones.

4. R. M. Devens, *Our First Century: Being a Popular Descriptive Portraiture of the One Hundred Great and Memorable Events of Perpetual Interest in the History of Our Country* (Springfield, Mass.: C. A. Nichols, 1878), 9–10.

5. Ibid., 10–14.

6. Rawls, *Great Book,* 37.

7. Frank H. Norton, ed., introduction to *Frank Leslie's Illustrated Historical Register of the United States Centennial Exposition, 1876* (New York: Frank Leslie's Publishing House, 1877), n.p. *The American Catalogue* lists several competing works that were still less expensive, including the *Official Catalogue of the Centennial Exhibition* at two dollars and *Gems of the Centennial Exhibition, Ill. Descriptions of objects of artistic character at the Phila. Exhibition of 1876* at six dollars. See R. R. Bowker and A. I. Appleton, eds, *The American Catalogue: 1876–1884* (New York: Office of the Publishers' Weekly, 1885), 38.

8. For more on the Leslie Pavilion and the controversy surrounding it, see William E. Huntzicker, "Frank Leslie (Henry Carter)," in *American Magazine Journalists, 1850–1900,* vol. 79, *Dictionary of Literary Biography,* ed. Sam G. Riley (Detroit: Gale Research), 218. See also Norton, introduction to *Frank Leslie's Illustrated Historical Register,* 146, 213.

9. Norton, introduction to *Frank Leslie's Illustrated Historical Register,* n.p.

10. George Everett, "Frank Leslie (Henry Carter)," in *American Newspaper Journalists, 1690–1872,* vol. 43 of *Dictionary of Literary Biography,* ed. Perry J. Ashley (Detroit: Gale Research, 1985), 299.

11. Huntzicker, "Frank Leslie," 220.

12. Neil Harris, "Pictorial Perils: The Rise of American Illustration," in Ward, *American Illustrated Book in the Nineteenth Century,* 18.

13. Michael Kammen, *Mystic Chords of Memory: The Transformation of Tradition in American Culture* (New York: Alfred A. Knopf, 1991), 101.

14. James D. McCabe, *The Centennial History of the United States from the Discovery of the American Continent to the Close of the First Century of American Independence* (Philadelphia: National, 1874), 3–4. For more on McCabe's background, see *The National Cyclopaedia of American Biography* (New York: James T. White, 1897), 7:511.

15. "Do You Want to Make Money?" circular for the National Publishing Company inserted in the back pages of McCabe, *Centennial History.*

16. James D. McCabe, *The Illustrated History of the Centennial Exposition* (Philadelphia: National, 1876), 6.

17. Ibid., 860.

18. Jussim, *Visual Communication and the Graphic Arts,* 282–84.

19. McCabe's book was issued in a German edition under the title *Geschichte der Vereinigten Staaten* (Philadelphia: National Publications–Gesellschaft, 1876). To avoid having to make new captions or engravings for this edition, the National Publishing Company inscribed the originals in both languages, an example of the kind of shortcuts typical of the industry.

20. Alexander H. Stephens, *A Pictorial History of the United States* (Philadelphia: National, 1882). For reviews of Stephens's book, see John C. Robertson, "Alexander Stephens," in *Dictionary of Literary Biography* 47:286–88, 289.

21. Stephens, *Pictorial History of the United States*, 544, and McCabe, *Centennial History*, 889.

22. Compare, for instance, McCabe, *Centennial History*, 829–30, with Stephens, *Pictorial History of the United States*, 769.

23. For more on this lack of pictorial depictions of the war from a southern perspective, see Campbell, *Civil War*, 10–11. See also Thompson, *Image of War*, 23, 93–95.

24. Stephens, *Pictorial History of the United States*, 774. The volume from which Stephens borrowed so liberally was John Laird Wilson, *Pictorial History of the Great Civil War* (Boston: Collins-Patten, 1881). Wilson was a correspondent for the *New York Herald*.

25. "Outline History of the United States," advertisement, Sheldon and Company, n.d., GA-28, Box 1, Lossing Papers–Hayes.

26. Porter and Coates to Benson J. Lossing, 15 March 1875, Box 2, Lossing Papers–Hayes. For more on Porter and Coates as a publishing firm, see *American Literary Publishing Houses, 1638–1899*, vol. 49, *Dictionary of Literary Biography*, ed. Peter Dzwonkoski (Detroit: Gale Research, 1986), 372–73.

27. Benson Lossing, *A Pictorial History of the United States* (Hartford, Conn.: T. Belknap, 1867). See also "Important Announcement!" A Centennial Edition of a Superb National Work," n.d., advertisement, T. Belknap, GA-28, Box 1, Hayes Library.

28. Mary L. D. Ferris, "Benson J. Lossing," *American Author* 1, no. 6 (May 1902): 165.

29. J. N. Larned, ed., *The Literature of American History: A Bibliographic Guide* (Boston: Houghton, Mifflin, 1902), 284.

30. Benson J. Lossing, *Our Country: A Household History For All Readers*, 3 vols. (New York: Henry J. Johnson, 1875–78). For sales figures, see Mahan, *Benson J. Lossing*, 109.

31. For the junior Michelangelo quote and other biographical information on Darley, see George B. Barnhill, "Felix Octavius Carr Darley," in Smith, Hastedt, and Dyal, *American Book and Magazine Illustrators to 1920*, 63. Also see Frank Weitenkampf, "F. O. C. Darley; American Illustrator," *Art Quarterly* 10 (Spring 1947): 100–113. Letters to and from Darley as well as collections of his works are at the New York Public Library; the Huntington Library; the Beinecke Library, Yale University; the Houghton Library at Harvard University; the Graphic Arts Collection, Princeton University; and the Library of Congress.

32. For more on these Mercury Stories, see "Felix Octavius Carr Darley," in Hamilton, *Early American Book Illustrators and Wood Engravers* 1:101–16. See also *The Library of Humorous American Works*, ed. J. B. Peterson (Philadelphia: Carey & Hart, 1846–59).

33. ". . . *Illustrated by Darley": An Exhibition of Original Drawings* (Wilmington: Delaware Art Museum, 1978), 16.

34. F. O. C. Darley, *Illustrations of Rip Van Winkle* (New York: American Art-Union, 1848) and *Illustrations of the Legend of Sleepy Hollow* (New York: American Art-Union, 1849). For more on the American Art-Union works, see Jay Cantor, "Prints and the American Art-Union," in *Prints in and of America to 1850*, ed. John D. Morse (Winterthur, Del.: Henry Francis du Pont Winterthur Museum, 1970), 310, 313–16. For a complete listing of books illustrated by Darley, see Theodore Bolton, "The Book Illustrations of Felix Octavius Carr Darley," *Proceedings of the American Antiquarian Society* 61, no. 1 (April 1951): 136–82.

35. Pierre Monroe Irving, *Life and Letters of Washington Irving* (New York: G. P. Putnam, 1850), 242.

36. *Bulletin of the American Art Union*, May 1850, 30, as cited in ". . . *Illustrated by Darley*," 10.

37. Barnhill, "Felix Octavius Carr Darley," 64.

38. Ibid., 20. See F. O. C. Darley, *Compositions in Outline from Hawthorne's Scarlet Letter* (Boston: Houghton, Osgood, 1879) and William Gilmore Simms, *The Works of William Gilmore Simms*, 18 vols. (New York: Redfield, 1853–59).

39. James Fenimore Cooper, *Cooper's Novels*, 32 vols. (New York: Townsend, 1859–61). See also F. O. C. Darley, *The Cooper Vignettes* (New York: James G. Gregory, 1862); F. O. C. Darley, *Scenes from Indian Life: A Series of Original Designs Etched on Stone* (Philadelphia: Colon, 1843); and John C. Ewers, "Not Quite Redmen: The Plains Indian Illustrations of Felix O.C. Darley," *American Art Journal* 3 (Fall 1971): 88–98.

40. Ethel King, *Darley: The Most Popular Illustrator of His Time* (Brooklyn, N.Y.: Theo. Gaus' Sons, 1964), 21–22.

41. ". . . *Illustrated by Darley*", 16. For more on W. H. Holbrooks and his historical prints, see *Bulletin of the American Art Union*, December 1850, 56–57. For a recent display of several of these works, see "Inventing the American Past: The Art of F. O. C. Darley," 17 April–26 June, 1999," Print Exhibition, in "Programs at the Humanities and Social Sciences Library," New York Public Library.

42. "Scrapbook belonging to F. O. C. Darley containing original drawings and publicity notices about the artist and the books he illustrated," No. 410074, Division of Prints and Photographs, Library of Congress.

43. ". . . *Illustrated by Darley*", 18.

44. Henry Tuckerman, *Book of the Artists* (New York: G. P. Putnam & Son, 1867), 471–76. In 1856, Darley was featured in two articles in the *Crayon* and the *National Magazine*, both of which labeled him America's preeminent illustrator. See also "Darley's Outline Illustrations of 'Margaret,'" *Crayon* 3, no. 12 (December 1856): 370.

45. Barnhill, "Felix Octavius Carr Darley," 64.

46. Lossing, *Our Country* 1:vii.

47. Lossing to Evert A. Duyckinck, 15 March 1874, Duyckinck Collection, New York Public Library. Also see Henry Johnson to Benson J. Lossing, 22 June 1876, LS 918, Addenda 1, Box 18, Lossing Papers–Huntington.

48. Tuckerman, *Book of the Artists*, 476.

49. David H. Wallace, *John Rogers* (Middletown, Conn.: Wesleyan University Press, 1967), 220, as cited in ". . . *Illustrated by Darley*", 11.

50. This review in the *Democratic Review* (August 1843) is collected in Darley Scrapbook, 410074, Library of Congress.

51. Johnson, Wilson and Co. to Benson J. Lossing, 31 December 1873, GA-28, Box 1, Hayes Library.

52. Henry J. Johnson to Benson J. Lossing, 27 September 1876 and Lossing to Johnson, 22 March 1877, Addenda 1, Box 16, Lossing Papers–Huntington.

53. Gouv[eneur] Kemble to Benson J. Lossing, 2 April 1875, GA-28, Box 1, Hayes Library.

54. Johnson, Wilson and Co. to Benson J. Lossing, 1 December 1874, Hayes Library.

55. Henry J. Johnson to Benson J. Lossing, 22 June 1876, Addenda 1, Box 17, Lossing Papers–Huntington.

56. King, *Darley*, 47. King notes that Darley exhibited *Street Scene from Rome*, which was "well received with many tributes and praise and favorable comments."

57. ". . . *Illustrated by Darley*", 9.

58. Nearly 150 proofs of woodcuts of drawings for *Our Country* with instructions for engraving are extant in the Sinclair Hamilton Collection of American Illustrated Books, *A Collection of Original Drawings in Pencil, Pen and Ink and Sepia by F. O. C. Darley; ca. 1824–1866*, Graphic Arts Collection, Department of Rare Books and Special Collections, Princeton University Library (hereafter cited as Sinclair Hamilton Collection). Published with permission of the Princeton University Library. Comparing these proofs with the illustrations in *Our Country* reminds one of the considerable detail lost in the translation of sketches to the printed page.

59. ". . . *Illustrated by Darley*", 15.

60. Oversize no. 684, item no. 1593, Sinclair Hamilton Collection.

61. Virginia Renner and Kelli Bronson, "Summary Report, Lossing Papers," Lossing Papers–Huntington.

62. Lossing to Mr. Johnson, 22 March 1877, Box 17, Addenda 1, Lossing Papers–Huntington. For more on the pricing of these subscription parts, see Leypoldt, *American Catalogue*, vol. 1, pt. 2, p. 449.

63. Benson J. Lossing to Dr. Samuel Ward Francis, 7 December 1876, Box 3, Lossing Collection–Syracuse.

64. Mahan, *Benson J. Lossing*, 109.

65. Patricia M. Burnham and Lucretia Hoover Giese, "Introduction: History Painting: How It Works," in *Redefining American History Painting*, ed. Patricia M. Burnham and Lucretia Hoover Giese (Cambridge: Cambridge University Press, 1995), 1.

66. Clarence Cook, "Artists as Historians," *Quarterly Illustrator* 3, no. 9 (January, February, and March 1895): 103, as cited in ibid., 7.

67. Andrew Peabody, "The Intellectual Aspects of the Age," *North American Review* 64 (April 1847): 276, as cited in ibid., 67.

68. For more on the construction of realism as a protection from the addictive qualities of sentimentalism, see Nancy Glazener,

Reading for Realism: The History of a U.S. Literary Institution, 1850–1910 (Durham, N.C.,: Duke University Press, 1997), 93–146, esp. 96 and 152.

69. Shi, *Facing Facts*, 262, 264.

70. "Biographical Sketches of Benson J. Lossing, LL.D., Author, and Felix O. C. Darley, Artist of *Our Country*," salesman's brochure, Addenda 3, Box 2, Lossing Papers–Huntington.

71. Lossing, *Our Country* 1:201, 198, 373–74, 304.

72. Ibid. 1:266, 347. Here Lossing seems to have relied heavily on Washington Irving's description of Dutch New York. Compare this passage, for instance, to those on Dutch colonial life in Washington Irving, *Knickerbocker's History of New York* (New York: G.P. Putnam's Sons, 1894), 248–60.

73. Lossing, *Pictorial History of the United States*, 17–20.

74. Lossing, *Our Country* 1:34.

75. Lossing, *Pictorial History of the United States*, 17–20.

76. Lossing, *Our Country* 1:55.

77. Ibid. 1:v, 32, 34, 204.

78. Ibid. 1:vii.

79. Ibid. 1:iii.

80. Ibid. 1:298, vii, 492, 211.

81. Ibid. 1:vi.

82. Burnham and Giese, *Redefining American History Painting*, 5–6.

83. Elizabeth Johns, *American Genre Painting: The Politics of Everyday Life* (New Haven, Conn.: Yale University Press, 1991), 3.

84. William Cullen Bryant, ed., *The Complete Works of William Shakespeare* (New York: Amies, 1888), 3:1252–53. See also Alfred Trumble, "The Original Drawings of Darley's Illustrations of the Works of Shakespeare," *Art Collector* (January 1893): 8–11.

85. Sue W. Reed, "F. O. C. Darley's Outline Illustrations," in Ward, *American Illustrated Book in the Nineteenth Century*, 114.

86. Henry James, *The Painter's Eye*, ed. John L. Sweeney (London: R. Hart-Davis, 1956), 140–43, as cited in Shi, *Facing Facts*, 131.

87. This comment comes from Baptist pastor Robert F. Y. Pierce, as cited in Morgan, *Protestants and Pictures*, 251.

88. Johns, *American Genre Painting*, xi–xvi.

89. Lossing, *Our Country* 3:1722–23.

90. Reed, "F. O. C. Darley's Outline Illustrations," 113–36.

91. Morgan, *Protestants and Pictures*, 345.

92. Ibid., 53, 217, 236–38.

93. Lossing, *Our Country* 1:389.

94. Lossing was attacked in the pages of the *Independent* by Henry Ward Beecher and his sister, Harriet Beecher Stowe, for failing to take a strong enough stand against slavery in his *Pictorial History of the United States* (1854 edition). For more on this episode, see Mahan, *Benson J. Lossing*, 73.

95. Lossing, *Our Country* 1:302.

96. Ibid. 3:1565.

97. See the original of the Lossing sketch of the Frietchie home in Addenda 2, Box 32 (1843–1898), Lossing Papers–Huntington.

98. Lossing, *Our Country* 3:1744–45, 1728, 1741.

99. Brian W. Dippie, *Custer's Last Stand: The Anatomy of an American Myth* (Lincoln: University of Nebraska Press, 1976), 32.

100. Benson J. Lossing to Dr. Samuel Ward Francis, 7 December 1876, Box 3, Lossing Collection–Syracuse.

101. See bindings enclosed in the salesman's dummy for *Our Country*, Addenda 3, Box 2, Lossing Papers–Huntington.

102. See also Benson J. Lossing, *Lossing's History of the United States*, 8 vols. (New York: Lossing History Company, 1909).

103. For a sampling of such reviews, see those from the *Plattsburgh Sentinel*, the *Syracuse Evening Star*, the *Portland (Maine) Weekly Advertiser* and the *Cumberland (Pa.) News* included in the salesman's dummy for *Our Country*, Addenda 3, Box 2, Lossing Papers–Huntington.

104. James Mitchell to Sheldon and Company, 5 May 1876, GA-28, Box 1, Lossing Papers–Hayes. Here Mitchell is criticizing Lossing's *Outline History*," although the "error" was repeated in *Our Country*.

105. Benson J. Lossing to "Sir," 3 August 1877, Addenda 1, Box 17, Lossing Papers–Huntington.

6. "Colors That Do Not Fade": Chromos and the Professional Attack on Illustrated Histories

1. For more on the publication rates of pictorial histories in this period, see James D. Hart, *The Popular Book: A History of America's Literary Taste* (New York: Oxford University Press, 1950) and Raymond Howard Shove, *Cheap Book Production in the United States, 1870 to 1891* (Urbana: University of Illinois Library, 1937).

2. The Historical Publishing Company, centered in Philadelphia and St. Louis, sold its books through subscription only as a way of keeping "current." For more on its methods and those of its primary competitors in this field, see Lehmann-Haupt, *Book in America*, 250–54.

3. E. A. Perry, *American History*, pts. 1–5 (Malden, Mass.: Perry Pictures, 1898). On the 1880s and 1890s as a "golden age" of illustrated history, see Delaware Art Museum catalogue, *The Golden Age of American Illustration, 1880–1914* (Wilmington, Del.: Wilmington Society of the Fine Arts, 1972).

4. Morgan, *Protestants and Pictures*, 301–2.

5. Jussim, *Visual Communication and the Graphic Arts*, 46. For more on this process, see David Clayton Phillips, "Art for Industry's Sake: Halftone Technology, Mass Photography and the Social Transformation of American Print Culture, 1880–1920" (Ph.D. diss., Yale University, 1996).

6. Jussim, *Visual Communication and the Graphic Arts*, 11.

7. For more on the debate concerning the effect of halftone on the history of illustration, see Neil Harris, "Iconography and Intellectual History: The Half-Tone Effect," in *New Directions in American Intellectual History*, ed. John Higham and Paul K. Conkin (Baltimore: Johns Hopkins University Press, 1979), 196–211. See also Jussim, *Visual Communication and the Graphic Arts*, 90–96.

8. See, for instance, the hand-colorized illustrations in James Thacher, *The American Revolution, from the Commencement to the Disbanding of the American Army* (New York: American Subscription, 1859). For more on the technique of lithotinting, see Rawls, *Great Book*, 56–57.

9. For more on the Bem Method, see James R. Mellow, *Nathaniel Hawthorne and His Times* (Boston: Houghton Mifflin Company, 1980), 365.

10. George E. Croscup, *History Made Visible: Croscup's United States History with Synchronic Charts, Maps and Statistical Diagrams* (New York: Windsor, 1911), [3]. The charts used by Ridpath in *A Popular History of the United States* (New York: Nelson & Phillips, 1877) were widely circulated as "Lyman's Historical Charts."

11. Murat Halstead, introduction to *The Discovery and Conquest of the New World*, ed. Murat Halstead (Philadelphia: Royal, 1892), xii.

12. Julian Hawthorne, *Hawthorne and His Circle* (New York: Harper & Brothers, 1903), 1–2. See also Elizabeth Palmer Peabody, *Chronological History of the United States, Arranged with Plates on Bem's Principle* (New York: Sheldon, Blakeman, 1856).

13. William M. Sloane, "History and Democracy," *American Historical Review* 1, no. 1 (October 1895): 4.

14. For more on the codes for the transmission of color, see Jussim, *Visual Communication and the Graphic Arts*, 69–73.

15. Miss Josephine Pollard, *The History of the United States, Told in One Syllable Words* (New York: McLoughlin Brothers, 1884).

16. Peter Marzio, *The Democratic Art: Pictures for a 19th-Century America* (Boston: David R. Godine, in association with the Amon Center Museum of Western Art, Fort Worth, 1979), 9–11.

17. For more on the nationalizing tendencies associated with the World's Columbian Exposition, see David F. Burg, *Chicago's White City of 1893* (Lexington: University Press of Kentucky, 1976).

18. Halstead, *Discovery and Conquest of the New World*, title page.

19. Murat Halstead, *Briton and Boer in South Africa* (Philadelphia, 1900) and *Life and Reign of Queen Victoria* [with Charles Morris] (Chicago: International Publishing Society, 1901).

20. "Murat Halstead," in *The National Cyclopedia of American Biography* (New York: James T. White, 1926), 1:270.

21. "Murat Halstead" in Malone, *Dictionary of American Biography* 8:163.

22. Halstead, introduction to *Discovery and Conquest of the New World*, ix.

23. Ibid., ix–xv.

24. Edgar W. Ames, "Pictures: Their Use and Abuse in History Teaching," *History Teacher's Magazine* 3, no. 1 (September 1911): 9. See also issues of the turn-of-the-century semimonthly magazine *History Study Pictures* (Chicago: Art Study Company, 1900), each issue of which featured ten reproductions of images of historic events and places for use by instructors of history.

25. *New York Herald*, 9 November 1871, as cited in Abrams, *Pilgrims and Pocahontas*, 257.

26. For more on the Smith-Pocahontas debate from the perspective of the 1890s, see Tilton, *Pocahontas,* 176–86, and Abrams, *Pilgrims and Pocahontas,* 261–71.

27. *Columbus and Columbia: A Pictorial History of the Man and the Nation* (Seattle: Dominion, 1892), esp. 35–62. For more on matters of colorization, see Marzio, *Democratic Art,* 110–15.

28. John Clark Ridpath, introduction to *Footprints of the World's History,* by William S. Bryan (Philadelphia: Historical, 1890), 2.

29. Lawrence Levine, *Highbrow/Lowbrow: The Emergence of Cultural Hierarchy in America* (Cambridge: Harvard University Press, 1988), 160. For more on matters of colorization, see Marzio, *Democratic Art,* 110–15.

30. Jussim, *Visual Communication and the Graphic Arts,* 294–95.

31. John Clark Ridpath, *People's History of the United States* (Philadelphia: Historical, 1895).

32. Theodore Roosevelt, "History as Literature," *American Historical Review* 18 (April 1913): 473–75, 485.

33. Harris, "Iconography and Intellectual History," 199–201. See also Harris, "Pictorial Perils," 7–19.

34. "The Contributor's Club," *Atlantic Monthly* 93, no. 555 (January 1904): 136–37, as cited in Harris, "Pictorial Perils," 8–9.

35. [Rollo Ogden], "Knowledge on Sight," *Nation* 57, no. 1464 (20 July 1893): 41–42, and E. L. Godkin, "'Cuts' and Truth," *Nation,* 56, no. 1453 (4 May 1893): 326, as cited in Harris, "Pictorial Perils," 10–11.

36. "Over-Illustration," *Harper's Weekly* 55 (29 July 1911): 6, as cited in Harris, "Iconography and Intellectual History," 204–5.

37. Ralph F. Bogardus, *Pictures and Texts: Henry James, A. L. Coburn, and New Ways of Seeing in Literary Culture* (Ann Arbor: UMI Research Press, 1974), 52.

38. Bret Gyle, "Meaningless Illustrations," *New York Times,* 7 April 1900, as cited in Harris, "Iconography and Intellectual History," 7.

39. "The Pictorial and the Literary Art," from Johnson's *Elements of Literary Criticism,* in *Literary News* 19, no. 5 (May 1898): 143–44.

40. Katherine Gordon Hyle to the Editor, *New York Times,* 5 November 1904, as cited in Harris, "Iconography and Intellectual History," 8.

41. Levine, *Highbrow/Lowbrow,* 160.

42. Charles T. Congdon, "Over-Illustration," *North American Review* 139, as cited in Bogardus, *Pictures and Texts,* 71–72.

43. Harris, "Iconography and Intellectual History," 204.

44. William Cullen Bryant and Sydney Howard Gay, *Bryant's Popular History of the United States,* 4 vols. (Scribner, Armstrong, 1876–81); Edward Eggleston, *The Household History of the United States and Its People* (New York: D. Appleton, 1890); and Julian Hawthorne, *Hawthorne's United States,* 3 vols. (New York: P. F. Collier, 1898).

45. See, for instance, [review of *Bryant's Popular History of the United States*], *American Bibliopolist* (February 1877): 14–17. "Incorrect School Books," *Florida Times-Union,* 21 October 1893, as collected in Box 1, Publications and Accounts, Eggleston Papers, Cornell University Archives, Ithaca, New York.

46. Congdon, "Over-Illustration," as cited in Bogardus, *Pictures and Texts,* 71–72.

47. Edwin Carlile Litsey, *Critic* 48, no. 6 (June 1906): 498–99, as cited in Harris, "Pictorial Perils," 7.

48. [Ogden], "Knowledge on Sight," 41–42, as cited in Harris, "Pictorial Perils," 10–11.

49. Peggy Samuels and Harold Samuels, *Frederic Remington: A Biography* (Garden City, N.Y.: Doubleday, 1982), 121–22.

50. Smith, Hastedt, and Dyal, introduction to *American Book and Magazine Illustrators to 1920,* xvi.

51. For more on the habits of these illustrators who worked for multiple publications, see Ken Kempke, "Edwin A. Abbey," in Smith, Hastedt, and Dyal, *American Book and Magazine Illustrators to 1920,* 4–7.

52. Smith, Hastedt and Dyal, introduction to *American Book and Magazine Illustrators to 1920,* xvi.

53. Eggleston, *Household History,* v–vi.

54. Samuels and Samuels, *Frederic Remington,* 78–79.

55. Melissa J. Webster, "Frederic Remington," in Smith, Hastedt, and Dyal, *American Book and Magazine Illustrators to 1920,* 286–98. Original copies of several illustrations in Eggleston's volume can be found at the Remington Art Museum, Ogdensburg, New York.

56. "Incorrect School Books," *Florida Times-Union,* 21 October 1893, as collected in Box 1, Publications and Accounts, Eggleston Papers, Cornell University Archives, Ithaca, New York.

57. C. F. Tucker Brooke, *Chicago Dial* 51, as cited in Harris, "Iconography and Intellectual History," 203.

58. Levine, *Highbrow/Lowbrow,* 47–48.

59. Trachtenberg, *Reading American Photographs,* 77.

60. Shi, *Facing Facts,* 128.

61. William Dean Howells, *A Hazard of New Fortunes* (New York: Harper & Brothers, 1889), 11.

62. Congdon, "Over-Illustration," as cited in Harris, "Iconography and Intellectual History," 204.

63. "Newspaper Pictures," *Nation,* 27 April 1893, 307. See also John Hopkins Denison, "How to Use Objects as Illustrations," *Chautauquan* 27, no. 1 (April 1898): 34.

64. Sidney Fairfield, "Tyranny of the Pictorial," *Lippincott's Monthly Magazine* 55 (1895): 863–64, as cited in Bogardus, *Pictures and Texts,* 72.

65. Thomas Haskell, *The Emergence of Professional Social Science: The American Social Science Association and the Nineteenth-Century Crisis of Authority* (Urbana: University of Illinois Press, 1977).

66. For more on the rise of the profession of history, see John Higham, *History: Professional Scholarship in America* (Baltimore: Johns Hopkins University Press, 1965), 6–25, and Peter Novick, *That Noble Dream: The "Objectivity Question" and the American Historical Profession* (New York: Cambridge University Press, 1988), 47–60.

67. On the origins of the American Historical Association, see American Historical Association Papers, Manuscript Division, Library of Congress, Washington, D.C., esp. vol. 1 (1886). See

also J. F. Jameson, "Early Days of the American Historical Association, 1884–1895," *American Historical Review* 40 (1934): 1–5.

68. Herbert B. Adams, "Report of the Organization and Proceedings, Saratoga, September 9–10, 1884," in *Papers of the American Historical Association* (New York: G. P. Putnam's Sons, 1885), vol. 1, no. 1, p. ii.

69. *Boston Herald*, 7 September 1884, as excerpted in *Papers of the American Historical Association*, vol. 1, no. 1, p. 9.

70. Andrew D. White, "On Studies in General History and the History of Civilization," *Papers of the American Historical Association*, vol. 2, no. 1, p. 25.

71. R. H. Darby, "Is History a Science," *Papers of the American Historical Association* 5:80.

72. Henry Charles Lea, "Ethical Values in History," *American Historical Association Annual Report* (Washington, D.C.: GPO, 1903), 1:60.

73. C. M. Andrews, "These Forty Years," *American Historical Review* 30 (January 1925): 225, 22, 228, 230, 237, 238.

74. Jules Champfleury, *Histoire de la caricature antique* (1865), xi–xii, and Johan Huizinga, *Verzamelde Werken*, 9 vols. (Haarlem, 1948–53), 2:19, as cited in Haskell, *History and Its Images*, 373, 491.

75. Harris, "Iconography and Intellectual History," 200.

76. Ames, "Pictures," 8–10.

77. Harris, "Pictorial Perils," 3.

78. Larned, *Literature of American History*, 284, 287.

79. Joel Dorman Steele and Esther Baker Steele, *A Popular History of the United States of America* (New York: A. S. Barnes, 1885).

80. Larned, *Literature of American History*, pt. 2, pp. 22–23.

81. See Anthony Comstock, *Traps for the Young* (1883). For more on the relationship of pictures and children, see Morgan, *Protestants and Pictures*, 217–23.

82. "Abstract of Dr. Hart's Paper," *Papers of the American Historical Association*, 2 vols. (New York: G. P. Putnam's Sons, 1888), vol. 2, no. 1, pp. 19–20.

83. "Secretary's Report," *Papers of the American Historical Association* 1, no. 1 (1885): 33.

84. Charles Henry Hart, "Frauds in Historical Portraiture, Spurious Portraits of Historical Personages," *Annual Report of the American Historical Association for the Year 1913* 1 (1915): 87–89.

85. For more on Wilson as historian, see Marjorie L. Daniel, "Woodrow Wilson—Historian," *Mississippi Valley Historical Review* 21 (December 1935): 361–74; Louis M. Sears, "Woodrow Wilson," in *The Marcus W. Jernegan Essays in American Historiography*, ed. William T. Hutchinson (Chicago: University of Chicago Press, 1937), 102–21; Henry W. Bragdon, *Woodrow Wilson: The Academic Years* (Cambridge: Harvard University Press, 1967).

86. Woodrow Wilson to Frederick Jackson Turner, 21 January 1902, *The Papers of Woodrow Wilson*, ed. Arthur S. Link (Princeton, N.J.: Princeton University Press, 1972), 12:240.

87. Wilson, "On the Writing of History," *Century Magazine* 50 (September 1895): 788–93.

88. Ibid.

89. On the periodical form and the rise of the modern aesthetic, see Shi, *Facing Facts*, 294–98.

90. Woodrow Wilson to Charles Scribner, 28 February 1899, *Papers of Woodrow Wilson* 11:108.

91. Woodrow Wilson to Richard Watson Gilder, 21 November 1899, ibid. 11:283.

92. Harper and Brothers to Woodrow Wilson, 27 January 1900, ibid. 11:380. See also Woodrow Wilson to Ellen Axson Wilson, 21 November 1899, ibid. 11:284–85.

93. Woodrow Wilson to Robert Bridges, 12 January 1900, ibid. 11:368–69; R. W. Gilder to Woodrow Wilson, 24 December 1899, ibid. 11:353.

94. Woodrow Wilson to Robert Underwood, 12 January 1900, ibid. 11:366–68.

95. Walter Hines Page to Woodrow Wilson, 23 December 1899, ibid. 11:349–51.

96. Woodrow Wilson to Henry Mills Alden, 22 January 1900, ibid. 11:377–79.

97. Henry Mills Alden to Woodrow Wilson, 9 January 1900, ibid. 11:359.

98. 13 February 1900, ibid. 11:409; The original contract and an amendment may be found in Harper and Brothers to Woodrow Wilson, 16 and 17 February 1900, ibid. 11:416–20.

99. Woodrow Wilson to John Franklin Jameson, 21 February 1900, ibid. 11:431.

100. Woodrow Wilson to Henry Mills Alden, 20 March 1900, ibid. 11:522–23; Henry Mills Alden, 26 March 1900, ibid. 11:527–28.

101. Henry Mills Alden to Woodrow Wilson, 13 March 1900, ibid. 11:510.

102. Wilson's suggestion is referenced in a letter from him to his editor, 3 April 1900, ibid. 11:531.

103. Jussim, *Visual Communication and the Graphic Arts*, 117. See also Elizabeth H. Hawkes, "Howard Pyle," in Smith, Hastedt, and Dyal, *American Book and Magazine Illustrators to 1920*, 274–85. See also Henry C. Pitz, *Howard Pyle: Writer, Illustrator, Founder of the Brandywine School* (New York: Clarkson N. Potter, 1975).

104. Hawkes, "Howard Pyle," 279.

105. "Art and Portraits," *New York Times*, 10 February 1898, 6, as cited in Mark Thistlethwaite, "A Fall from Grace: The Critical Reception of History Painting, 1875–1925," in Ayers, *Picturing History*, 188.

106. Samuel Isham, *History of American Painting*, 504, as cited in Thistlethwaite, "Fall from Grace," 188–89.

107. Hawkes, "Howard Pyle," 280.

108. Woodrow Wilson to Howard Pyle, 31 October 1900, *Papers of Woodrow Wilson* 12:31. For more on Wilson's biography of Washington, see Woodrow Wilson, "In Washington's Day," *Harper's Magazine* 92 (January 1896): 168–89; "Colonel Washington," ibid. (March 1896): 549–73; "At Home in Virginia," ibid. (May 1896): 931–54; "General Washington," ibid. 93 (July 1896): 165–90; "First in Peace," ibid. (September 1896): 498–512; and "The First President of the United States," ibid.

(November 1896): 843–67. These articles were later published in revised form in *George Washington* (New York: Harper & Brothers, 1897).

109. Howard Pyle to Woodrow Wilson, 32 October 1900, *Papers of Woodrow Wilson* 12:29.

110. Henry Mills Alden, "Editor's Study," *Harper's Magazine* 102 (January 1901): 322.

111. Woodrow Wilson, "Colonies and Nation. A Short History of the People of the United States. I.—Before the English Came. II.—The Swarming of the English—The Virginia Company. III.—New Netherlands and New Plymouth," *Harper's Magazine* 102 (January 1901), 173–203, esp. 173. The other articles in the series included "The Province of Maryland," "The Expansion of New England," and "The Civil Wars and the Commonwealth," ibid. 102 (February 1901): 335–69; "The Restoration. New Jersey and Carolina," ibid. 102 (March 1901): 529–54; "The Revolution. Common Undertakings," ibid. 102 (April 1901): 709–34; "Common Undertakings," ibid. 102 (May 1901): 903–18; "Common Undertakings," ibid. 103 (June 1901): 115–30; "The Parting of the Ways," ibid. 103 (July 1901): 285–300; "The Parting of the Ways, ibid. 103 (August 1901): 465–74; "The Approach of the Revolution," ibid. 103 (September 1901): 639–54; "The War of Independence," ibid. 103 (October 1901): 791–807; "The War of Independence," ibid. 103 (November 1901): 933–43; and "The Coming of Peace," ibid. 104 (December 1901): 104–10.

112. Henry Mills Alden to Woodrow Wilson, 8 January 1901 and 14 February 1901, *Papers of Woodrow Wilson* 12:69, 91.

113. Howard Pyle to Woodrow Wilson, 18 December 1895, ibid. 9:364–65.

114. Howard Pyle to Woodrow Wilson, 5 October 1895, ibid. 9:324.

115. Howard Pyle to Woodrow Wilson, 11 January 1896, ibid. 9:377. See also Wilson's reply, Woodrow Wilson to Howard Pyle, 12 January 1896, ibid. 9:378–79.

116. Woodrow Wilson to Howard Pyle, 12 February 1896, ibid. 9:421–22. See also 22 February 1901, ibid. 12:97.

117. Howard Pyle to Woodrow Wilson, 23 October 1900, ibid. 12:29.

118. Woodrow Wilson to Howard Pyle, 28 March 1901 and 1 April 1901, ibid. 12:115, 117.

119. Howard Pyle to Woodrow Wilson, 23 October 1900, ibid. 12:29.

120. Howard Pyle to Woodrow Wilson, 5 February 1896, ibid. 9:406–7.

121. Woodrow Wilson to Howard Pyle, 7 February 1896, ibid. 9:413–14.

122. Howard Pyle to Woodrow Wilson, 30 November 1900, ibid. 12:38.

123. Woodrow Wilson to Howard Pyle, 1 December 1900, ibid. 12:39.

124. Howard Pyle to Woodrow Wilson, 3 December 1900, ibid. 12:39.

125. Howard Pyle to Woodrow Wilson, 31 March 1896 and 16 March 1896, ibid. 9:494–95, 488–89.

126. *Pearson's Magazine* (September 1907), as cited in Hawkes, "Howard Pyle," 280. See also Michael H. Bogart, "Artistic Ideals and Commercial Practices: The Problem of Status for American Illustrators," *Prospects* 15 (1990): 225–81.

127. Howard Pyle to Woodrow Wilson, 5 October 1895, *Papers of Woodrow Wilson* 9:323–24.

128. Woodrow Wilson to Howard Pyle, 7 March 1901, ibid. 12:103–4.

129. Woodrow Wilson to Howard Pyle, ibid. 9:495–96.

130. Woodrow Wilson to Howard Pyle, 7 October 1895, ibid. 9:324–25.

131. Wilson to Pyle, 7 February 1896, ibid. 9:413–14. For a similar exchange regarding *A History of the American People*, 5 vols. (New York: Harper & Brothers, 1902), see Howard Pyle to Woodrow Wilson, 23 February 1901, *Papers of Woodrow Wilson* 12:95–96.

132. Howard Pyle to Woodrow Wilson, 11 February 1896, *Papers of Woodrow Wilson* 9:418–19.

133. Howard Pyle to Woodrow Wilson, 6 March 1901, ibid. 12:103.

134. Henry Mills to Woodrow Wilson, 26 June 1900, ibid. 11:552.

135. Hawkes, "Howard Pyle," 279.

136. Woodrow Wilson to Howard Pyle, 23 December 1895, *Papers of Woodrow Wilson* 9:367–68.

137. William Milligan Sloane, "Review of George Washington," *New York Book Buyer* 13 (December 1896): 728–29.

138. Henry Mills Alden to Woodrow Wilson, 6 February 1901, *Papers of Woodrow Wilson* 12:90.

139. Woodrow Wilson to Edith Gittings Reid, 27 January 1901, ibid. 12:82–83.

140. Woodrow Wilson to Henry Mills Alden, 22 January 1900, ibid. 11:378.

141. Harper and Brothers to Woodrow Wilson, 27 January 1900, ibid. 11:380.

142. Woodrow Wilson to Henry Mills Alden, 8 January 1900, ibid. 11:358–59.

143. Woodrow Wilson to Ellen Axson Wilson, 22 July 1902, ibid. 14:38. See also Henry Mills Alden to Woodrow Wilson, 11 October 1900, ibid. 12:23.

144. C. H. Van Tyne, "History of the American People," *Annals of the American Academy of Political and Social Science*, 21 (May 1903): 473–76. Van Tyne was an instructor at the University of Pennsylvania.

145. See, for instance, Goldwin Smith to Woodrow Wilson, 10 March 1903, *Papers of Woodrow Wilson* 14:387.

146. Woodrow Wilson to William Jackson, 13 January 1903, ibid. 14:327.

147. William Edmond Pulsifer, 27 February 1903, ibid. 14:379.

148. George McLean Harper, "A History of the American People," *New York Book Buyer* 25 (January 1903): 589.

149. Jenny Davidson Hibben to Woodrow Wilson, 9 August 1903, *Papers of Woodrow Wilson* 14:551.

150. Howard Pyle to Stanley Arthurs, 11 January 1911, as cited Jussim, *Visual Communication and the Graphic Arts*, 147.

151. Hawkes, "Howard Pyle," 282.

152. Woodrow Wilson to Harper and Brothers, 14 September 1896, *Papers of Woodrow Wilson* 10:3.

153. Harper and Brothers to Woodrow Wilson, 28 September 1896 and 2 October 1896, ibid. 10:4.

154. Woodrow Wilson, "Notes for a Letter to Harper & Brothers," 26 April 1901, ibid. 12:134.

155. Woodrow Wilson to Cyrus Hall McCormick, 21 August 1902, ibid. 14:98–99. For the McCormick family's response, see Frederick A. Steuert to Harper and Brothers, 25 August 1902, ibid. 14:108.

156. Harper and Brothers to Woodrow Wilson, 8 May 1901, ibid. 12:142–43.

157. Woodrow Wilson, "Notes for a Letter to Harper & Brothers," 26 April 1901, ibid. 12:134.

158. Woodrow Wilson to Frederick Jackson Turner, 21 January 1902, ibid. 12:240.

159. Ibid.

160. Frederick Jackson Turner to Woodrow Wilson, 1 July 1902, ibid. 12:473.

161. Woodrow Wilson to Frederick Jackson Turner, 21 January 1902, ibid. 12:240.

162. Van Tyne, "History of the American People," 474.

163. MacDonald, "History of the American People," 118.

164. Charles McLean Andrews, "A History of the American People," *Independent* 54 (11 December 1902): 2959.

165. MacDonald, "History of the American People," 118.

166. Francis Shepardson, "History of the American People," *Chicago Dial* 33 (1 December 1902): 393–95. Shepardson was a historian and secretary to the President of the University of Chicago.

167. Van Tyne, "History of the American People," 473–76.

168. George Beer, "History of the American People," *New York Critic* 42 (February 1903): 172–76.

169. Van Tyne, "History of the American People," 473–76.

170. William MacDonald, "History of the American People," *Nation* 76 (5 February 1903): 117–18. MacDonald was a professor of American history at Brown University.

171. Andrews, "History of the American People," 2957–59.

172. For more on Wilson's relationship with Charles M. Andrews, see A[braham] S. Eisenstadt, *Charles McLean Andrews: A Study in American Historical Writing* (New York: Columbia University Press, 1956).

173. Frederick Jackson Turner, "History of the American People, *American Historical Review* 8 (July 1903): 763. Turner was professor of American history at the University of Wisconsin.

174. Ibid., 762–65.

175. Sigmund Freud and William C. Bullitt, *Thomas Woodrow Wilson: Twenty-Eighth President of the United States: A Psychological Study* (Boston: Houghton Mifflin, 1967). See also Alexander L. George and Juliette L. George, *Woodrow Wilson and Colonel House: A Personality Study* (New York: Dover Publications, 1956).

176. Ray Allen Billington, *Frederick Jackson Turner: Historian, Scholar, Teacher* (New York: Oxford University Press, 1973), 521 n. 28.

177. Ellen Axson Wilson to Woodrow Wilson, 30 April [1903], *Papers of Woodrow Wilson* 14:438–39 and 439 n. 3.

178. Billington, *Frederick Jackson Turner*, 176.

179. Francis Ignatius Drobinski to Woodrow Wilson, 2 February 1912, 29 February 1912, *Papers of Woodrow Wilson* 14:131–32, 219; Nicholas L. Piotrowski to Woodrow Wilson, ibid. 14:241–42, and Woodrow Wilson to Nicholas L. Piotrowski, 11 March 1912, ibid. 14:242–43; and Woodrow Wilson to Marcus Braun, 7 February 1912, ibid. 14:135–36.

180. Woodrow Wilson to John Arthur Aylward, 7 March 1912, ibid. 14:226.

181. Woodrow Wilson, "An Address on Robert E. Lee at the University of North Carolina," 19 January 1909, ibid. 18:638–39.

7. "The Subjective Eye and the Conventionalizing Hand": Photography and Realism

1. Morgan, *Protestants and Pictures*, 19.

2. For more on the numbers of pictorial histories marketed after 1900, see Joseph Sabin, *Bibliotheca Americana: A Dictionary of Books Relating to America, from Its Discovery to the Present Time. Begun by Joseph Sabin, Continued by Wilberforce Eames, and Completed by R.W.G. Vail for the Bibliographical Society of America*, 29 vols. (New York: various publishers, 1868–1936) and *Writings on American History, 1902–[1913]: A Bibliography of Books and Articles on United States History Published during the Years 1902–[1913]*, 10 vols. (various publishers, 1903–14).

3. For more on the "skeptics" and a definition of their credo, see Novick, *That Noble Dream*, 167–205, esp. 167.

4. "Science in Its Relations to Art," *New Path* 2 (November 1865): 169–70, as cited in Shi, *Facing Facts*, 131; see also 153.

5. Kenyon Cox, "The Field of Art: The Lesson of Photography," *Scribner's Monthly* 23 (May 1898): 637–38.

6. Jussim, *Visual Communication and the Graphic Arts*, 238.

7. Shi, *Facing Facts*, 96.

8. Trachtenberg, *Reading American Photographs*, xiv. The Whitman quote comes from Horace Traubel, *With Walt Whitman in Camden*, 6 vols. (New York: Mitchell Kennerly, 1914), 3:552–53, as cited in Trachtenberg, *Reading American Photographs*, 60.

9. Lake Price, *American Journal of Photography*, n.s., 1 (1858–59): 148, as cited in Robert Taft, *Photography and the American Scene: A Social History, 1839–1889* (New York: Dover Publications, 1938), 137.

10. Jussim, *Visual Communication and the Graphic Arts*, 289. For more on the relationship between photography and history as Cox and others understood it, see "Mirrors of the Past: Historical Photography and American History," in Thomas J. Schlereth, *Artifacts and the American Past* (Nashville: American Association for State and Local History, 1980), 11–47.

11. John Clark Ridpath, *Royal Photograph Gallery* (Philadelphia: Historical, 1893), [3–4].

12. Ibid., [4].

13. Benson Lossing, "The Kodak" [c. 1890], LS 77, Lossing Papers–Huntington.

14. Benson J. Lossing, *A History of the Civil War: Illustrated with Re-

productions of the Brady War Photographs (New York: War Memorial Association, 1912).

15. Cox, "Field of Art," 637–38.

16. Trachtenberg, *Reading American Photographs*, 12.

17. For a listing of history books illustrated by photos, see Julia Van Haaften, "'Original Sun Pictures': A Check List of the New York Public Library's Holdings of Early Works Illustrated with Photographs, 1844–1900," *Bulletin of the New York Public Library* 80 (Spring 1977): 355–415.

18. R. M. Devens, *Our Land and Country: Life and History, Treasures and Splendors, a Panorama of 400 Years' American Progress, 1492–1892* (Springfield, Mass.: C. A. Nichols, 1892), i–ii. I am grateful to Maggi Smith-Dalton for alerting me to this book.

19. Ibid. See also Jussim, *Visual Communication and the Graphic Arts*, 74.

20. Bogardus, *Pictures and Texts*, 97.

21. Harris, "Iconography and Intellectual History," 202.

22. For more on the "contemporizing" quality of photographs, see Jussim, *Visual Communication and the Graphic Arts*, 211.

23. William M. Sloane, "Substance and Vision," as cited in Novick, *That Noble Dream*, 100.

24. Shi, *Facing Facts*, 189.

25. This phrase, "the New Messiah" was used contemptuously by Baudelaire to condemn photography's influence on the creative arts. See Jussim, *Visual Communication and the Graphic Arts*, 7.

26. Edward S. Ellis, *Seth Jones; or, The Captives of the Frontier* (New York: Beadle, 1860).

27. Paul Eugene Camp, "Edward S. Ellis," in *American Writers for Children Before 1900*, vol. 42, *Dictionary of Literary Biography*, ed. Glenn E. Estes (Detroit: Gale Research, 1985), 166.

28. Edward S. Ellis, *The Youth's History of the United States from the Discovery of America by the Northmen to the Present Time*, 4 vols. (New York: Cassell, 1886–87). Interestingly, while Ellis modeled his works after the Peter Parley tales, he did not believe that Samuel Goodrich was their author. "It is a fact not generally known that Hawthorne was the author of the educational and juvenile works which appeared under the pen name of 'Peter Parley' (S. G. Goodrich)," he wrote in Edward S. Ellis, *The History of Our Country From the Discovery of America to the Present Time*, 8 vols. (Philadelphia: History Company, 1899), 7:1746–47.

29. Robert W. Johannsen, *The House of Beadle and Adams and Its Dime and Nickel Novels* (Norman: University of Oklahoma Press, 1950), 1:31–37, 2:93–100.

30. Ellis, *History of Our Country* 1:1, 10.

31. Shi, *Facing Facts*, 31.

32. Ellis, *History of Our Country* 6:1503–21, esp. 1503.

33. Trachtenberg, *Reading American Photographs*, xv, 233.

34. Ellis, *History of Our Country* 6:1492–95.

35. *New York Times*, 26 October 1935, p. 14, as cited in Taft, *Photography and the American Scene*, 317.

36. For more on the work of Davis, see "John Steeple Davis (1844–1917)," in *Arts in America: A Bibliography*, ed. Bernard

Karpel, 4 vols. (Washington, D.C.: Smithsonian Institution Press, 1979), 3:54.

37. Kenneth Ames, "Afterward: History Pictures Past, Present, and Future," in Ayres, *Picturing History*, 228–29.

38. Oliver Wendell Holmes, "Stereoscope and Stereograph," *Atlantic Monthly* 3 (1859): 747, as cited in Bogardus, *Pictures and Texts*, 95–96. For more on the "surreal" aspect of photographs, see Susan Sontag, "Shooting America," *New York Review* (18 April 1974): 17–24.

39. Bogardus, *Pictures and Texts*, 95–96.

40. Roland Barthes, "Rhetoric of the Image," in *Image, Music, Text*, by Roland Barthes (New York, 1977), 32–52, as cited in Trachtenberg, *Reading American Photographs*, 5–6.

41. Joshua C. Taylor, *William Page: The American Titan* (Chicago, 1957), 225–26, as cited in Trachtenberg, *Reading American Photographs*, 36.

42. Fairfield, "Tyranny of the Pictorial," as cited in Bogardus, *Pictures and Texts*, 104.

43. Jussim, *Visual Communication and the Graphic Arts*, 73.

44. Alfred Stieglitz, "Pictorial Photography," *Scribner's Magazine* 26 (November 1899): 528–37, as cited in Trachtenberg, *Reading American Photographs*, 182–83, 174, 172.

45. Taft, *Photography and the American Scene*, 324–25.

46. Marzio, *Democratic Art*, 10–11.

47. Thistlethwaite, "Fall from Grace," 180.

48. Taft, *Photography and the American Scene*, 319.

49. For a discussion of this understanding of history relative to images of Christ, see Morgan, *Protestants and Pictures*, 262, 287–88.

50. In particular, see the debate between Frederic Remington and Eadweard Muybridge as discussed in Jussim, *Visual Communication and the Graphic Arts*, 214–25.

51. Trachtenberg, *Reading American Photographs*, 5–6.

52. Joseph Pennell, *The Graphic Arts: Modern Men and Modern Methods* (Chicago: University of Chicago Press for the Art Institute of Chicago, 1921), 130.

53. "Holiday Books," *Atlantic Monthly* 67 (January 1891): 121, as cited in Jussim, *Visual Communication and the Graphic Arts*, 96.

54. For a good discussion of how such manipulations occurred in the photographic work of Frederic Remington, see Jussim, *Visual Communication and the Graphic Arts*, 211.

55. *Century*, n.s., 18 (June 1890): 312. See also "Wood Engraving and the Scribner's Prizes," in *Scribner's Magazine* 21 (April 1881): 937–45.

56. The "Critic," in "Book Illustration," Philip Gilbert Hamerton, *Portfolio Papers* (Boston: Roberts, 1889), 334–35, as cited in Jussim, *Visual Communication and the Graphic Arts*, 235. For other examples of such "imaginary dialogues," see Francis Hopkinson Smith, *American Illustrators*, 5 pts. (New York: C. Scribner's Sons, 1892).

57. For more on the reactions of professionals to the use and misuse of photographs in historical works like those of Ellis in the 1890s, see the discussion of Michael Lesy's seminar conducted at Yale and Emory in the 1970s in Marsha Peters and Bernard

Mergen, "'Doing the Rest': The Uses of Photographs in American Studies," *American Quarterly* 29, no. 3 (1977): 298–99.

58. Ellis, *History of Our Country* 6:1588–90.

59. Morgan, *Protestants and Pictures*, 277.

60. Ellis, *History of Our Country* 6:1588–90.

61. Trachtenberg, *Reading American Photographs*, 6.

62. Edwin E. Sparks, "Ellis, Edward Sylvester," in Larned, *Literature of American History*, 279.

63. Taft, *Photography and the American Scene*, 448.

64. Jussim, *Visual Communication and the Graphic Arts*, 308. Jussim uses the quote to suggest that images and "words" are symbolic reports, raising an issue with which pictorial historians wrestled only rarely in the nineteenth century; that is, whether narrative strategies are any more objective than visual representations.

65. Morgan, *Protestants and Pictures*, 198. (The normally discreet *Dictionary of American Biography* noted that Ellis wrote so many books of history that they were "beyond any patient counting." "Edward Sylvester Ellis," in *Dictionary of American Biography*, ed. Allen Johnson and Dumas Malone [New York: Charles Scribner's Sons, 1943], 6:102–3.)

66. An exception would be P. Dorf, *Visualized History Series: Ancient and Medieval History* (New York: Oxford Book Company, 1933), v–vi.

67. Morgan, *Protestants and Pictures*, 196.

68. Edward Channing and Albert Bushnell Hart, *Guide to the Study of American History* (Boston: Ginn and Company, Athenaeum Press, 1897), 45–46.

69. "Project of a Co-operative History," *American Historical Review* 6, no. 3. (April 1901): 425–26.

70. For more on the discussion concerning AHA sponsorship of the project, see *Annual Report of the American Historical Association for the Year 1900 and 1901* (Washington, D.C.: GPO, 1901, 1902) and [Notes on Washington Meeting], *American Historical Review* 7, no. 3 (April 1902): 433. See also John Higham, *The American Nation: A History—An Appraisal*, publisher's brochure, J. & J. Harper Editions, Fall–Winter 1968–69.

71. Carol F. Baird, "Albert Bushnell Hart: The Rise of the Professional Historian," in *Social Sciences at Harvard, 1860–1920: From Inculcation to the Open Mind* (Cambridge: Harvard University Press, 1965), 166–67.

72. Albert Bushnell Hart, ed., *The American Nation: A History*, 27 vols. (New York: Harper & Brothers, 1903–7), 1:xv–xviii.

73. Ibid. 1:xviii.

74. Albert Bushnell Hart to Phayre, 28 November 1904, Folder 1, "Publishers, Harper & Brothers," HUG 4448.29, Box 2, Papers of Albert Bushnell Hart, Harvard University Archives (hereafter cited as Papers of Albert Bushnell Hart).

75. Albert Bushnell Hart, ed., *Harper's Atlas of American History, with Map Studies by Dixon Ryan Fox* (New York: Harper & Brothers, 1920).

76. Albert Bushnell Hart to [T. H.] Sears, 23 January 1904, HUG 4448.29, Box 2, Papers of Albert Bushnell Hart.

77. Frank Weitenkampf, "Pictorial Documents as Illustrating American History," *History Teacher's Magazine* 8 (February 1914): 48–51. See also Schlereth, *Artifacts and the American Past*, 15.

78. Ames, "Afterward," 228.

79. *Boston Sunday Globe*, 10 May 1885, as cited in Jussim, *Visual Communication and the Graphic Arts*, 90.

80. Guy Carleton Lee, "Editor's Introduction," in *The History of North America*, 20 vols. (Philadelphia: George Barrie & Sons), 1:ix.

81. Ibid. 1:v, viii. For more on Lee and his intellectual projects, see Guy Carleton Lee, Redpath Chautauqua Collection, Special Collections Department, University of Iowa Libraries, Iowa City, Iowa.

82. Ibid. 1:vi, vii, x, xi, xii.

83. Albert Bushnell Hart to [T. H.] Sears, 23 January 1904, Folder 1, "Publishers, Harper & Brothers," HUG 4448.29, Box 2, Papers of Albert Bushnell Hart.

84. Albert Bushnell Hart to [T. H.] Sears, 21 January 1904, Papers of Albert Bushnell Hart.

85. Colin Campbell, *The Romantic Ethic and the Spirit of Modern Consumerism* (Oxford: Basil Blackwell, 1987), 187–90, as cited in Morgan, *Protestants and Pictures*, 17.

86. Hart to Sears, 23 January 1904, HUG 4448.29, Box 2, Papers of Albert Bushnell Hart.

87. [J. T.] Phayre to Albert Bushnell Hart, 4 August 1904, Papers of Albert Bushnell Hart.

88. Albert Bushnell Hart to [F. A.] Duneka, 30 October 1907, Folder 2, Papers of Albert Bushnell Hart.

89. Albert Bushnell Hart to [T. H.] Sears, 23 January 1904, Papers of Albert Bushnell Hart.

90. J.[ulian] H.[awthorne], "Review of Edward Eggleston's *The Transit of Civilization from England to America in the Seventeenth Century*," as collected in Scrapbook 2, Banc MSS 72/236z, Hawthorne Family Papers, Bancroft Library, Berkeley.

91. Edwin E. Sparks, [review of Julian Hawthorne's *History of the United States*], in Larned, *Literature of American History*, 281.

92. Julian Hawthorne, *Hawthorne's United States* (New York: P. F. Collier, 1898), 102–3.

93. Trachtenberg, *Reading American Photographs*, 27.

94. Thomas A. Janvier, "New York Slave-Traders," in *Harper's New Monthly Magazine* 90 (December 1894–May 1895): 293–307.

95. Edward Eggleston, *The Transit of Civilization: From England to America in the Seventeenth Century* (New York: D. Appleton, 1900), 302–7.

96. For information on the sales of these and other such books, see Appendix C in Jack Carter Thompson, "Images for Americans in Popular Survey Histories, 1820–1912" (Ph.D. diss., University of Michigan, Ann Arbor, 1976).

97. W. H. Holmes, [review of vol. 2 of the *American Nation: A History*], *American Historical Review* 10 (April 1905): 638.

98. Levine, *Highbrow/Lowbrow*, 160–61.

99. Higham, *History*, 20.

Epilogue: Endings

1. As Neil Harris has noted, "The single generation of Americans living between 1885 and 1910 went through an experience of visual reorientation that had few earlier precedents." See Harris, "Iconography and Intellectual History," 199.

2. Claude Bowers, introduction to *The Story of America in Pictures*, by Alan C. Collins (1935; reprint, Garden City, N.Y.: Doubleday, 1953), xi.

3. I have borrowed the term "visual propaganda" from Morgan, *Protestants and Pictures*, 251–52, 261.

4. James Truslow Adams, ed., *Album of American History*, 4 vols. (New York: Charles Scribner's Sons, 1944), 1:v–iv.

5. See, for instance, the categories for historical literature in *Publisher's Weekly* and *Book Review Digest* for the first decade of the twentieth century.

6. "Cameras *that* Do *Not* Lie," in "Let's Tell the Truth: The War in Pictures," *Leslie's Illustrated Weekly Newspaper*, 22 June 1918, 857. For more on the duration of *Leslie's Weekly* as a viable illustrated newspaper, see Frank Luther Mott, *American Journalism: A History of Newspapers in the United States through 250 Years, 1690–1940* (New York: Macmillan, 1941), 378–79, 591.

7. Ralph Gabriel, ed., *The Pageant of America*, 15 vols. (New Haven, Conn.: Yale University Press, 1925), 1:345.

8. Adams, *Album of American History* 1:v–vi.

9. Higham, *History*, 81–84.

10. Bowers, introduction to Collins, *Story of America in Pictures*, xi.

11. Ibid.

12. For more on the debate regarding the effects of television on cultural and historical literacy, see Christopher Lasch, *The Culture of Narcissism: American Life in an Age of Diminishing Expectations* (New York: W. W. Norton, 1978), 128, 118–22. For a more generalized discussion of the notion of cultural literacy, see Allan Bloom, *The Closing of the American Mind* (New York: 1987), 185–88, and E. D. Hirsch Jr., Joseph Kett, and James Trefl, "What Literate Americans Know: A Preliminary List," in *Cultural Literacy: What Every American Needs to Know*, ed. E. D. Hirsch Jr. (Boston, Houghton Mifflin, 1987), 146–215.

13. Thomas Dixon, *The Clansman: An Historical Romance of the Ku Klux Klan* (New York: Doubleday, Page, 1905).

14. For more on Wilson's reaction to the film, see 21 February 1915, *Papers of Woodrow Wilson* 32:267 n. 1. See also Thomas Dixon Jr. to Woodrow Wilson, 20 February 1915, and David Wark Griffith to Woodrow Wilson, 2 March 1915, ibid. 32:310–11. Monroe Trotter among others wished for Wilson to condemn "Birth of a Nation" publicly, which he never did, although his public relations advisor, Joseph P. Tumulty, offered a partial retraction. For more on this episode, see Daniel J. Leab, *From Sambo to* SUPERSPADE: *The Black Experience in Motion Pictures* (Boston: Houghton Mifflin, 1975), 23–39.

15. "Edward S. Ellis," in *The National Cyclopaedia of American Biography* (New York: James T. White, 1926), 19:205.

16. Edward Ellis, *The Life of Colonel David Crockett* (Philadelphia: Henry T. Coates, 1884).

17. "Davy Crockett: Oliver Morosco Photoplay Co.," *Motion Picture Magazine*, September 1916, 89–98, as cited in Norman Bruce, "A Newly Discovered Silent Film," in Lofaro, *Davy Crockett*, 125–36.

18. [Review of "Davy Crockett"], 4 August 1916, *Variety Film Reviews, 1907–1920* (New York: Garland, 1983), vol. 1, as cited in Lofaro, *Davy Crockett*, 115.

19. For more on the early history of filmmaking and the reaction of turn-of-the-century audiences, see Thomas Cripps, *Slow Fade to Black: The Negro in American Film, 1900–1942* (New York: Oxford University Press, 1977), 8–12.

20. [Review of "Davy Crockett"], 4 August 1916, as cited in Lofaro, *Davy Crockett*, 115.

21. For more on these relationships, see Roland Barthes, *Image, Music, Text* (New York: Hill and Wang, 1977), 25–26, 46.

Index

colorization process in, 163; cost ratio of pictorial to printed pages in, 176; criticisms of, 120–21, 173–76, 182–83, 204–5, 208; defined, 230; demise of, 208, 230–36, 237, 239; didactic purposes of, 52; diversification of function in, 141; dropoff in sales of, 208; early efforts in producing, 14; emblematism of, 180; evaluative standard for, 227; expenses associated with, 176–77; general readers consumption of, 207; as genre, 62, 237–38, 242–43; golden age for, 161; identification of market for, 65; objectivity of, 133; obstacles to efficient production of, 40; overillustration of, 174–75, 176; photography in, 209–10, 213–14; portraits in, 40; professional attack on, 161–205; publishing during the centennial, 134–35; reception of, 177; recycling of illustrations in, 162; standardized look of, 110; transition of, 207; turn toward realism in, 102–6; unreliability of, 208

Pictorial History of America (Goodrich), 14–15, 16

Pictorial History of the Civil War in the United States (Lossing), 156; advertising campaign for, 111–13; chronological sequence of, 115; contents of, 114–15; Dawson's review of, 119–20; delayed publication of, 113–14, 120; failure of, 117; illustrations in, 115–16, 118, 139; "Pemberton and Grant" from, 116, **116**; reviews of, 117–19; sales of, 120; text of, 116

Pictorial History of the Great Civil War (Wilson), 134

Pictorial History of the United States (Frost), 21, 22, 23, 24; "Columbus in Chains" from, **32;** cost-cutting in illustrations for, 25–26; Croomer as primary illustrator and engraver of, 23–24, 57; "Death of Pulaski" from, 23–24, **24,** 26; "Death of Wolfe" from, **25;** defects of illustrations in, 24–25; frontispiece to volume 1 of, **28;** "General Thaddeus Kosciusko" from, 35, **36;** "General Wayne Defeating the Indians" from, 35, **36;** "George III in the First Year of His Reign" from, 35, **37;** "George Washington" from, **31;** head-letter emblem from, **29,** 30; illustrative content of, 26, 27, 28, 35, 52; "Lord North" from, **34,** 35; organization of, around the principle of liberty, 22; "Pocahontas Rescuing Captain Smith" from, **27,** 29; portraits in, 31, **31, 32,** 33, **33;** publisher shortcuts in, 35–36; "Scalping Knife" from, **29;** success of, 36

Pictorial History of the United States (Lossing): "Lincoln and His Cabinet" from, **114,** 115

Pictorial History of the United States (McCabe): re-release of *Centennial History of the United States* as, 170–71

Pictorial History of the United States (Northrop), 171

Pictorial History of the United States (Stephens), 133–35, 187

pictorial images, 13; acceptance of, in the United States, 11–12; children as market for, 13–14; copyright and, 26, 70; delay of, in publication, 109–10; development of, 17; distortion of, on publication, 108–9;

dominance of narrative by, 12; in eliciting reader response, 23; gleaning from history paintings, 13–14; for the historian, 18; in history books, 107–8; implications of, for history, 17; in popular history, 17–21; power of, 3, 61, 83–84, 87; public distrust of, 11; relationship between vernacular history and, 2; Walker's use of, 39

Picture Gallery of the National Century (Devens), 129

Pitz, Henry, 40

Pocahontas: illustrations of, 18–20, **27,** 29

Poe, Edgar Allen, 17

political broadsides, 128

political satire, 132

Pollard, Josephine: *The History of the United States, Told in One Syllable Words,* **164,** 164–65; pictorial histories of, 180

popular histories: of the Civil War, 117; pictorial mode in, 17–21; potential for sales, 125

Popular History of the United States (Mabie), 183

Popular History of the United States (Ridpath), 163

Popular History of the United States (Steele and Steele): "Assassination of President Garfield" in, 183–84, **184;** "Execution of a Spy at Kingston, New York" in, 183, 183–84

popular presses: illustrated books produced by, 4

Porter and Coates, firm of, 135–36

Portfolio of the World's Photographs (Ridpath), 210

portraits: in *History of the American People* (Wilson), 199; photographic, 223; in pictorial histories, 31, **31, 32,** 33, **33,** 40, **58**

Potter's American Monthly:

"Andrew Jackson" from, **122,** 124; format change in, 124; Lossing as editor of, 124, 125; "Mrs. Rachel Jackson" from, **123,** 124; name change from *American Historical Record,* 124

Poughkeepsie Telegraph, 42

Powell, William Henry, 79–81

Prang, Louis, 139, 165

pre-photographic imagery: failures of traditional, 210

Prescott, William Hickling, 21, 23

printing, 209; invention of, 209

professional historians: criticisms by, 180–82, 202

professional history, 239

publishers: problems between authors and, 41

Pulsifer, William, 198

Punch, 188

Putnam, G. P., 138

Pyle, Howard, 183, 188, 189, 190, 191–92, 238; collaboration between Wilson and, 190, 191, 193, 194–95, 196; illustrations by, in *Harper's Magazine,* **182,** 182–83, 235, **235;** illustrations by, in *History of the American People,* 191–95, **193, 194, 195,** 198, 199, 201; illustrations of, 208; rule of theatricality, 191

Quakers: illustrations of, 153, **154**

Ramble, Robert (pseudonym). *See* Frost, John

realism: in coverage of Civil War, 102–6

Recollections of a Lifetime (Goodrich), 14

Redfield, J. S., 43

Remarkable Events on the History of America (Frost), 22

Rembrandt, 183

Remington, Eva, 177

Remington, Frederic, 177–78, 215, 226, 238; illustrations